Humanity and inhumanity

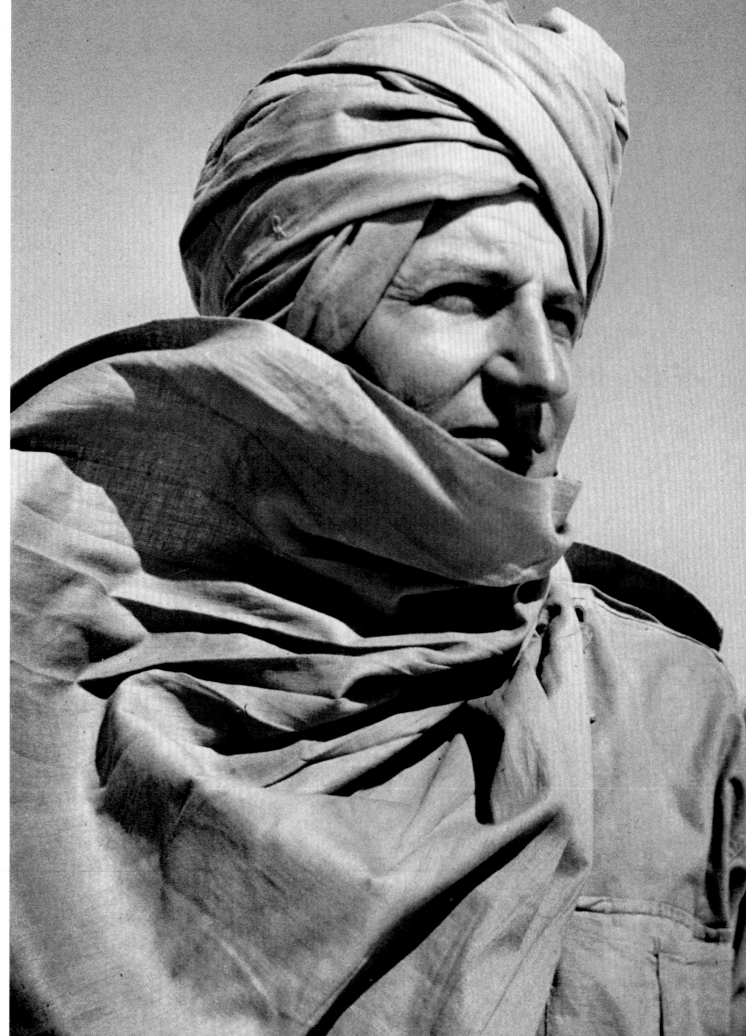

1941, Chad
George Rodger

Humanity and inhumanity **The photographic journey of George Rodger**

Text by Bruce Bernard

Picture research by Peter Marlow
in association with Magnum Photos

Foreword

Meeting George Rodger for the first time one wonders 'Who is he? What is his profession?' Certainly he does not look like a businessman in real estate or advertising nor an opera singer, despite his considerable presence. It is more credible that, with his fine figure, he is a gentleman farmer, the kind of man who would be using his camera - if he had one - to photograph his dogs and horses, and perhaps his family.

But George has used his many cameras with remarkable effect to record his visual reactions, often in dangerous situations. In spite of his impassive bearing, his emotions have become inscribed on film.

Many of his images contribute to our collective memory: the London Blitz, Bergen-Belsen, Paris the day after liberation. And George recorded the magnificent Nuba tribe long before Leni Riefenstahl and with infinitely more humanity.

George Rodger belongs to the great tradition of explorers and adventurers. Now, having returned to his roots, he has created a home in a Kent village, a warm nest for his family.

His work is a moving testimony through time and space.

Henri Cartier-Bresson

February 1994

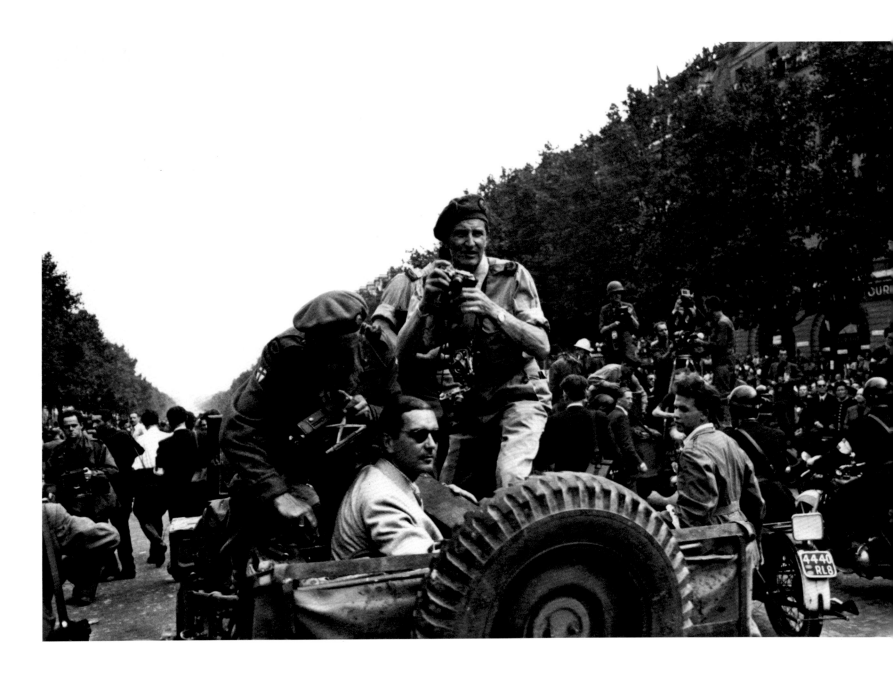

1944, Paris
George Rodger, photographed by Henri Cartier-Bresson during the liberation
of Paris. Both men, although they were ignorant of each other's identity at
the time of this photograph, were to become co-founders of Magnum.

1948, Uganda
A fisherman in the Nile at Laropi

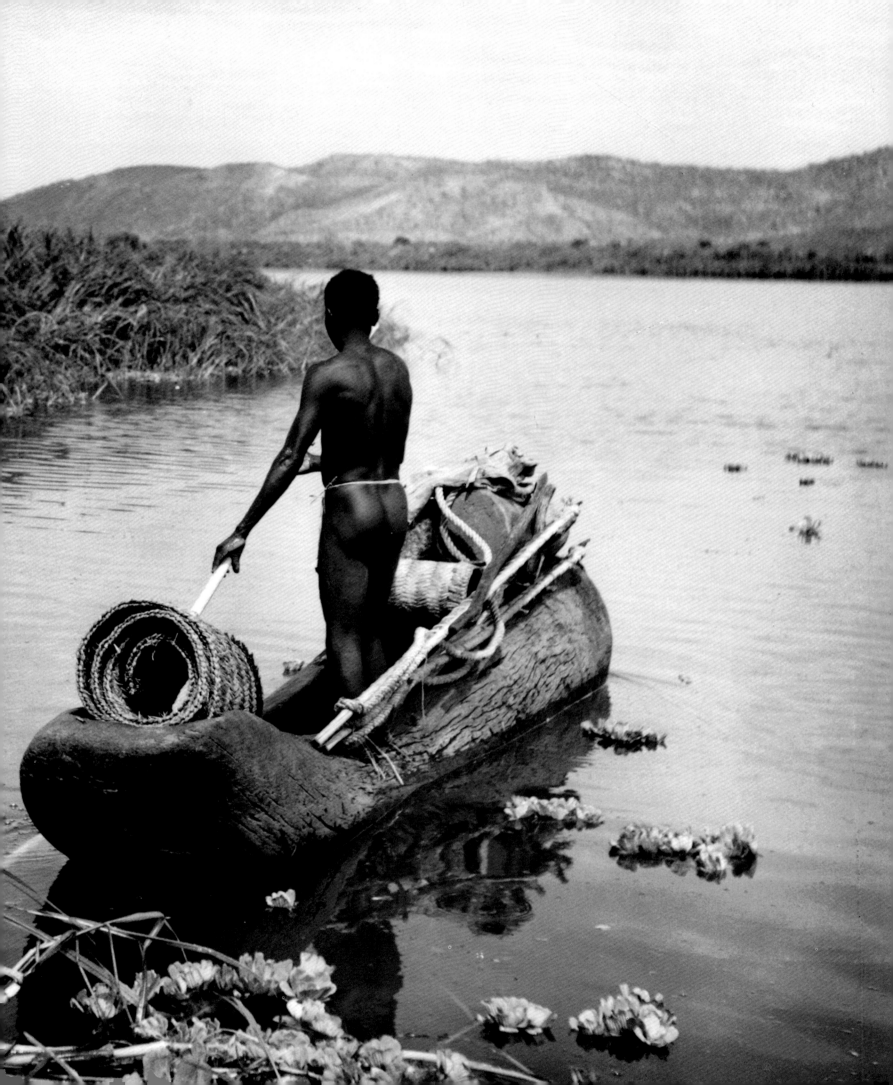

'Looking back over 50 years to my early days in photography, I see no burning urge to be a photographer, rather a sort of wonderment that I ever made the grade at all.'

Beginnings

So wrote George Rodger of his feelings about the very secure niche he has carved out for himself in the annals of photo-journalism. Rodger was the only British freelance photographer to travel with various armies to the battlegrounds of the Second World War, and he was later instrumental, with Robert Capa, David Seymour and Henri Cartier-Bresson, in founding the greatest post-war photo agency: Magnum Photos. Rodger insists that he has never been an artist, simply a recorder of the places and circumstances in which he has found himself. Yet he has of given us perhaps the most curiously vivid photograph of the bombing of London, as well as a particularly great image of Nuba wrestlers, among other very memorable pictures. This photo somehow stays more securely in the memory than any one by the brilliant former Nazi propagandist Leni Riefenstahl, who, much to Rodger's distaste, followed him to their territory 15 years later. George Rodger's career has consisted of finding a new and proudly self-effacing way of becoming a master photographer.

He was born in 1908 in Hale, Cheshire, of a Scottish Presbyterian father who was involved in the shipping business and the Lancashire cotton trade and a mother whose virtues had, in his own words 'certainly been noted by the Angel Gabriel'. He was educated at St Bees College, Cumbria, where he distinguished himself mainly as a brilliant rifle shot, and also for a prank with a harmless 'bomb' that was interpreted as a serious assassination attempt on a visiting grandee. He was also a keen and reckless horseman and found he had an overwhelming love of nature and the open air that would never leave him.

George Rodger's father, George F E Rodger, born in Selkirk, Scotland in 1873. He was a shipping agent and worked in the Lancashire cotton trade before retiring to a farm in Cheshire. He died in 1956.

But his father's business did not prosper and George was sent to work on a farm owned by well-to-do relatives in Yorkshire. He didn't mind milking cows too much but he detested the idea of castrating piglets, which was part of his work.

He had already discovered his urge to travel and his benefactors had connections in shipping. So in 1926, kitted out by his disapproving father, he set out to see the world as an apprentice deck officer on a tramp steamer – without the faintest notion of how much of it he would one day perceive through the view finder of a camera, and at first too seasick to contemplate his future at all. He soon discovered that his main ambition was to record his experiences and perceptions in words and he published his first story (from the northern wilds of Assam) in the *Baltimore Sun* in 1928 at the age of 20. Appalled by the falsehood of the drawings that were used to illustrate the piece, he became determined that only his own photographs should do so in future. By 1928 he had sailed twice round the world in the Merchant Service with a folding Kodak camera in his pocket. He persisted in writing stories and taking pictures but they all went unpublished.

In 1929 he went to the USA, where the difficulty of surviving during the Depression while doing all kinds of basic jobs made him shelve his ambitions as a writer/photographer. He returned to England, penniless, in 1936. In London, much to his amazement, he got a job, taking portraits for the BBC magazine *The Listener*, thus beginning his photographic career at the age of 28. He was considerably helped by a nice girl named Esmeralda, who had studied photography. (One gets the impression that quite a few nice girls liked George Rodger and he them, and he kept in touch with Esmeralda until her recent death.) He was moved on to Alexandra Palace where he documented the earliest television programmes, first with one of the famous American Speed Graphic cameras, and then (as its shutter made such an intrusively loud noise in the studio) with a 35mm Leica, whose lightness, quietness and manoeuvrability would make it the basic tool of the photo-journalist for a whole generation.

Rodger quite soon tired of his confinement in the first TV studio and in 1939 he started freelancing for the Black Star agency, covering charity balls, galas and garden parties, with stories such as 'Hand-made Cricket Balls' and, during the 'phoney war', 'Dogs Surviving the Blackout'. He even tried his hand (and failed) at 'artistic' nude photography. When the war started in earnest, Rodger, disillusioned with his career as a photographer, decided to give it up and, because of his good marksmanship, join the RAF as a rear gunner. But as a photographer he was classed as being in a 'reserved occupation'. Providentially, though, the great and influential American *Life Magazine* had, meanwhile, used a story he had shot for the Black Star agency, and offered him a freelance contract for their coverage of the war in Europe. The die was now irrevocably cast, and Rodger's urge to explore and record at last given as free a rein as he could have dreamed of; as well as a very welcome sense of mission.

His appointment to *Life* was the springboard from which Rodger was to travel across Africa, Europe, the Middle and Far East during the next 40 years. Since his final trip in 1979, Rodger has exhibited his work several times, published books and received honours. He is often in pain from an affliction of his ankle and his eyesight is now greatly impaired, but at the age of 85 he is mentally 20 years younger and remembers in detail all the great journeys he has made in pursuit of pictures and human understanding. Looking at the photographs taken of him throughout his career, one is aware that he has always known that he is not a bad looking man. He still isn't, by any means, and is now distinguished by a defiant, even baroque, head of white hair.

As this short narrative and these photographs show, George Rodger is one of the least pretentious photographers of stature. The modicum of spiritual pride one can sometimes detect in him seems rather well justified, and his lack of ordinary vanity or anxiety about his status is refreshing, given the jealousies and ego problems one comes across so much in the world of photography. It has been moving for me to note his warm admiration for the buccaneering Robert Capa and also the friendship he feels for Henri Cartier-Bresson, one of the most brilliant and wily photographic artists, who evidently in his turn appreciates Rodger's rock-like virtues. Physically tough and brave, nervously and spiritually sensitive, Rodger seems to me to have been more steadfast and decent than most other journalists or photographers I have come across. He has set a very high standard.

He does, though, whatever he says, have the soul of an artist, albeit a diffident one. It is very interesting to me how he introduces human warmth into a photograph – and consequently his whole body of work – almost invisibly but nevertheless potently and genuinely. Humanity and inhumanity have been recorded even-handedly, but in a way that demonstrates beyond all doubt which side George has always been on. I feel very honoured to have been asked to write this brief account of the most chivalrous of photo-journalists.

A still-life example of George Rodger's early interest in photography as a hobby. This was one of the set of pictures that got him the job with the BBC as a stills photographer in 1936.

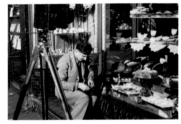

George Rodger in 1939 photographing a Lyons teashop in London during his early freelance period before the Second World War. He is using a Speed Graphic camera.

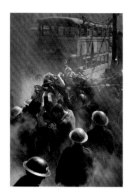

Rodger's 'Blitz icon': a woman is rescued from the ruins of her home (page 42).

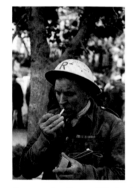

An example of one of Rodger's unpretentious Blitz images: a rescue worker captures a moment of consolation during a bombing raid (page 35).

It was the coming of the war in 1940 and Rodger's engagement by *Life Magazine* that provided him with his real baptism as a photo-reporter. Rodger had been taking photographs with moderate success for about four years for the BBC and for the Black Star agency. *Life* had bought a story taken for Black Star, calling it '*Life* Spends a Wartime Weekend on the Thames' and they offered him a freelance or 'stringer's' contract, which would pay him $100 a week and allow him to sell all his work to any British magazine as well. His next story for *Life* was 'The Balloon Goes Up', about barrage balloons, which was also published in *Illustrated*; followed by a story for *Picture Post* entitled 'Running the Gauntlet', about motor torpedo boat patrols in the Channel, which were continually bombed and strafed by German aircraft. One of Rodger's photographs, with its neat composition of Lewis guns, the boats and their wakes, would surely have served as a recruitment poster for the navy.

The beginning of the Blitz is remembered very vividly by Rodger. In September 1940, nearly three months after the evacuation from Dunkirk, he found himself sitting on Shakespeare Cliff near Dover with a few other reporters and photographers awaiting the invasion of Britain by Germany. The weather was perfect, but no Armada came in sight. Rodger recalls that he lay on the grass thinking of Cicely, the girl he loved and was to marry in 1942. She was safe but, sadly, inaccessible in Sweden. 'I longed for Cicely to be with me, to share such tranquillity, and to hold my hand', he wrote. But his pleasant fantasy was shattered by the roar of German bombers and fighters, together with anti-aircraft fire from the ground and the rattle of machine gun fire from the defending Spitfires, as the Battle of Britain approached its climax. On that sunny afternoon of 7 September, the approach of 400 German bombers and fighters made the cliff seem to tremble as they roared overhead towards London. They caused 2,000 civilian casualties in the East End alone that day, but the loss of 175 bombers compelled them thereafter to visit London only by night. This they did for 200 consecutive nights (except for one owing to dense fog). Thus began the Blitz, and George Rodger's first really serious assignment.

Rodger had not much liked London before, but now he found it, as many did who were not bereaved, dispossessed or seriously injured, somehow exhilarating, with human contacts warmer and more spontaneous than they had seemed before the bombs threatened. He was saddened by the death of some friends in the raids, but he seems to have been remarkably resilient, photographing a feature for American *Life Magazine* on the fortitude of the ordinary Londoner, celebrating their courage at this time. His pictorial understanding constantly developed. He composed his shots ever more carefully and cleverly, but did not try to emphasize drama or express emotion with contrived camera angles as other photographers did. The extraordinary image that Rodger calls his 'Blitz icon', actually the result of an attack in 1944, achieves its depth and strength by seeming not sought for but just something happening deftly captured. And, curiously, the absence of any overt 'Britain Can Take It' message seems to prove that the country could, indeed, endure, more convincingly than posed or sought-after images of calmly defiant Londoners looking skywards. 'It seems we have to put up with this strange and unpleasant experience, so we will', Rodger's subjects seem to say. One such picture shows a veteran of the First World War pausing for a cigarette in his rescue work (these were the days when smoking was a thoroughly manly source of consolation), while seeming as phlegmatic as the photographer. The work of Bill Brandt at this time (or any other) is, of course, poles apart from Rodger's.

Brandt's poetic and evocative vision of the London Underground and other shelters, his romantic view of bomb-ruined streets and buildings may live in our imaginations more vividly than Rodger's documentary reports, but the latter are more vital to a real understanding (as far as photographs can convey it) of the Blitz.

Rodger recounts some rather grimly amusing incidents during the raids, like seeing a man in his bath on the third floor waving to the firemen going to his rescue after the whole wall of his house had been blown away. And Rodger himself was once given an unexpected view of London, when, having just pulled a lavatory chain, a friend's house he was visiting was deprived of the privacy afforded by a wall.

For *Life* Rodger also used a Rolliflex, producing larger negatives ($2\frac{1}{4}$ inch square) than his Leica, because the magazine's style demanded sharper and generally more static photographs than *Picture Post*. Rodger felt driven to convey to *Life*'s 20,000,000 readers the urgent message that Britain did not consider itself on the brink of defeat, and to engage their sympathy against American pessimists and Anglophobe isolationists or uncaring figures like Joe Kennedy (father of Jack), who was recalled as Ambassador in London by President Roosevelt because of his dismissive view of Britain's chances, as the country stood alone against Hitler.

Once *Life* had told America about Britain's dramatic ordeal in London, they wanted Rodger to go further afield for images of war. So they sent him to Africa to record the progress of the Free French under General de Gaulle against the Italians and the French loyal to the Vichy government, which had conceded complete dominion to the Nazis. His journey was to become the longest and most arduous photographic expedition ever undertaken.

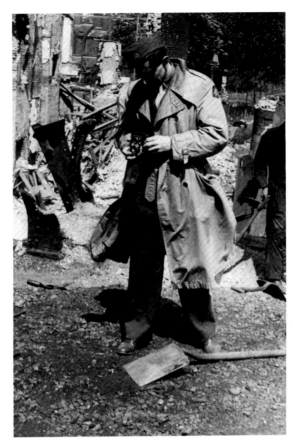

George Rodger with his Rolliflex camera in 1944.

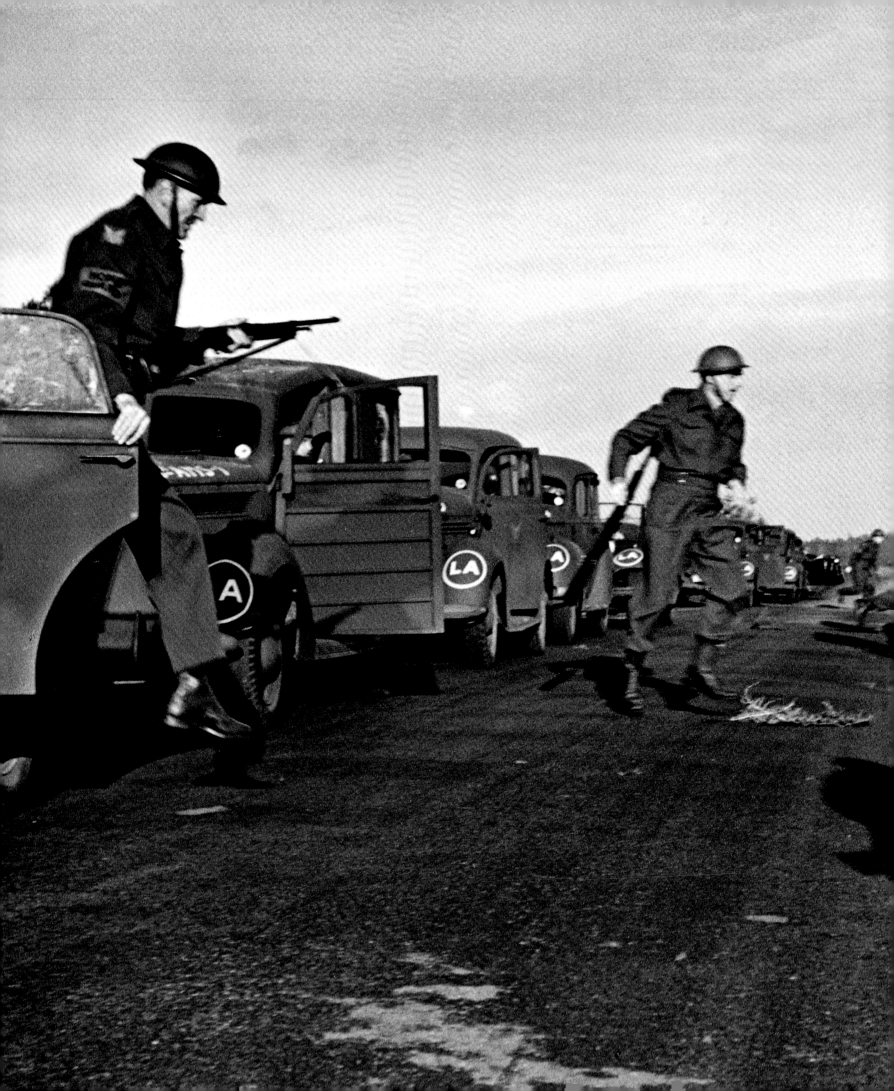

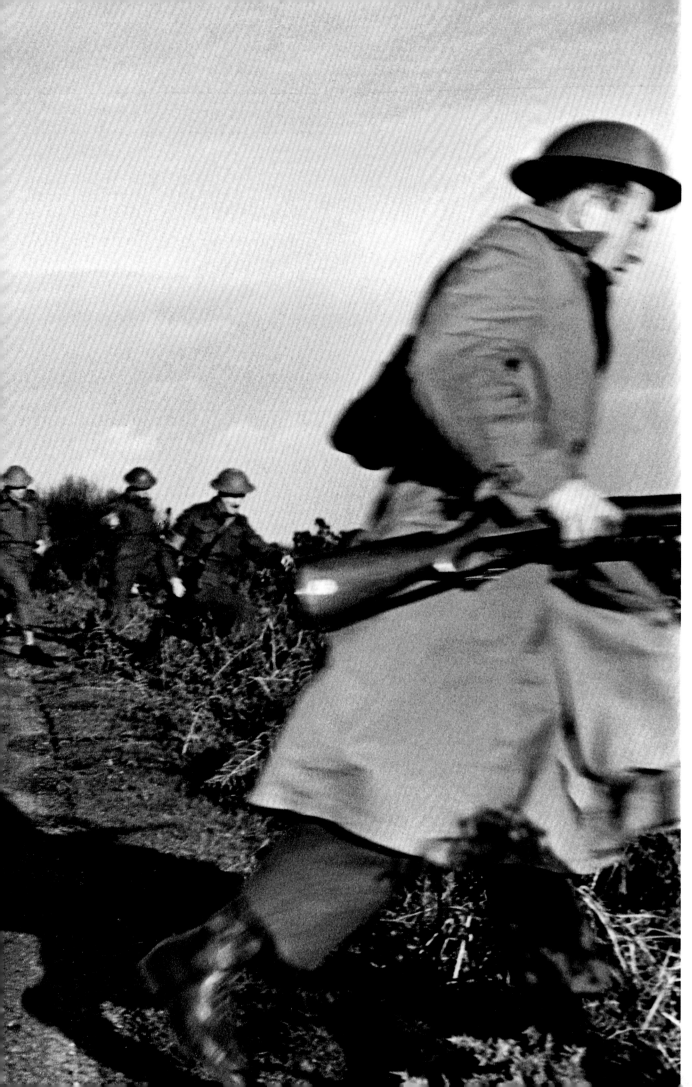

1939, London
American businessmen in
training for the Home Guard

1940, Dover
Waiting for the invasion
on Shakespeare Cliff

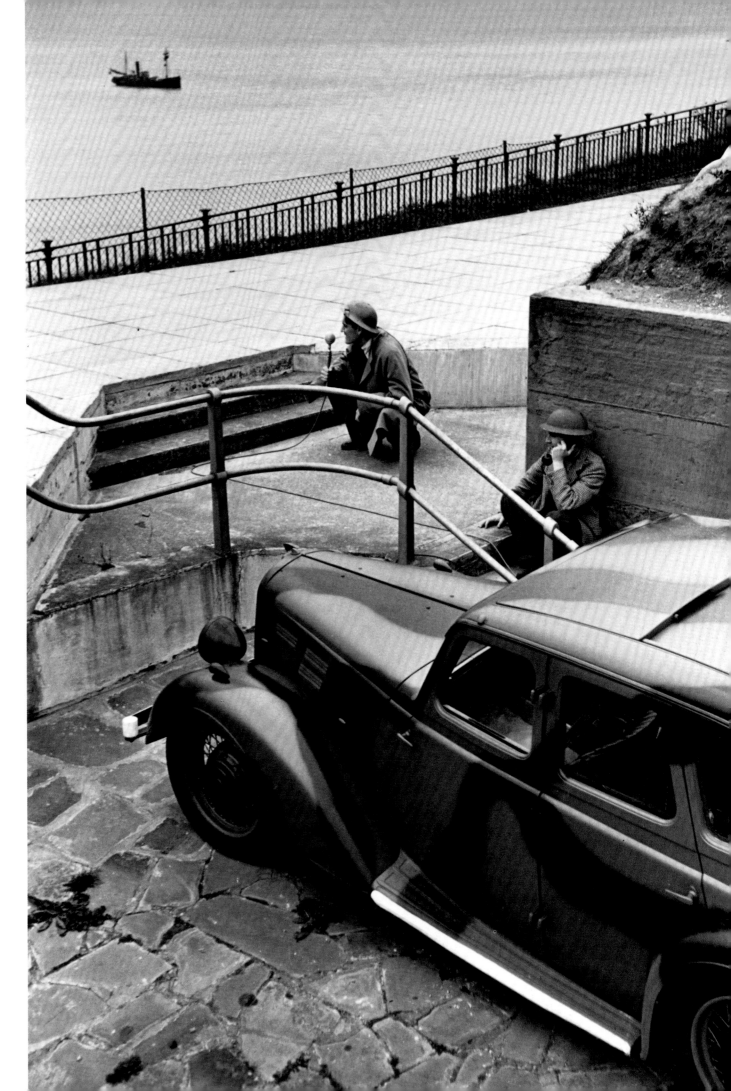

1940, Dover
American radio commentator
Eric Sevareid broadcasting live
during an air-raid

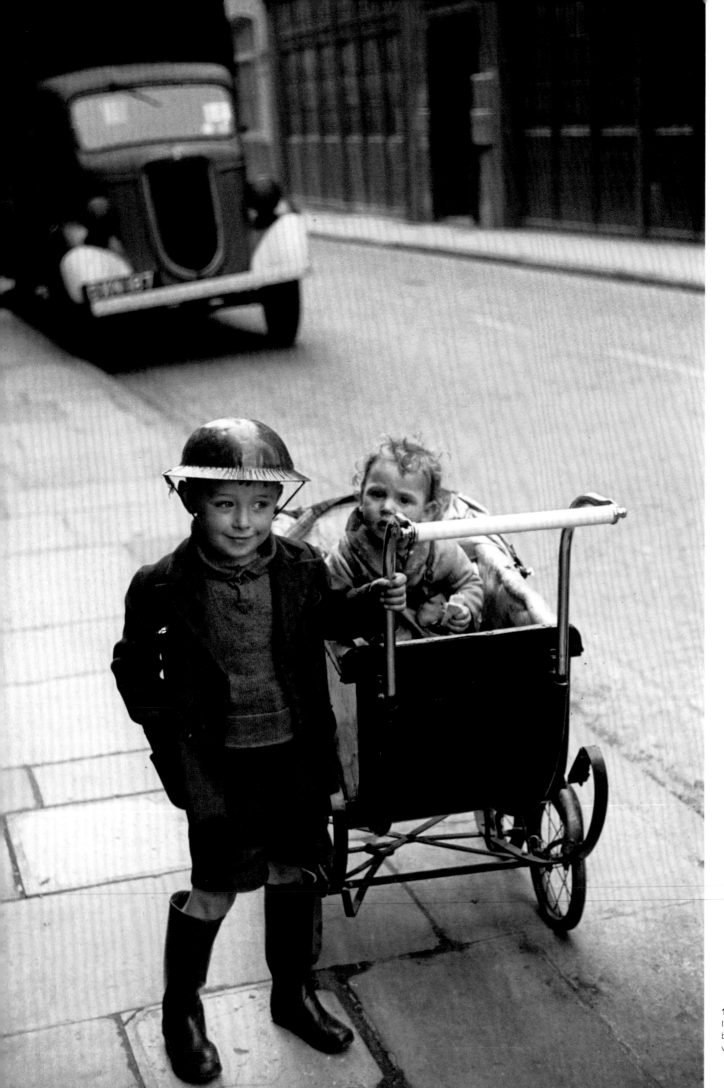

1940, London
In the East End a young
boy wears his steel helmet
with pride

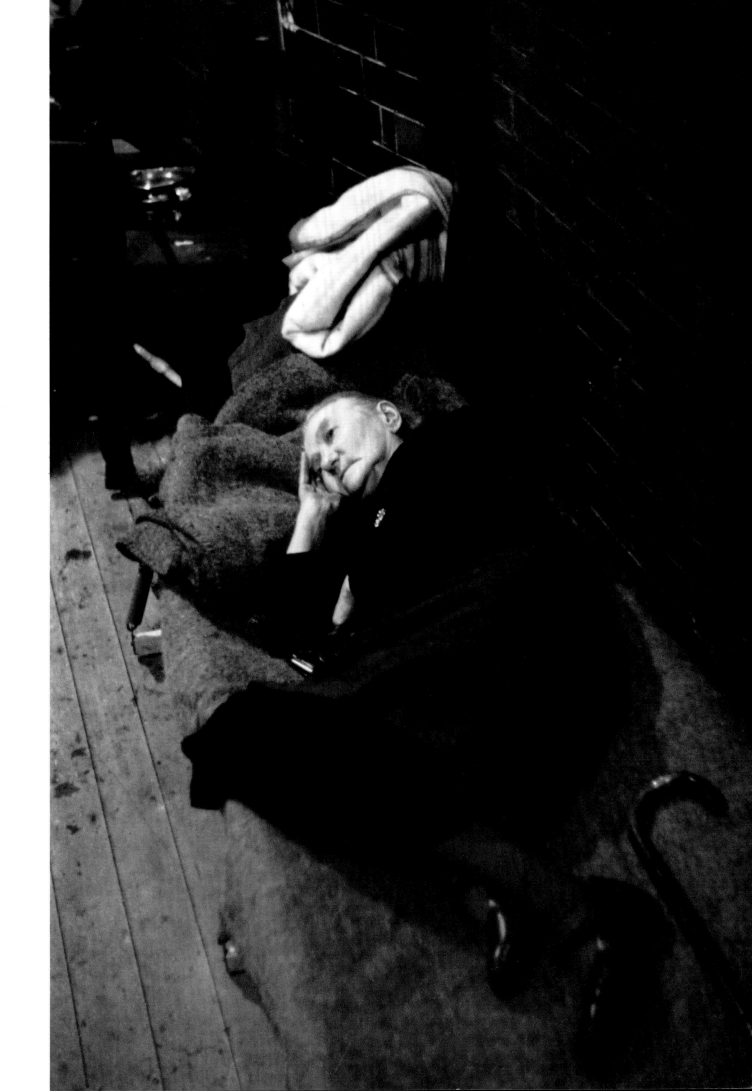

1940, London
An underground shelter
in the East End

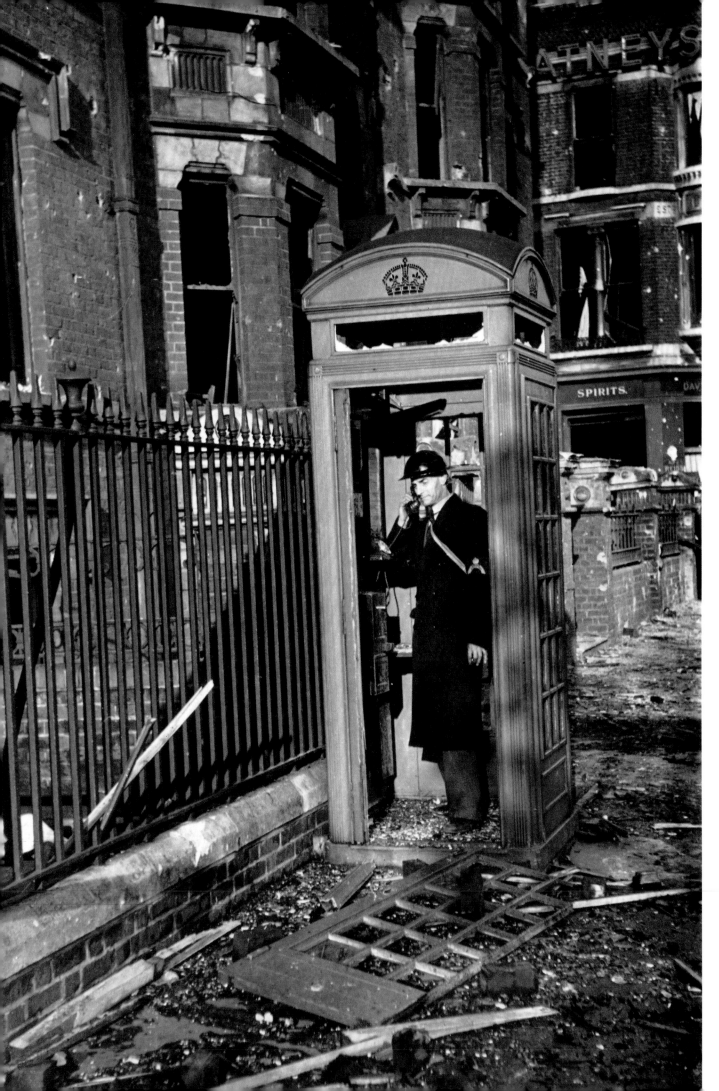

1940, London
An air-raid warden
telephones from a shattered
booth in central London

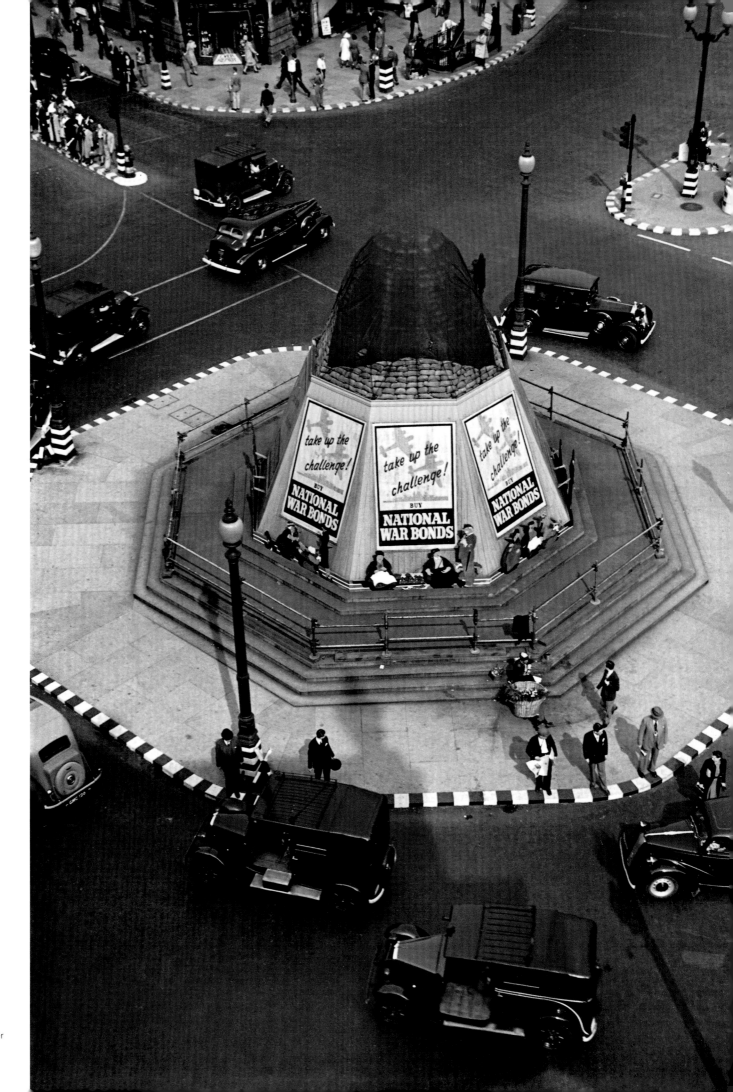

1940, London
Piccadilly Circus: cut-out
plyboard figures replace flower
girls to keep up morale

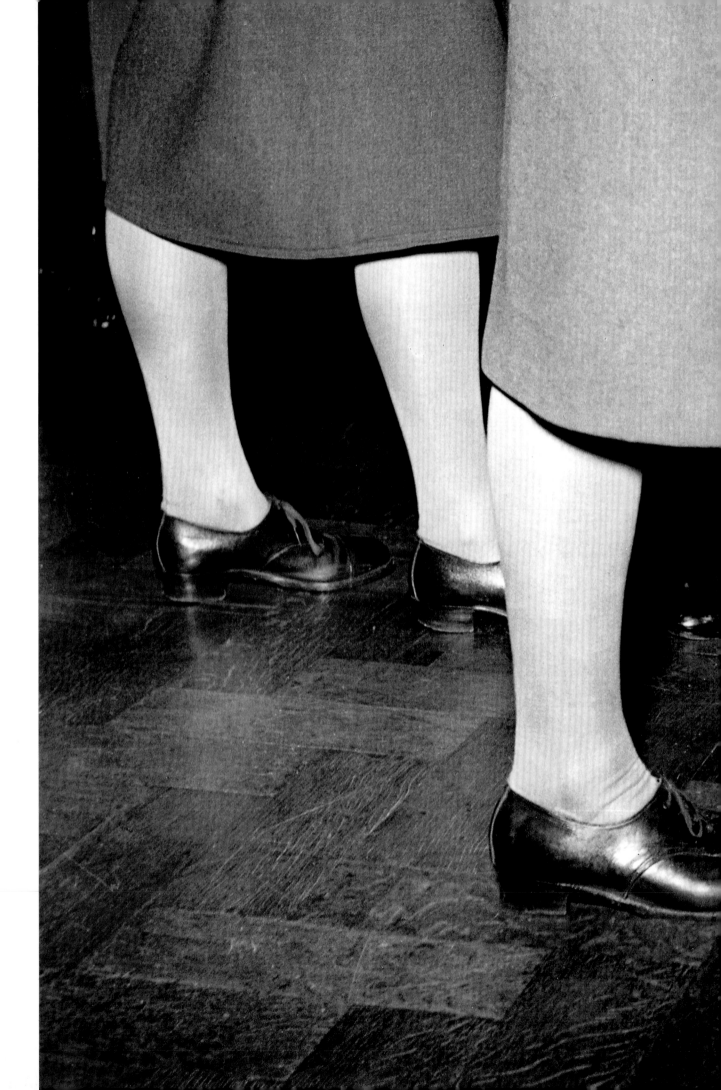

1940, London
Dancing feet: utility footwear

1940, London
An underground chapel for women
services personnel in Whitehall

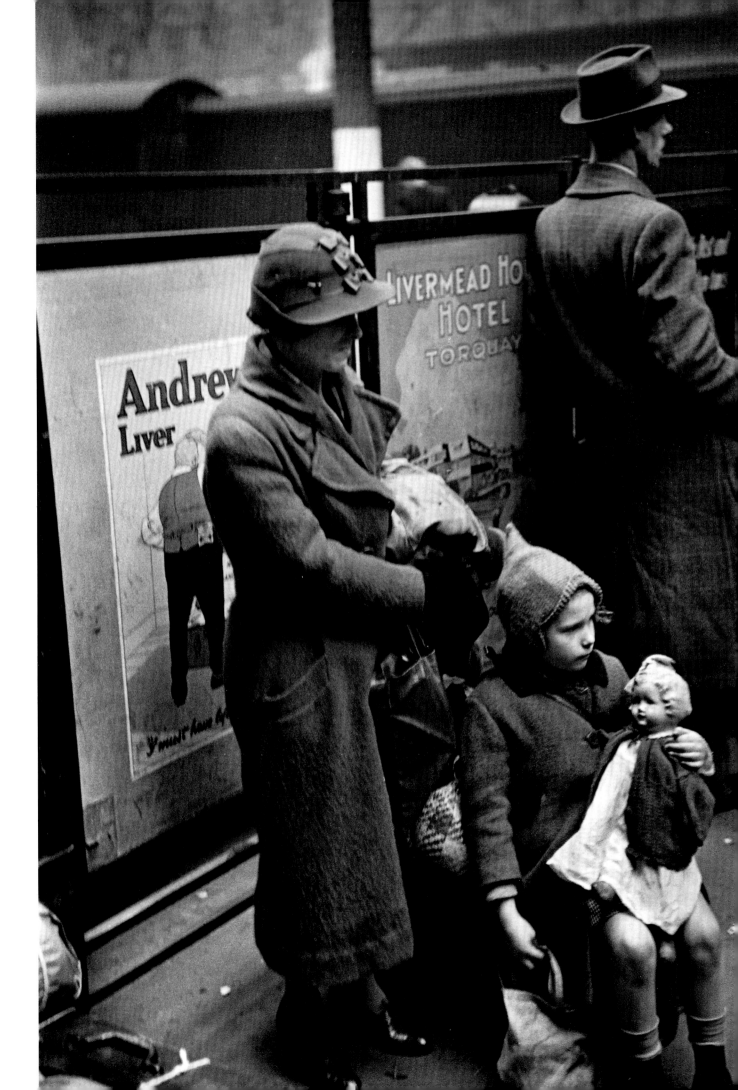

1940, London
Evacuation of children from
Paddington Station

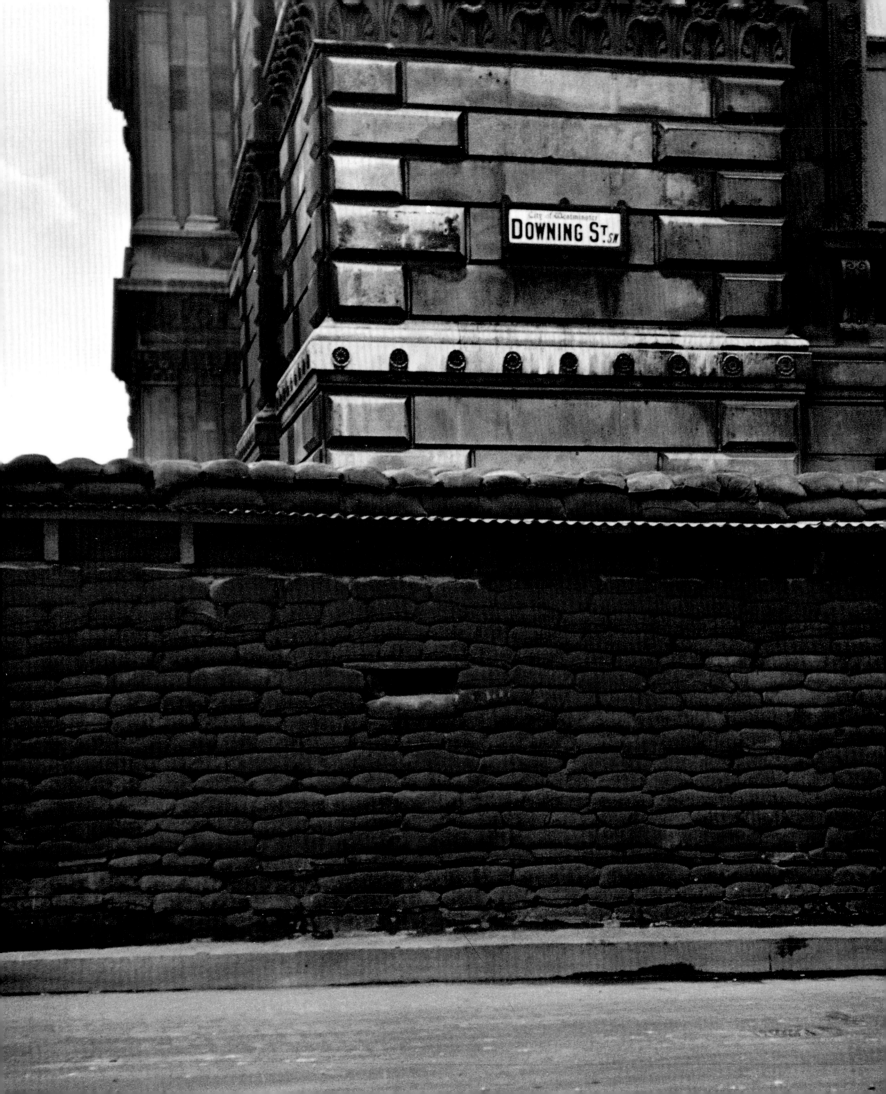

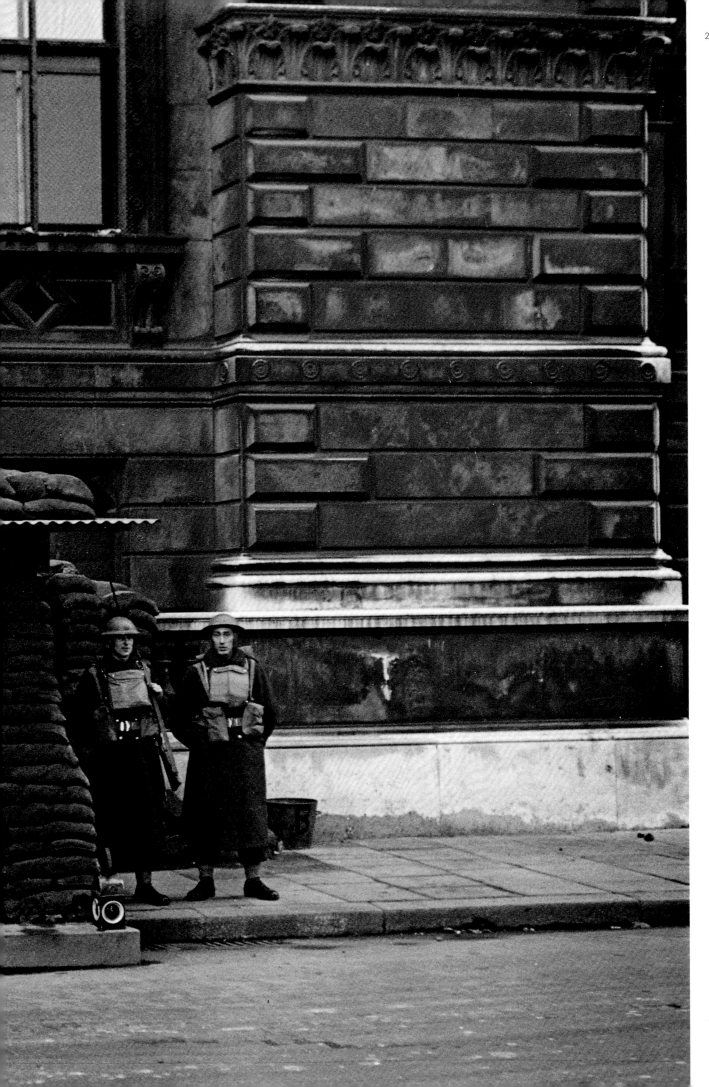

1940, London
A sandbagged machine gun
position in Downing Street

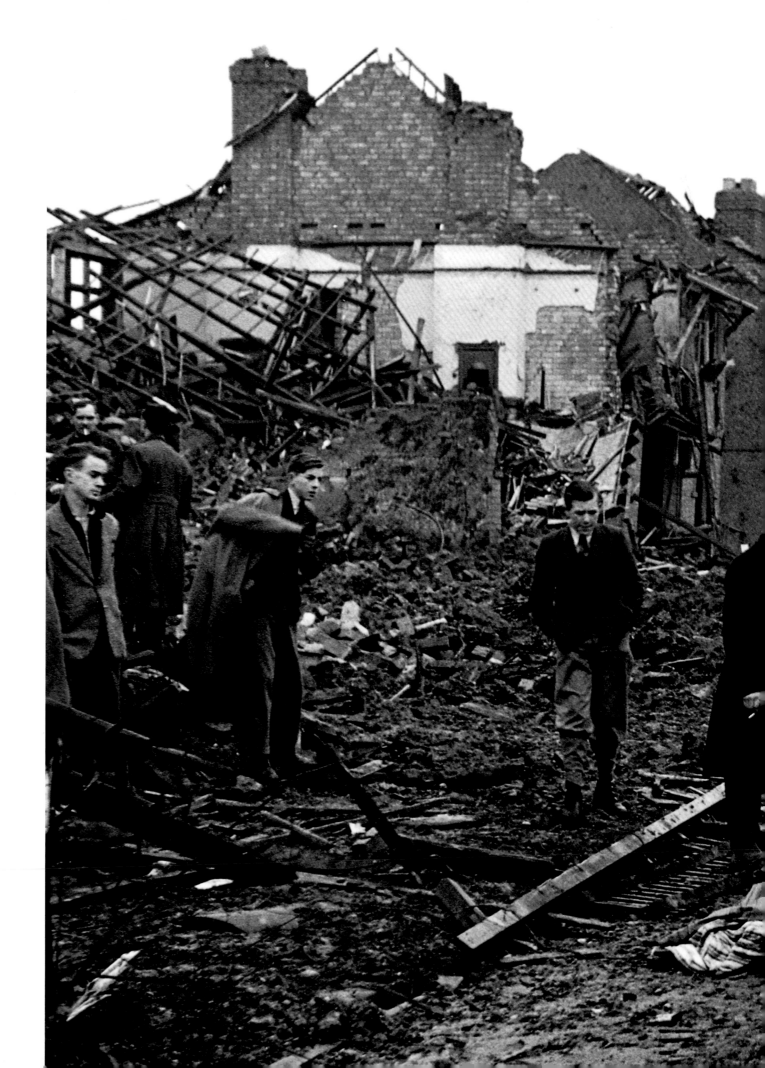

1940, Coventry
Identifying the dead
after the November
Baedeker raid

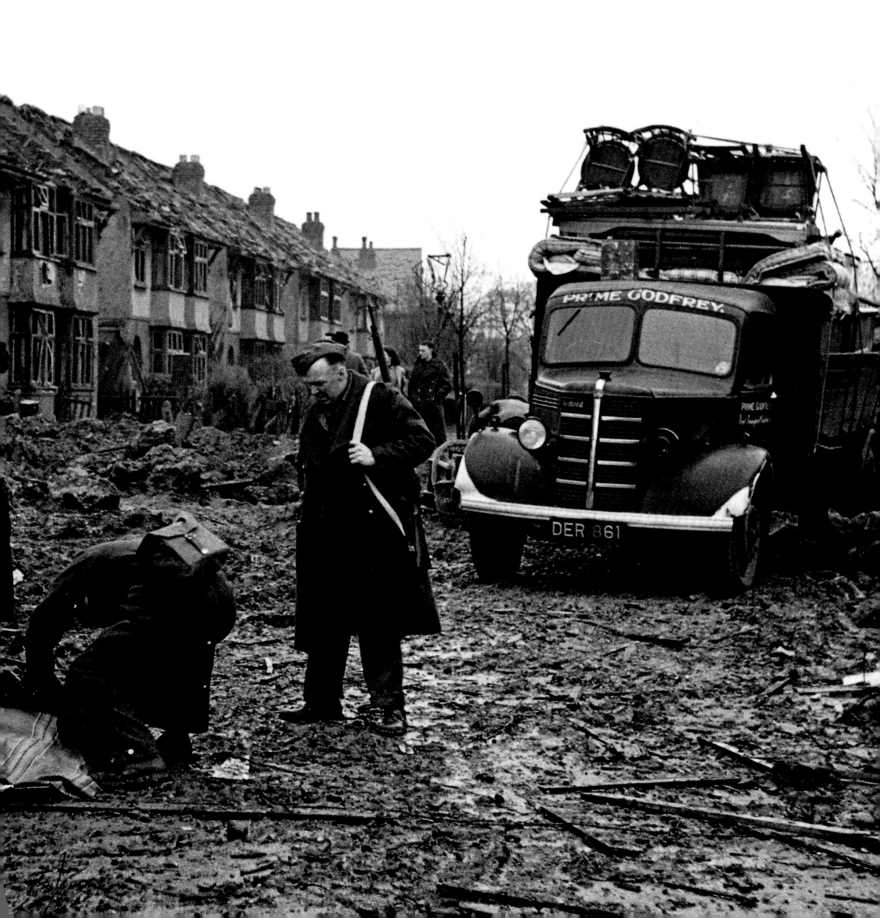

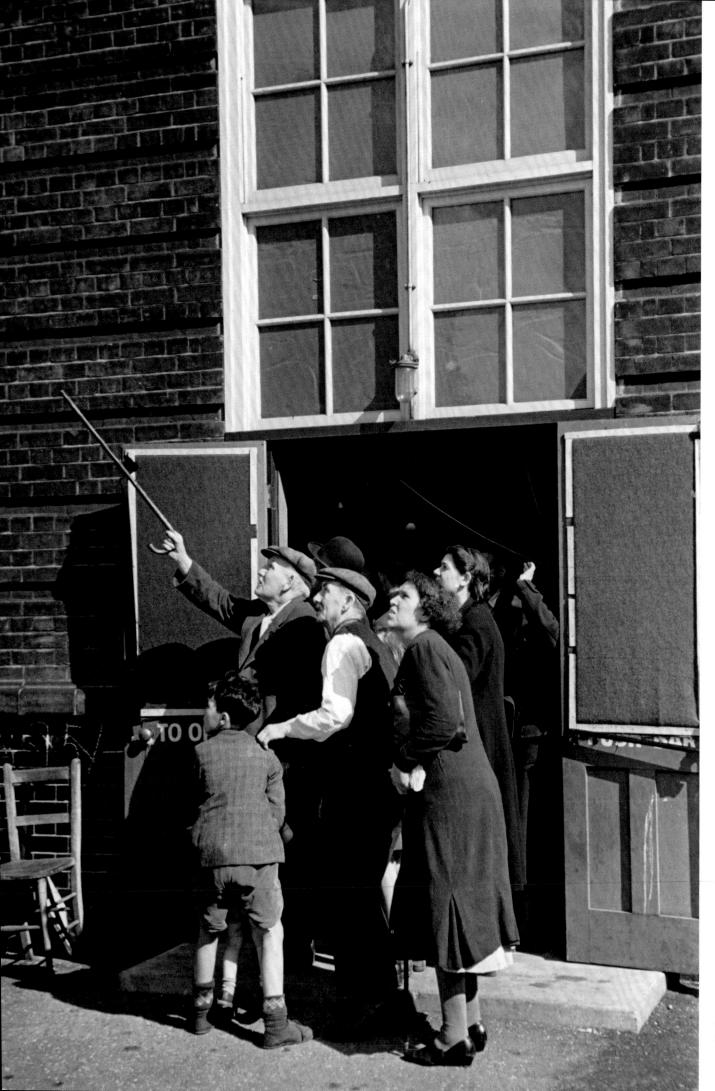

1940, London
Watching a day-time raid
at a shelter entrance

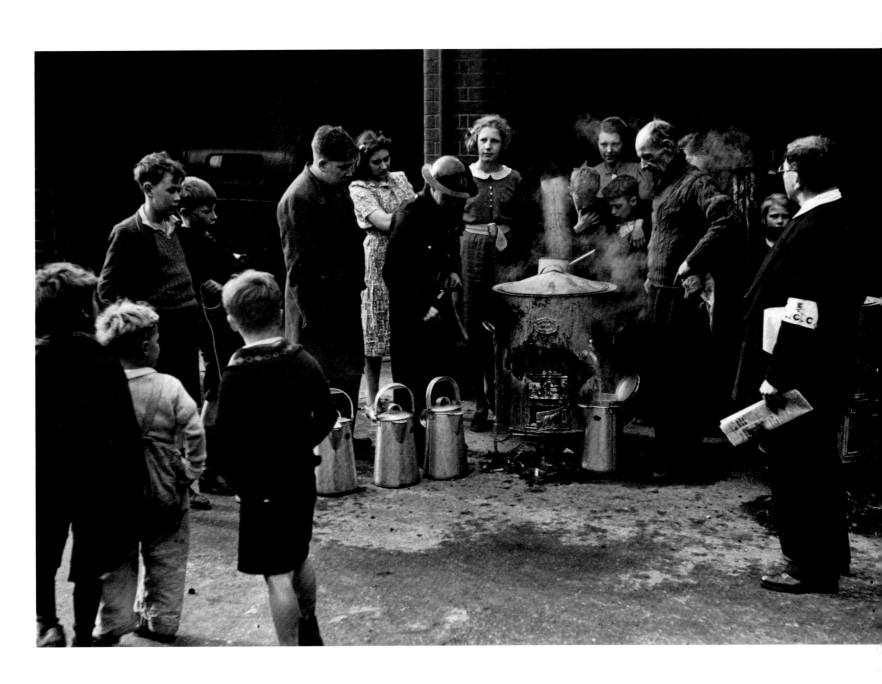

1940, London
A tea canteen up and running
at dawn for bombed civilians

1940, London
Heavy Rescue Squad workers set
out after an all-night bombing raid

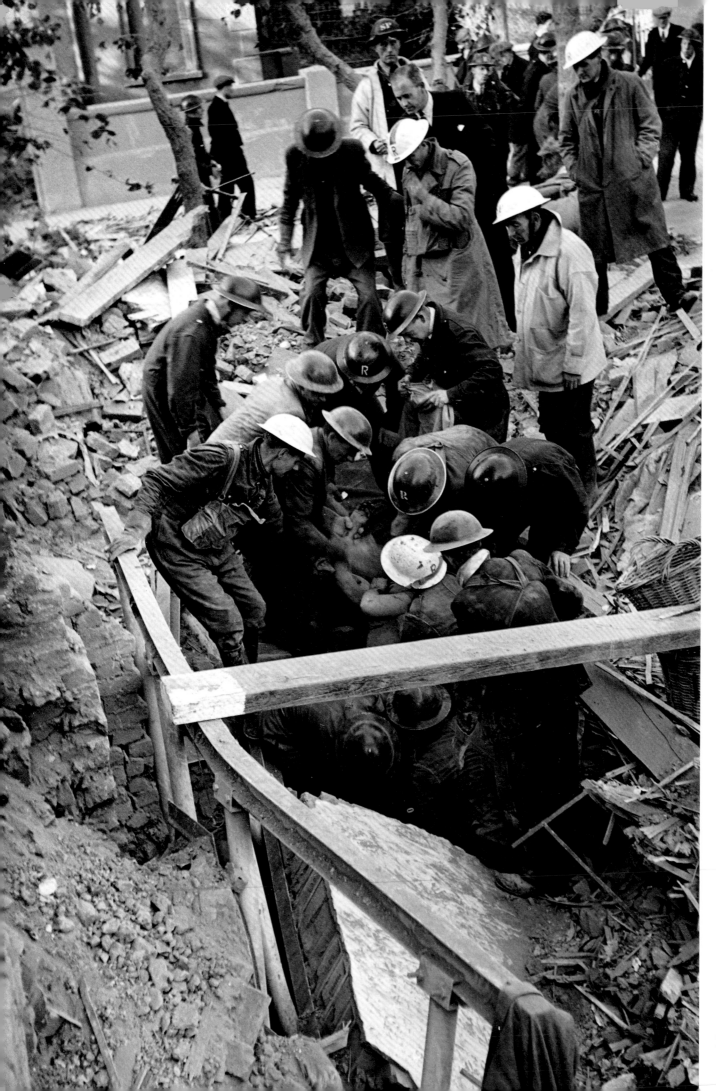

1940, London
Rescue workers try to save
people buried in the debris of
their homes

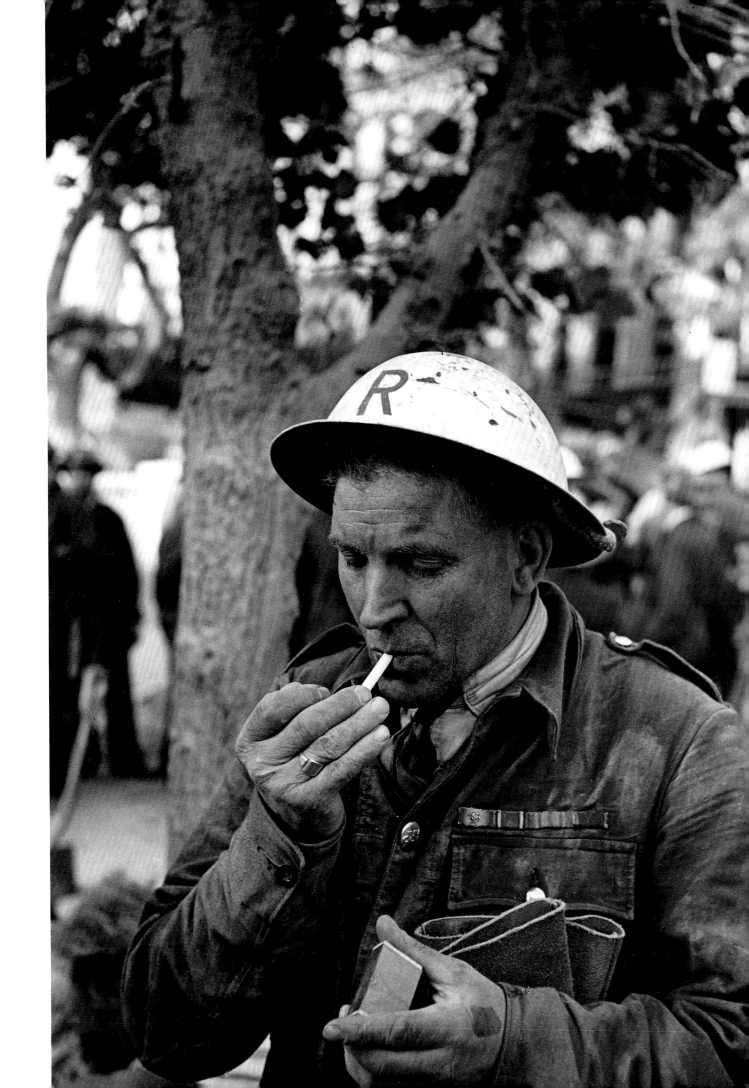

1940, London
A Heavy Rescue Squad
worker, exhausted after
a night's bombing raid

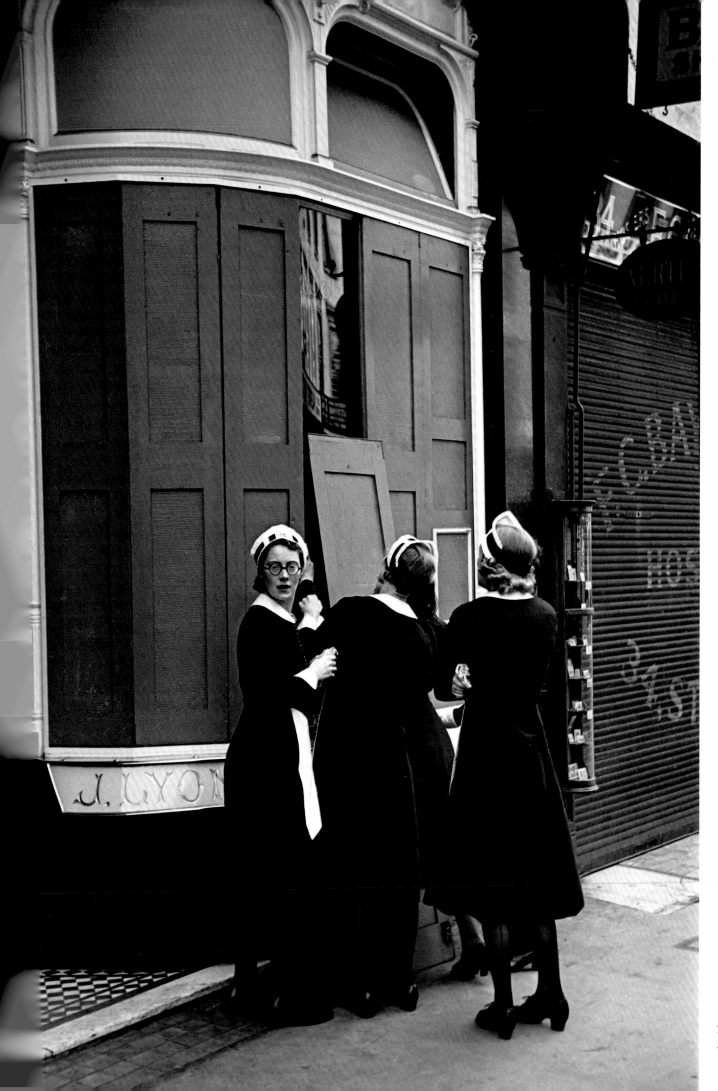

1940, London
After an air-raid alert, Lyons
Tea House 'nippies' protect the
windows with wooden shutters

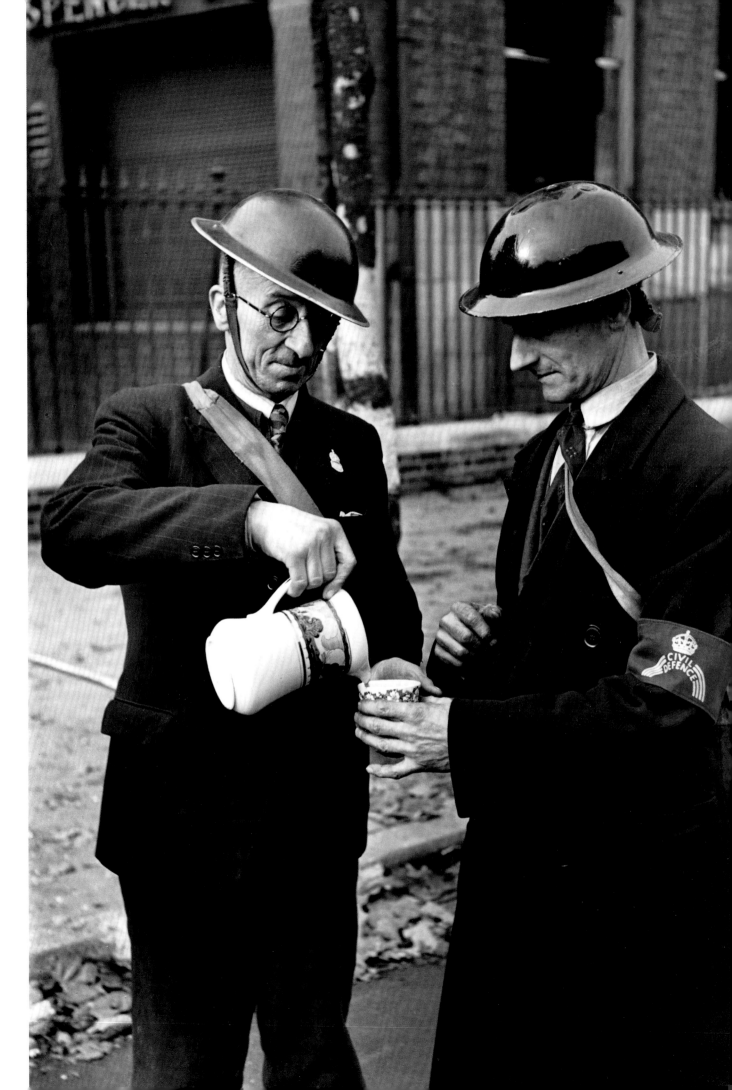

1940, London
Civil defence workers take
time off for tea in a china cup

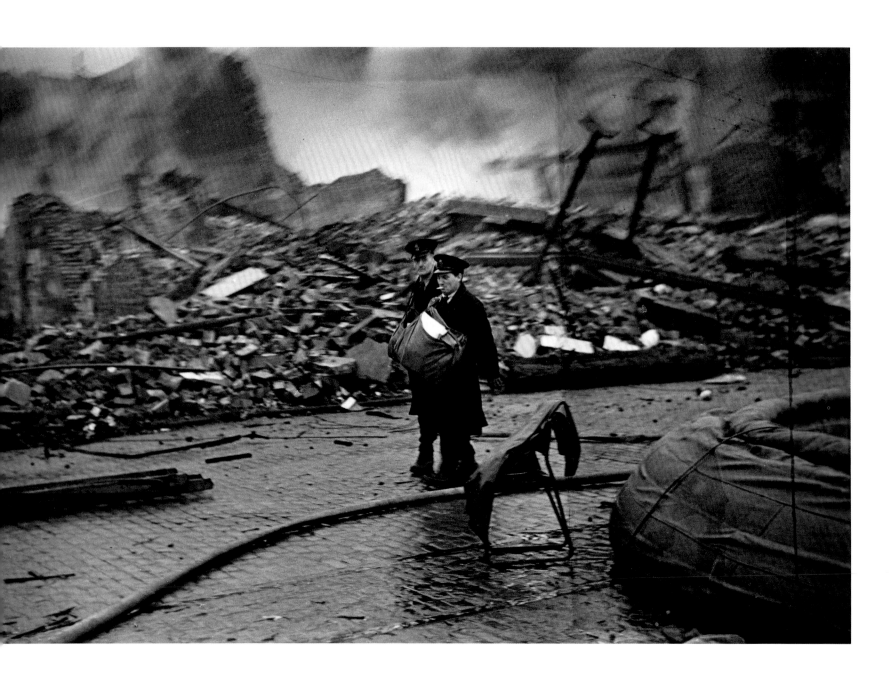

1940, Coventry
Postmen on their rounds
are unable to find addresses

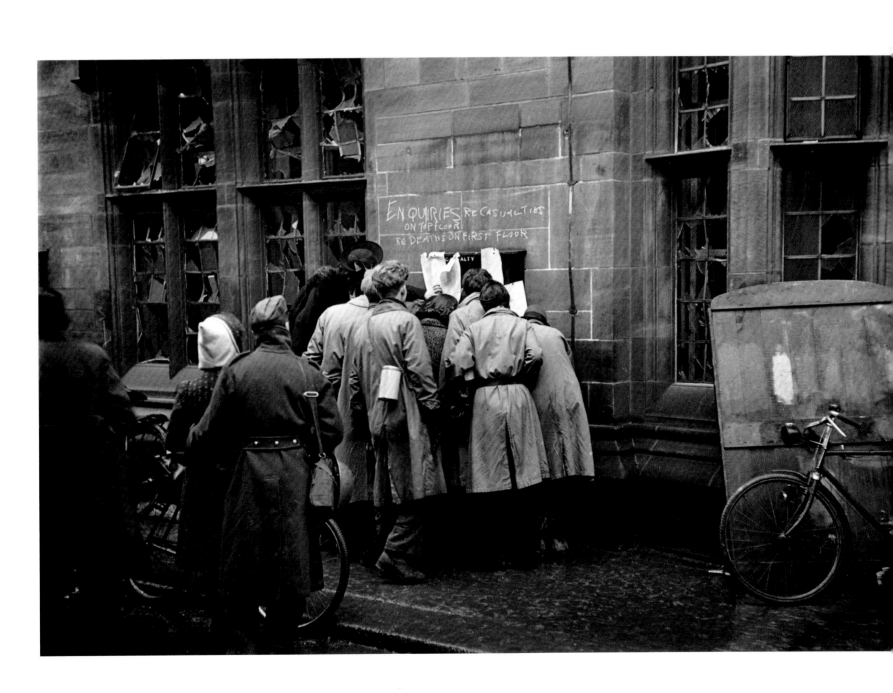

1940, Coventry
A casualty list is posted on the wall of a bombed
civic building after a night-time attack

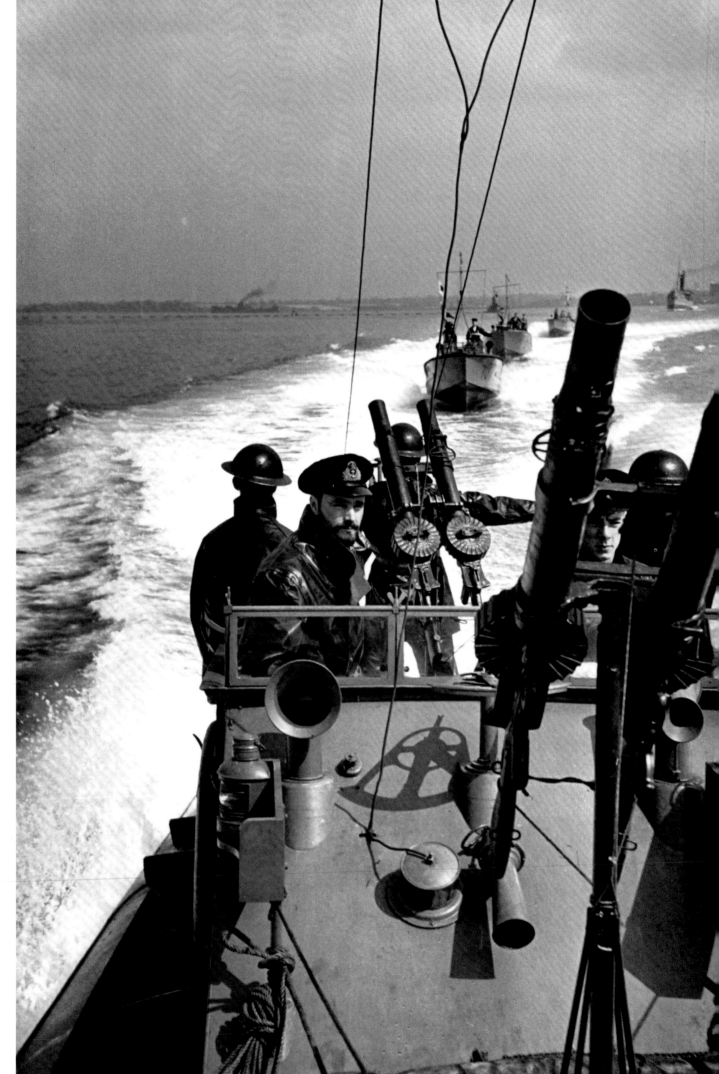

1940, The English Channel
Motor torpedo boats on patrol

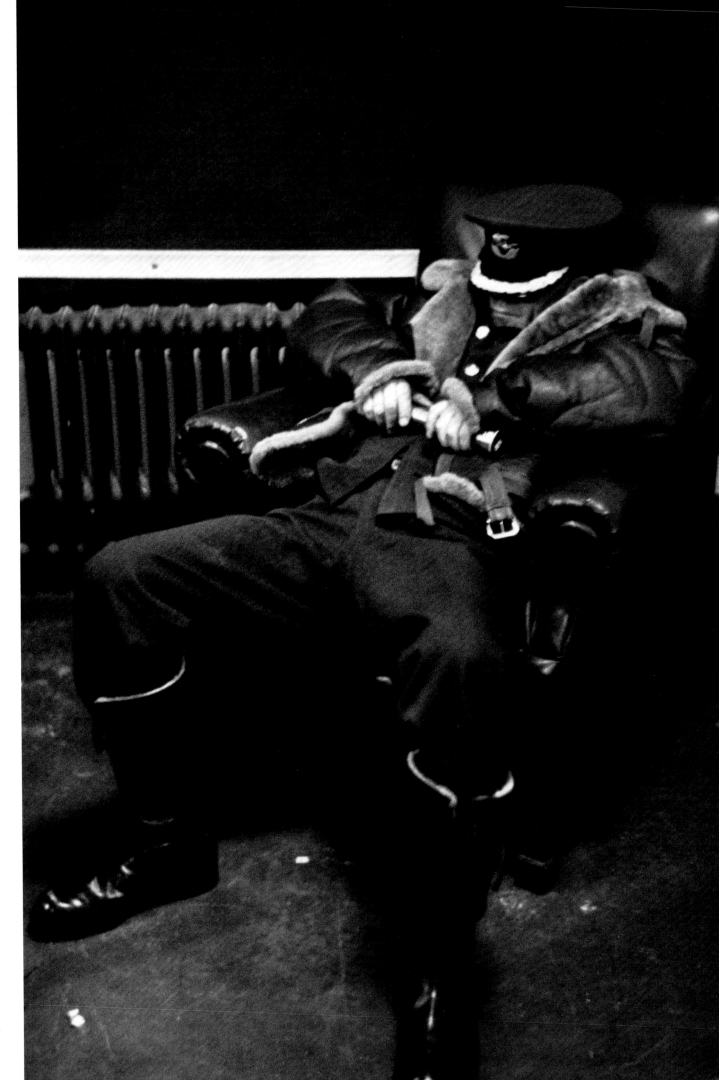

1940, near London
A station commander sleeps
briefly while awaiting the return
of his night bomber crews

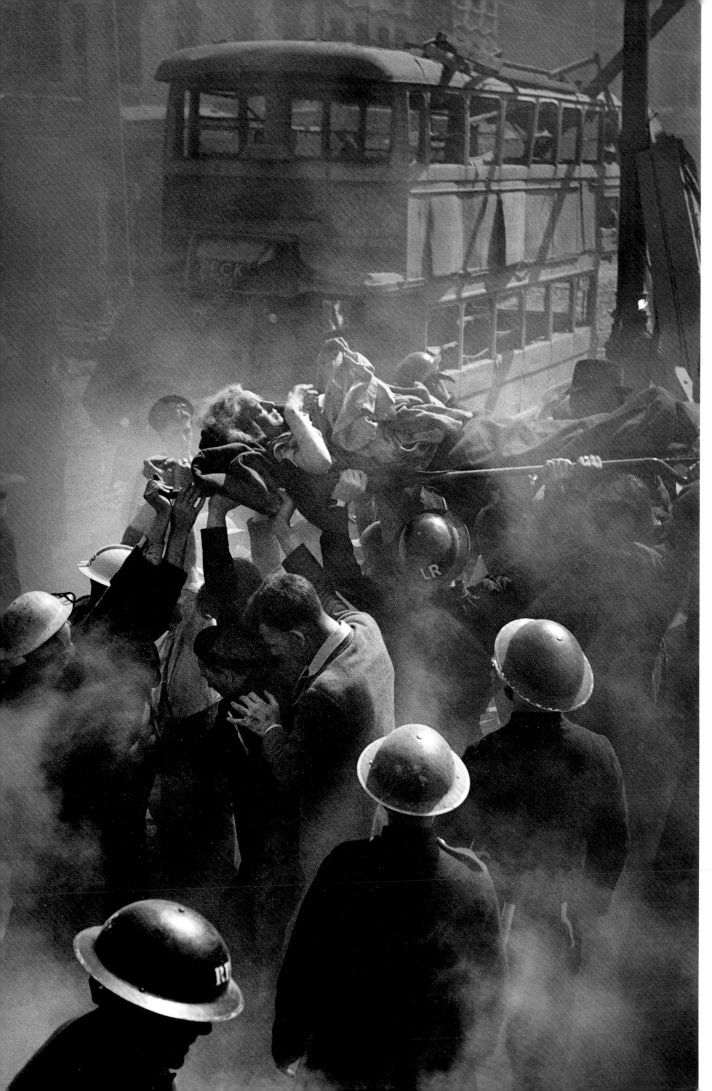

1944, London
A woman is rescued from
the ruins of her house after
a V2 raid

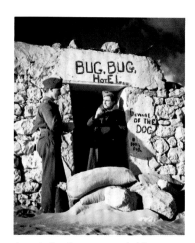

An ex-Italian desert outpost in Libya abandoned by their retreating army, taken over by George Rodger as his temporary headquarters. It was infested with lice, hence the name of the 'hotel'.

Rodger started on his four-week assignment for *Life* in French Cameroun late in 1940. He was to stay away for over two years, during which he suffered extreme hunger and thirst, tropical pests and all kinds of harassment – including some from the British Army. He had meetings with General de Gaulle, Haile Selassie, Randolph Churchill, Chiang Kai-Shek and various Arab rulers – and several brushes with death. All this was in pursuit of photographs (which he would not see until his return) that would show America how the Germans, the Italians, the Japanese and their various collaborators were being fought with some success, but at this time mostly failure, over nearly the whole width of Africa and Asia. His circumstances, unprecedented in photo-journalism (as it later became known) obliged him to create an entirely new 'package' system, writing captions on the spot for each numbered frame and sending the unprocessed film to his employers with a full summary of relevant information, as well as the details of each shot. He recorded his journey meticulously (listing nearly 400 places where he stopped for the night) and overcame all obstacles with the qualities he eventually decided were essential to a photo-journalist in such circumstances: patience, tolerance, initiative, endurance, discretion and, he added, the sense always to carry a long piece of rope. He covered a distance of roughly 75,000 miles.

The journey began on a tramp steamer, the SS Seaforth, on the blacked-out Clyde with a cargo of aeroplanes, guns and munitions, and two American fellow journalists from *Liberty* and the *Chicago Daily News*. The ship's captain was an odd, adventurous character who chose to go it alone and beat the U-boat blockade with speed and smart manoeuvre. But the devious route he took to Africa was destined to be his last voyage; his ship was sunk with all hands a few days after Rodger, whose friends had already disembarked,

had left her in Douala. No other ship would have been allowed to respond to her distress signal, and the incident must, for Rodger, have been a source of sombre reflection and regret.

The story Rodger was pursuing concerned de Gaulle's newly born Free French forces. French Cameroun had declared for the General against the Vichy government, and his small army, with one aircraft and one field gun, were determined to harass the Italians in Chad and Libya. Rodger had been granted military accreditation, but the French at first refused to recognize it. He could only cover the culture and economy of the country, they insisted – which he did for *Life* and *Illustrated* in London, while waiting for a General de Larminat to arrive and sort things out. Guided by an extraordinary Frenchman who claimed to be a Baron, owned a small goldmine and drove and cursed like a madman, he set off hoping to photograph a Colonel Leclerc (later the celebrated General) taking the fort of El Tadj from the Italians at the oasis of Kufra.

It was only 1,000 miles away as the crow flies but 4,000 by land, and they arrived with champagne for the Colonel to find that he had accepted the surrender of the fort the day before and flown away. So they loaded their vehicles with Italian guns, ammunition and Pirelli tyres and set off for Eritrea, 3,000 miles to the east. They had been told that the direct route over the desert was impossible for anything except camels but decided to risk it – Rodger trusting somehow in the Baron's undoubted courage. Soon one of their two vehicles, being overloaded, broke its back axle and the Baron took the other one 200 miles back for spare parts. If they had brought a rope long enough to reach the water of a depleted well, there would have been no problem about survival, but one of Rodger's team drank their small supply during the night and the Baron failed to return. 'The sky was like burnished brass, and without water the heat was

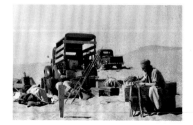

Rodger takes advantage of a vehicle breakdown in the Libyan desert to write his captions on a packing crate.

intolerable', wrote Rodger. 'By the end of the fourth day my tongue was blue and swollen and I was already writing out a farewell message to put in a bottle for some wandering camel rider to find, when the Baron arrived in a swirl of dust and a torrent of vitriolic French obscenities.' He had been put in hospital with sunstroke but had left against doctor's orders to come back to Rodger's rescue.

Somehow the party reached Khartoum after several gruelling days and there Rodger found that the War Office in London had withdrawn his immunity from conscription and was insisting that he be sent home as soon as possible. Rodger, however, possessed a magical letter from de Gaulle; he immediately had himself accredited to the Foreign Legion who were fighting the Italians in Eritrea and left for the Sudanese border. Naturally he enjoyed his freedom from military discipline, but he genuinely believed that he could be of far more use to the war effort telling *Life*'s readers about it than being a photographer in the British Army. So he returned to Khartoum where he parted company with his eccentric and choleric guide. What had been called 'La Mission de Reportage' was no more, and Rodger set off back to Cairo to give himself up. There he was intemperately upbraided by a brigadier, but had a bright idea. He cabled the Viceroy of India, describing his value as the pictorial voice of Britain in America, and suggesting that the Indian Army could use his advocacy.

Wearing a brand new set of badges, Rodger drove to Abyssinia to join the Fourth Indian Division, where he just managed to catch the last gasp of the Great Italian East African Empire as the Duke of Aosta surrendered his last mountain top. He continued to Addis Ababa, where he saw Haile Selassie put back on his throne. 'It was all a bit rushed,' he wrote. He then hitchhiked back to Cairo, but his assignment was coming to an end.

It was good to be working for *Life* in Cairo, as they had a permanent suite at the famous Shepheard's Hotel, and by a lucky chance de Gaulle was in residence, so Rodger soon had himself accredited to the Free French again for their fight with their Vichy compatriots in Syria. On the way he had his lone truck unskilfully dive-bombed by Vichy planes and was personally machine-gunned with equal lack of success. On arrival he tried to use his Leica while on a galloping horse charging a Vichy strongpoint with the Circassian Cavalry, but he had to resort to more conventional methods. Then, after Damascus had fallen to the Free French (where he photographed two soldiers examining a pristine gramophone record in a half-wrecked room at the Vichy HQ), Rodger visited Glubb Pasha's desert patrol of Bedouin Arabs and made good friends with Emir Abdullah ibn Hussein (who, as King of Jordan, was assassinated in 1951).

Back in Cairo Rodger developed a hardening of the skin which deactivated the sweat glands on his back. A condition previously known only in polo ponies, and apparently only those from Karachi, it necessitated enormously painful surgery obtainable only in Jerusalem. Before it was quite finished he was urged to return to Cairo where Randolph Churchill was offering a scoop which turned out to be about a naval operation to relieve Tobruk. Churchill was at this time trying to divert journalists he didn't favour from the more interesting story of a simultaneous British and Russian invasion of Iran from south and north. Rodger and his Time Life colleague got wind of it and, through sheer determination and the acquisition of a taxi and its intrepid driver in Baghdad, they drove at breakneck speed through Iran. There Rodger photographed the meeting of Russian and British forces before the official press party arrived, and foiled a Russian attempt to sequester the film. Sometimes Rodger had managed to develop his own film, and he did so now in his Baghdad bathroom. With his

The terrace of the Shepheard's Hotel, Cairo in 1941: a busy meeting-place for journalists and officers on leave.

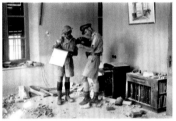

Two Indian army personnel in the wrecked Vichy HQ in Damascus (page 63).

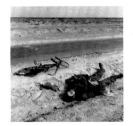

A young German soldier (page 74).

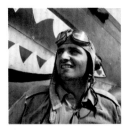

One of the Flying Tiger pilots who did not return (page 94).

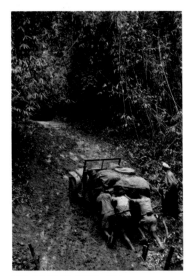

George Rodger escaping from the Japanese invaders in Burma in 1942. The rains came and the only route to India became almost impassable. He had to abandon his jeep in the jungle and start walking.

accustomed determination and luck he got back to Jerusalem and despatched it, then proceeding to Cairo yet again and to the desert to photograph General Auchinleck's offensive against Rommel. Tanks scattered over large distances do not make good photographs and most of the well-known action shots taken there were set up. Nevertheless, Rodger produced some memorable images including one of an innocent-looking young German soldier lying dead by his bicycle. On his return to Cairo he received instructions from *Life* to go to Burma.

He arrived in Rangoon by flying boat while the Japanese were attacking the harbour from the air. But the most promising story for *Life*'s readers was about the Flying Tigers, a squadron of American volunteers who had been fighting in China against the Japanese before Pearl Harbor and with their government's blessing. They seemed, like the astronauts later, to be made of the Right Stuff. They reckoned that each of them was, in terms of skill, worth ten Japanese pilots, and Rodger photographed them all individually and with their shark-toothed Curtis Tomahawks. He witnessed a 'scramble' to repel a Japanese raid and saw all return bar one – the most popular of the team, whose picture Rodger had taken the day before. While they were away Rodger found himself alone on the field while a Japanese Zero made a Kamikaze attack on a servicing area for British bombers but missed completely. 'His fighter seemed all motor, with just a few sticks for fuselage, from which we scraped off the pilot', he wrote.

Ordered soon afterwards to go to Singapore, but forestalled by the Japanese occupation of the port, Rodger went northwards to photograph the building of the Yunnah-Burmah railway, leaving behind the depressing spectacle of military vehicles being unloaded from ships, feverishly assembled and

then almost immediately destroyed so as not to fall into enemy hands. After photographing the railway, Rodger returned again to Rangoon, which was on the verge of falling and was being set fire to at night by Burmese collaborators. He escaped the city and went with a Movietone News camera operator towards Shwegyin, which was about to be recaptured by the Indian Army from the Japanese. This is how Rodger reported this small but encouraging victory on 12 March 1942:

'After weeks of retreating before the little yellow men who filtrate unseen and unheard through the jungle, our forces in Burma were considerably heartened by the recapture of Shwegyin on 11 March, which had been in enemy hands for the past three weeks. Greatest effect of this local success has been on our troops' morale: playing catch-as-catch-can with an unseen enemy in steaming tropical jungle; finding the heads of their officers and comrades jabbed on bamboo stakes in jungle clearings; having unseen hands light firecrackers round their camps at night; having their patrols and sentries spirited mysteriously away and continual retreats westward; all went to undermine morale, and the kick in the pants we gave the 'Japs' at Shwegyin has had the same effect as a great strategic victory. Now troops are all raring to go, especially the Indians who took part in the actual attack.'

Rodger then went to photograph the Burma Road, now the only supply route to China. After getting shots of Chiang Kai-Shek and his formidable wife together with the American General 'Vinegar Joe' Stilwell, he proceeded in the company of Alec Tozer but found they had no permission to enter China. They were obliged to spend three days in a local warlord's jail before hearing the bad news that the Japanese had taken Rangoon. Burma was cut in two south of Lashio and both the Americans and British were in retreat. Their best route back lay

through the territory of the Naga head-hunters (who, fortunately, weren't after theirs). They forded rivers, widened bridges and built rafts, but then encountered conditions under which the jeeps could go no further. So having acquired some coolies and bought peanut butter and cocktail (sic) cherries, the only food of any kind on sale, they set off on an almost unendurable 300-mile walk which took three weeks over hills and through steamy, leech-infested jungle. When he reached Ledo, over the Indian border, Rodger took a train to Calcutta.

In Calcutta he received orders to go straight to New York, where *Life* had just published a resumé of his work for them, using 76 photographs. He flew there in a Sunderland flying boat via Arabia, Egypt, the Congo, Nigeria, the Gold Coast and Liberia, where he took an American clipper to Brazil via the Azores. He finally reached New York via Trinidad and Miami. Suffering a terrible shell shock headache, Rodger reluctantly found himself welcomed as a hero, and he was expected to make emollient speeches to *Life*'s well-heeled advertisers. He brought this ordeal to an end by inadvertently telling the President of Boeing Aircraft that the RAF's Lancasters were proving more effective than Boeing's Flying Fortresses. He had been saddened throughout his last journey to hear a constant denigration of the British war effort by Americans which would only be partly stifled by the imminent victory at El Alamein. Rodger, despite a reasonable measure of gratitude towards the magazine, felt obliged to disappoint them as an exhibit.
They allowed him to go home to get married before continuing his adventures (now as a staff photographer) in Africa again, then Italy, France, Belgium and Holland, and finally to record the rejoicing in Denmark in 1945. On the way he was to see Belsen, which would scar him far more than all the other scenes of death and suffering.

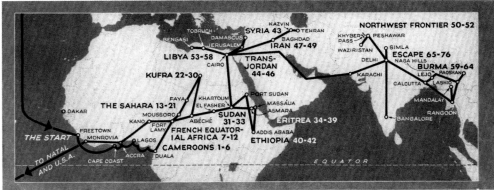

LINE TRACES LONGEST CONTINUOUS TREK BY A WAR CORRESPONDENT IN WORLD WAR II. NUMBERS, MARKING STOP-OFFS, CORRESPOND TO CAPTION NUMBERS UNDER PICTURES BELOW

GEORGE RODGER, LIFE PHOTOGRAPHER

75,000 MILES

IN HIS OWN PICTURES AND WORDS, GEORGE RODGER
TELLS OF HIS TRAVELS AS LIFE WAR PHOTOGRAPHER

Early the morning of July 9, 1942, a lean young Englishman in British Army uniform stepped alone from an Atlantic Clipper at LaGuardia Airport in New York and lit a cigaret. This ritual marked for George Rodger, LIFE staff photographer, the end of the longest journey by any photo-reporter or newswriter in this or probably any other war. He had gone 75,000 miles from December 1940 to early last month—more than three times around the world. His war picture odyssey

took him from Glasgow, Scotland, to Duala, Africa, across the Sahara and into Eritrea, Ethiopia, Iran, Syria, Libya, India, China and Burma (*see map above*). Constantly doubling back on his tracks, he saw battle action in a dozen places.
From time to time LIFE has published photo-reportage by George Rodger on this roving assignment. Now the editors let him tell his own story of his travels, with his own pictures arranged chronologically and his own words used as captions.

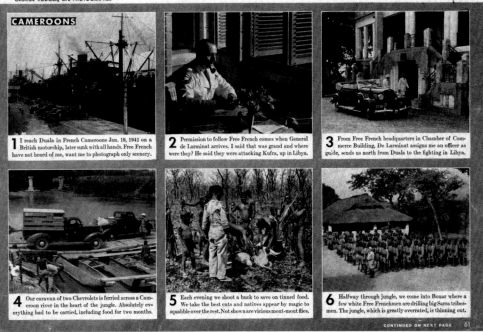

CAMEROONS

1 I reach Duala in French Cameroons Jan. 19, 1941 on a British motorship, later sunk with all hands. Free French have not heard of me, want me to photograph only scenery.

2 Permission to follow Free French comes when General de Larminat arrives. I said that was grand and where were they? He said they were attacking Kufra, up in Libya.

3 From Free French headquarters in Chamber of Commerce Building, De Larminat assigns me an officer as guide, sends us north from Duala to the fighting in Libya.

4 Our caravan of two Chevrolets is ferried across a Cameroon river in the heart of the jungle. Absolutely everything had to be carried, including food for two months.

5 Each evening we shoot a buck to save on tinned food. We take the best cuts and natives appear by magic to squabble over the rest. Not shown are vicious mout-mout flies.

6 Halfway through jungle, we come into Bouar where a few white Free Frenchmen are drilling big Sarra tribesmen. The jungle, which is greatly overrated, is thinning out.

CONTINUED ON NEXT PAGE 61

The first of a seven-page article on George Rodger's travels as a war correspondent, published in *Life* (vol.13, no.6, 10 August 1942, pp.61-7).

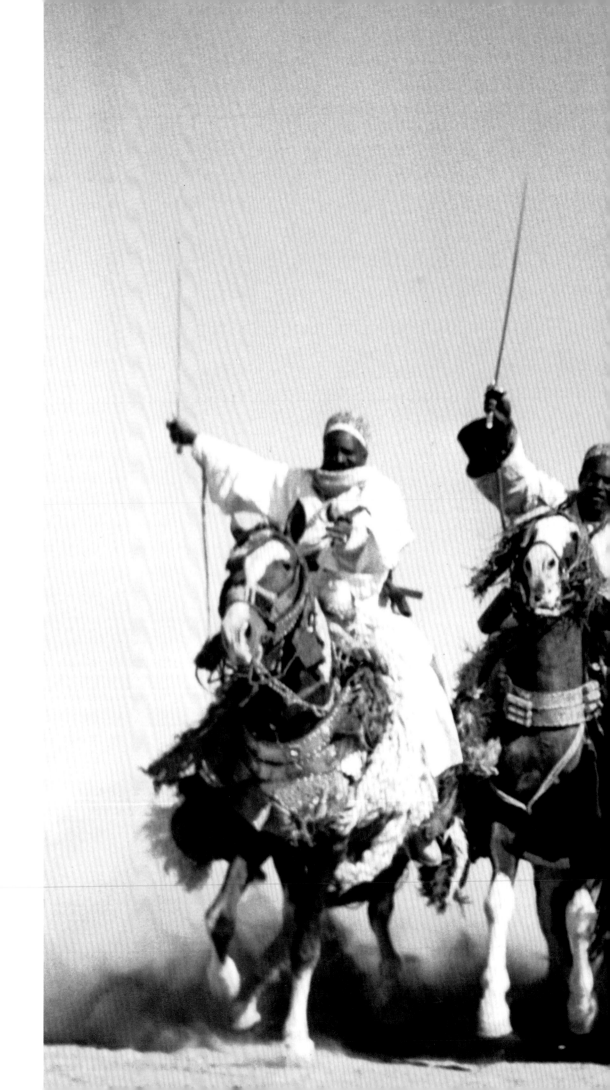

1940, Chad
The Hausa of Chad demonstrate their superb
horsemanship in a 'fantasia' of military prowess

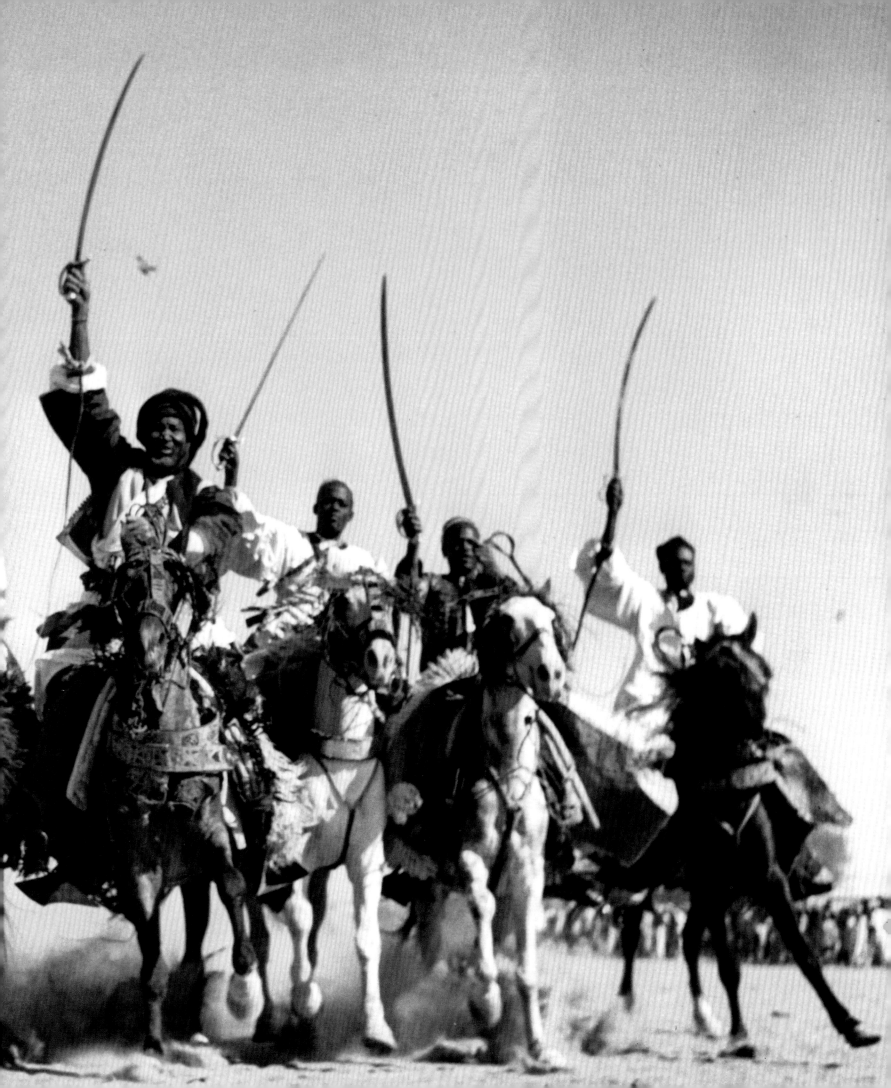

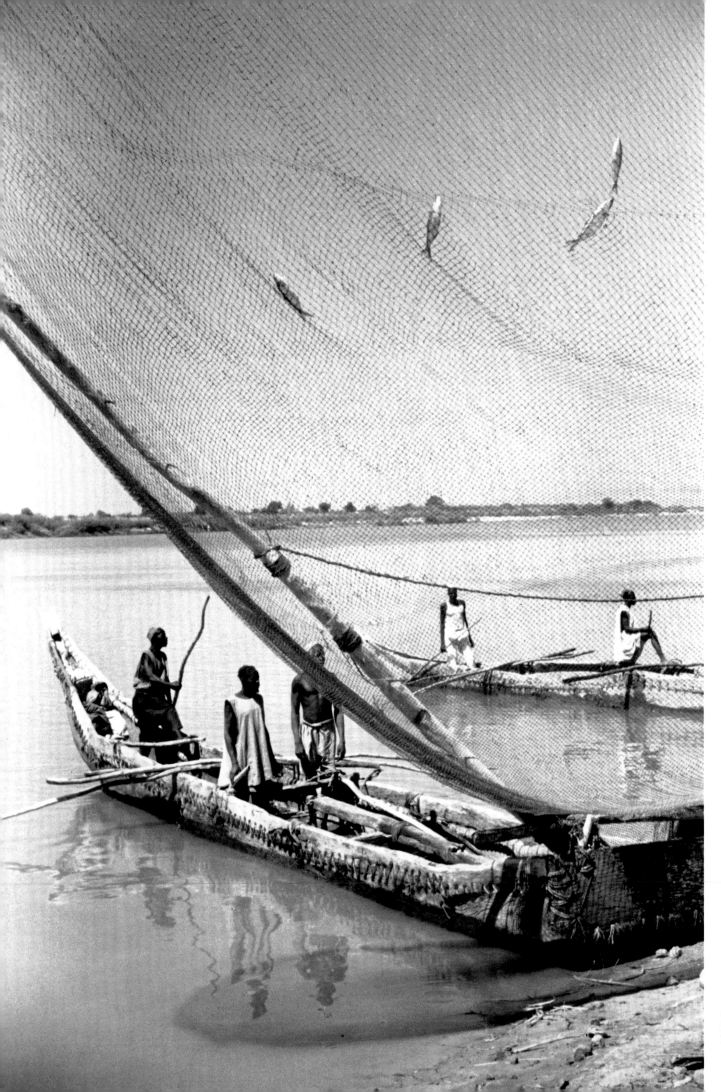

1941, Chad
Fishermen on the Shari River,
Fort Lamy

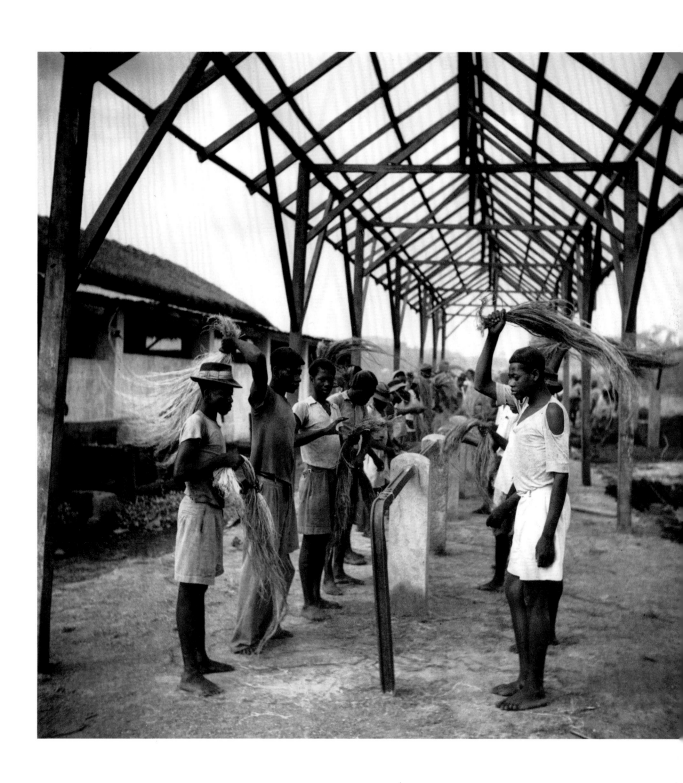

1941, French Cameroun
Processing ramie (a fibre used in textiles)
near the Sanaga River

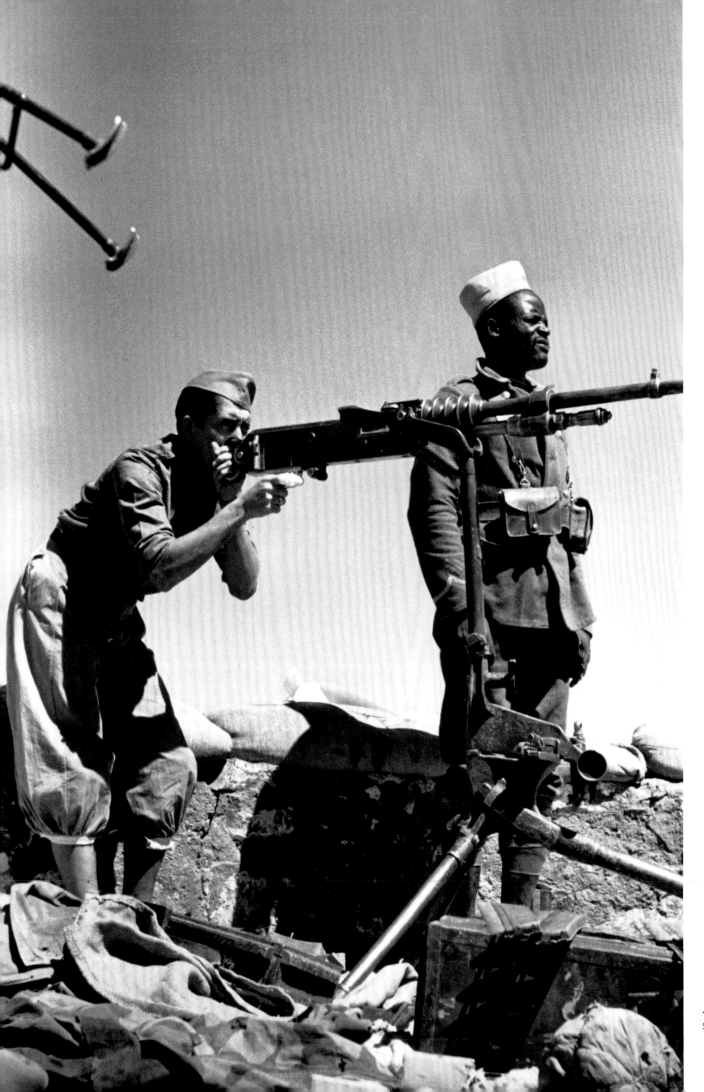

1941, Eritrea
Soldiers of the Free French Army

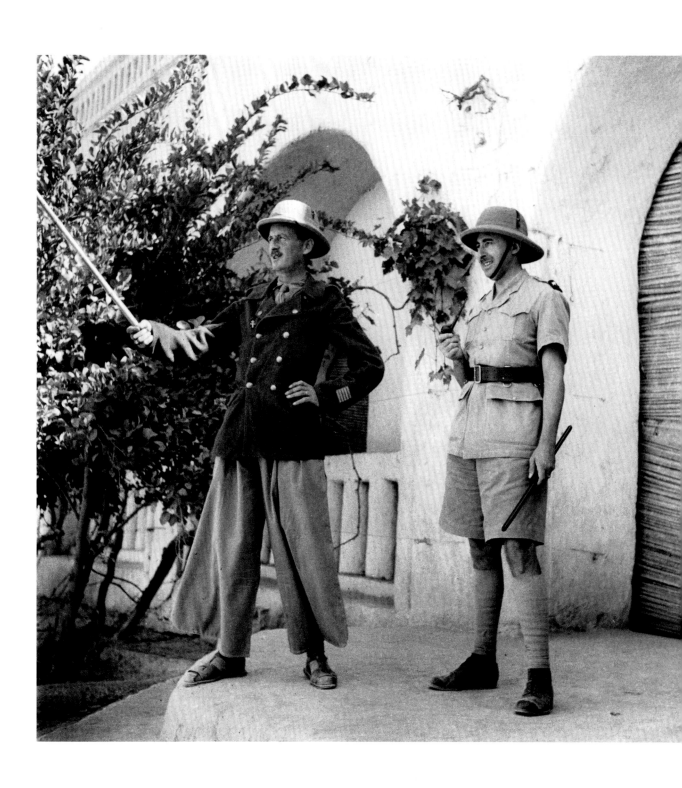

1941, Chad
General de Larminat (right) and Colonel Leclerc (left)
of the Free French, after the capture of Kufra

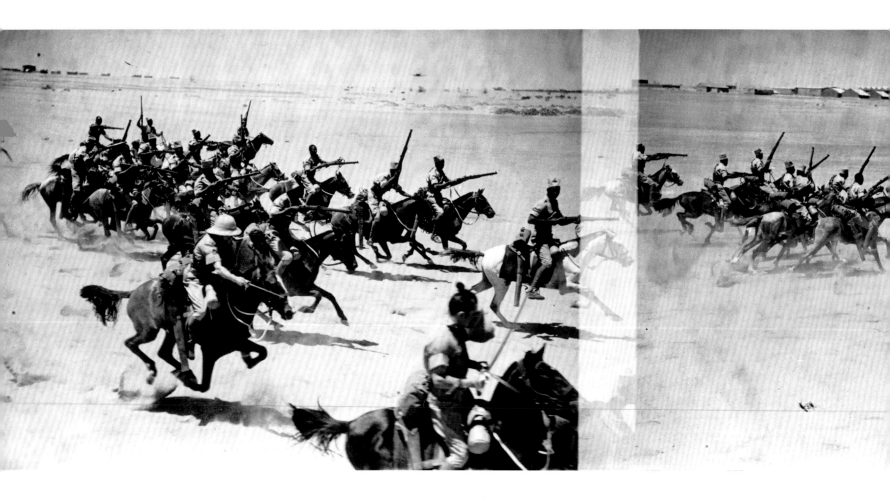

1941, Sudan
Sara tribesmen from Chad, members
of the Free French Forces, training in the
Sudanese desert

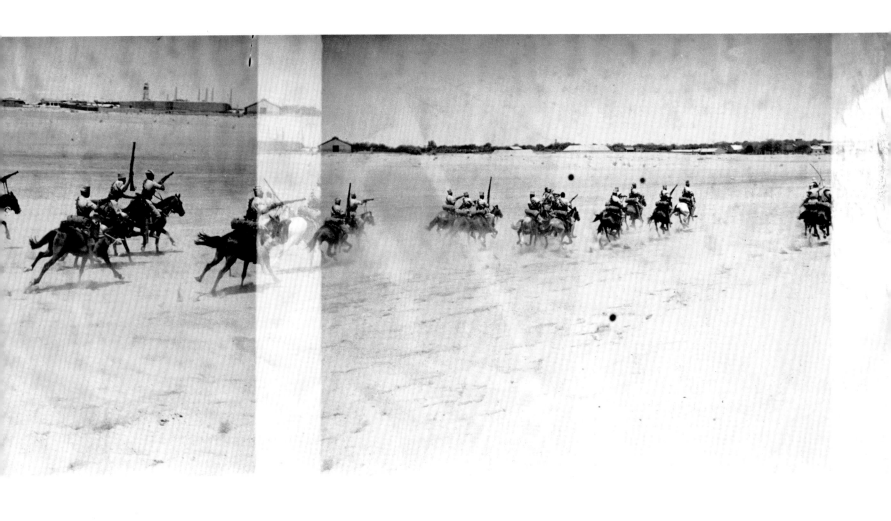

1941, Eritrea
The Free French Foreign Legion
fighting the Italians from the hills
around Asmara

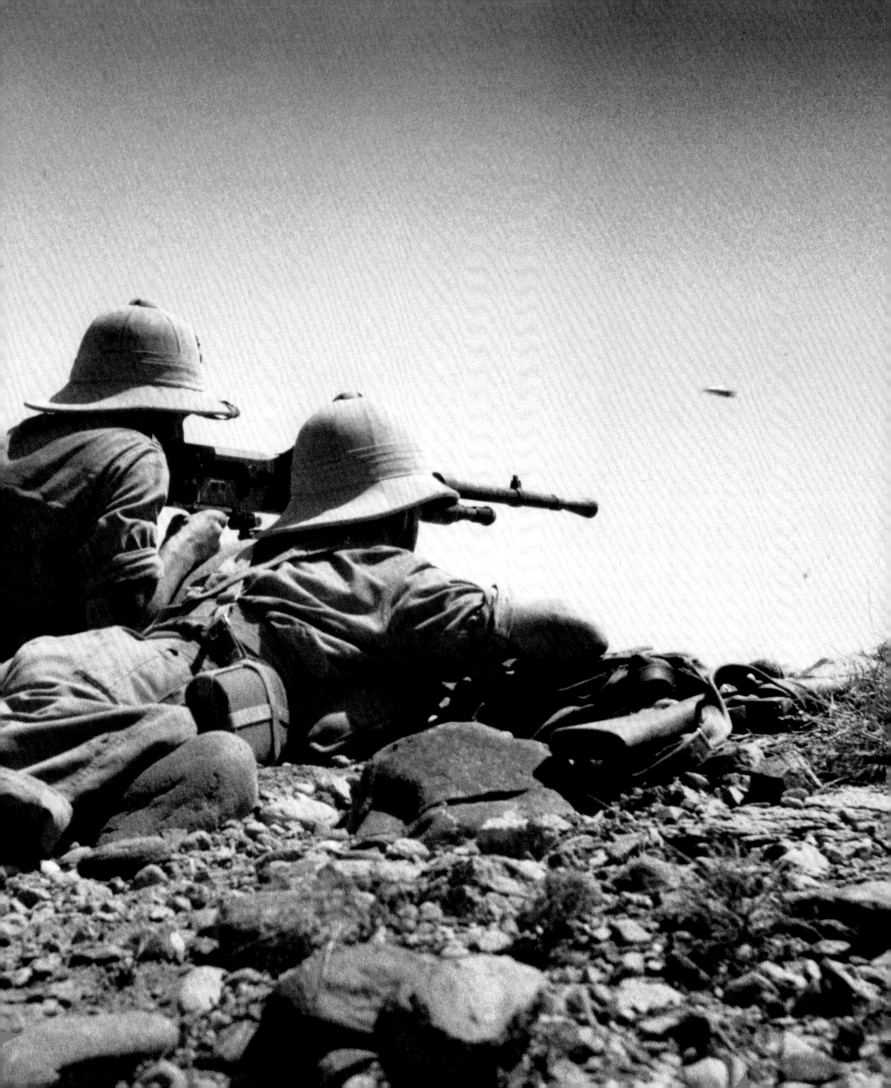

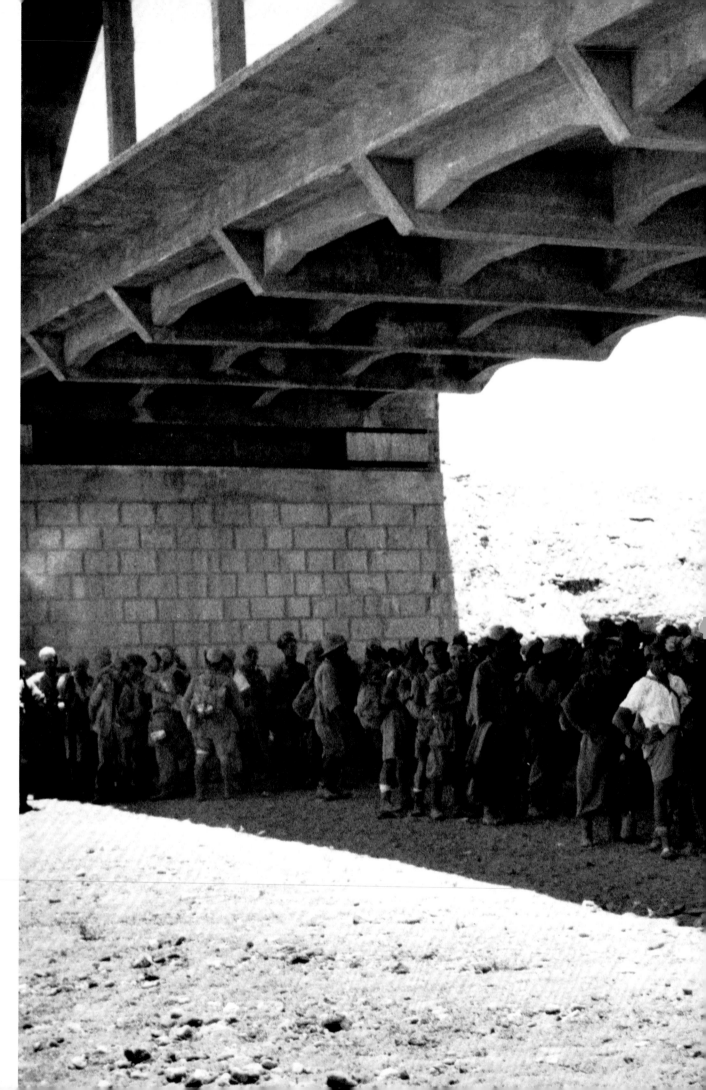

1941, Eritrea
Italian prisoners of war guarded by
Free French soldiers at Massawa

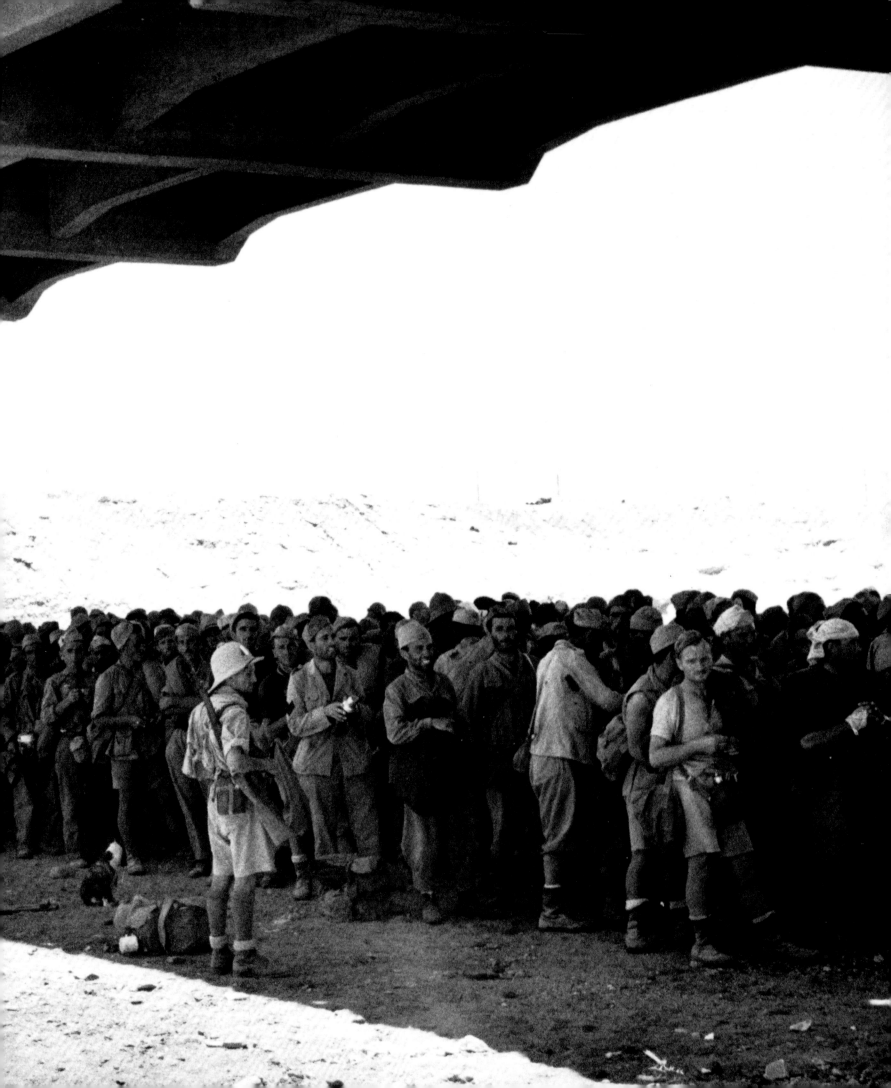

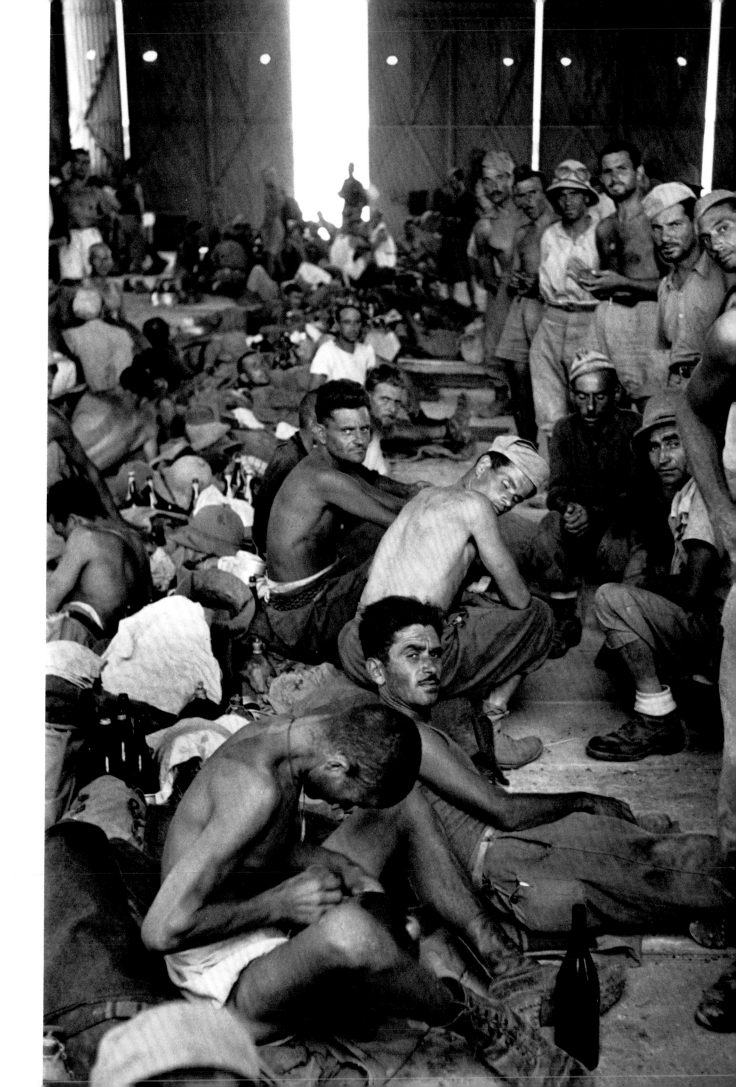

1941, Eritrea
Italian prisoners from
Fort Umberto awaiting
imprisonment by Allied
Forces at Massawa

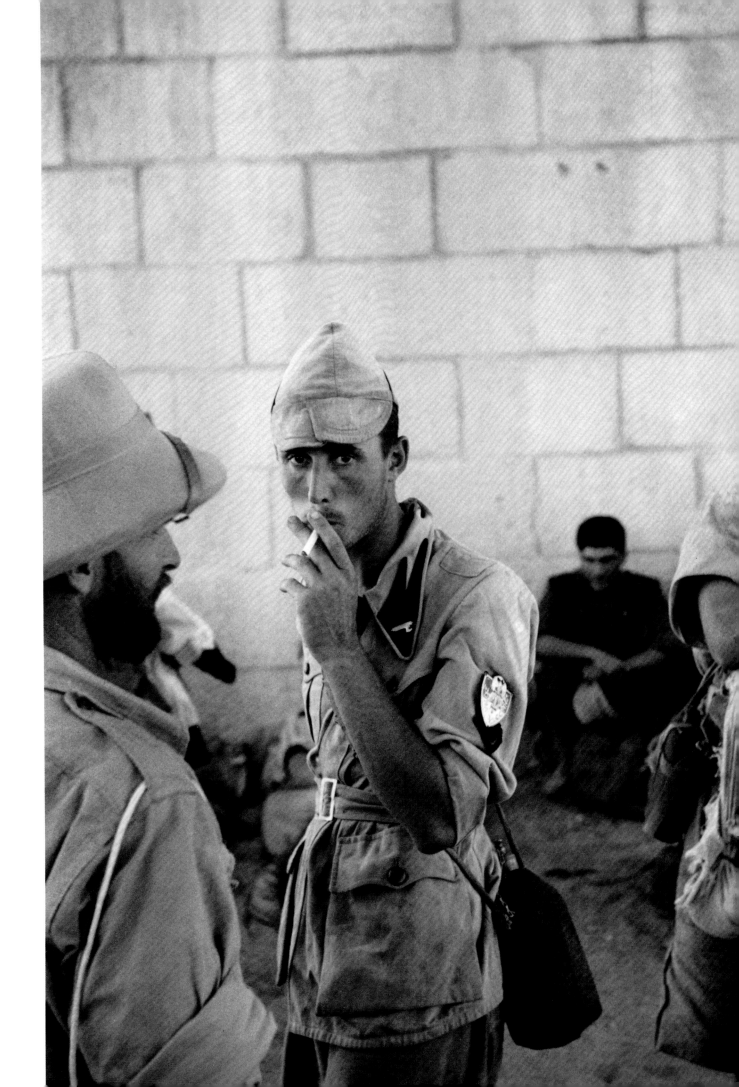

1941, Eritrea
Italian prisoners from
Fort Umberto guarded by
Free French soldiers

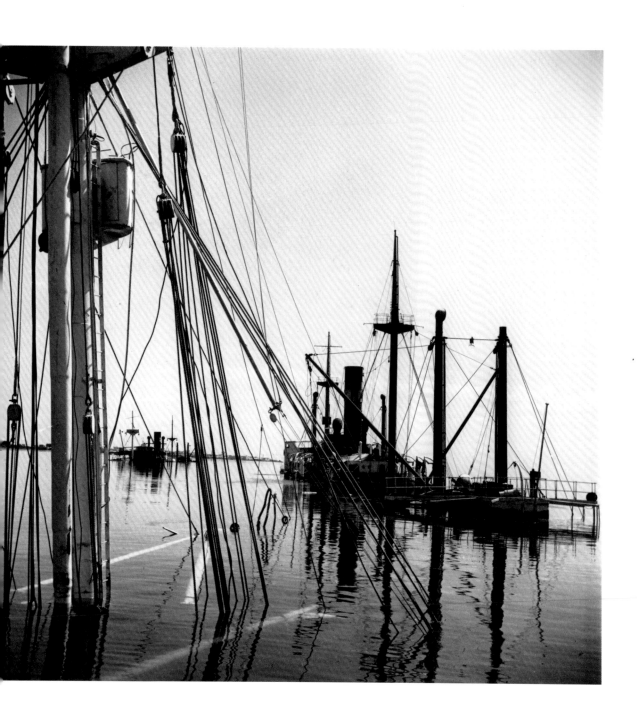

1941, Eritrea
Ships are scuttled by Italians to prevent the use
of the port by Allied shipping at Massawa Harbour

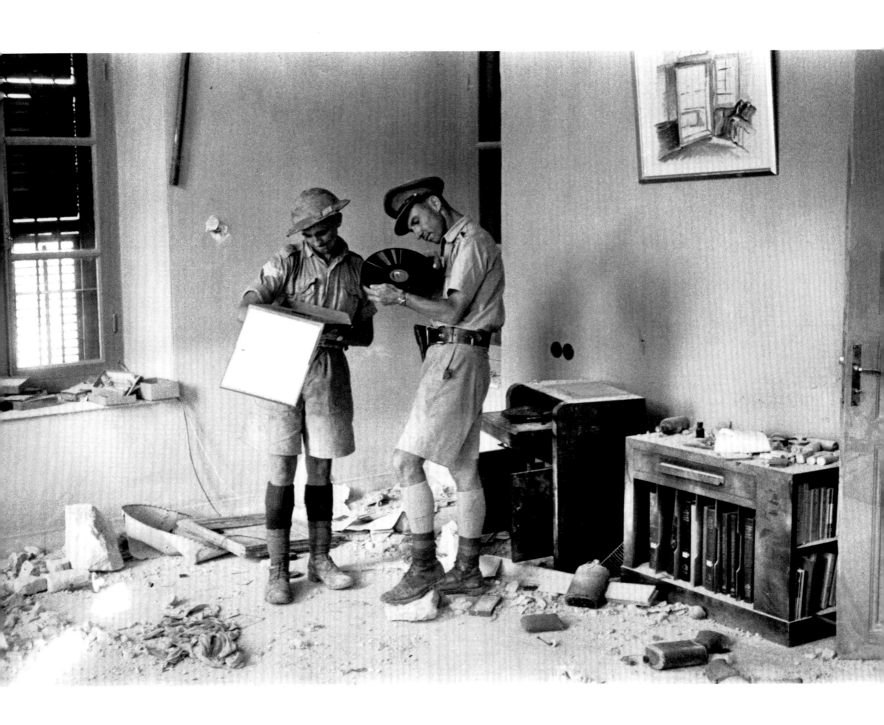

1941, Syria
Officers of the Indian Army discover the Vichy
French HQ at Damascus after the surrender

1941, Jordan
His Hashemite Highness Emir Abdullah ibn
Hussein of Jordan, later to become King

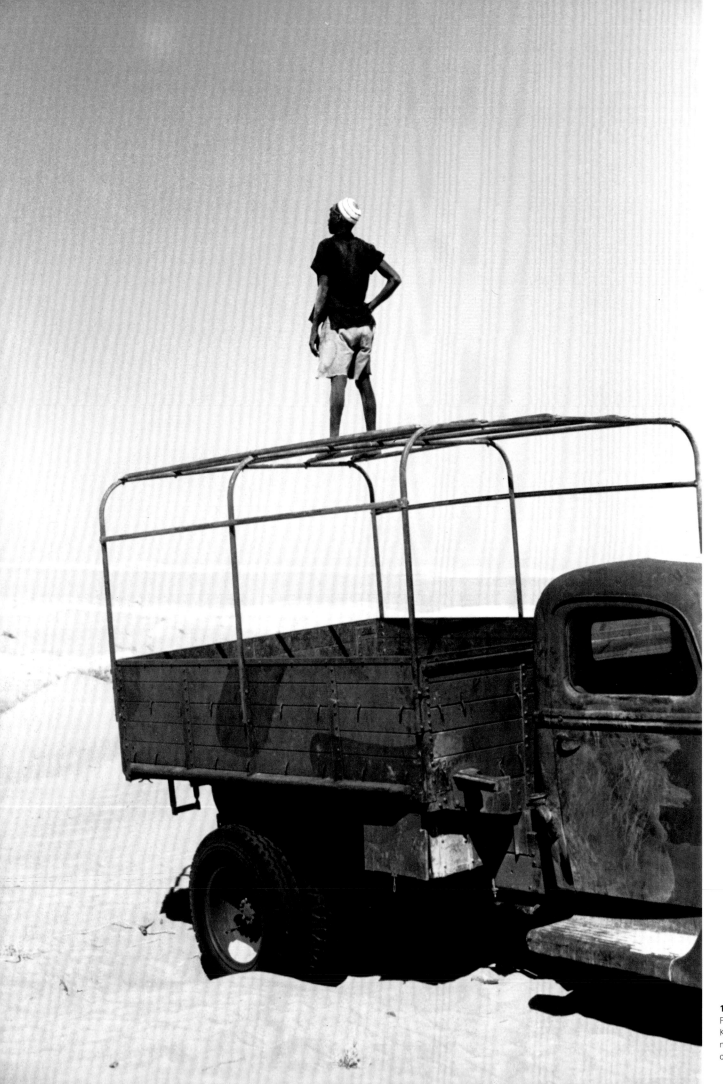

1941, Chad
For his attack on the Oasis of Kufra, Colonel Leclerc had no military transport and relied on civilian trucks and local support

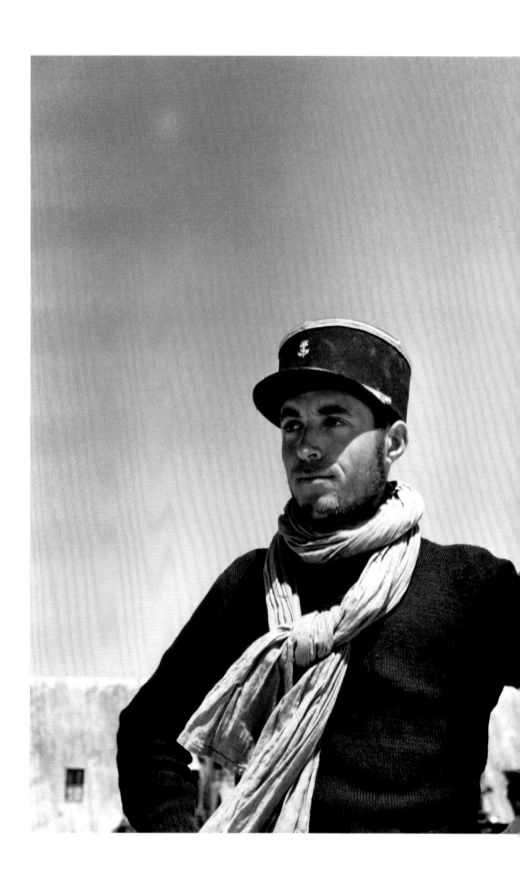

1941, Libya
One of Leclerc's Free French officers
after the fall of the Oasis of Kufra

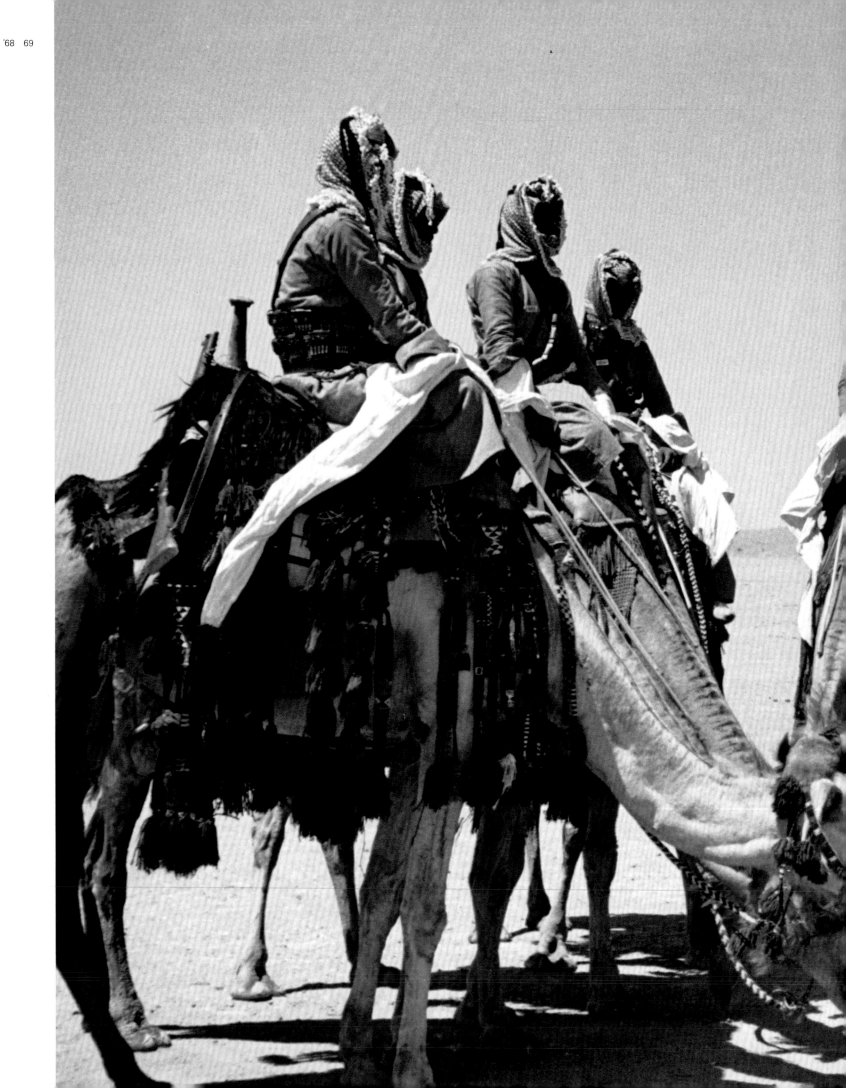

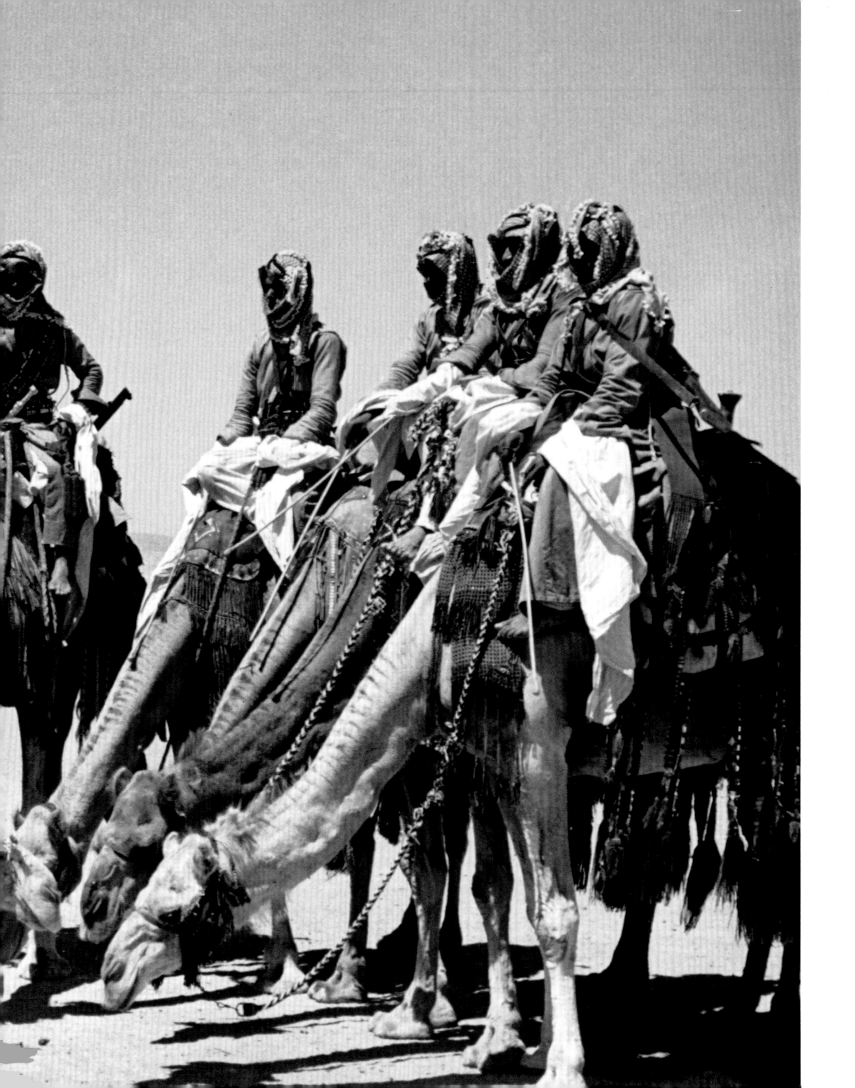

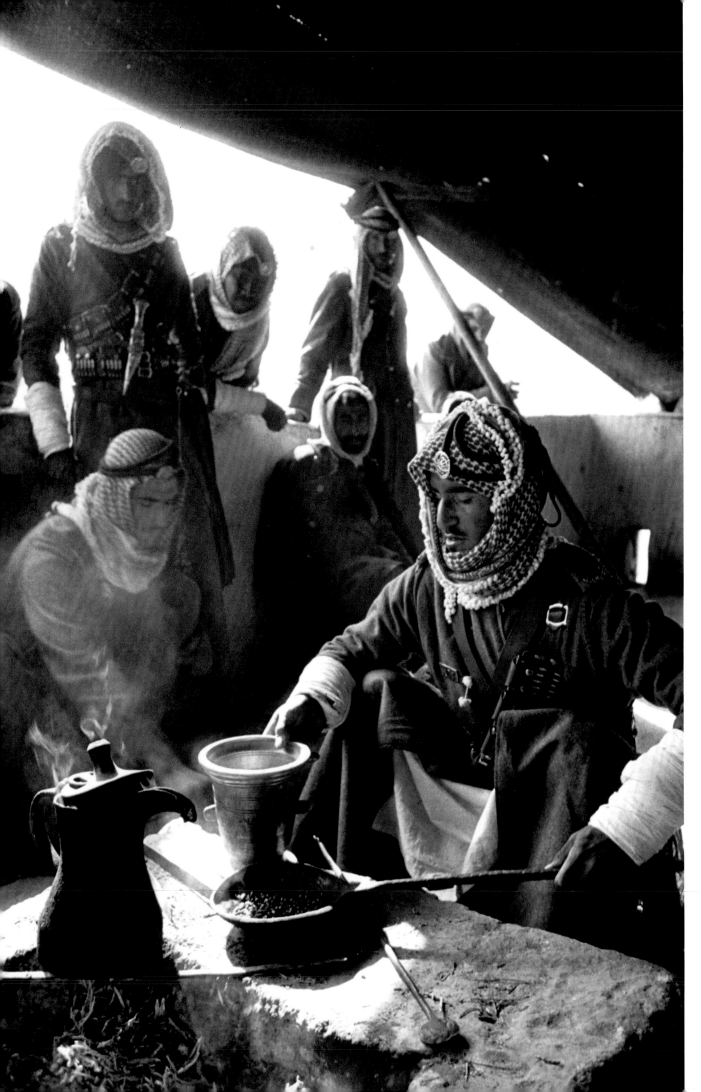

1941, Jordan
Soldiers of the Transjordan
Desert Patrol making coffee
in their camp near Mafrak

Pages 68, 69
1941, Jordan
Camel Corps of the
Arab Legion at Mafrak

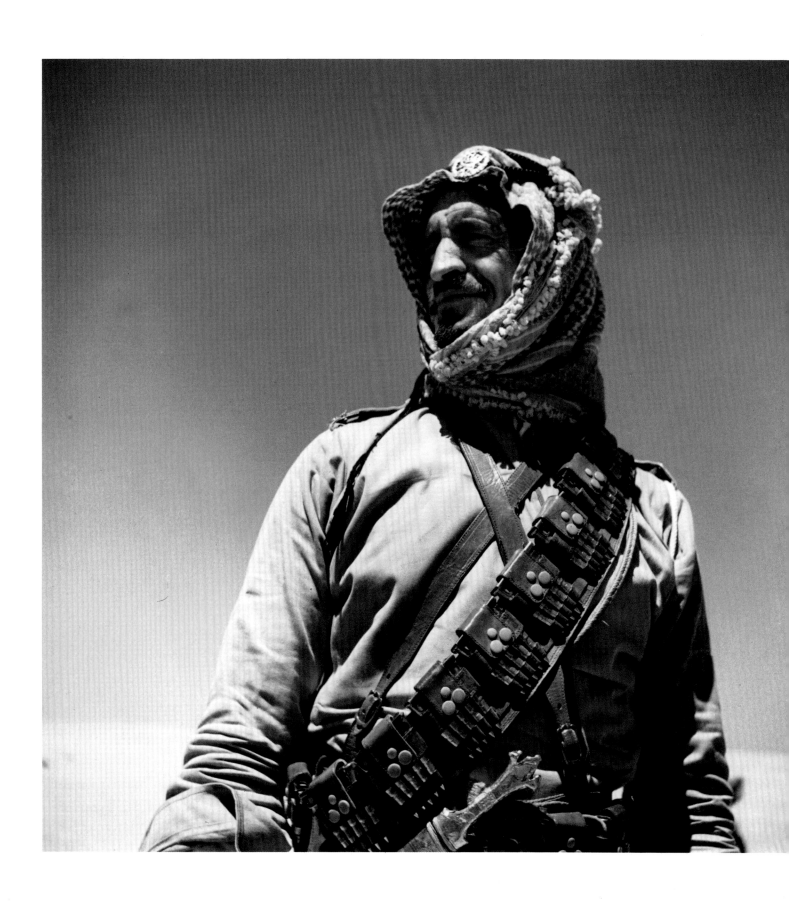

1941, Jordan
A soldier of the Camel Corps,
the Arab Legion, Jordan

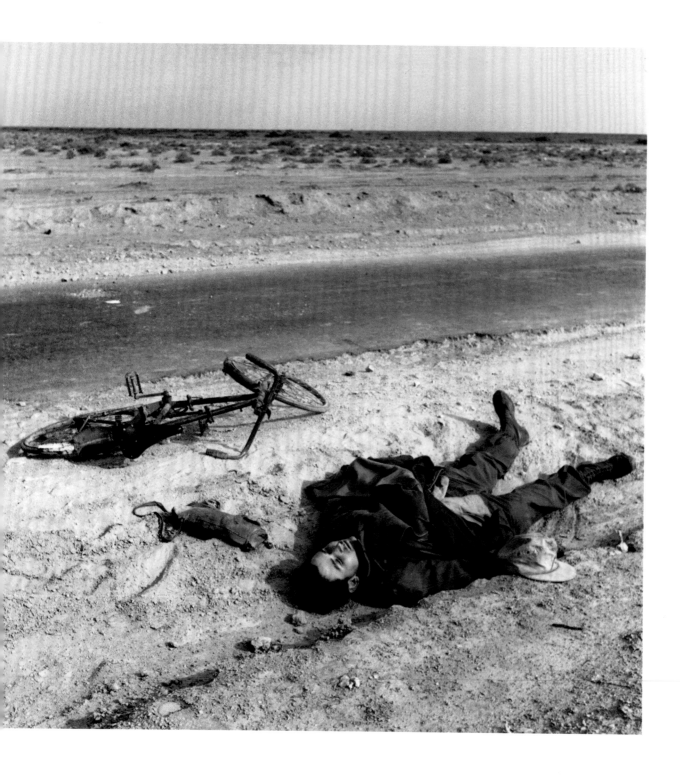

1941, Western Desert
A young German soldier lies dead beside his
bicycle in the desert west of Gazala

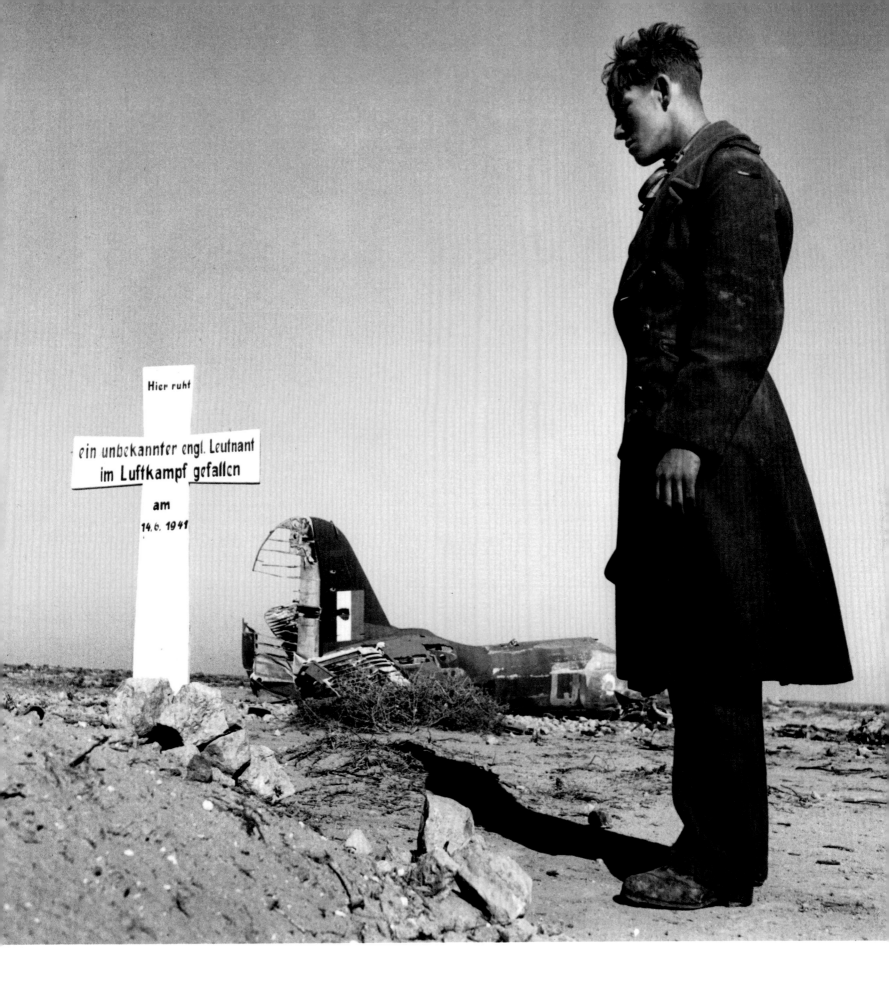

Hier ruht

ein unbekannter engl. Leutnant
im Luftkampf gefallen

am
14.6.1941

1941, Western Desert
An example of the chivalry of Rommel's Afrika Corps.
The inscription reads 'Here lies an unknown English
lieutenant who died in the air war'

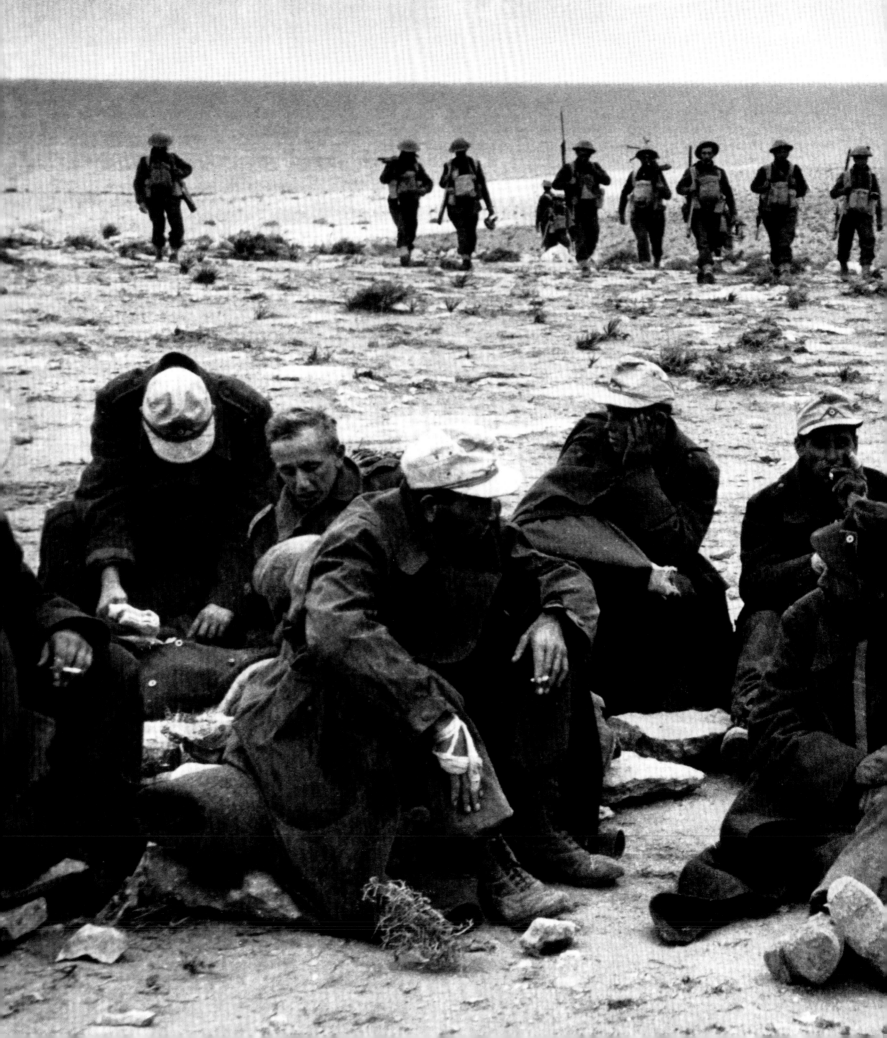

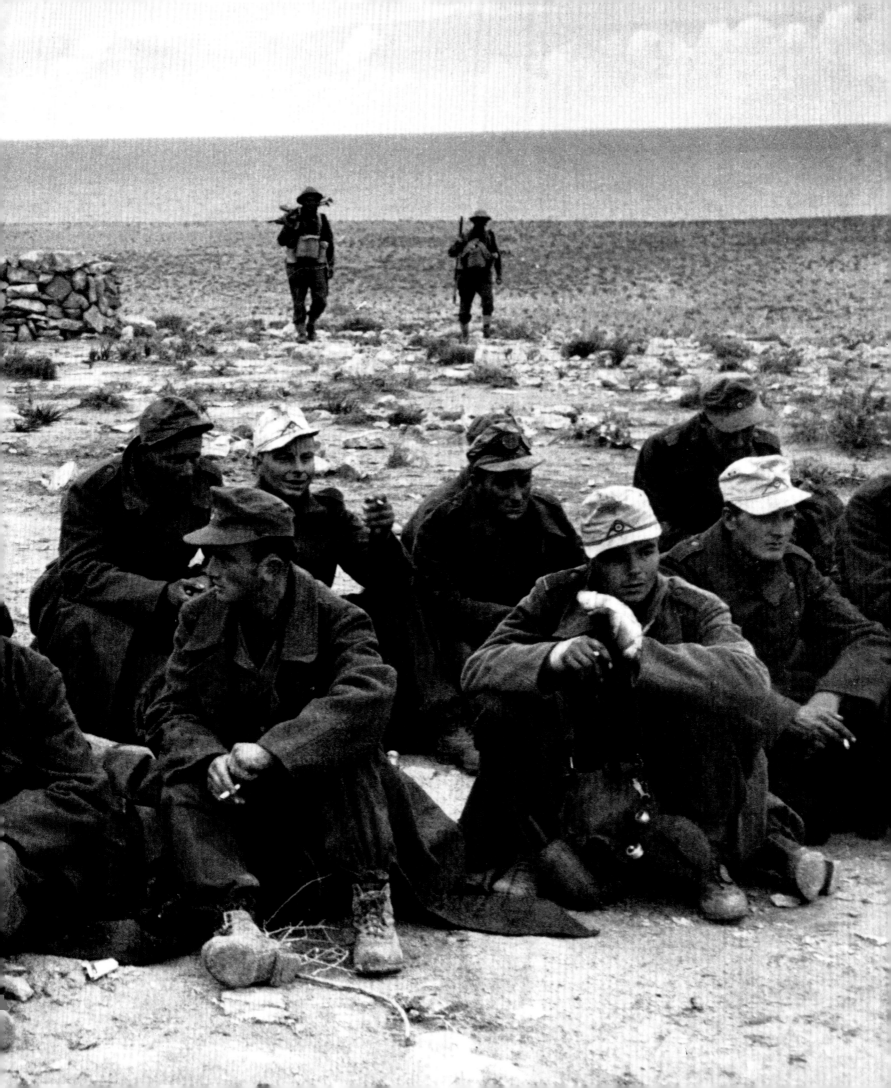

Burma

Opposite
1942, Burma
Signs in several languages nailed
to a tree in Kyuhkok indicate offices
of traders, contractors and merchants

Pages 76, 77
1941, Western Desert
German prisoners assembled near
the sea close to Derne

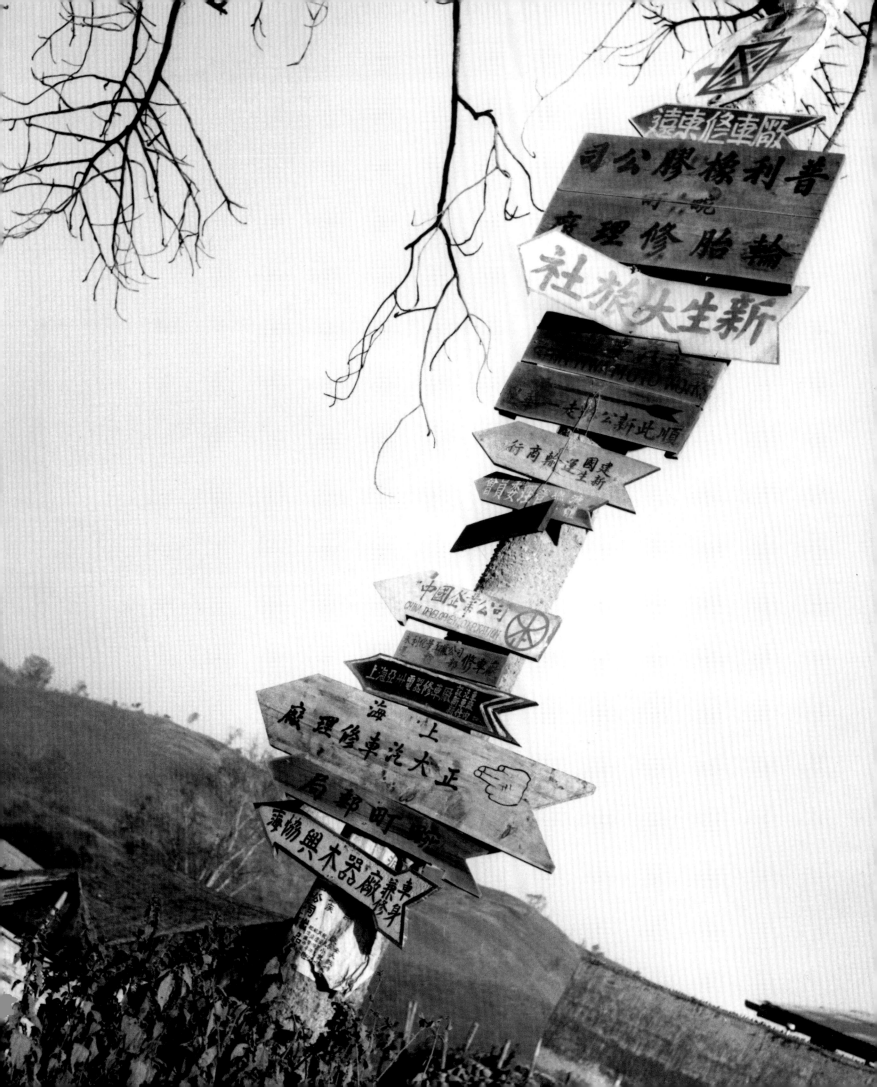

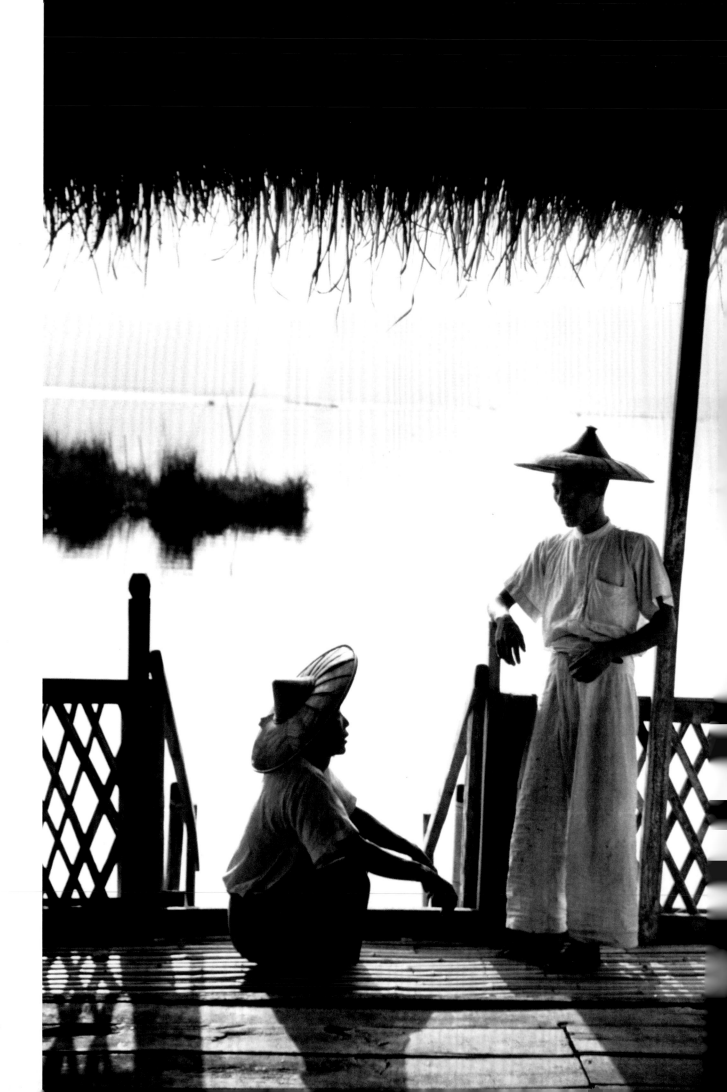

1942, Burma
A bamboo house built on
stilts on Inle Lake

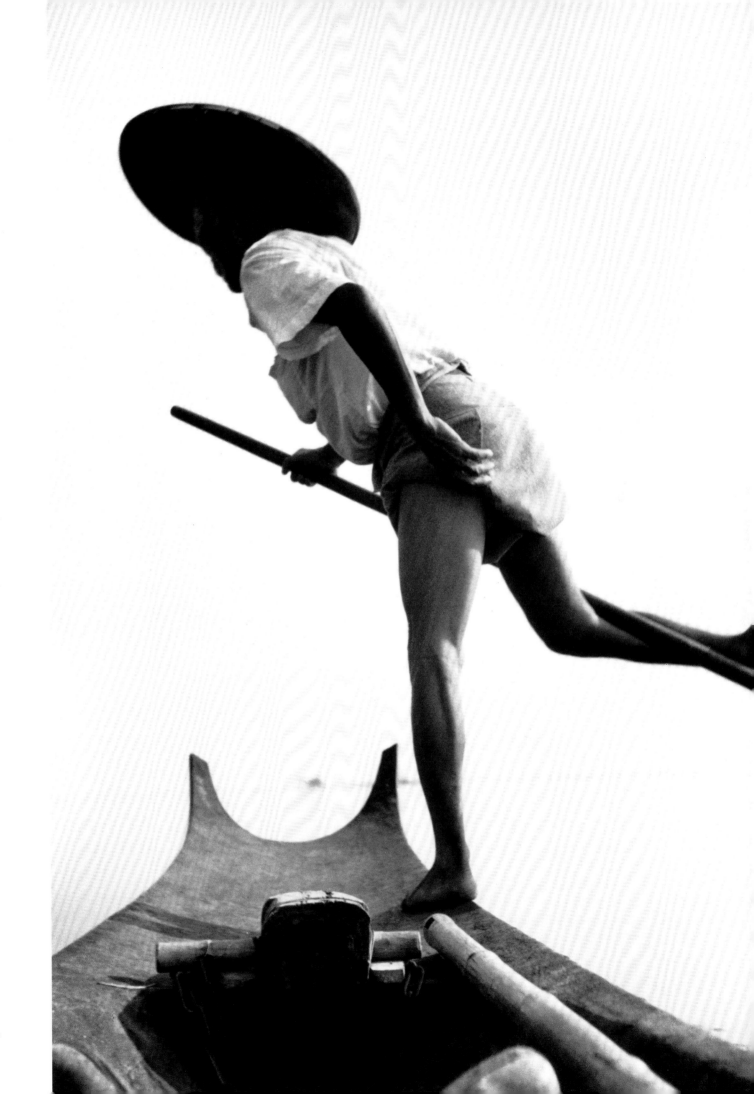

1942, Burma
A leg-rower propels
his canoe over Inle Lake
in the Shan States

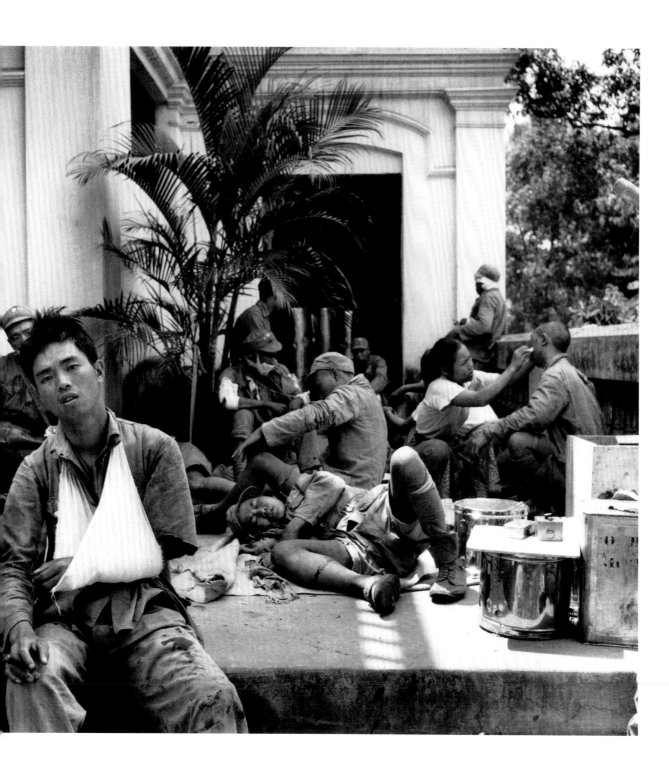

1942, Burma
Dr Seagrave's emergency hospital, in a school building in Pynmana.
Chinese army wounded are treated by Burmese nurses

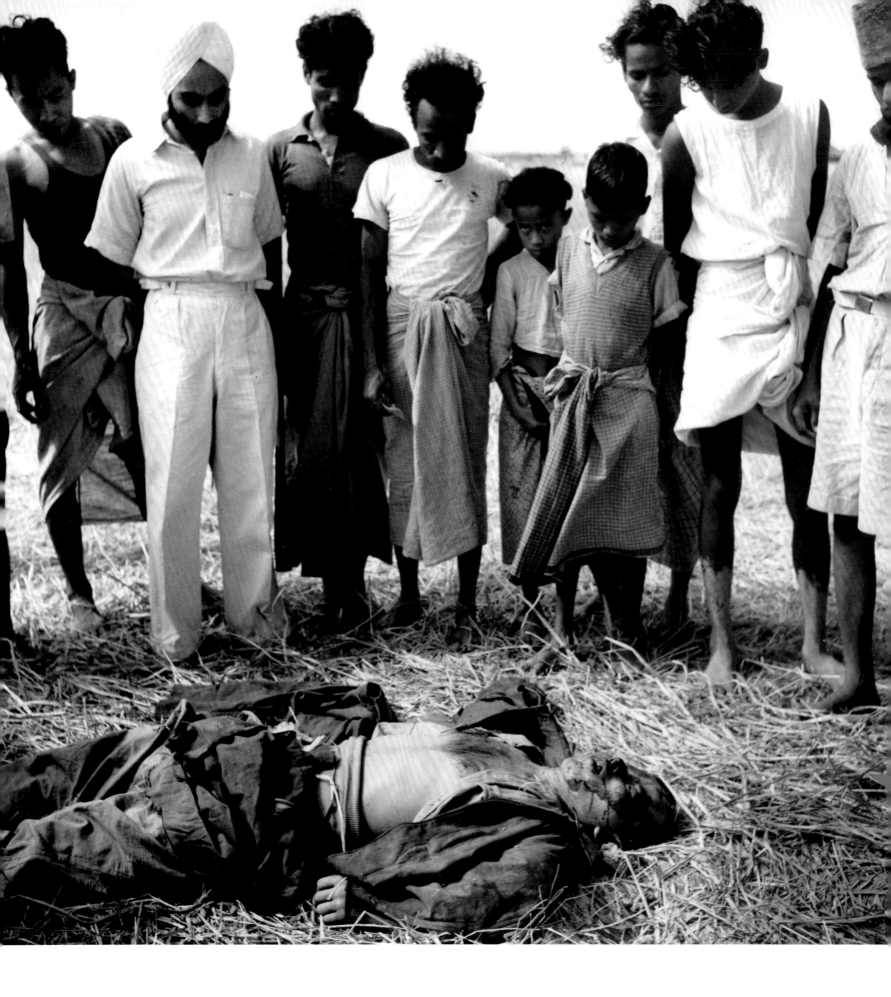

1942, Burma
A body from a crashed Japanese bomber
excites the interest of locals near Rangoon

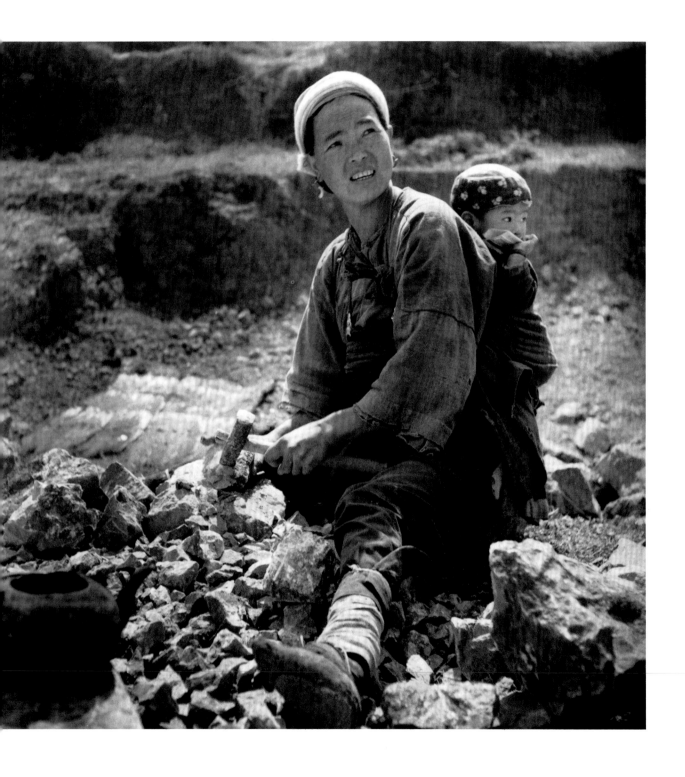

1942, Burma
A Chinese woman breaks stones
for repair of the Burma Road

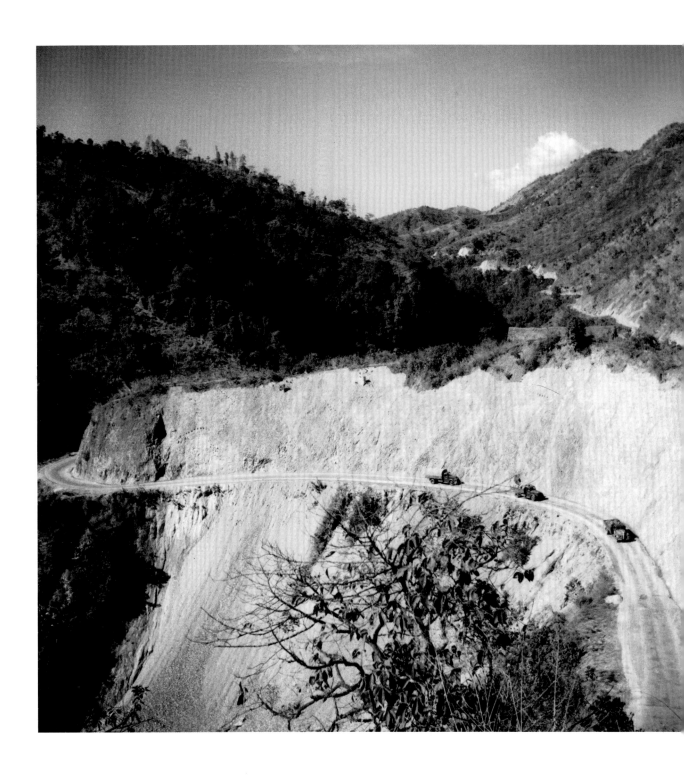

1942, Burma
The Burma Road snakes up the mountain
between Wan-Ting and Paoshan

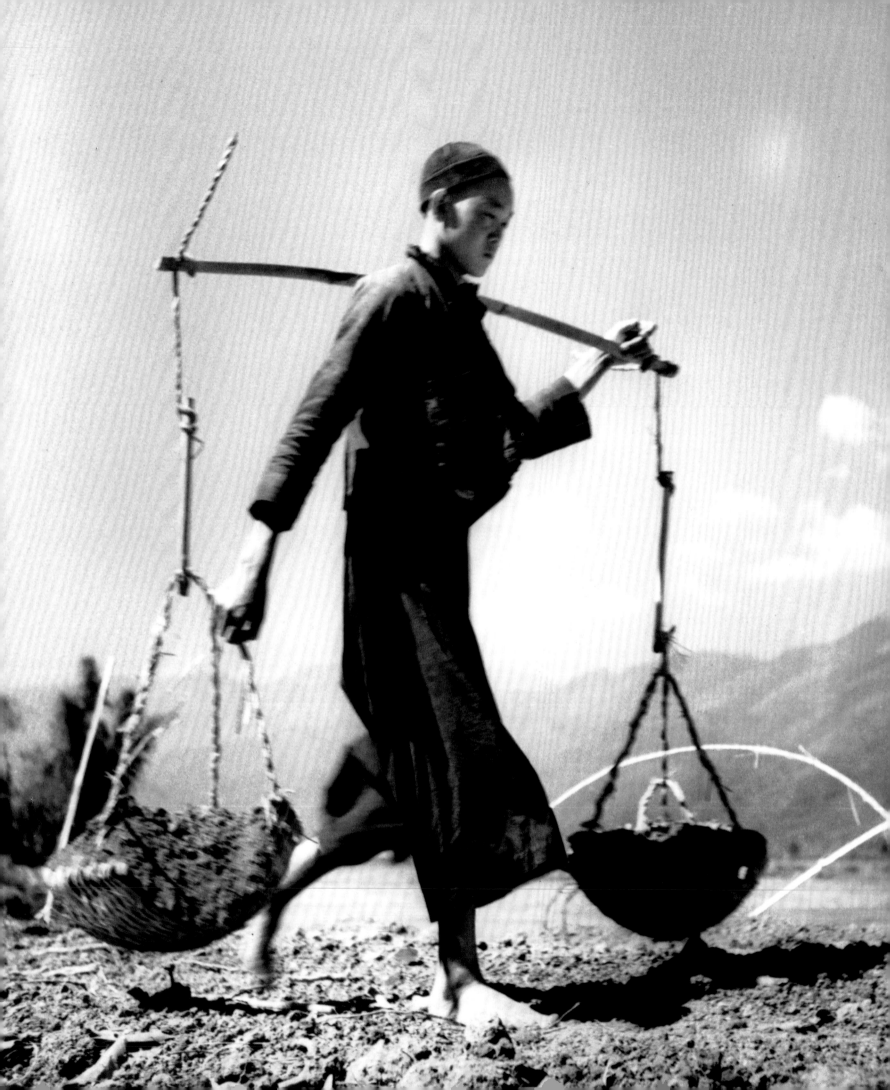

1942, Burma
A Chinese coolie works on the
Yannan-Burma railway

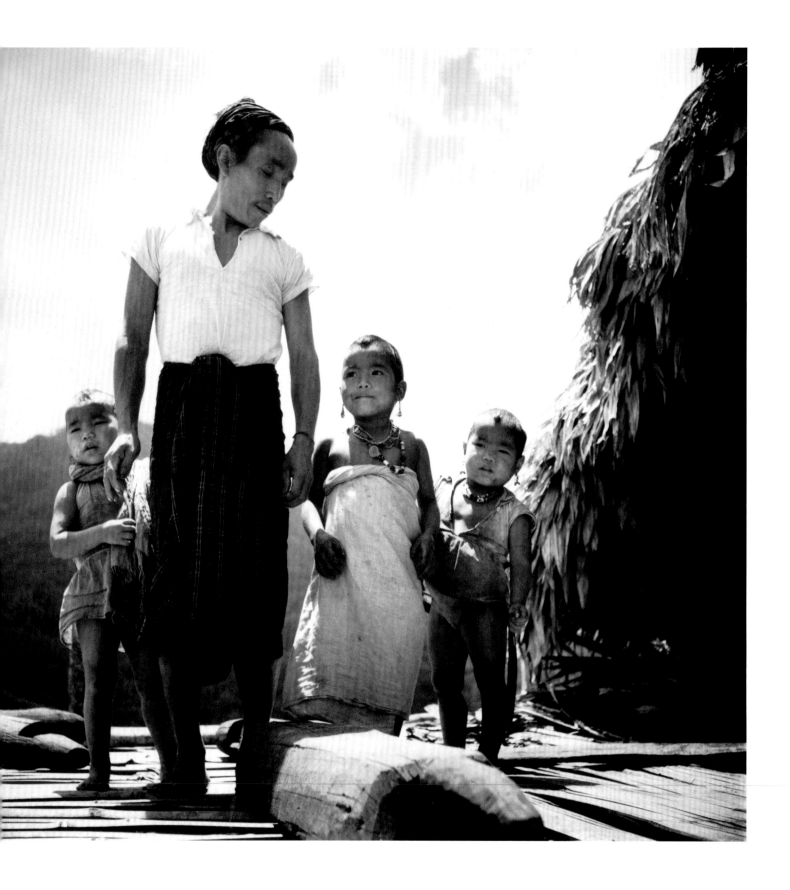

1942, Burma
A Naga family in the Patkai Range of
mountains between Burma and India

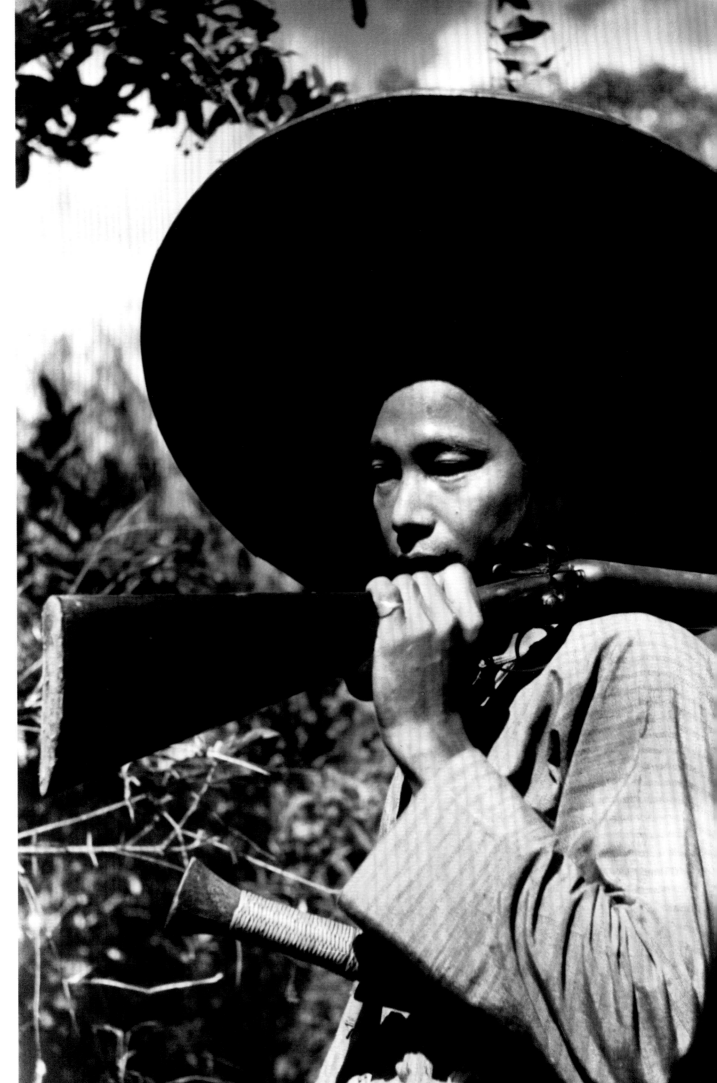

1942, Burma
A Kachin hunter in Upper Burma

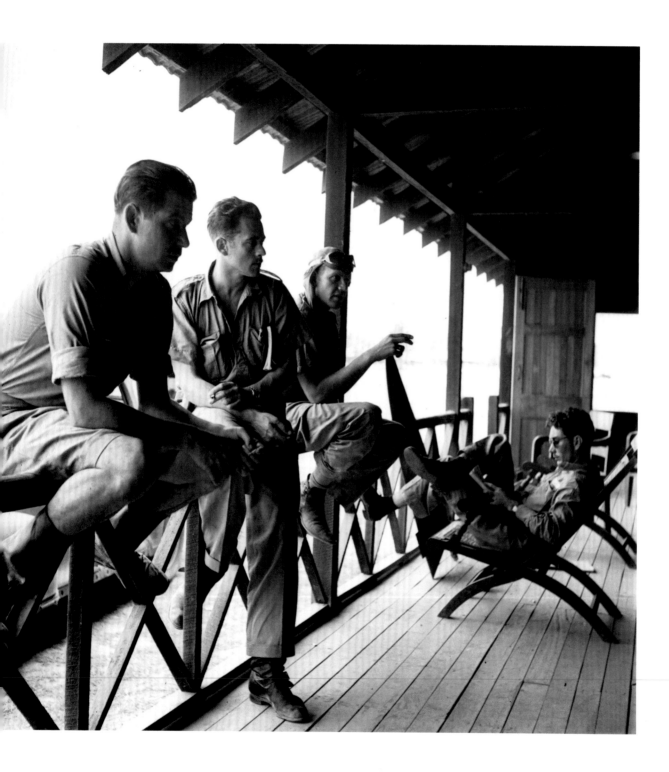

1942, Burma
Flying Tigers at Mingladon Airfield
outside Rangoon

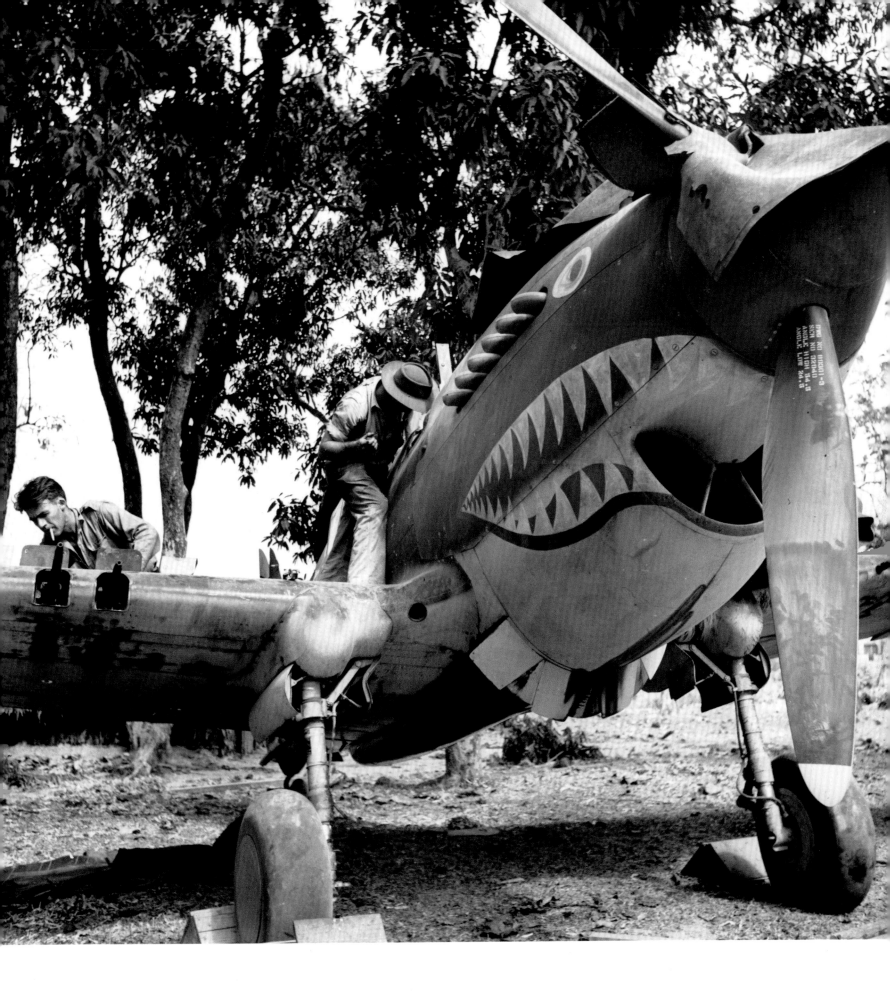

1942, Burma
Ground crew of the Flying Tigers repair
the fuselage of a Curtiss P-40 fighter plane

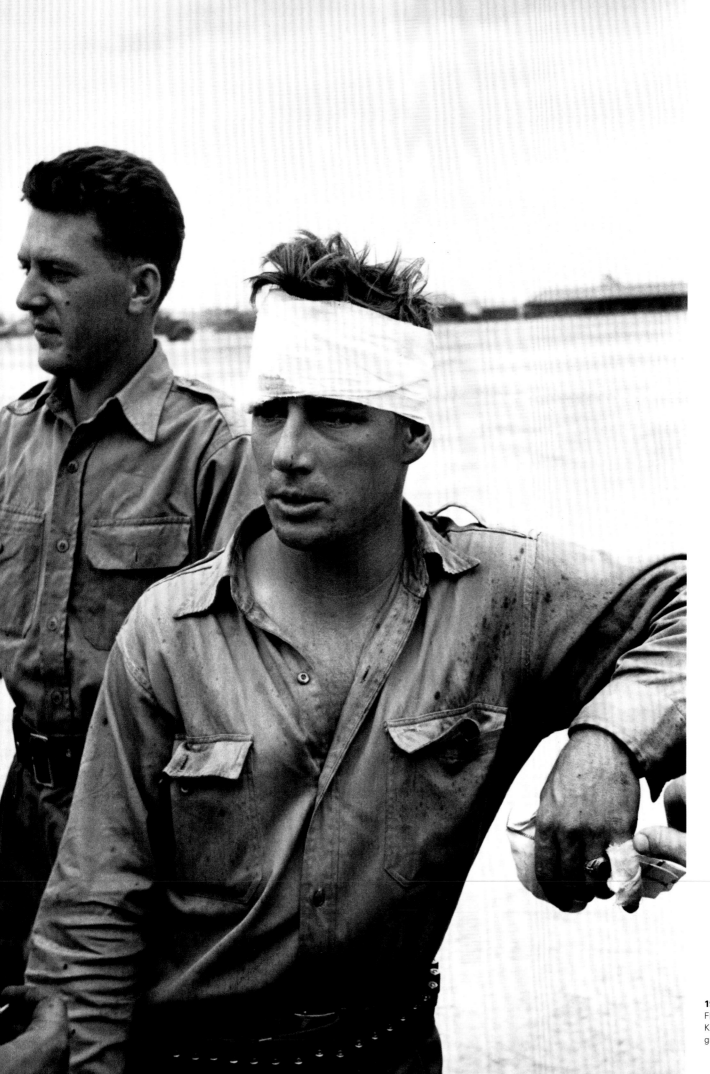

1942, Burma
Flying Tigers pilot Matthew
Kuykendall of San Saba, Texas,
grazed by a Japanese bullet

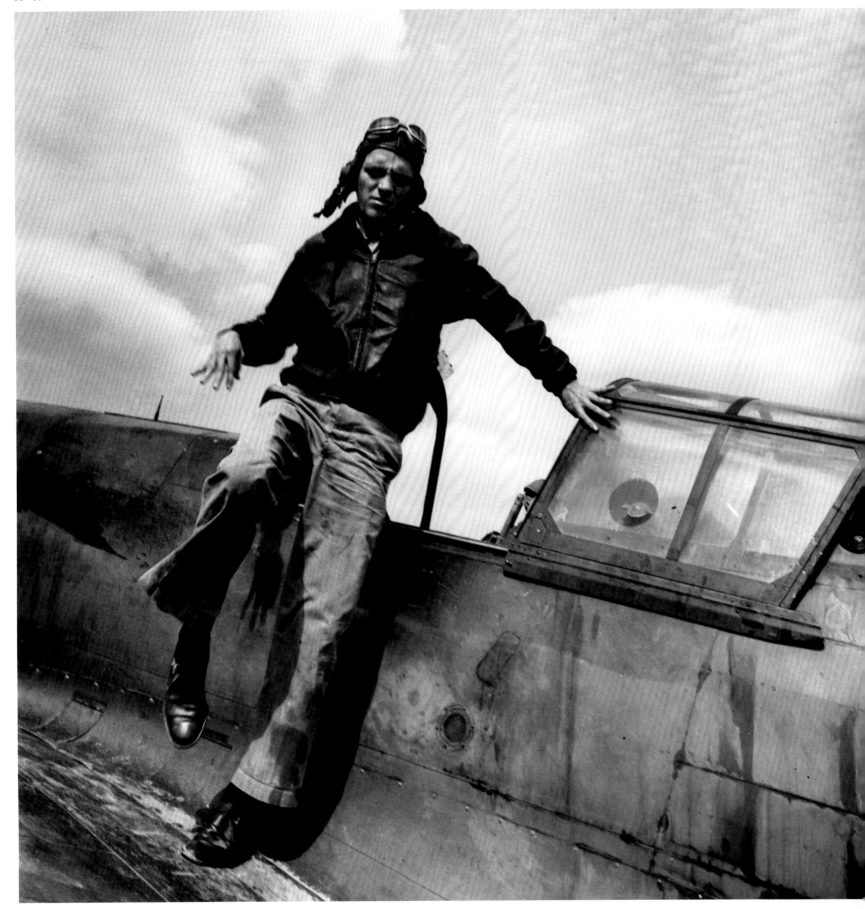

1942, Burma
Flying Tigers pilot Frank Lawler

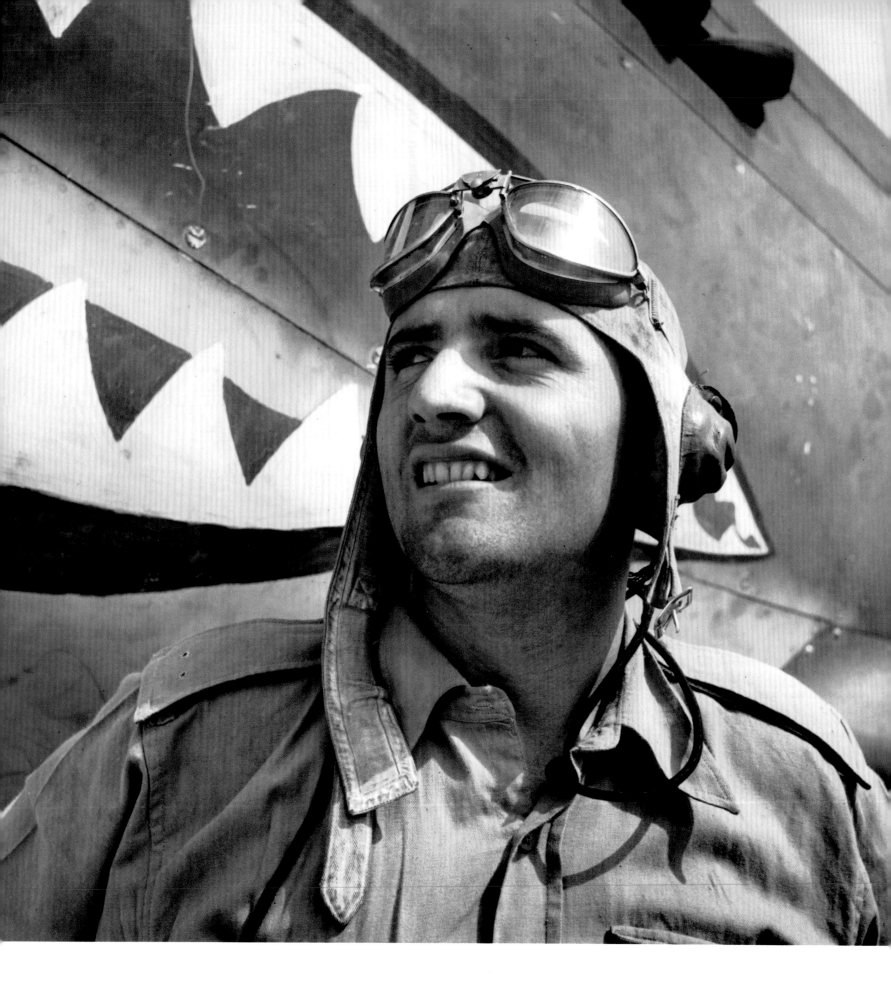

1942, Burma
Flying Tigers pilot Tom Cole from Missouri, shot down
and killed the day after this photograph was taken

Europe

On his return from America, Rodger was accredited to the US forces. He was, however, exhausted from his harrowing 75,000-mile trek and he rested most of the time until August 1943, when he joined General Mark Clark's Army in Algiers, Sicily and finally the landing at Salerno on mainland Italy. In London he ordered a personally designed composite 'uniform' which was tailored in Savile Row, as the way many soldiers and camp followers had dressed in Burma or the desert was unacceptably scruffy to the officers of the armies in Europe. Rodger had already shown a flair for costume when he had affected a kind of 'Rodger of Arabia' headdress in the desert, and now with his Savile Row outfit he wore a cravat of camouflage patterned parachute silk, looking, no doubt, the height of photomilitary elegance. On approaching the legendary American General Patton for a picture and story, he was told severely that he was entirely unacceptable without a steel helmet. He had no time to explain the impossibility of shooting, thus accoutred, vertical pictures with a Leica, so he told the notorious bully that he didn't need his picture that badly. At this, the irascible general seemed to reach for his famous pearl-handled revolvers, so Rodger turned his back on him and walked away – an infallible tactic, he decided, which possibly saved his life later on.

In Italy he had his own jeep, which he used freely along the battle lines. But he found that bridges over rivers were unprotected by the steep hills from German fire and that he could only cross them by ducking his whole body below the level of their stone parapets and driving the jeep blind as German bullets sprayed pieces of the bridge over him. He visited several friendly fishing villages and had himself rowed out to a Capri deserted except by fishermen and their families, with Naples just across the water still occupied by the Germans. He has described an extraordinary idyll: a fisherman singing with his guitar, and his large wife weeping

with emotion. They didn't mind their two beautiful daughters, who called Rodger 'my brother', bathing naked in his presence. The whole episode seems to him now like an impossibly beautiful dream, which was broken by the arrival of the Americans, who took over the island as a rest camp. Rodger left feeling an immense gratitude towards the family and the island. Any scepticism about this story fades completely when one remembers other examples of Rodger's empathy with strangers, and the poet whom the journalist manages largely to conceal.

Rodger then joined Montgomery's Eighth Army advancing up the Adriatic coast of Italy, and then crossed over to Naples when it fell to the Americans. Here he photographed the great eruption of Vesuvius that coincided with the Germans' departure. He was based for several weeks outside Naples with the mercurial Hungarian Robert Capa in a beautiful villa and they talked there for the first time of Capa's brilliant idea for a photographers' co-operative that would become Magnum. But before the Allied armies reached Rome, Rodger was called back to England where D-day was afoot.

In 1944 Rodger followed the armies on to the liberation of Paris, where he met Capa again, celebrated with some illegal absinthe and was, without knowing it, photographed by Henri Cartier-Bresson, whom he had never met, in General de Gaulle's great victory parade. Capa was already talking to Cartier-Bresson about Magnum, and the future careers of all three – and many others – were beginning to unfold. Rodger pressed on to Belgium. On crossing the frontier, the British armoured column that he accompanied was greeted with the most fervent joy imaginable and showered with cigarettes, sweets, fruit, beer and endless bouquets of flowers. He continued to Holland, where he photographed the flooding of Walcheren

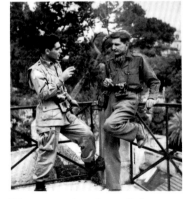

War correspondents George Rodger (right) and Robert Capa (left) took up residence in a requisitioned villa in Vomero, Naples, in 1943.

Island, then crossed the Rhine into Germany. It had been a sometimes uncertain progress behind the armoured spearheads, with excitement and rejoicing, contrasted with an endless litter of corpses, wreckage and smouldering ruins. At the Rhine crossing Rodger heard Churchill addressing the British troops: 'You are now entering the dire sink of iniquity,' he told them, which Rodger thought a rather fanciful example of the Prime Minister's famous rhetoric. But soon afterwards he found himself driving into a camp called Belsen, where he came upon a horror that no words could ever adequately describe.

It gave him his worst shock of the entire war, and his reaction to it was pivotal to his future. He had continually seen corpses in all parts of Africa, Asia and Europe, and in varying degrees of decomposition; but here was, in is own words, 'the ultimate in human degradation', with its perpetrators or supervisors seemingly unmoved, except by fear of the British soldiers who made them tidy up the scene of their terrible handiwork. During the previous month of March, 17,000 people had died of starvation in this one camp and even now, being beyond all hope of recovery, they were expiring at the rate of 300 to 350 a day. In Rodger's words:

'Under the pine trees the scattered dead were lying, not in their twos or threes or dozens, but in thousands. The living tore ragged clothing from the corpses to build fires, over which they boiled pine needles and roots for soup. Little children rested their heads against the stinking corpses of their mothers, too nearly dead themselves to cry.'

Rodger described a horribly emaciated man trying to say something to him, but dropping dead at his feet in the attempt. Bodies with gaping wounds in the region of the kidneys, liver and heart testified to the cannibalism that had been resorted to, degradation begetting degradation.

Rodger took several photographs there, and they seem as dispassionate as ever. But adjusting the camera better to frame each terrible image seemed to him an abomination, and he resolved never to photograph any war again.

Soon afterwards he found himself one of only two stills photographers in the famous tent on Lüneburg Heath, where he had the satisfaction of seeing some of those who had known of and condoned the existence of such places as Belsen sign the unconditional surrender, directed by General Montgomery, hands in his pockets, and in his driest manner.

After the relief of witnessing the surrender, Rodger decided to set out for Denmark, by now surely celebrating its freedom from the Nazi yoke. With a Union Jack on his windscreen he passed tens of thousands of demoralized German troops struggling along in the same direction with one truck often towing several others owing to lack of petrol. They had no idea the war was officially over; they just looked bemused at Rodger's jeep and flag, some waving, smiling or even cheering, and then looking back to see the army of which Rodger might be the vanguard. But there was, of course, none.

When he arrived in Schleswig, he was threatened with a pistol by an SS officer, and successfully used the same tactic as he had with General Patton. He then showed several sceptical officers a copy of the Lüneburg Surrender terms, and they agreed, after some delay, that the Third Reich was no more. Rodger was provided with a Mercedes and two colonels to escort him to the Danish border, but through a forest in which ominous figures and tanks still lurked. And then in Rodger's own jubilant words 'the light at the end of the tunnel. The bright red Danish flag with its white cross. Cheering crowds. Flowers. Wine. Kisses. And my war was over!'

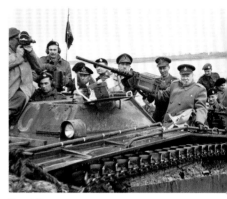

Churchill crossing the Rhine into Germany.

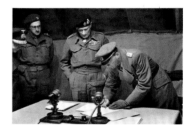

General Montgomery looks on as the surrender is signed in Lüneburg, Lower Saxony (page 152).

1943, Italy
An American GI directs landings at Salerno

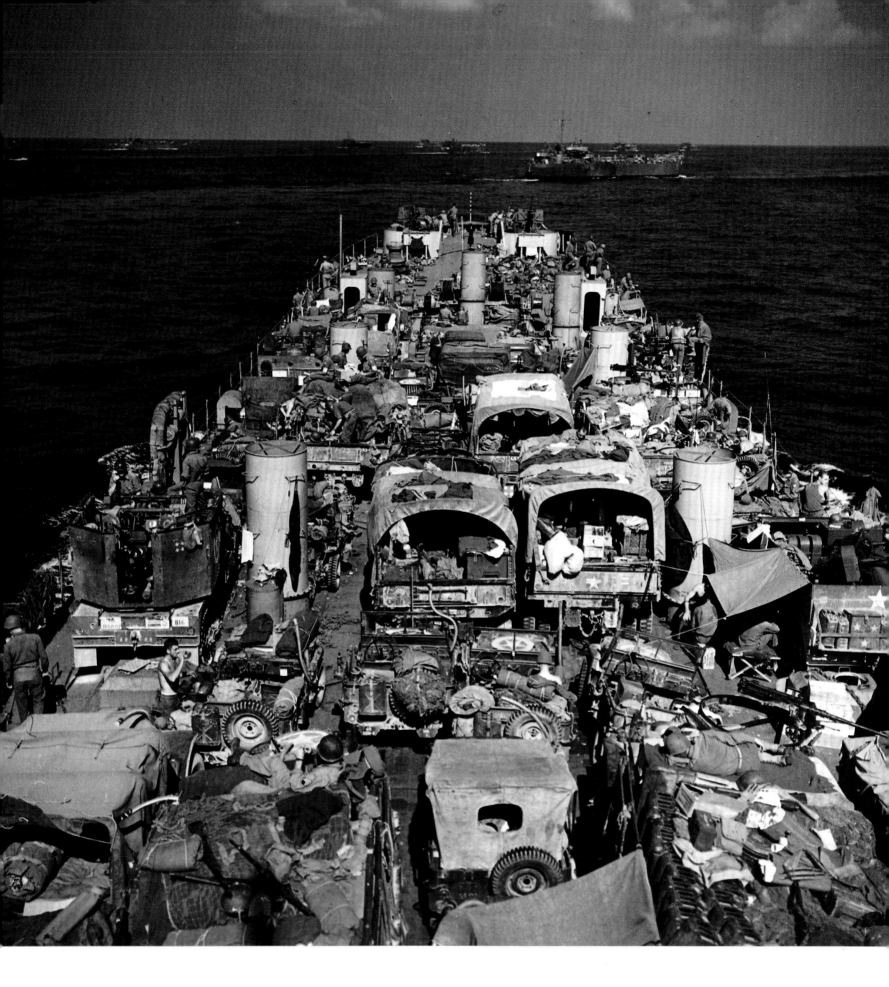

1943, Italy
American Invasion Forces en route to Salerno

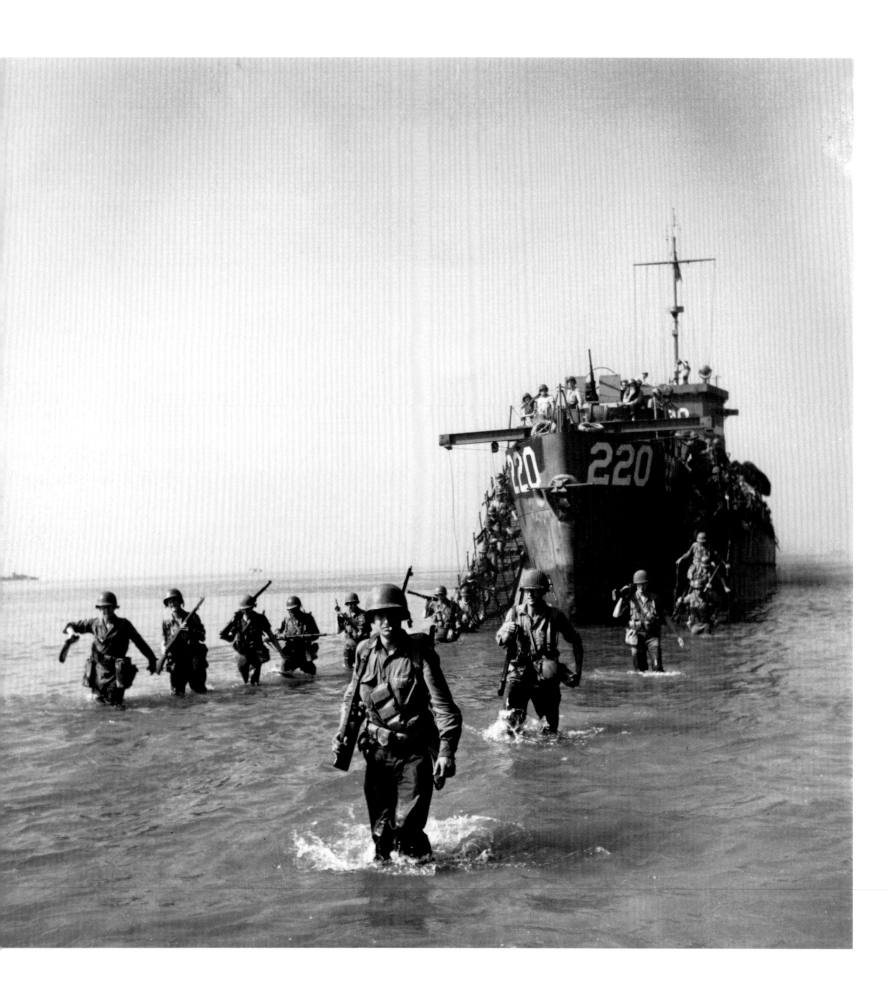

1943, Italy
American Invasion Forces
disembarking at Salerno

1943, Italy
The German Luftwaffe attacks
British shipping in Bari harbour

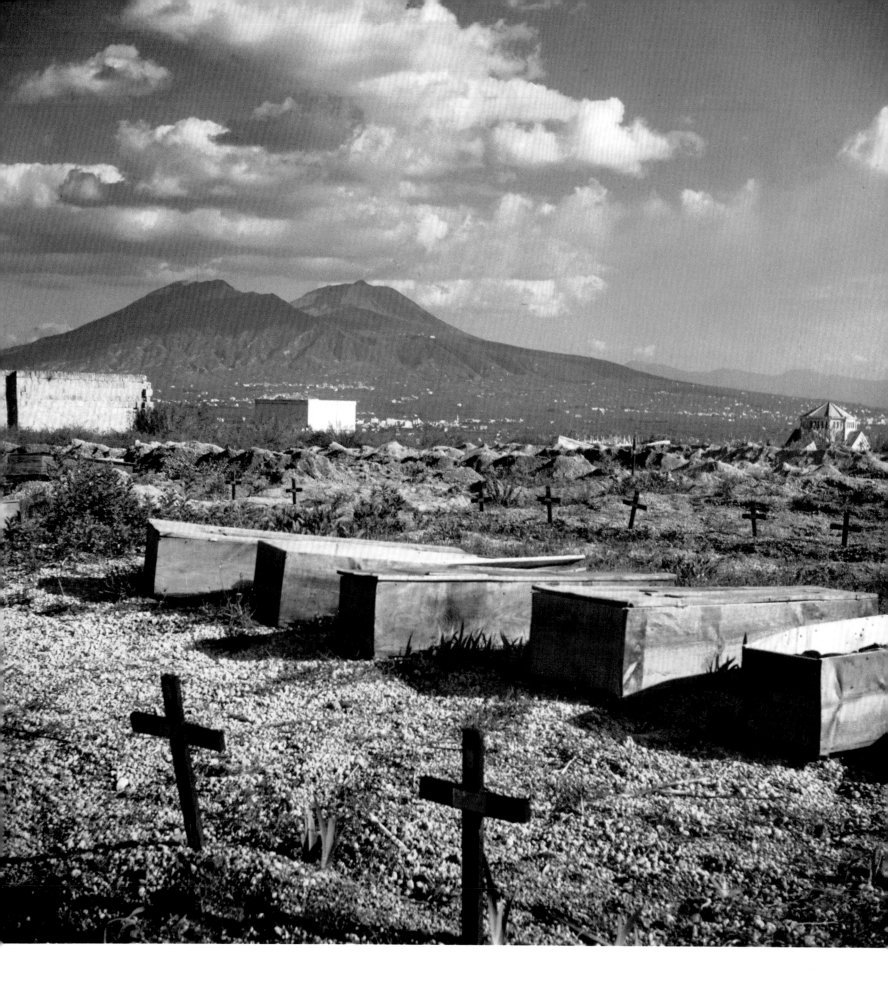

1943, Italy
A cemetery for American soldiers.
Vesuvius is in the background

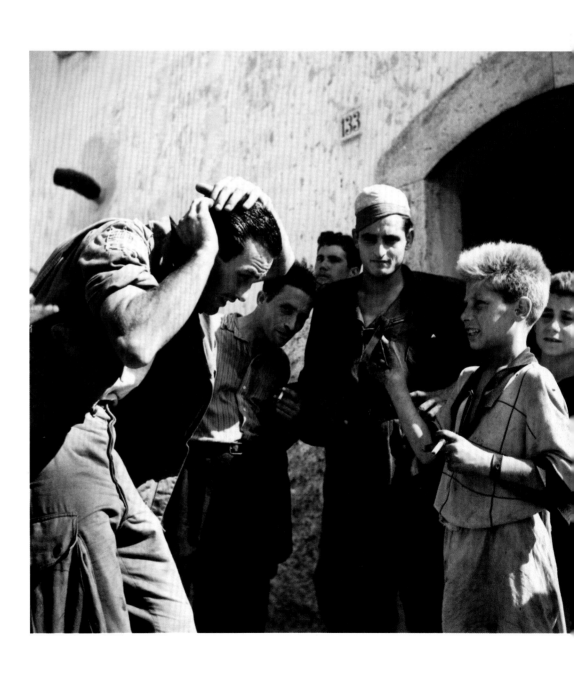

1943, Italy
An American GI stationed in Eboli spruces
himself up with the help of the locals

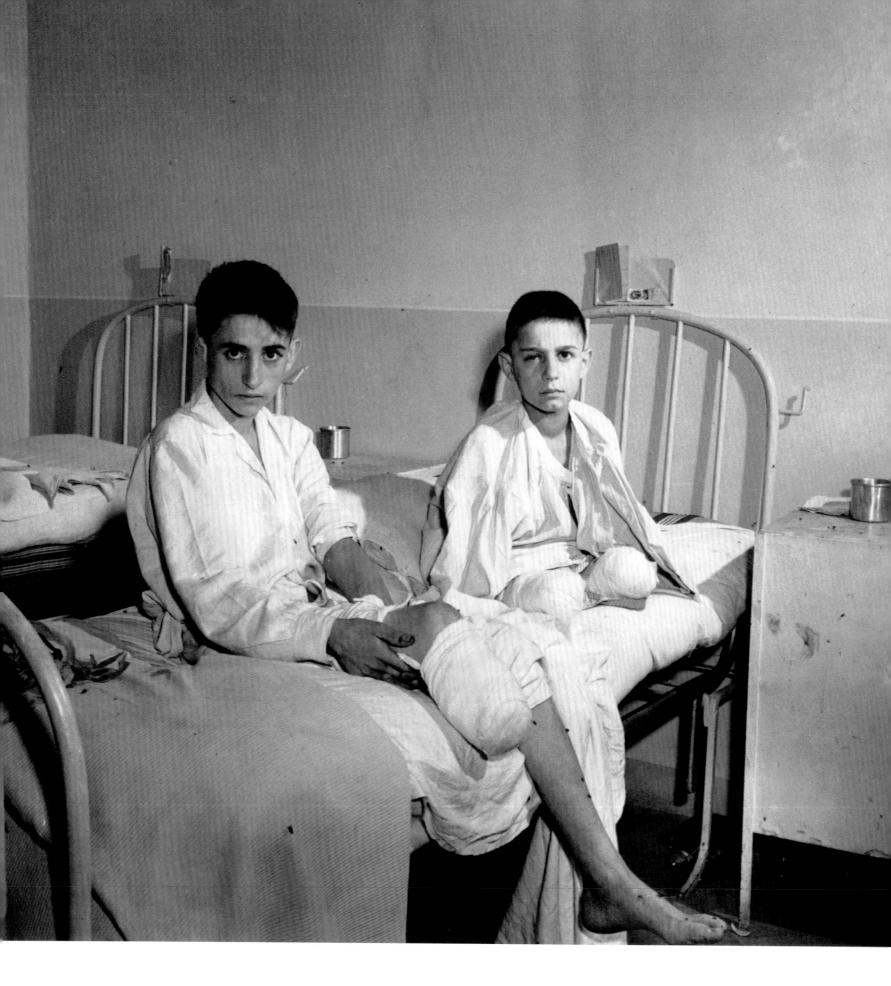

1943, Italy
Boys injured in the bombing of
Naples recovering in hospital

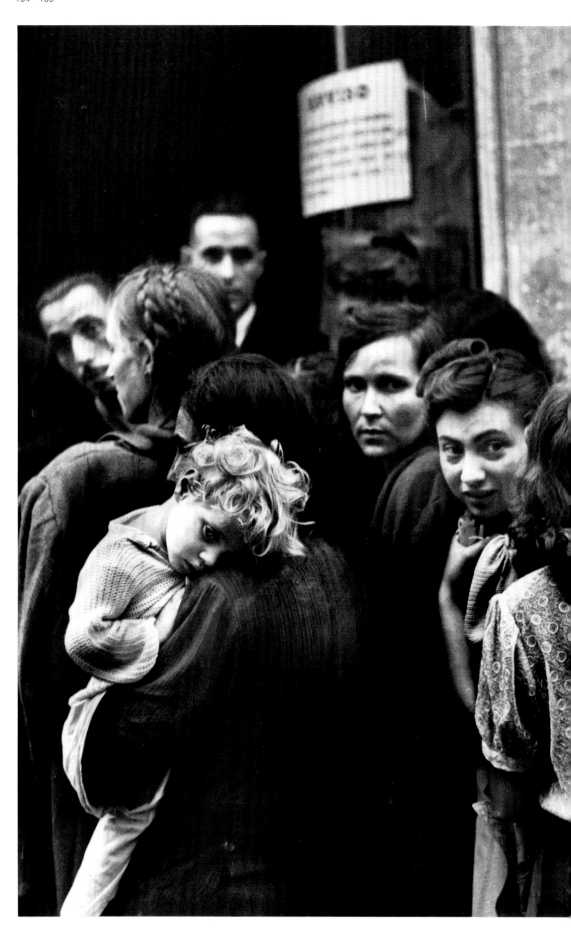

1943, Italy
Bread queue

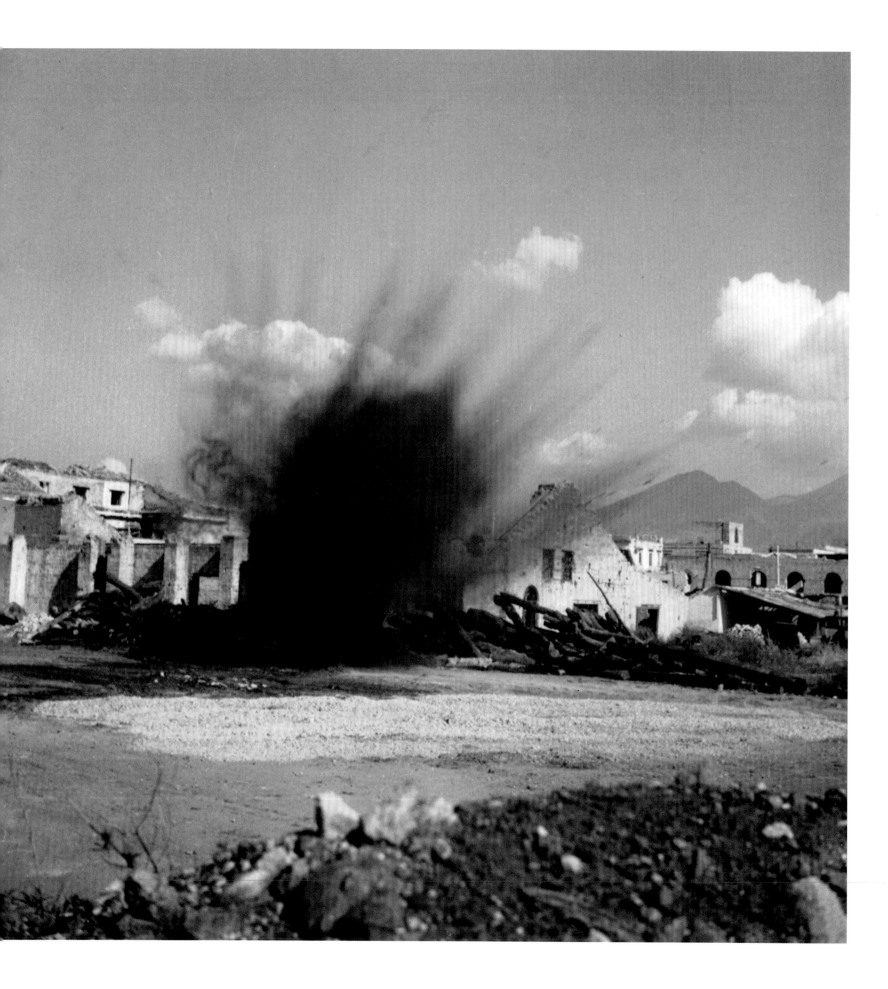

1943, Italy
The Luftwaffe attack on Naples

1944, Italy
General Montgomery on the
Ortona Front

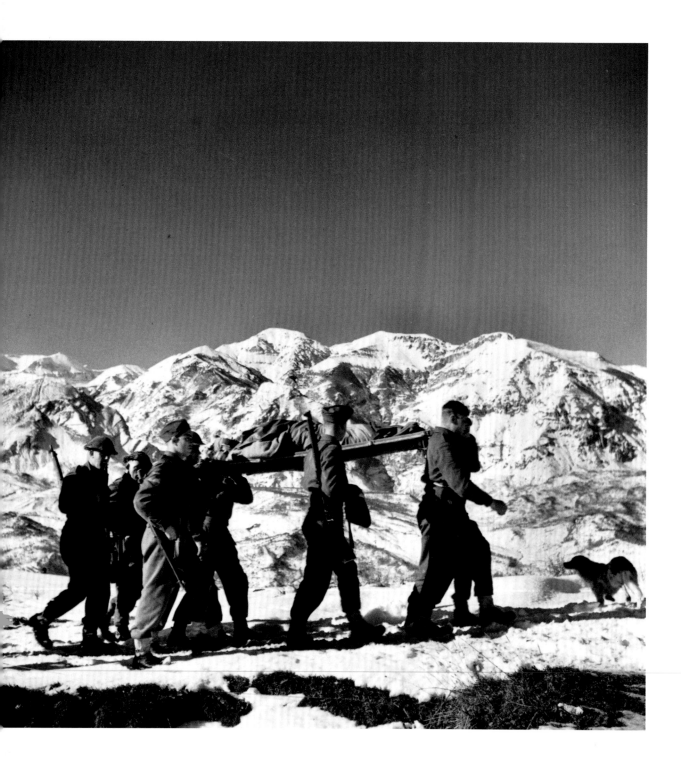

1944, Italy
Men of the British Eighth Army evacuate
the wounded at the Ortona Front

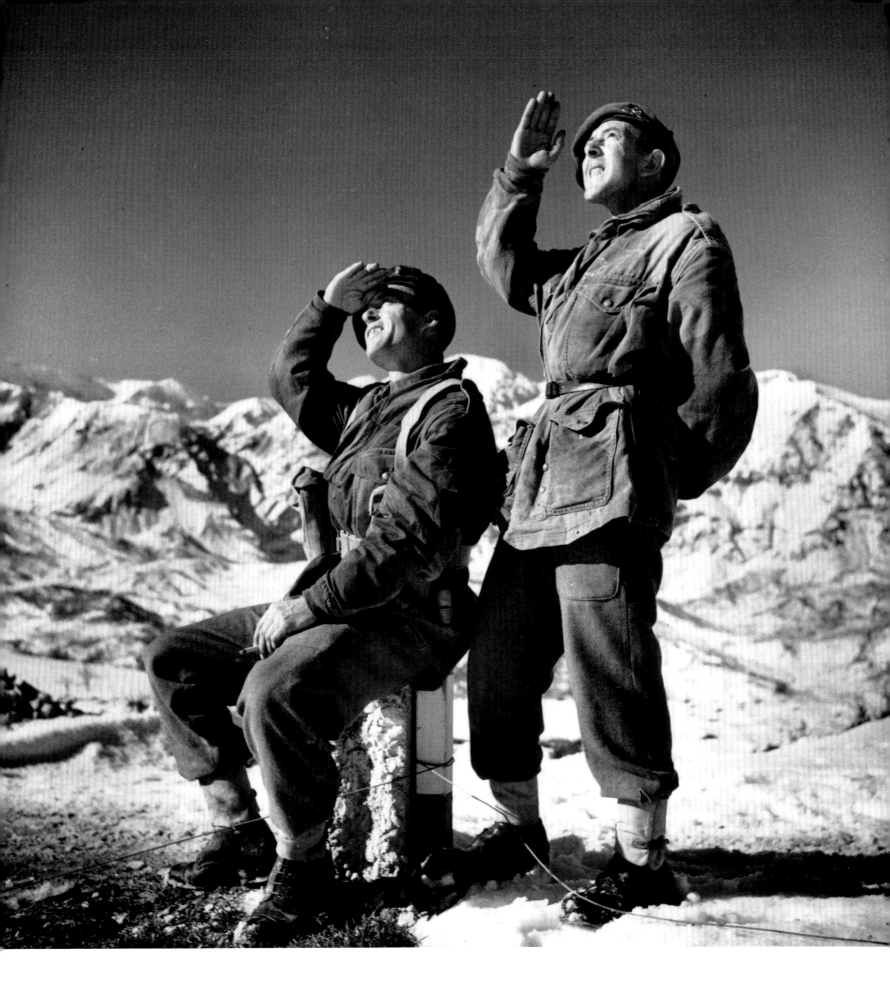

1944, Italy
The British Eighth Army signallers
on the Ortona Front

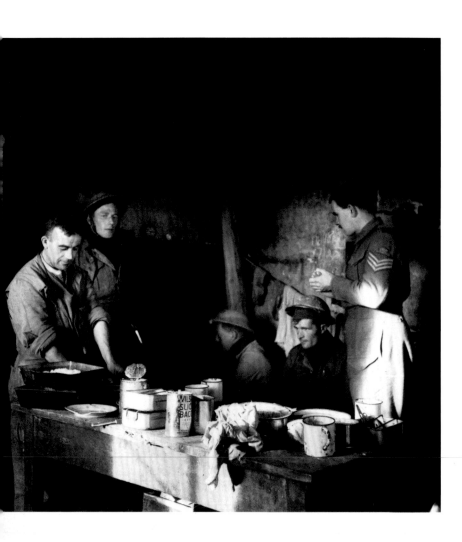

1944, Italy
A British Eighth Army mess tent
on the Ortona Front

Opposite
1944, Italy
An advance patrol investigates a ruined
village on the Ortona Front

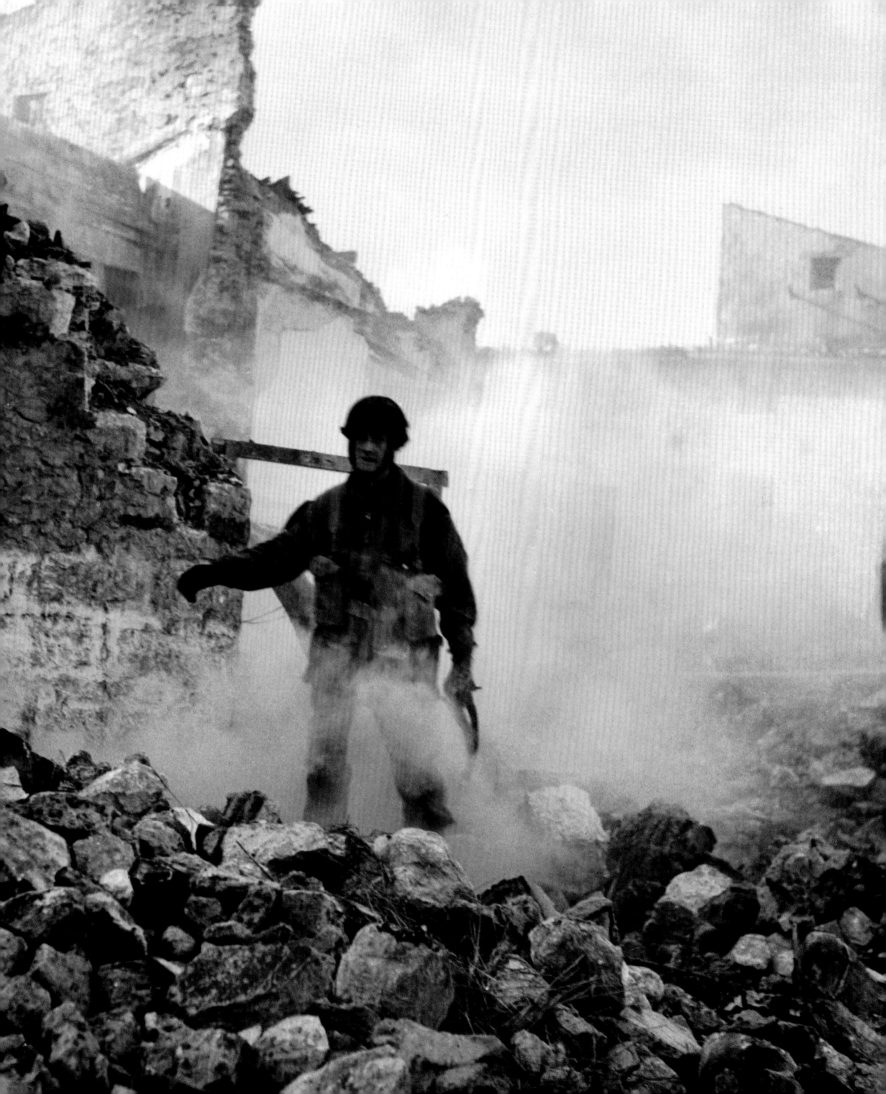

1944, Italy
The first meeting of the National
Liberation Party in Naples

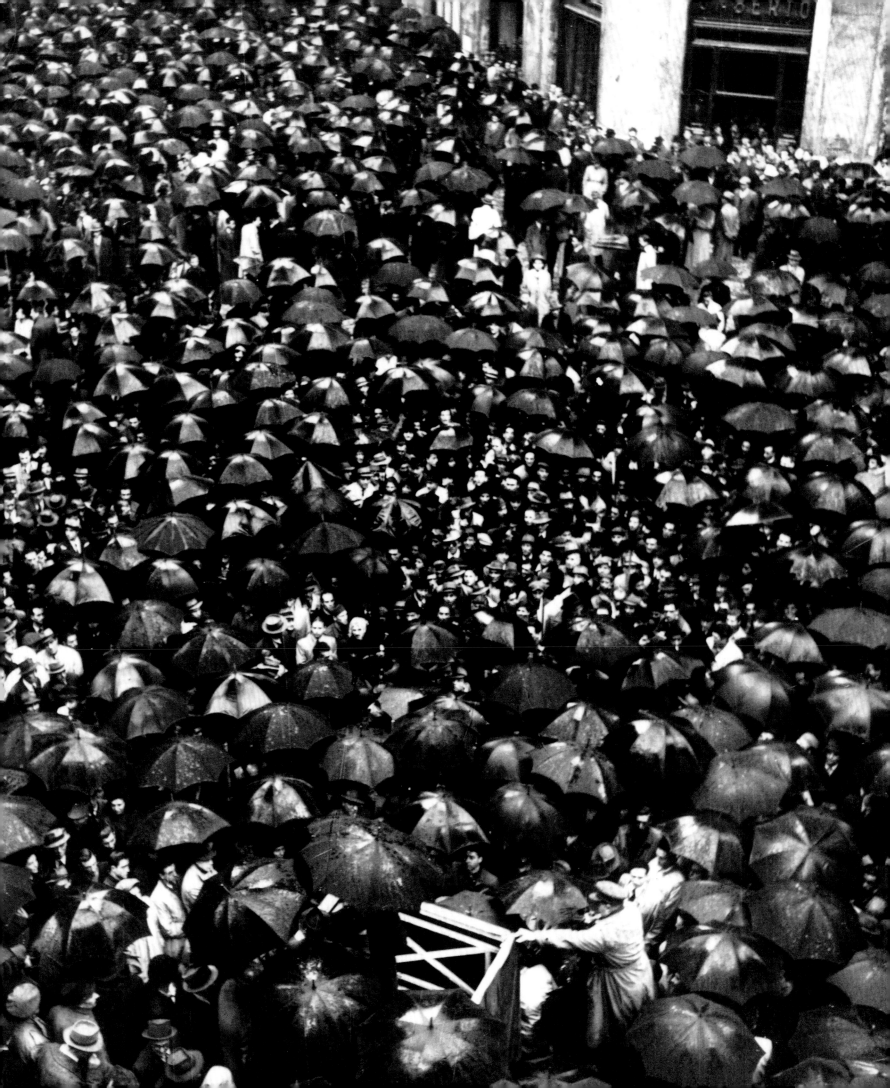

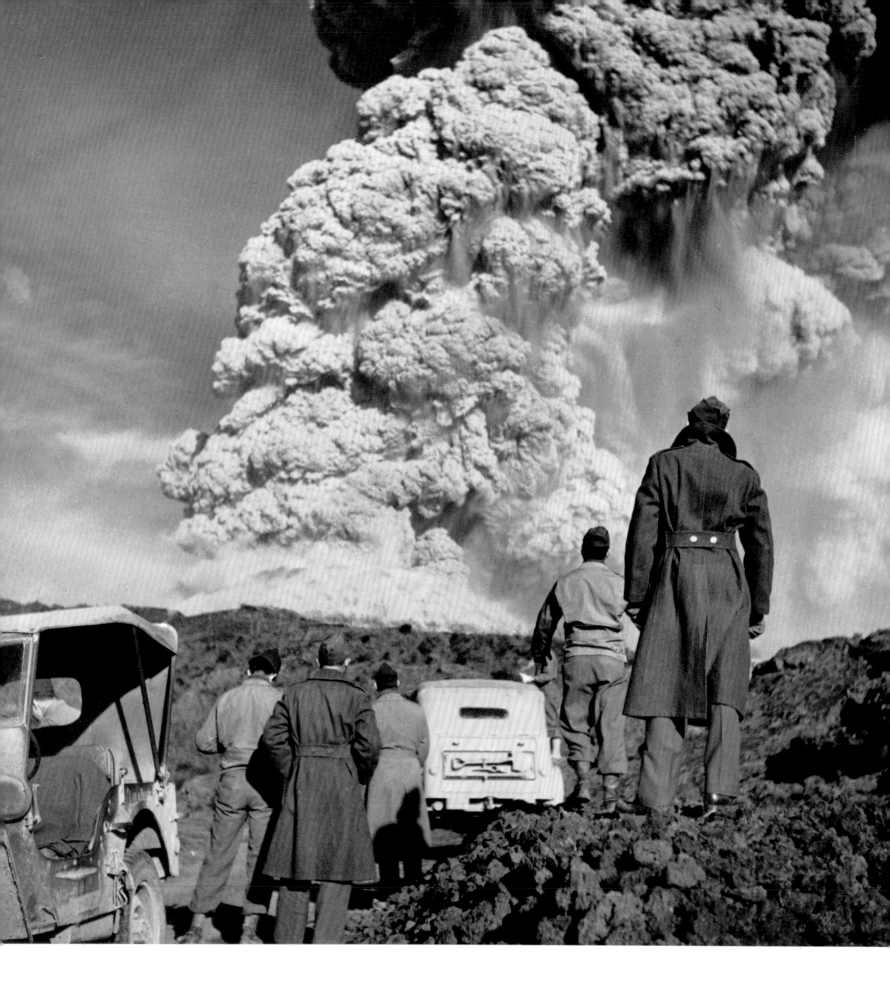

1944, Italy
Allied army personnel watch the eruption of Vesuvius

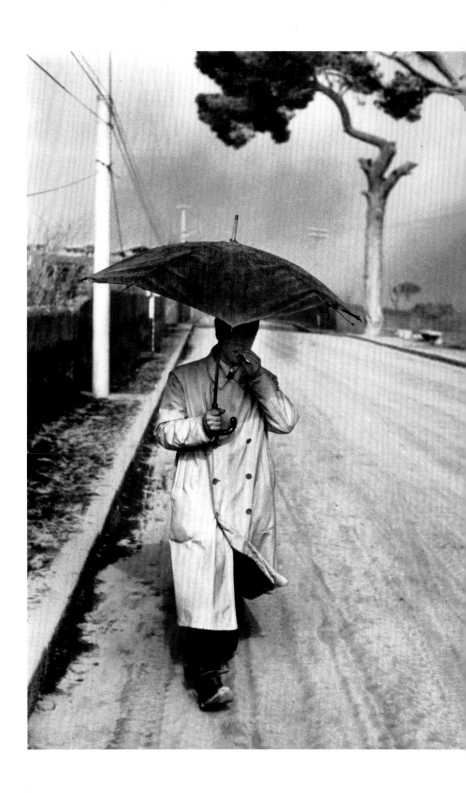

1944, Italy
An Italian civilian takes cover under
his umbrella from Vesuvius fallout

1944, Italy
On the slopes of Vesuvius villagers take
shelter from the eruption in a church

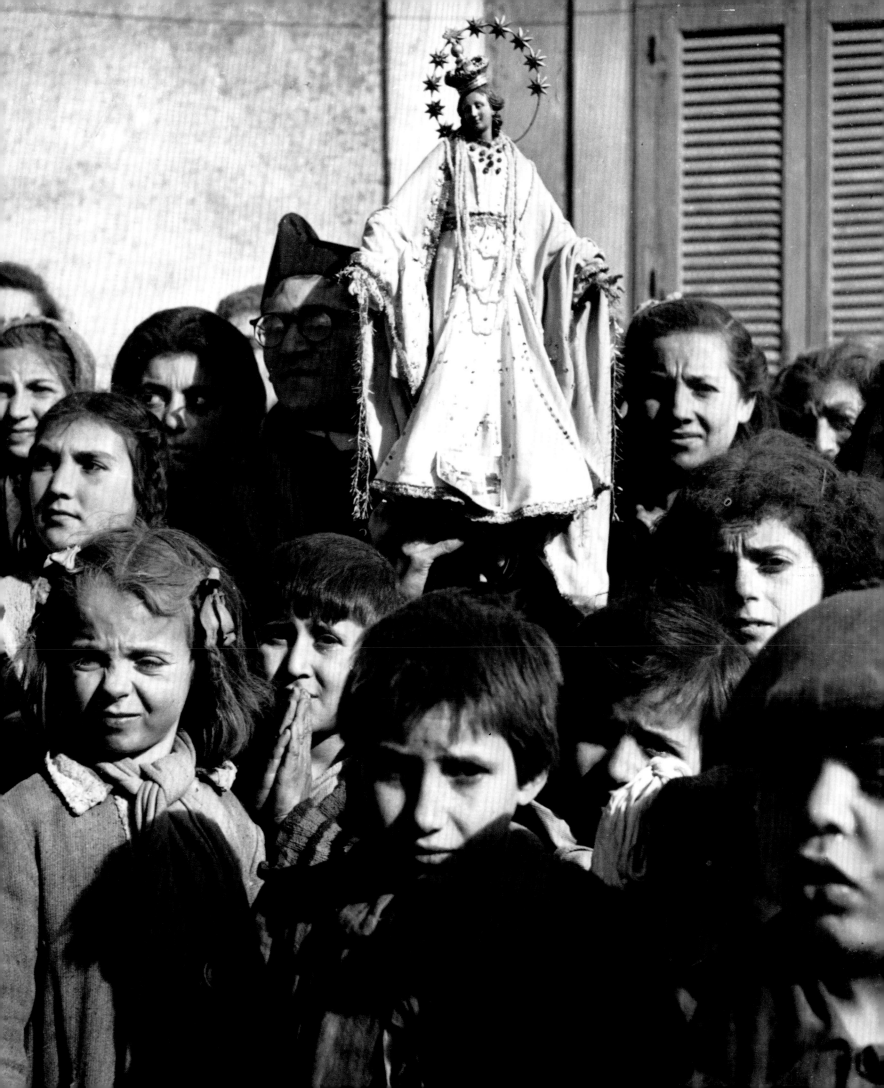

1944, Italy
The British tank repair shop
on the Ortona Front

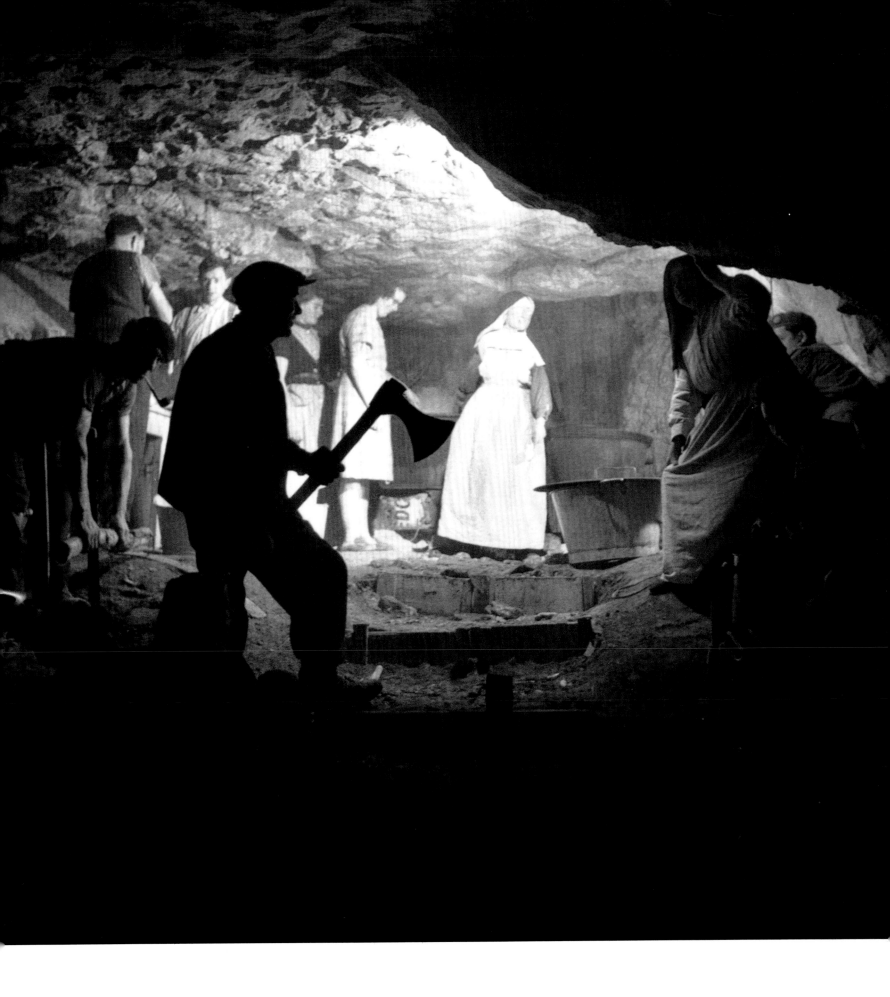

1944, France
During the American landings,
civilians take shelter in the Caves of
Fleury-sur-Orne near Caen

1944, France
A British dispatch rider on the Orne Front
makes friends with the locals

Opposite
1944, France
Wrecked German tanks in the
Battle of Falaise

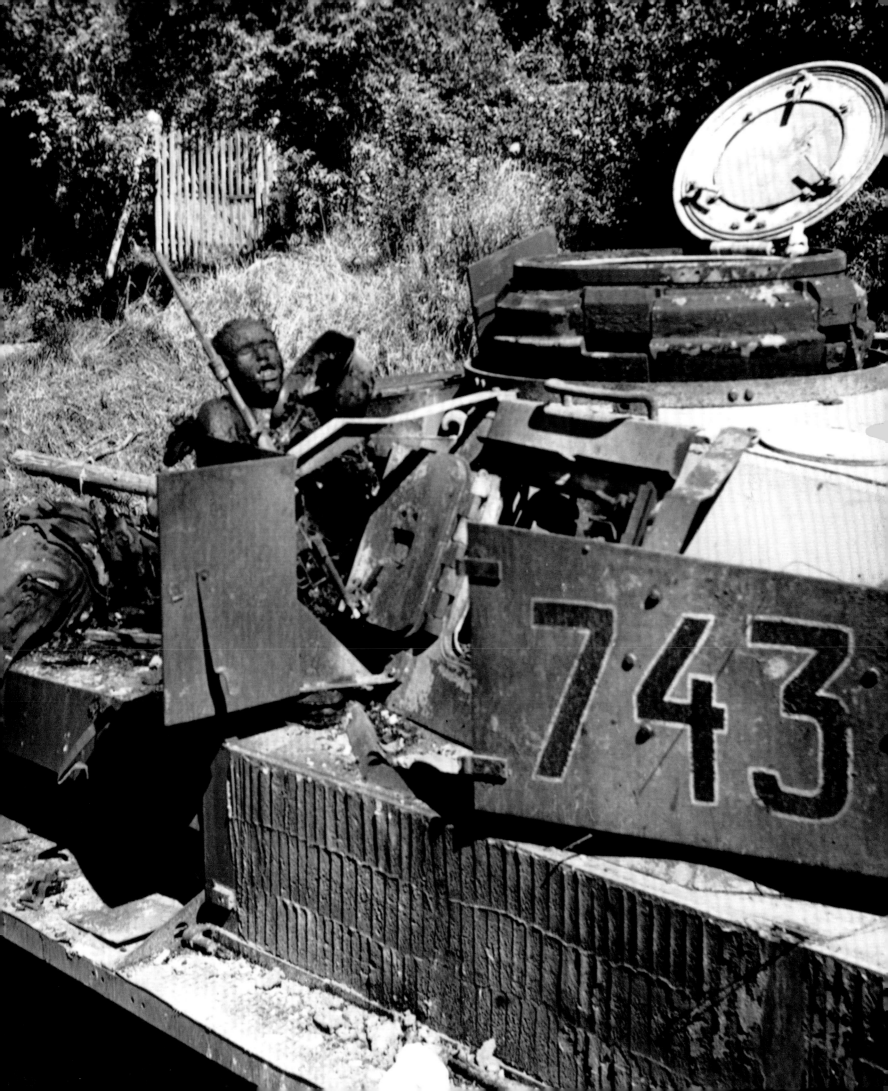

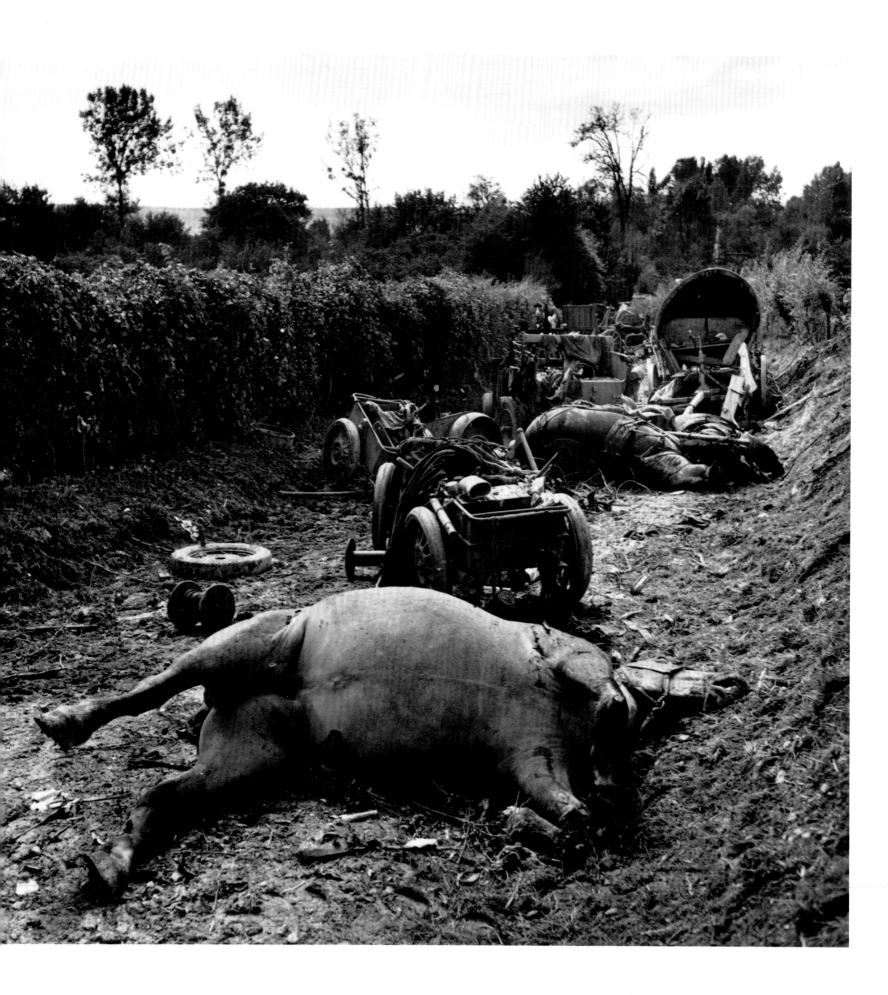

1944, France
Horse-drawn artillery destroyed
in the Falaise Gap

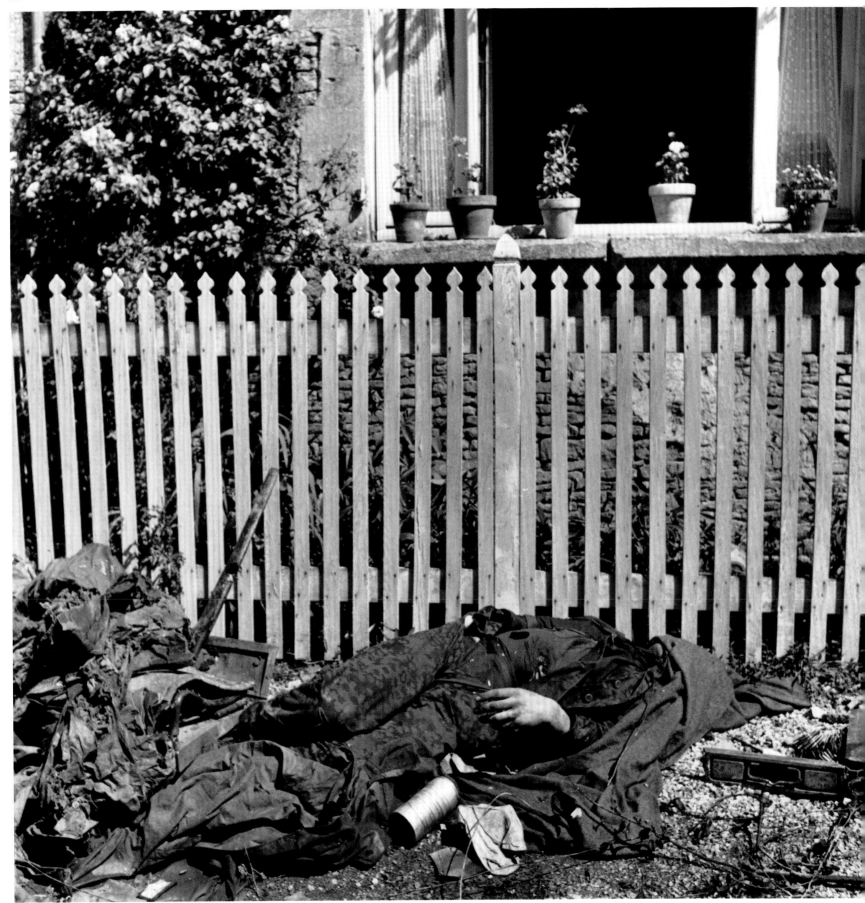

1944, France
A German soldier lies dead
in front of a suburban villa
in Falaise

1944, France
Bastille Day, Bayeux

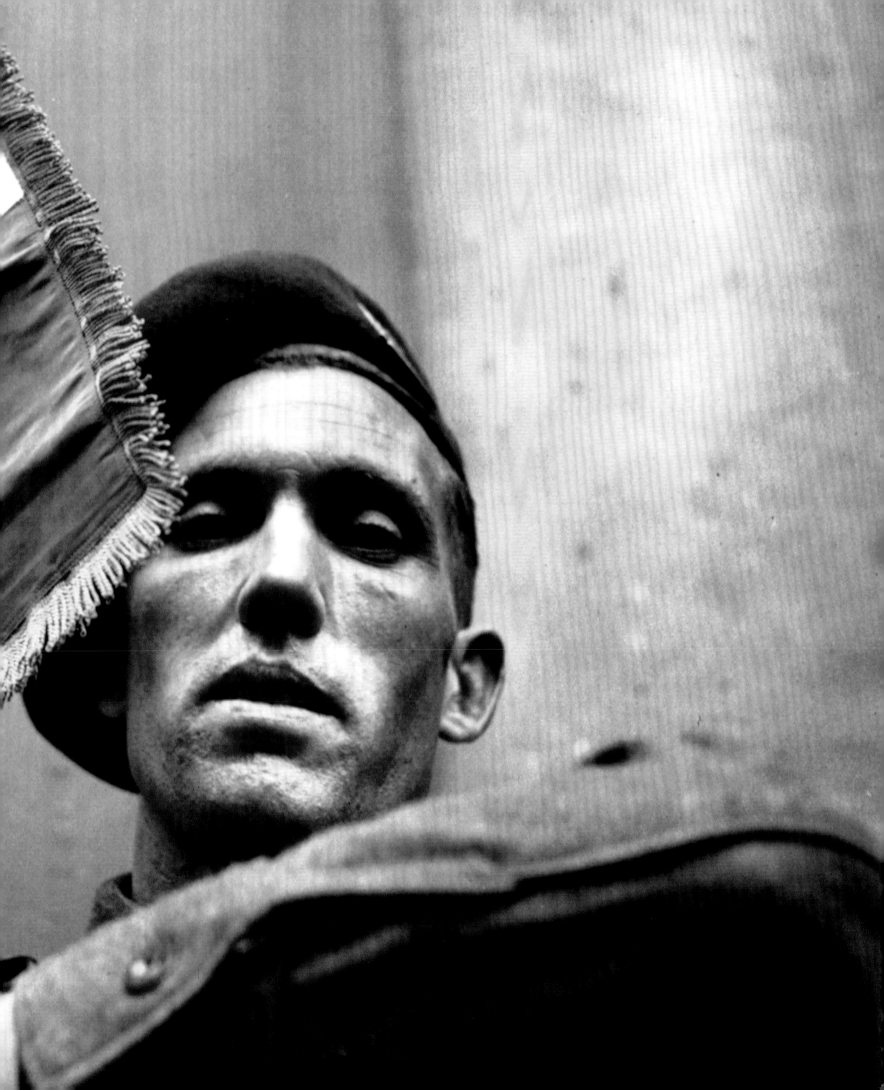

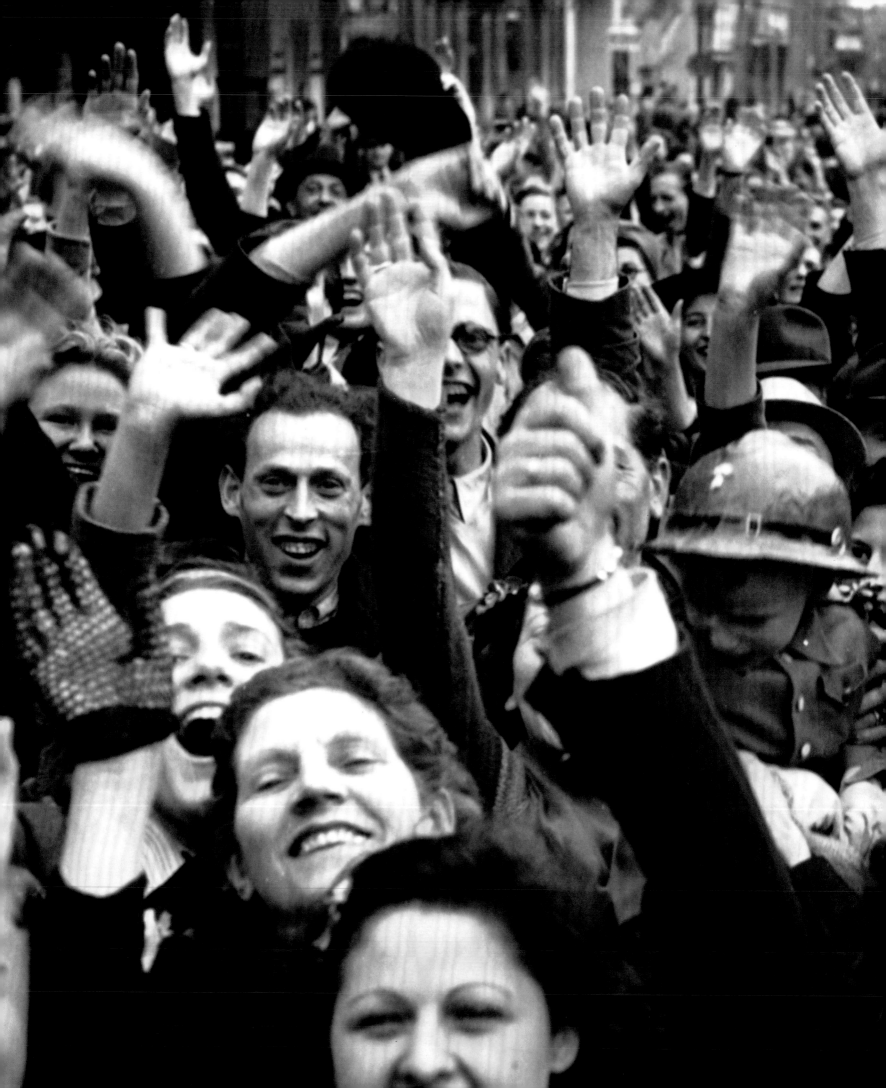

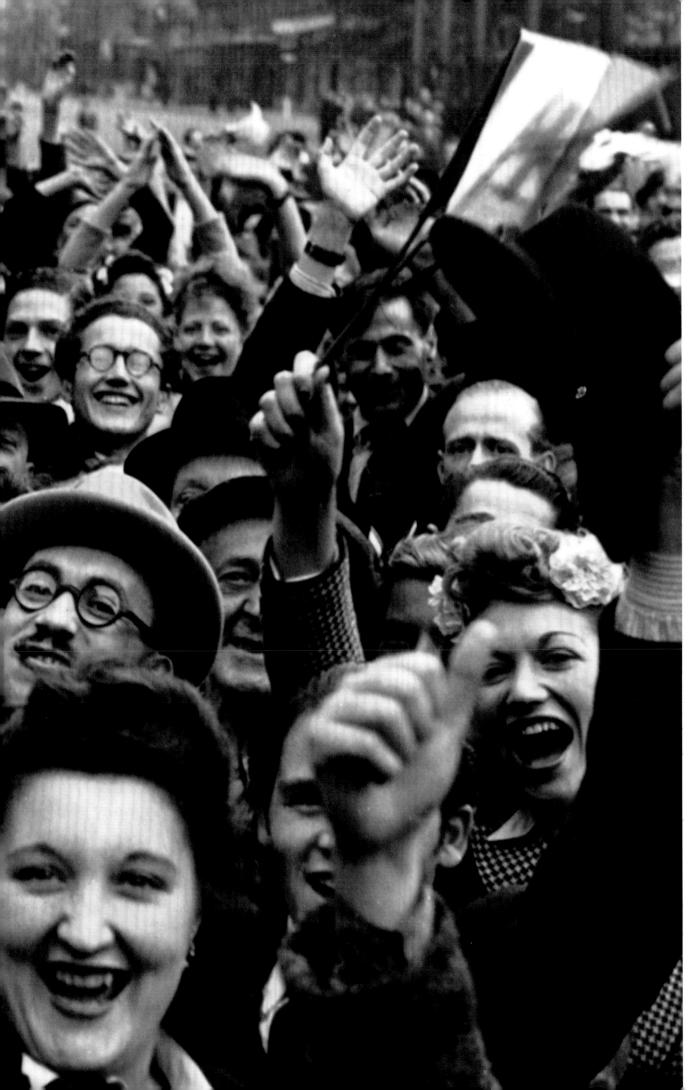

1944, Paris
The liberation

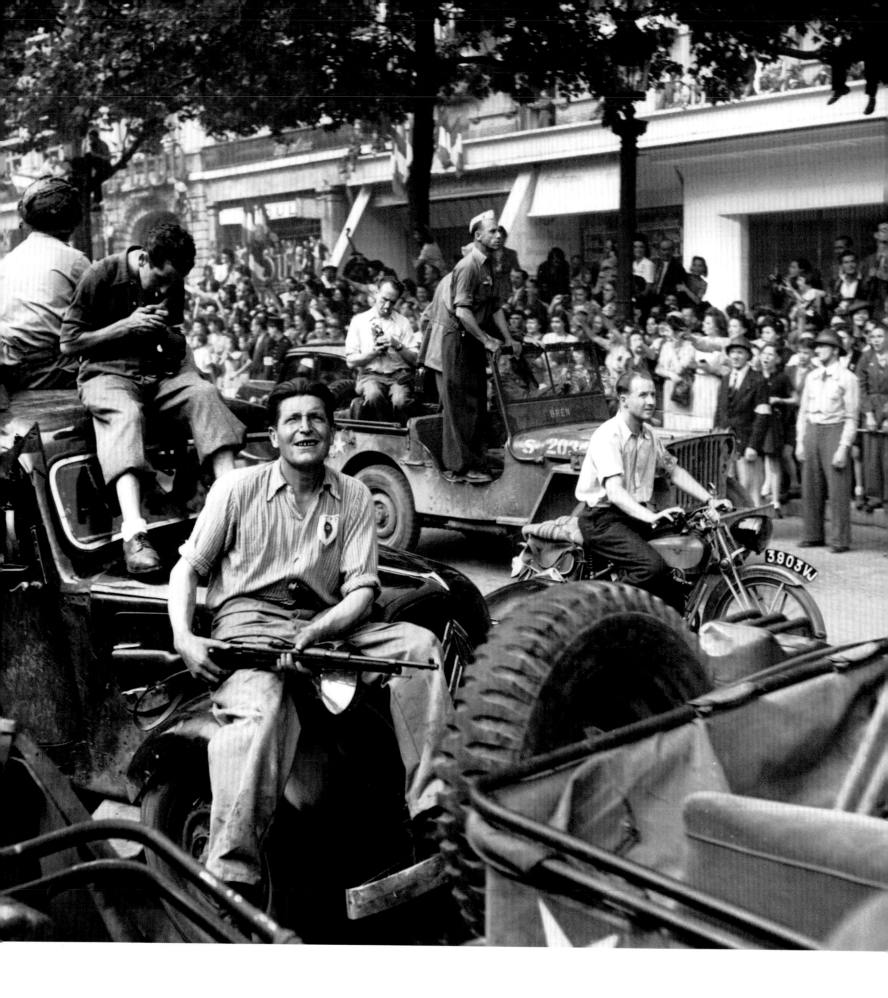

1944, Paris
The liberation

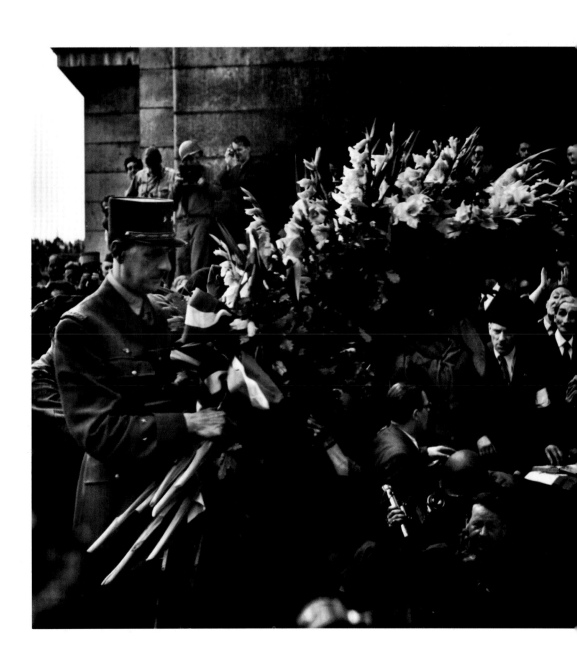

1944, Paris
General de Gaulle lays a wreath at the Arc de Triomphe

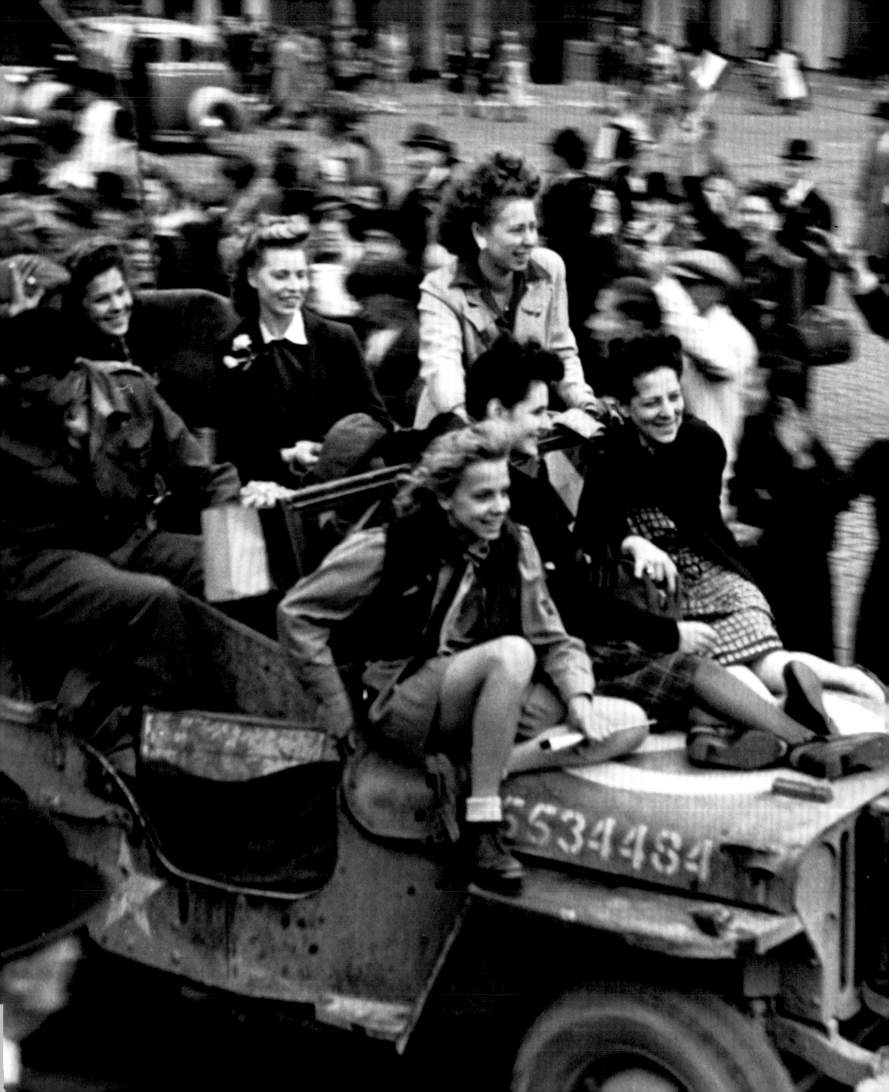

1944, Belgium
Brussels is liberated

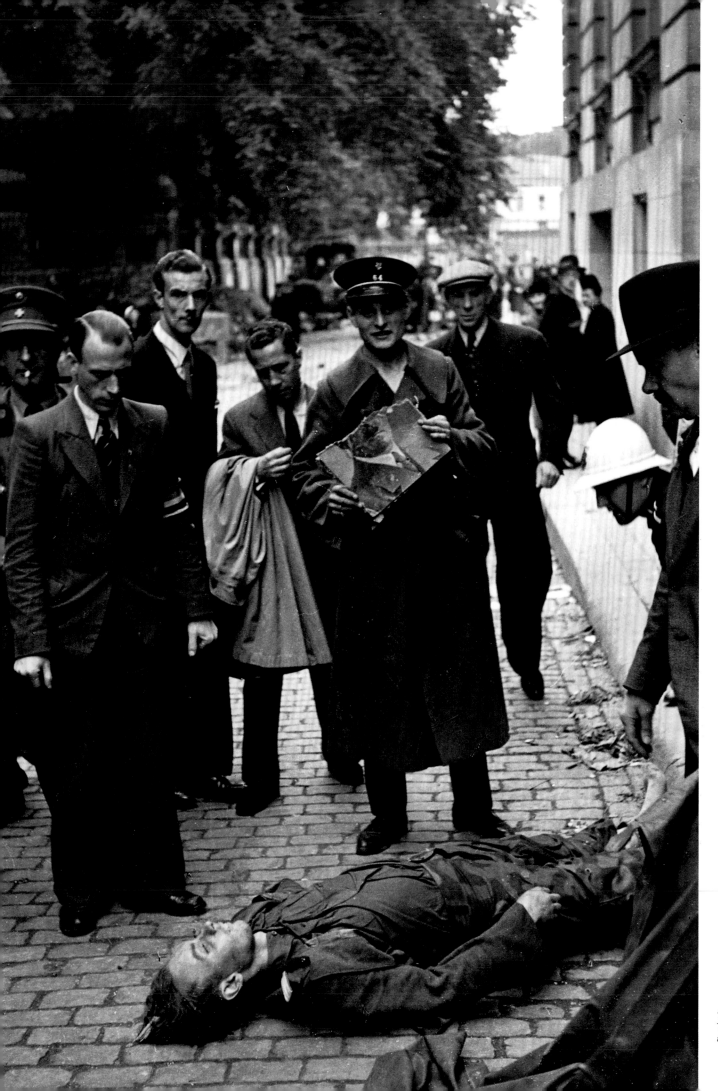

1944, Belgium
The liberation of Brussels
and death of a collaborator

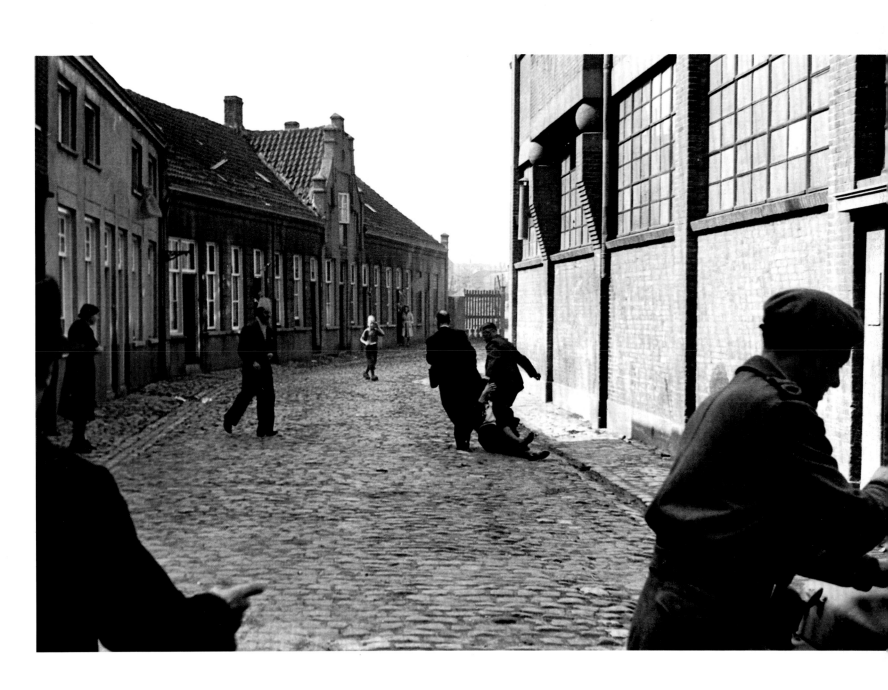

1944, Holland
A fifth columnist is dragged through
the streets of Eindhoven

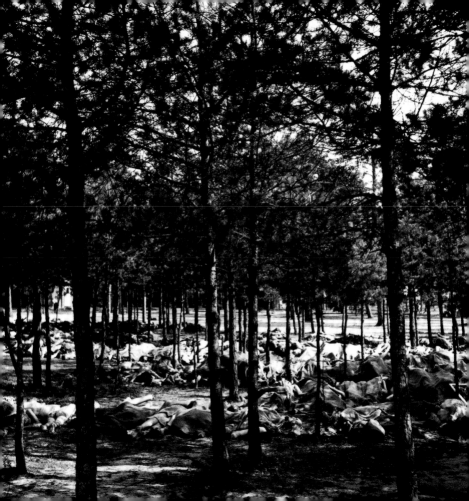

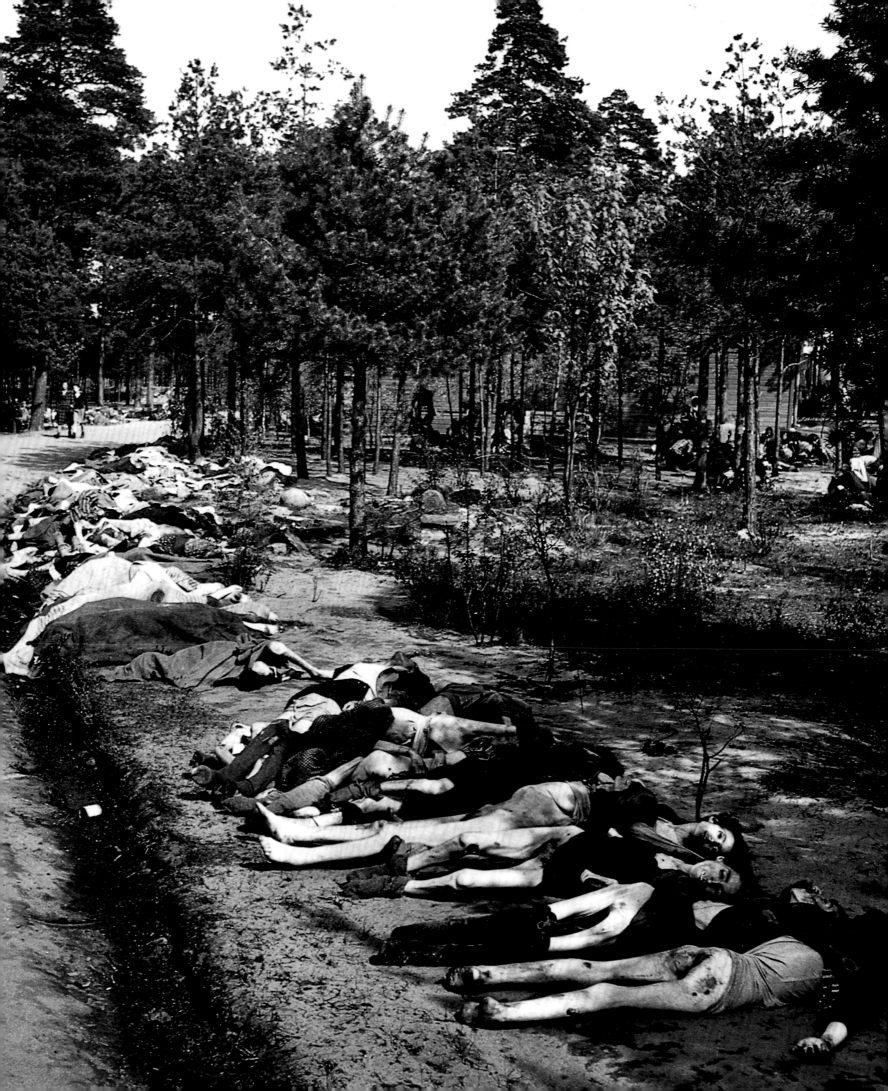

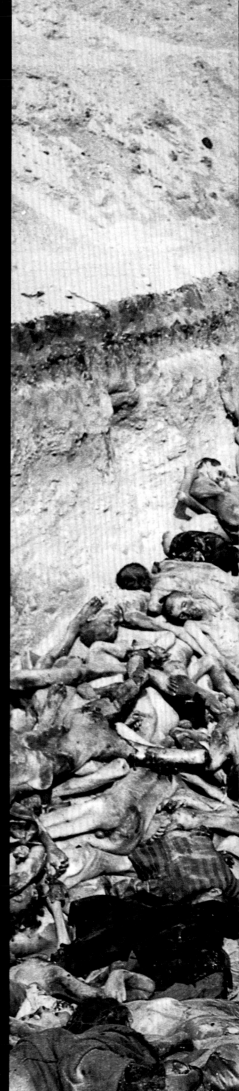

1945, Belsen
Mass grave

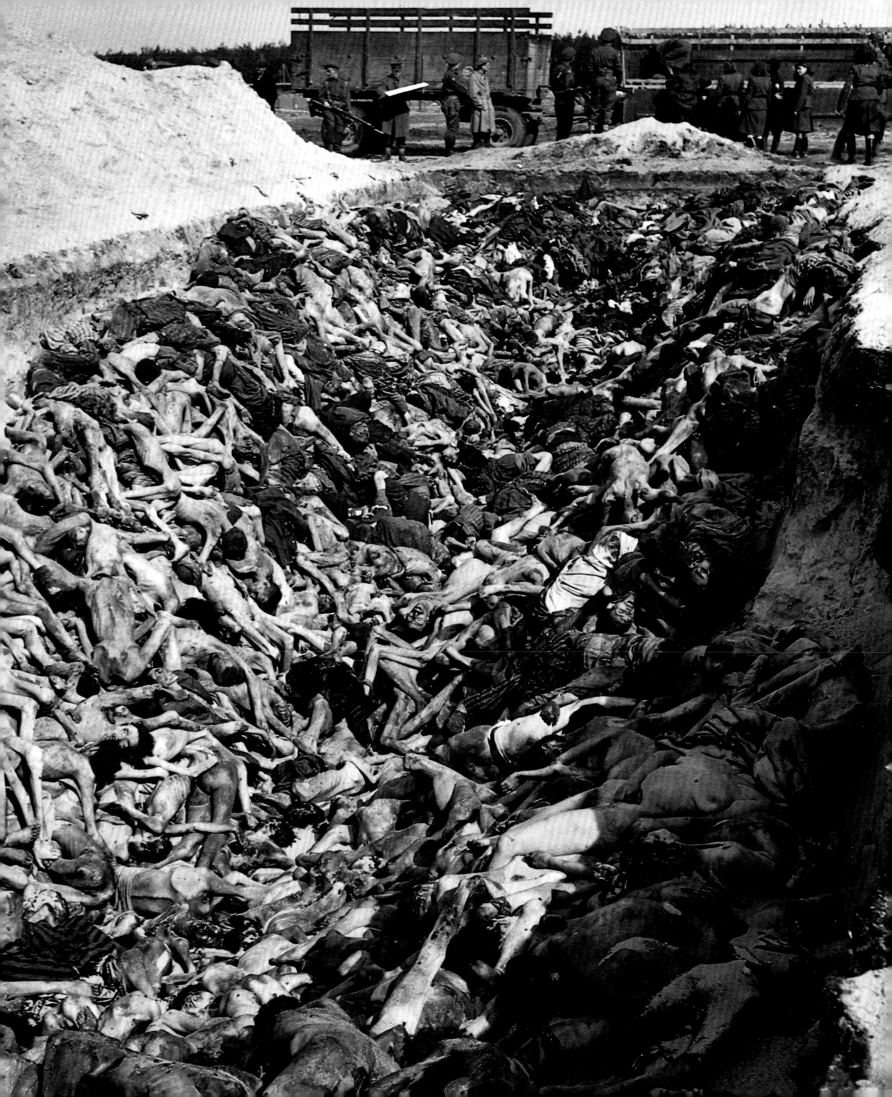

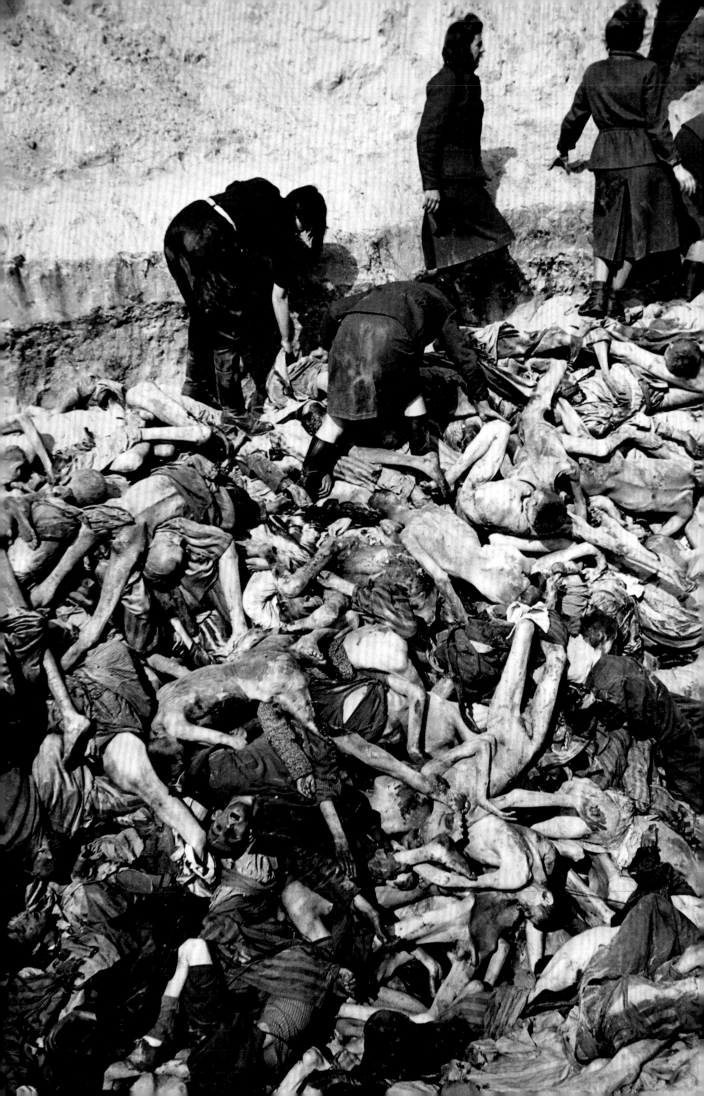

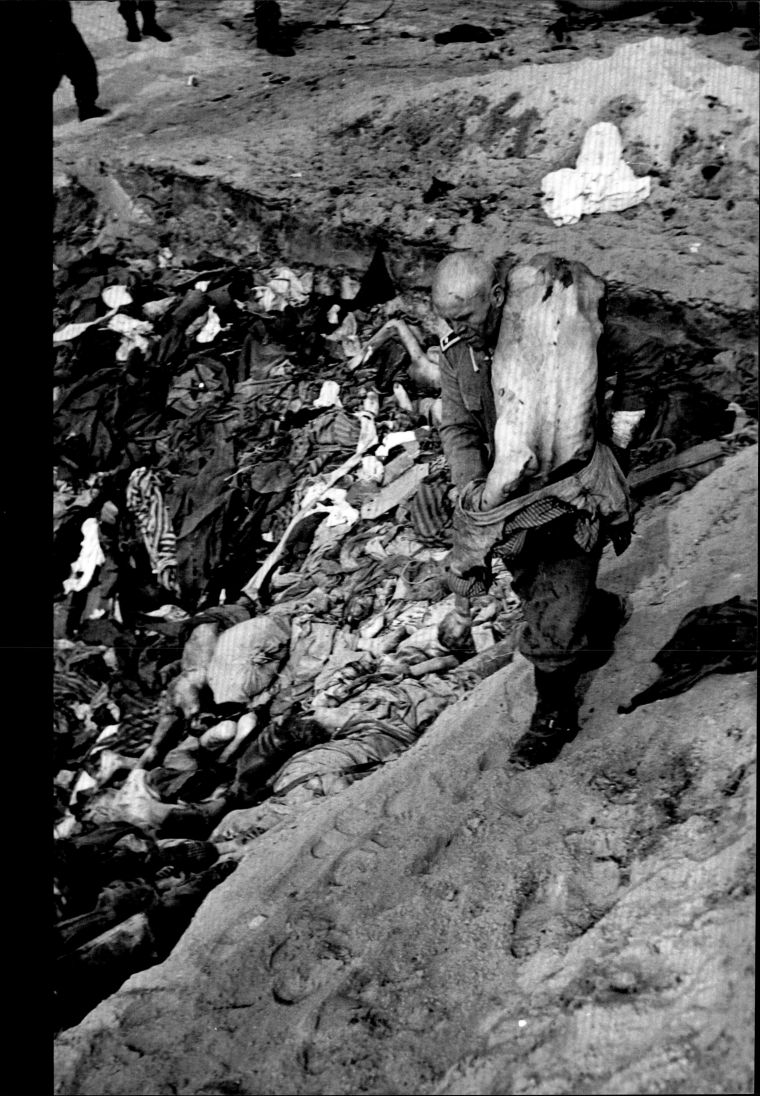

45, Belsen
llecting the dead

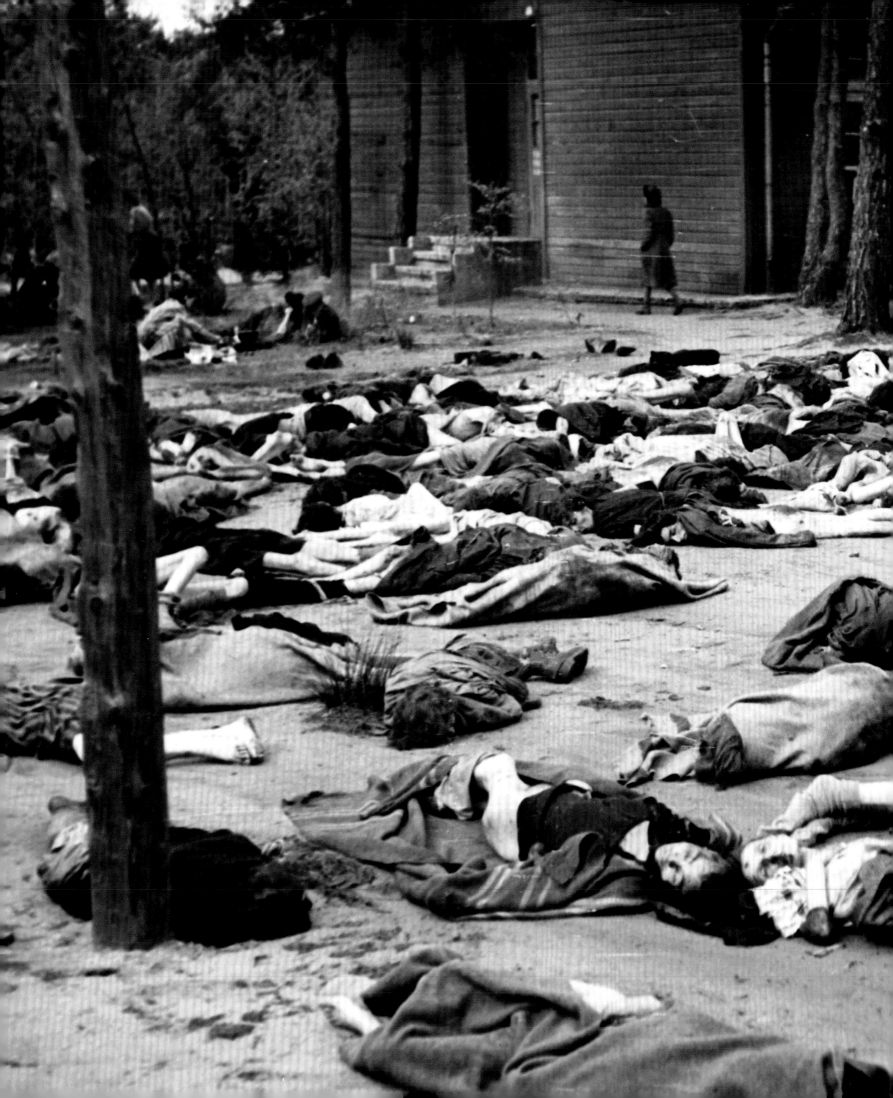

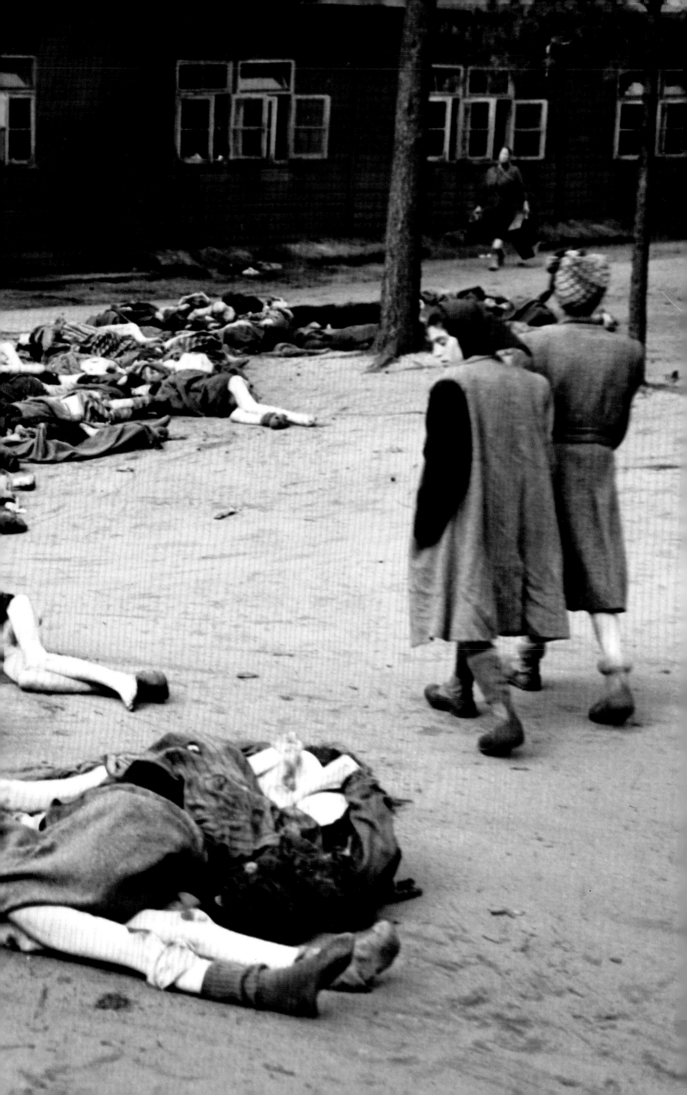

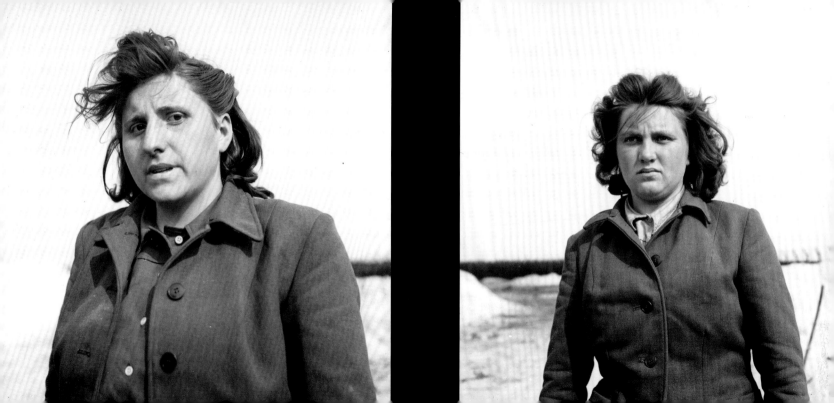

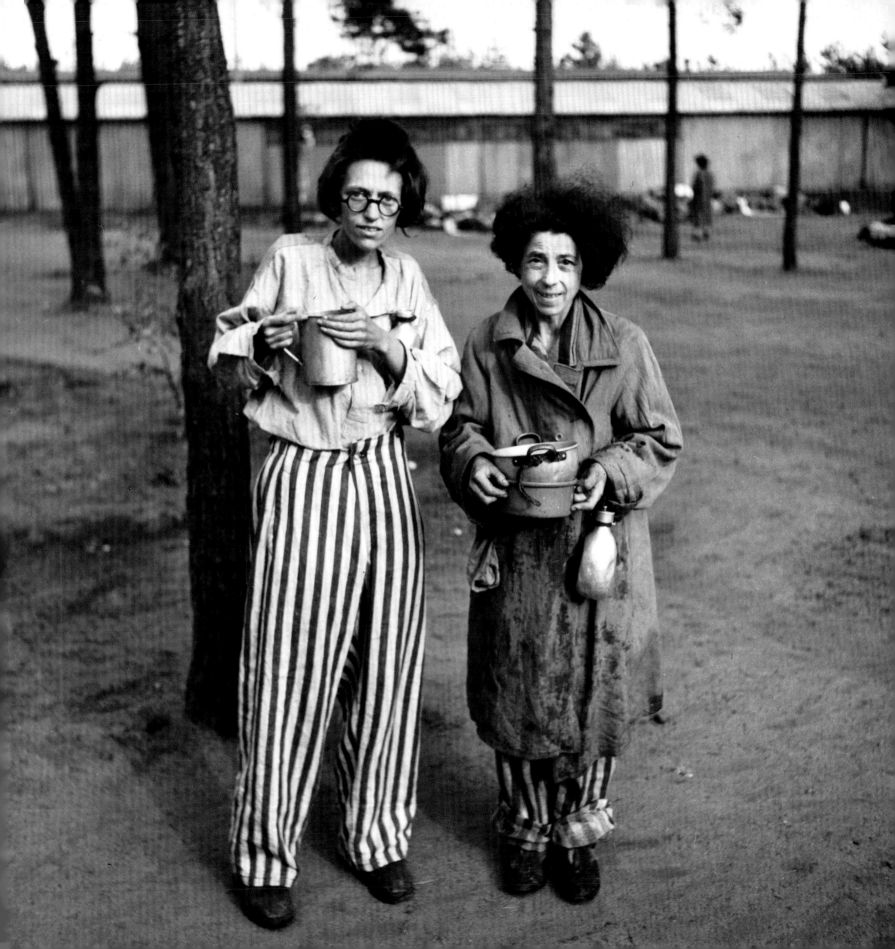

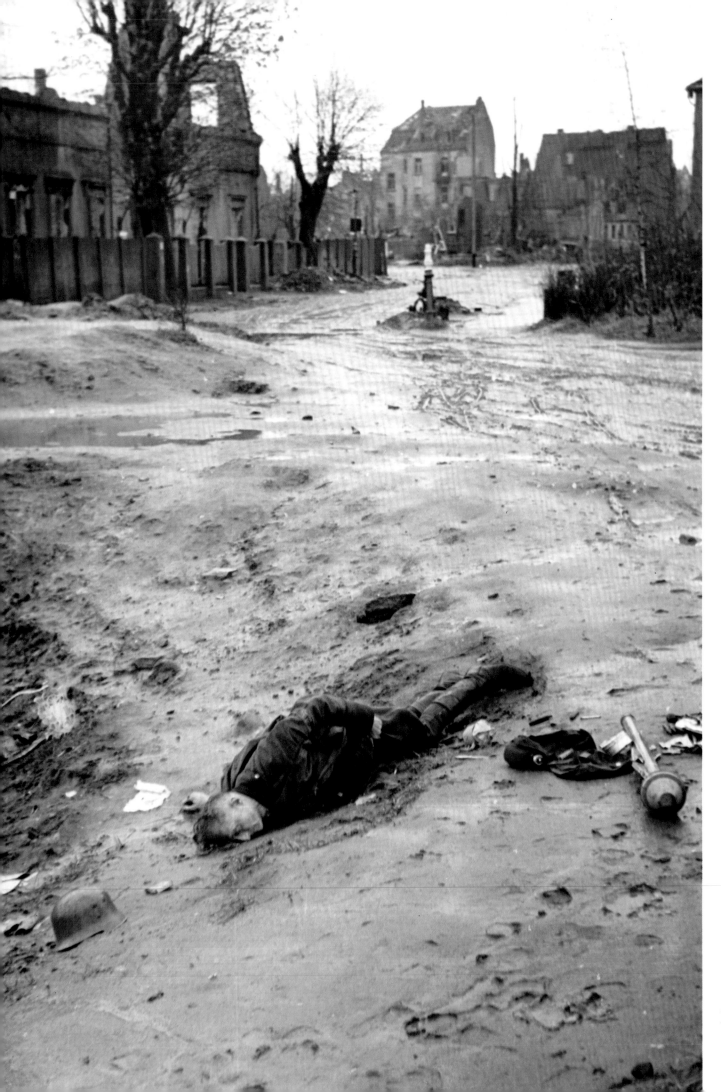

1945, Germany
The road to Münster

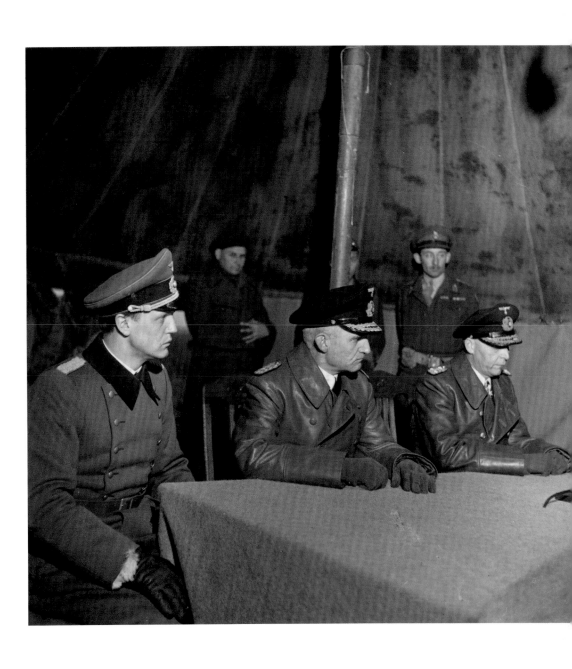

May 1945, Germany
The Luneburg Surrender. Officers of the German High Command.
Left to right: Rear Admiral Wagner, General Friede, Admiral Von Friedeberg

1945, Germany
The Luneburg Surrender:
German General Kinsel signs surrender
terms with General Montgomery

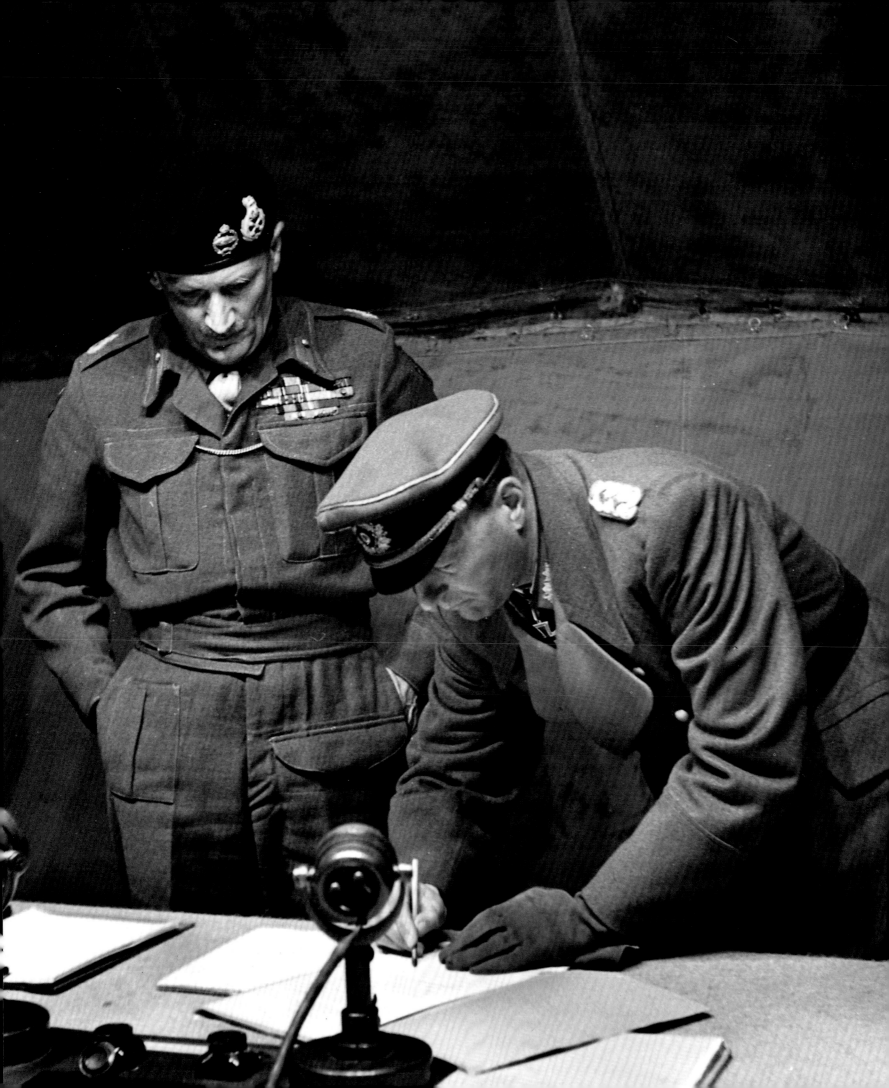

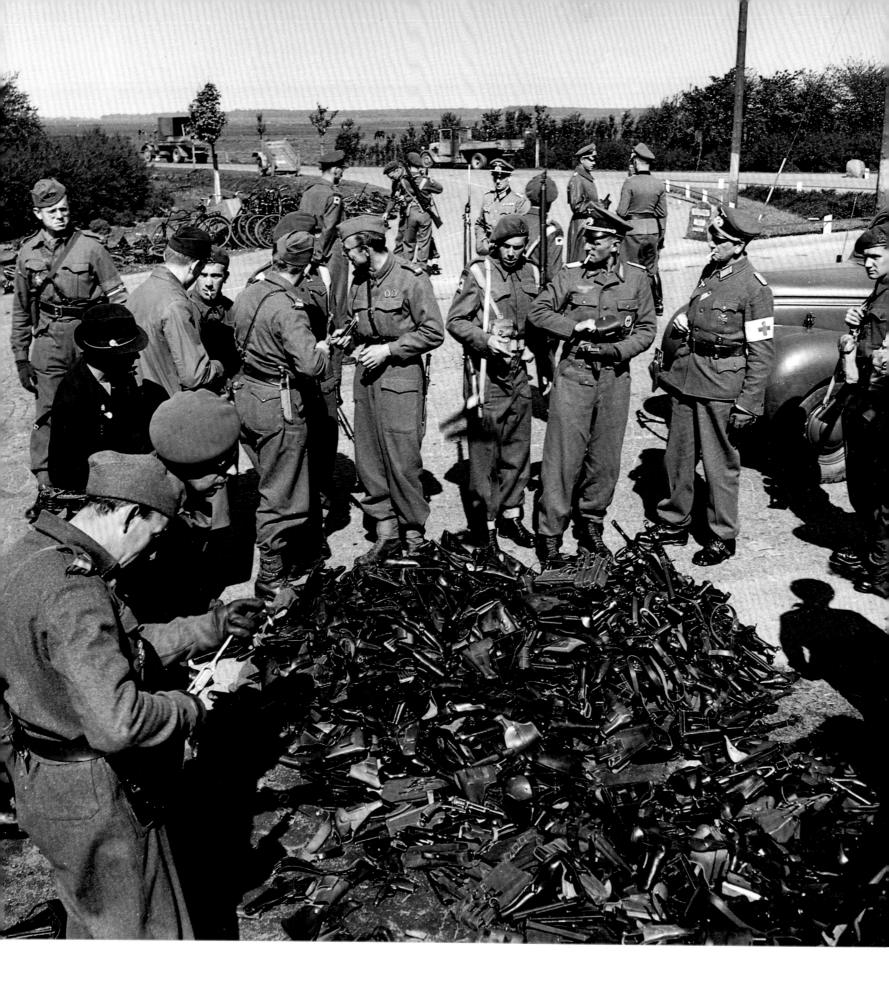

1945, Denmark
German prisoners surrender
small arms to the British

A Magnum meeting in 1952.
'Chim' Seymour (left), Len Spooner,
editor of *Illustrated* (centre) and
Robert Capa (right).

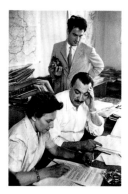

Maria Eisner, head of the Magnum office
in Paris, with the Italian publisher
Mondadori (centre) and Ernst Hass
(background), at a Magnum meeting.

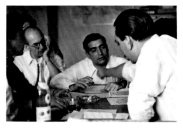

Researcher Joan Bush (far left) with
Len Spooner (left) and Robert Capa
(centre), in discussion with Mondadori.

After his trip through exultant Denmark, Rodger returned to Paris. There, with his wife Cicely, he lived for a time a life which must have seemed a marvellous relief from the dangers and anxious separation of the previous four years. They stayed at the Hotel Lancaster on the rue de Berri and were showered with gifts and kindness, no doubt partly due to their own personal aura of happiness, but also perhaps the elation everyone felt with the way things had turned out. Rodger was longing to go to Africa, but this time his desire to leave Europe was more urgent than his ever-present instinct to explore new places. He felt that only distance could get rid of the stench of war and particularly the ultimate horror of Belsen. To do so he had to break free from *Life* magazine, and, moreover, get the sack in order to qualify for the severance pay he needed for the trip.

In May 1947, after a few annoyingly successful stories, he somehow contrived his own dismissal. While the Magnum agency that he and Robert Capa had worked and prayed for was approaching its birth, he was able to leave for North Africa on a story for *Illustrated*. He and Cicely drove off in a bullet-scarred straight-eight Packard that Rodger had liberated from the German army in Brussels, to retrace the progress of Montgomery's Eighth Army backwards from the Mareth Line to El Alamein. This was little trouble to a battle-hardened photographer in such congenial company, and on the story's completion they crossed the water to Cyprus, where they were to buy a house. Here they heard of Magnum's safe delivery and made speed to Paris to celebrate.

The idea that became Magnum had been formed in the mind of Robert Capa and imparted to Rodger after the liberation of Naples. It was both an idealistic and commercial concept which would give feature photographers an editorial and economic independence that the best employers could never offer them. When Rodger had learned that *Life* were preparing a 'golden' obituary for him towards the end of his marathon in Africa and Asia, he had concluded that he was as valuable to them dead as he was alive, so Capa's idea fell on fertile ground. Capa had also persuaded Henri Cartier-Bresson (already famous), and David 'Chim' Seymour, together with an American, Bill Vandivert, to form the photographic fellowship, though Vandivert soon dropped out.

The measure of the four photographers' ardour is expressed most intensely in a few sentences Rodger wrote in 1972. Magnum was never created, he explained:

'...it came somehow from the barren hills like a spring of clear water, and flowed down into the plain which was parched and thirsty for what we had to offer...news of a world of men, who for years had been isolated from one another by war and the brainwash of propaganda. Then through the years, as new members joined us like tributaries, the main stream swelled to become a river. In time of drought it shrank to a precarious trickle. In spate it overflowed its banks and was uncontrollable. It seldom flowed quietly.'

Rodger defined the necessary attributes for a member of Magnum, and no doubt unwittingly described himself — except, perhaps, in the last prerequisite: it required 'a mixture of talent and dignity, the ability to walk with kings and not to lose the common touch, and the will to work as a team'.

To get the show on the road, Capa imperiously divided the world into four. Cartier-Bresson was given China and the Far East, Rodger Africa and the Middle East, and Seymour Europe, with Capa himself as the wild card, crossing and recrossing the Atlantic, making contacts and bursting with ideas. 'Project after project flowed from Bob's

fertile mind,' Rodger has written. The first joint venture was for the popular *Ladies' Home Journal*. Each of the four adopted a family in their area for 'People are People the World Over' and saw the results run over 12 issues. Later *Holiday* magazine ran a generation series, 'Generation X', the story of children who had grown up during the war, 'Generation Women' (Rodger chose an airline hostess outside his territory in the Philippines) and 'Generation Child', for which he found a subject in Uganda. Everything seemed to be working very well and the Swiss Werner Bischof joined the team, followed by the Austrian Ernst Haas and in time many others. Magnum went on growing, its simple idea of photographers giving 40 per cent of their fees to an office which is a focus for assignment ideas, a fixer of contracts and travel arrangements, and also a profitable archive of the members' work, being something that photographers all over the world have aspired to become part of – not least because membership itself was very soon seen as an accolade.

In 1948, after the successful first joint venture, however, Rodger decided that he wanted to wander the length and breadth of Africa in search of his own stories. With Cicely, and financed by his *Life* severance pay, he set off with no plans, no commitments and no worries.

Rodger decided it was best to equip themselves in Johannesburg for the gruelling 28,000-mile journey, to minimize red tape and cut out shipping, but it took a long time and necessitated a trip to Cape Town before they were ready to start. Their preparations were fairly complex, and involved fitting out their Willys jeep truck and station wagon with extra petrol and water tanks, together with well-padded and protected crates for cameras and film. Rodger also had a kind of conning-tower constructed on their trailer, on which he could stand to take photographs or in which he could

conceal most of himself in order not to alarm the game he would shoot, with a camera. (It surely says something about his character that, though a crack shot with a rifle, he declined to take one.) While he was waiting impatiently to start, Dr Malan won the electoral victory which would ultimately lead to apartheid and the establishment of the Republic. Rodger had little time for white supremacists and perhaps his basic feelings about them are expressed by the bald heads he photographed in Uganda in 1954 on one of his visits to the Continent. Gratefully leaving the Union after some adventures with game in the Kruger National Park, they headed northwards.

Africa had always been the continent of true magic and mystery to George Rodger and his wartime privations there did not put him off it at all. His curiosity was continually stimulated by human life lived on such a totally different material and spiritual plane to the Western world or almost anywhere else. The aboriginal Africans outside the Union of South Africa had not been quite as culturally damaged as their equivalents in Australia or most of the Americas. Rodger had become fascinated by them and anxious to experience their life at first hand before it became, to paraphrase his own description, ruled more by the ball-point than the spear. This feeling for Africans and their natural environment which has always been so rich (and hazardous) in wildlife has been the central passion of his life as an explorer/photographer.

They covered 13,000 miles before reaching the Equator, Rodger photographing every kind of human and animal life on the way. He covered the disastrous British Ground Nut Scheme in Tanzania, a story that *Illustrated* would not publish on being threatened with legal action by John Strachey, the Minister for Food. Rodger also visited the fabulously rich Williamson Diamond Mine there. He photographed the lions of the Serengeti Plains

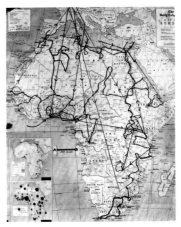

George Rodger's African journeys.

A hunter's camp in the Kenya bush (1948).

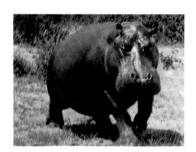

In the Kazinga Channel, Uganda, Rodger was charged by a hippo, but managed to snap the shutter. He first saw the picture as a full page in *Life*.

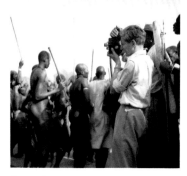

George Rodger using a Paillard Bolex 16mm cine camera to record the Dinka tribe in Southern Sudan.

and the great herds of game virtually trapped in the huge Ngorongoro volcanic crater. He endured the squalor of Portuguese Africa and every kind of beetle and flying insect. From the Williamson mine he wrote the following to a friend:

'At the moment I am writing by the light of a hurricane lantern. It attracts the bugs and the beetles from miles around. Crawling around me are long ones, short ones, thin ones and fat ones, some with clogs on and some which stamp around on big flat feet, some that jump and some that fly. The mosquitoes are dreadful. They zoom down, do a three-point landing on the table then sit back on their heels and roar at me. If it hadn't been for Williamson finding that diamond under the boabab tree and then setting to and digging them out of the thick black soil at the rate of 50 million dollars a year, I wouldn't have had to come here at all.'

But he wouldn't have missed most of it for anything. He met an Irishman in Uganda with the unlikely name of Peter Matthews who was regarded by a pygmy tribe as their king, attended the wedding of the Kabaka of Buganda in Kampala and had numerous other interesting encounters. They also stayed at Nyeri by Mount Kenya, which Rodger referred to in his diary as 'perhaps one of the most beautiful places in the world'.

The crowning experience and achievement of the journey came to its end in the mountains of the Kordofan province in Southern Sudan. They found the people entirely strange, fascinating and likeable as well as the most hospitable in Africa. The Nuba found the Rodgers equally interesting, and the women, who had never encountered a white female before, touched and prodded Cicely to satisfy their entirely friendly curiosity.

Happily, Rodger did not know that their visit was, in fact, the first link in a chain of events that would

bring great ill fortune to these people. Among many beautiful photographs, he made one particularly striking picture of a wrestler being carried in triumph on the shoulders of another after one of their fierce bouts of fighting (some nearby tribes fought with heavy metal bracelets that drew blood and crushed bone). The magnificent specimen of manhood seems the epitome of the 'noble savage' and despite his awesome strength is much more impressive than alarming. When she saw the photograph in *Stern* magazine Leni Riefenstahl, the famous German film director and friend of Hitler who made the extraordinary Nazi propaganda film 'The Triumph of the Will', was overwhelmed by it and asked Rodger exactly where the tribe was located. He very understandably refused to say, as the horrors inflicted by the Nazis were still fresh in his mind (and always would be) and he had no wish to help a sworn admirer of Hitler. Fifteen years later, however, she arrived there and took a remarkable series of colour photographs that were published all over the world. They became justly famous and immediately attracted more visitors to the area. The reaction of the puritan Islamic Government of the Sudan was to encourage encroachment by Arabs onto the Nuba territory and oppress their culture to a degree that has now amounted to their destruction as a free people.

George and Cicely had been deeply touched by the sweet nature of the Nuba people and found that the savage character of their trials of strength between males in wrestling or stick fighting was entirely confined to their ritual bouts (which 'seconds' or 'referees' could stop if life was endangered). Rodger wrote some years later:

...when we came to leave the Nuba Jebels (mountains) we took with us only memories of a people, primitive it is true, but so much more hospitable, chivalrous and gracious than many of us who live in the "Dark Continents" outside Africa.'

But tragedy was looming for George and Cicely – and soon. On settling into the house they had acquired in Cyprus, Cicely was delivered of a stillborn daughter. She died a few days later. It is a memory that Rodger can still hardly bear to contemplate, even after 40 years of happy marriage to his second wife and the raising of their three children. Rodger returned, shattered by the worst experience a devoted husband could possibly undergo, first to Paris. He went on in 1950 to New York where he worked with a friend, Allan Michie, who, with his wife Barbara, gave him moral sustenance and encouragement.

After photographing speculatively in Haiti and Jamaica, his next project was in French West Africa for the American Economic Corporation Administration (ECA) which was part of the great Marshall Plan for Western world recovery. The ECA had asked him to document what the French were doing with the economic aid they were getting from them. On this journey he took Lois 'Jinx' Witherspoon as his assistant. He had known her for four years as a researcher on the *Ladies' Home Journal*. On their way they spent a fortnight at Albert Schweitzer's hospital at Lambaréné. Schweitzer was nearly as famous for his commitment to the hopelessly poor and sick as Mother Theresa is today and both Rodger and Witherspoon were thoroughly convinced of his goodness and integrity (which has sometimes been questioned). They later visited him in Strasbourg, his native city, where he sometimes returned to make money for his hospital by giving organ recitals.

They went back to Magnum and then on again to Palestine. Rodger then worked on Capa's 'Generation' series for two years, accompanied by his new wife, Jinx. She would travel with him on many assignments before they settled (in 1958) into their house in Kent (refashioned by George's own hands from four cottages) to raise their family.

On the way home in 1954 after the last 'Generation' story – 'Child', in Uganda – they were appalled to read in a back issue of *Time* magazine of Capa's and Bischof's deaths weeks before, which would make Rodger as important to Magnum's morale as it had so recently been to his own. During the following year when the worst of the shock had been absorbed, Rodger went on what he describes as 'an ideal assignment' for STANVAC (Standard Oil) on oil-related stories from Saudi Arabia to Indonesia. Agreeable as these stories were, Rodger was overworked and under stress and he was prevented from leaving for an Indian assignment by a nervous breakdown which lasted a year. In 1956 he was once again in Africa and the Middle East, but he was soon obliged to return to Paris after the tragic shooting, while covering the Suez crisis, of David 'Chim' Seymour, who had himself done so much to help Magnum over its first great bereavement.

In 1957 George Rodger continued his travels with Jinx on a four-month journey across the Sahara, on the trail of stories on oil. It resulted in several published articles and 32 pages of pictures in *National Geographic*, who would later offer him a lifelong commitment to that rich and prestigious publication. His decision to settle in Kent, however, with Jinx expecting their first child, Jennifer, obliged him to decline their offer.

During the 1960s Rodger worked mostly in England on various reports for industry and film companies while their second and third children, Jonathan and Peter, were in their very early years. In 1965 Rodger took some remarkable images of Churchill's funeral. But when Peter was a year old Rodger was off again alone on a book commission, *The Ancient Cities of the Middle East*, in Lebanon, Syria, Israel, Jordan, Iran, Turkey and Cyprus, and he continued in archaeological subjects for *Newsweek* magazine in Italy, Greece and Crete. Another journey, this

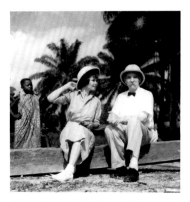

Jinx Witherspoon Rodger and Doctor Albert Schweitzer at his jungle hospital in Lambaréné, Gabon. The Grand Docteur insisted that everyone wear a solar topee helmet against the tropical sun.

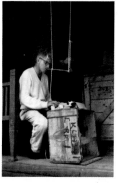

George Rodger in Moyo, Uganda (1954). He had difficulty smoking his long *Dinka* pipe while typing captions to his story.

On assignment in the Sahara in 1957, sandstorms made driving conditions for Rodger's Landrover hazardous.

time for ICI to Nigeria, Ghana and Kenya came in 1977 and in that same year Rodger also went to India, to Jaipur and Kashmir.

In 1978, when Rodger reached the age of 70, the Arts Council awarded him a substantial bursary to return to Africa and take photographs of the tribes he had encountered 30 years previously. But back in Nairobi, he was appalled to find that he could not reach any of the old tribal territories owing to political bias or tribal strife, and this time he was homesick for 'Jinxy', their children, and the rambling cottage at Smarden.

It is surely testimony to his remarkable capacity for empathy with all races of people that Rodger was finally encouraged, without asking, to photograph a hitherto entirely taboo ritual of the Masai tribe in Kenya – that of the circumcision of a young male. Rodger had, in 1948, been threatened with a spear for trying to take perfectly straightforward pictures of these young men. Their attitude to the camera may have been changed since then but no photographer, he believes, had been allowed anywhere near this important ritual.

It may stretch credulity to relate that the person who made it possible was an African of mixed Masai blood whom Rodger had befriended in a hospital in Brussels, but it was so. To his surprise, there the man was in Nairobi, and he got a trader with the tribe to drive them out to the settlement. It took over 12 hours into the bush over very rough road, which petered out, giving way to tall grass that cut off all visibility. They reached the Masai settlement in darkness and waited for dawn to break. Circumcision always took place before full daybreak as it was thought that less blood would flow than later.

The initiate was first mocked and goaded while being told what unspeakable pain he was about to suffer, before the crude operation started, in a very poor light for photography. The cutting of the prepuce with an ordinary pocket knife was prolonged over a quarter of an hour to test the boy's mettle (it was essential to his qualification as a warrior that he betrayed no sign of being in pain at all) and Rodger took several pictures without the slightest hint of disapproval from anyone concerned. Afterwards the boy, who had not flinched for a second, was served in privacy, by a woman, with fresh bullock's blood to drink. The stoicism of the initiate is movingly conveyed in Rodger's photographs, as is the sternness of the 'surgeon', and the quite friendly detachment of those who had already passed their test. Then there was dancing and feasting and Rodger was offered roast goat's brains which he managed politely to decline. Strong spirits were drunk and the Masai became so affectionate towards him that he was unable to take more photographs. The ritual and party lasted four-and-a-half hours and he returned to Nairobi with his high regard for the Masai reinforced. Thus did Rodger through character alone obtain pictures that no one before had been allowed to take.

It was an entirely fitting conclusion to a career that had been much more concerned with honour than with the volume of photographs published or prominent by-lines achieved. In George Rodger's work it seems quite clear that integrity and photographic excellence have gone firmly hand in hand, and it is that which has given Rodger's photographs such lasting value.

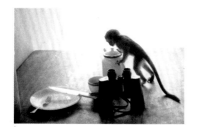

In the Amboseli Game Reserve in Kenya a vervet monkey was an uninvited guest at breakfast (1979).

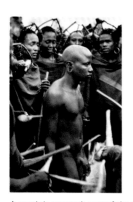

A youth is taunted: part of the Masai ritual at his circumcision ceremony (page 311).

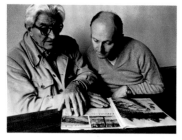

In 1981 George Rodger was reunited in Amsterdam with Sieg Mandaag, whom he had photographed as a boy walking through the Belsen concentration camp in 1945 (page 136). The boy's aunt identified him from the picture published in Life and contacted Rodger through the Red Cross.

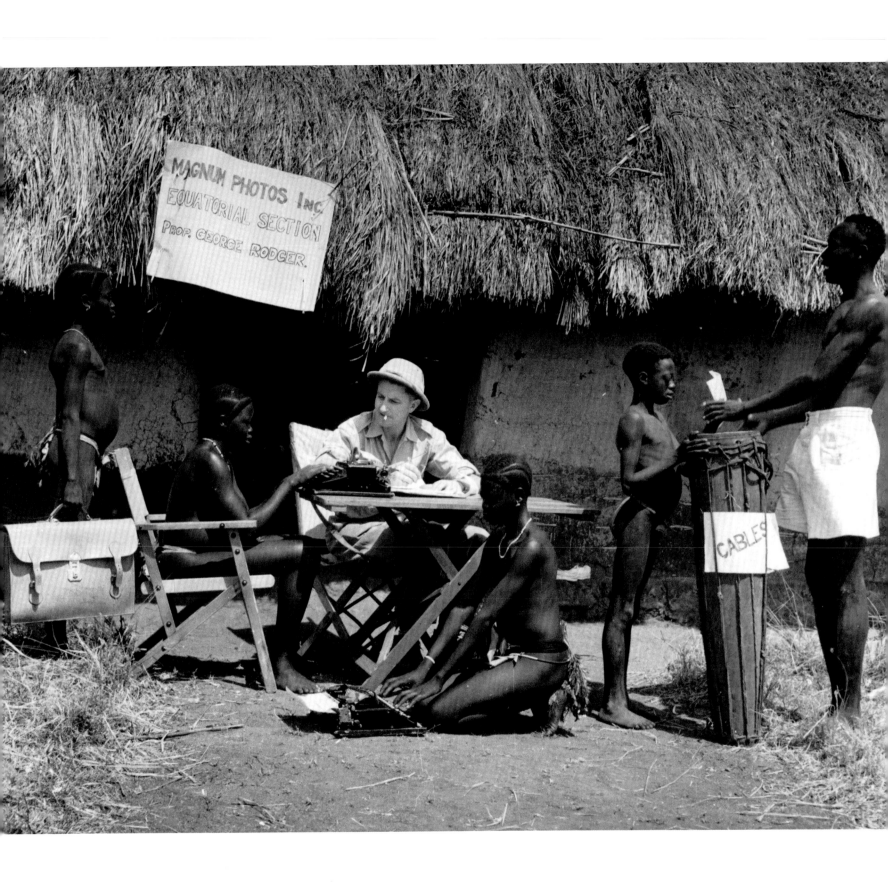

A picture used as a Christmas card (1948)
of 'Magnum Photos Equatorial Section'.
The tribal drum on the right is for
sending out cables.

1945, Spain
Crops are sown again

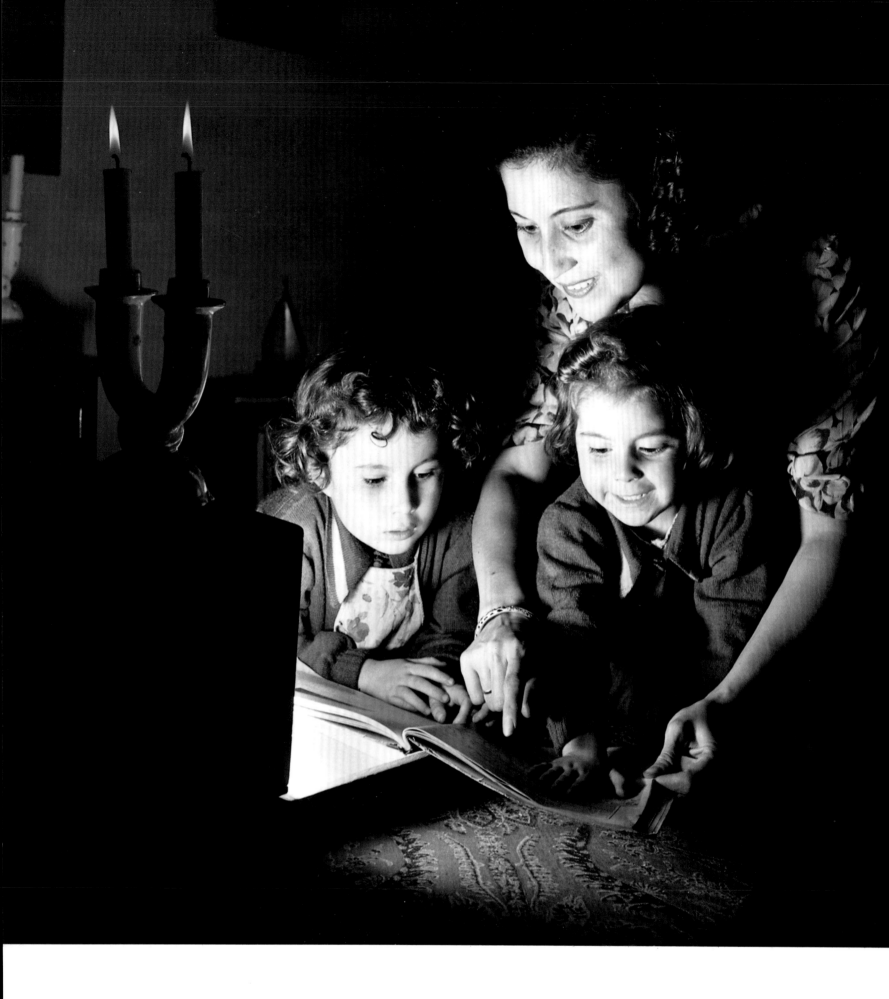

1945, Norway
A mother and her children on
a Norwegian farm

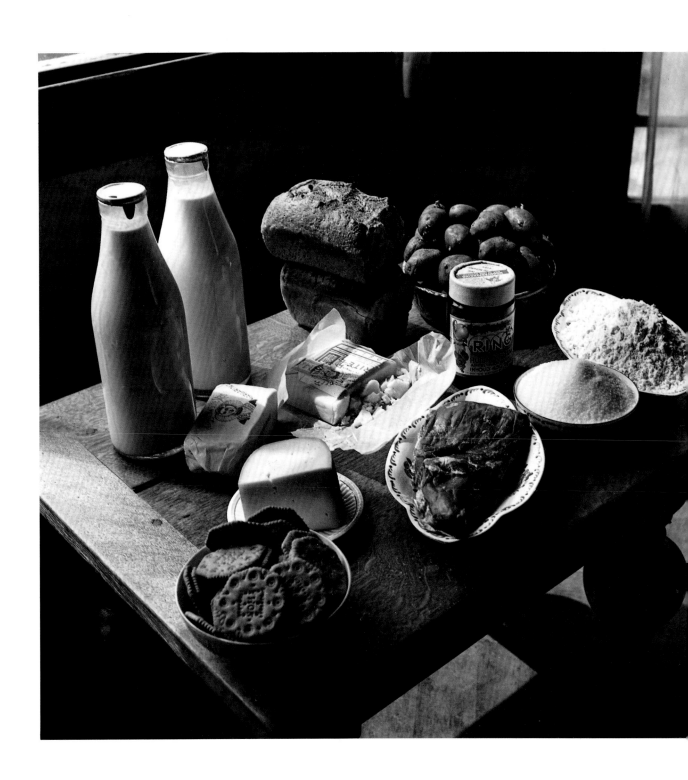

1945, Holland
A Dutch family's postwar
weekly ration

1945, Holland
Klompen (wooden shoes) at the foot of
the stairs in Middleburg, Walcheren

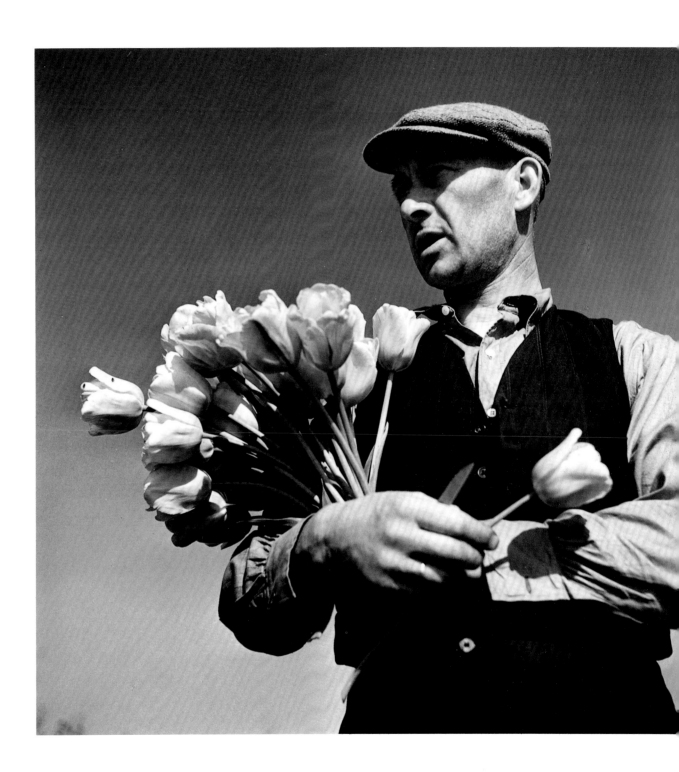

1946, Holland
Postwar: tulips again in Aalsmeer

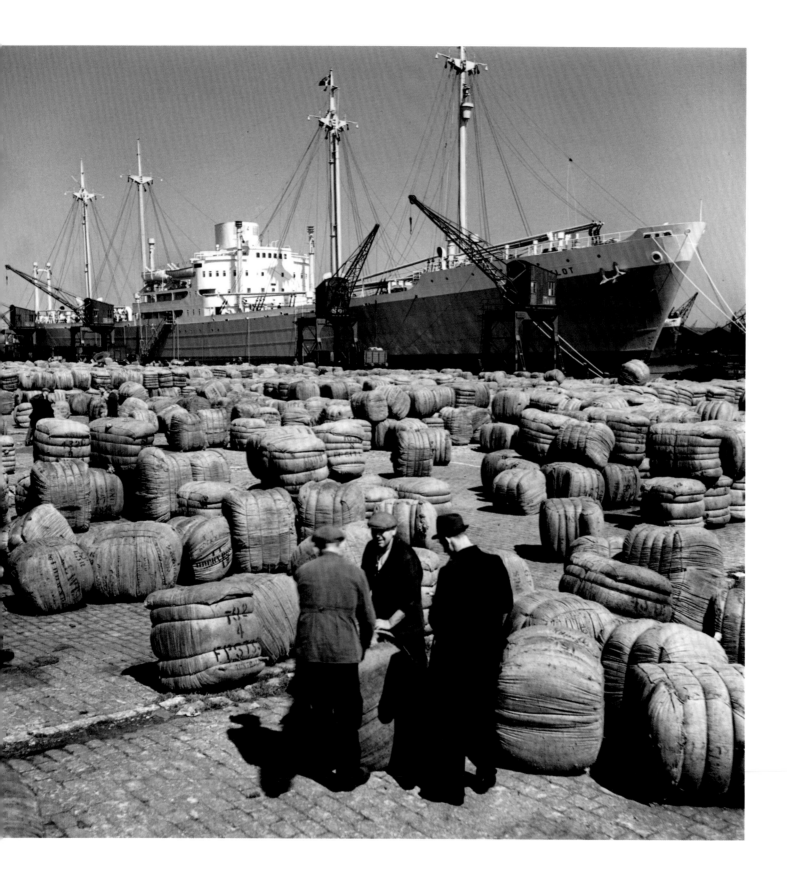

1946, Belgium
Bales of wool discharged onto the docks are then
transferred to barges of the inland waterways in Antwerp

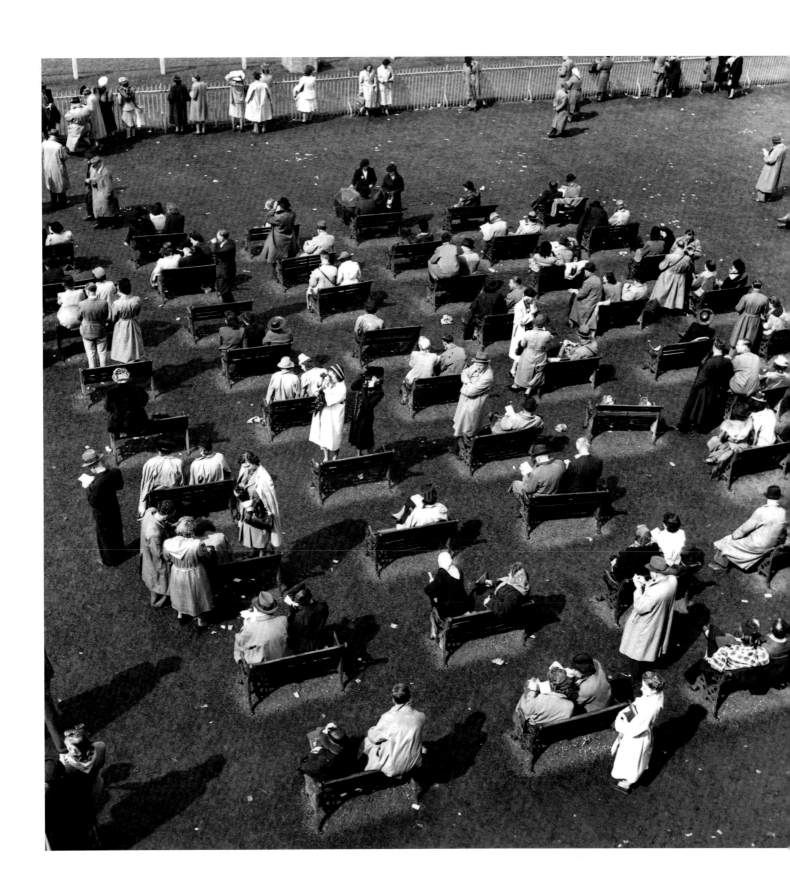

1946, Ascot
The first race meeting after the war

1946, London
Postwar: shops re-open

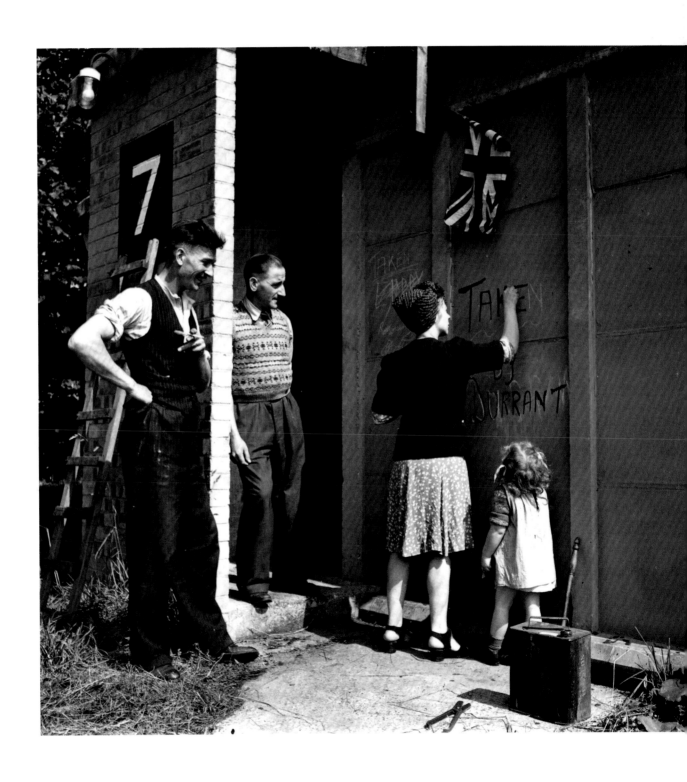

1946, London
Squatters occupy ex-military
housing near London

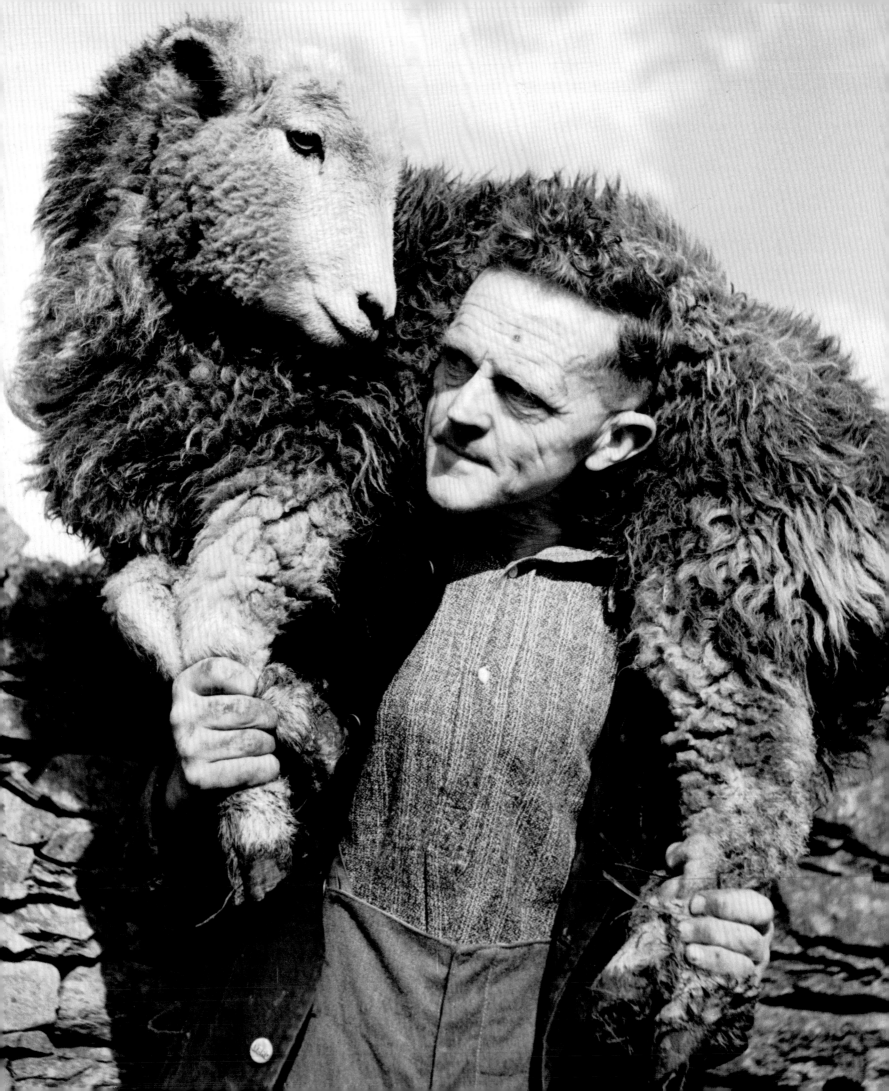

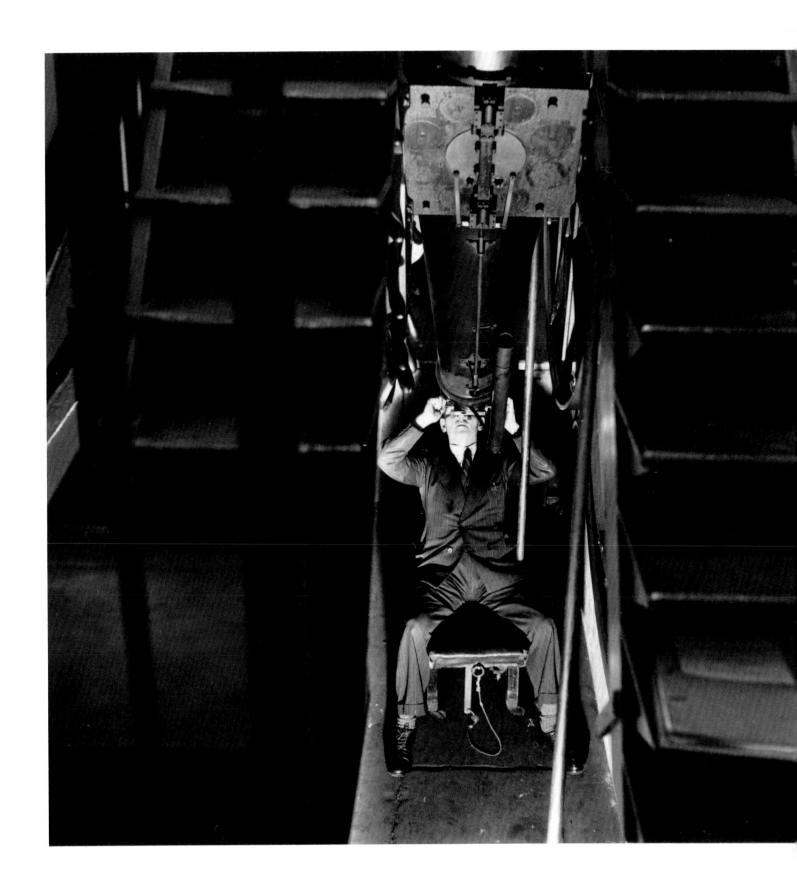

Above
1946, London
Greenwich Observatory

Opposite
1946, England
A shepherd rescues an
injured lamb in Cumbria

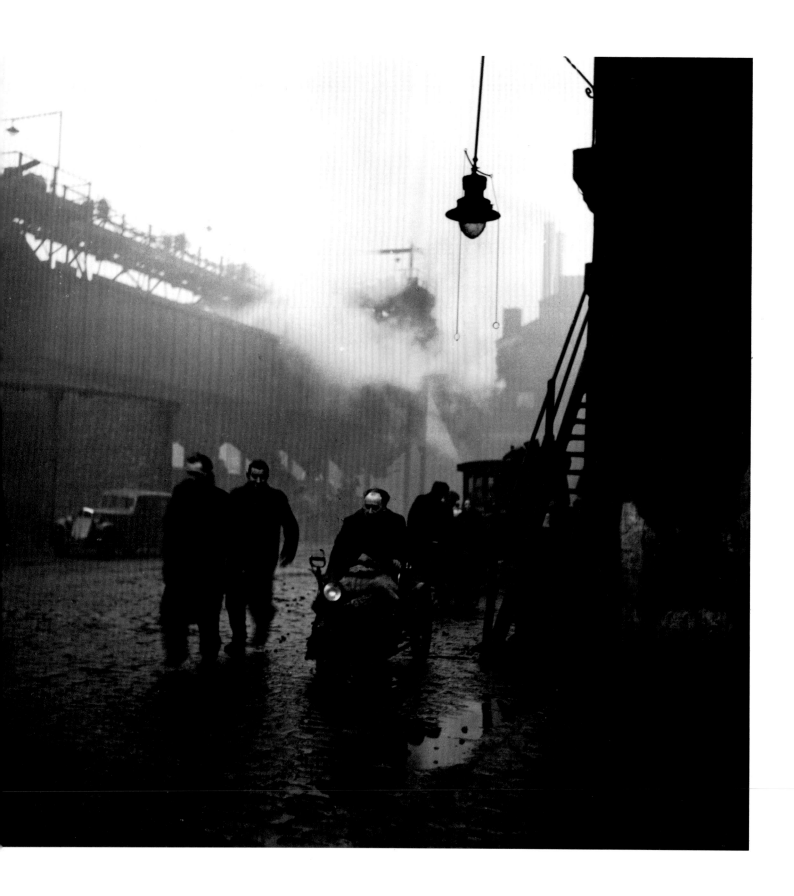

1946, London
Postwar fuel shortage in the East End. These men are
carrying scraps of coal gleaned from slag heaps

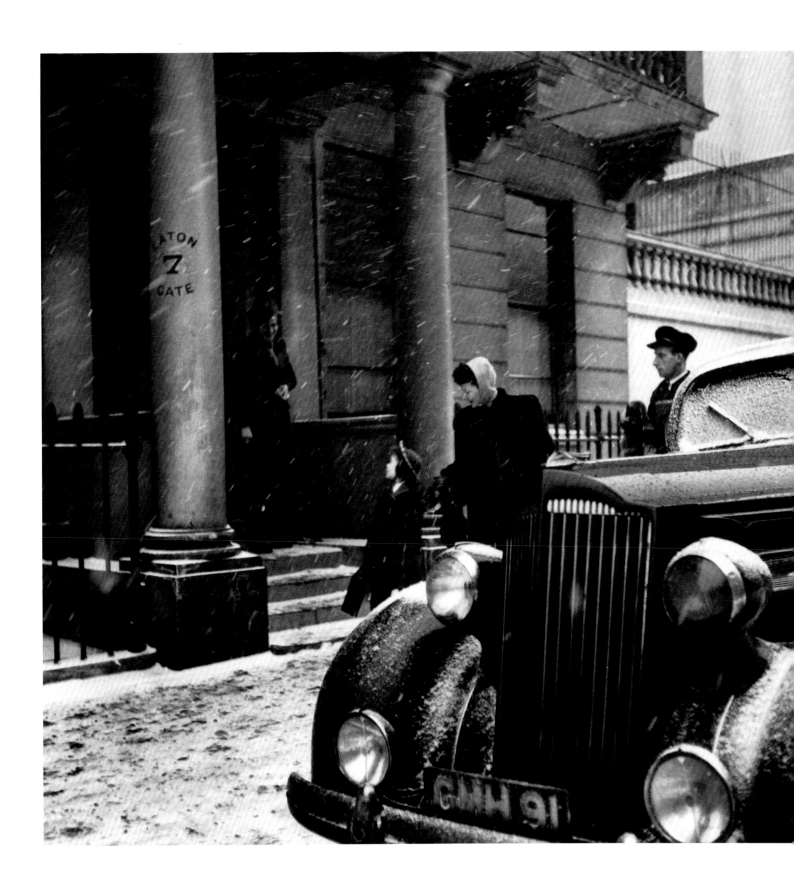

1946, London
Mary Martin, star of 'South Pacific'
and her daughter

1946, London
Trained rabbits

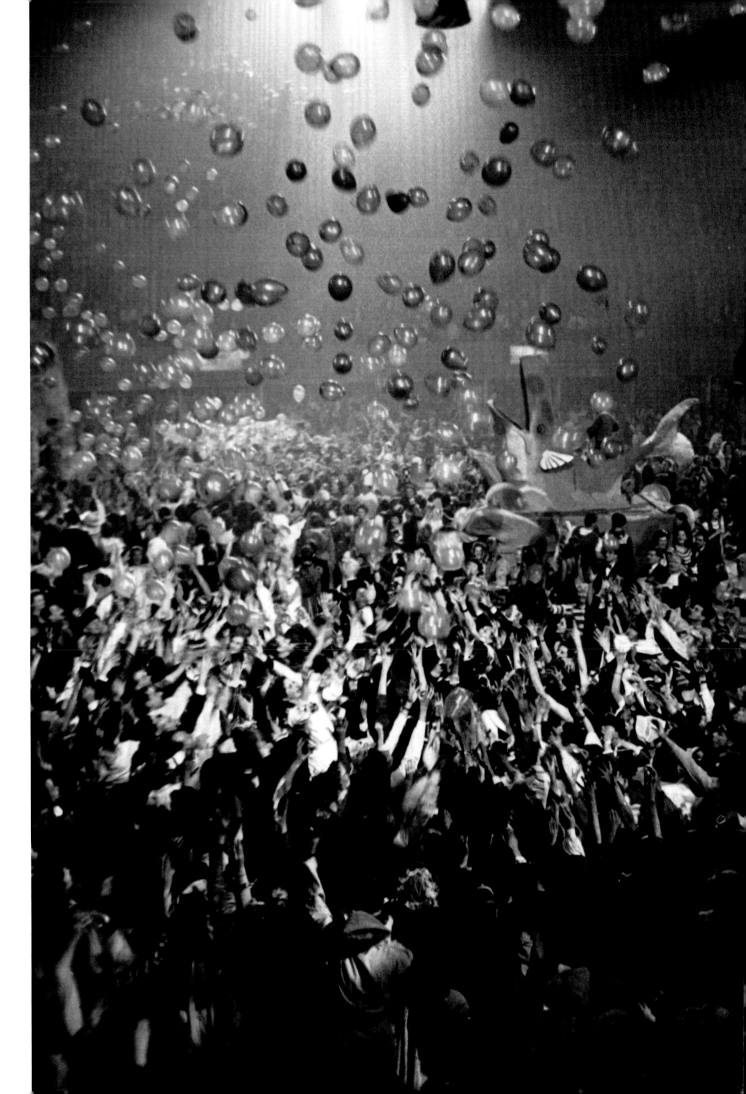

1946, London
The first Chelsea Arts Ball
after the war

Africa

1948, Tanzania
Boys of the Wagogo tribe wear special
headgear for the circumcision ceremony

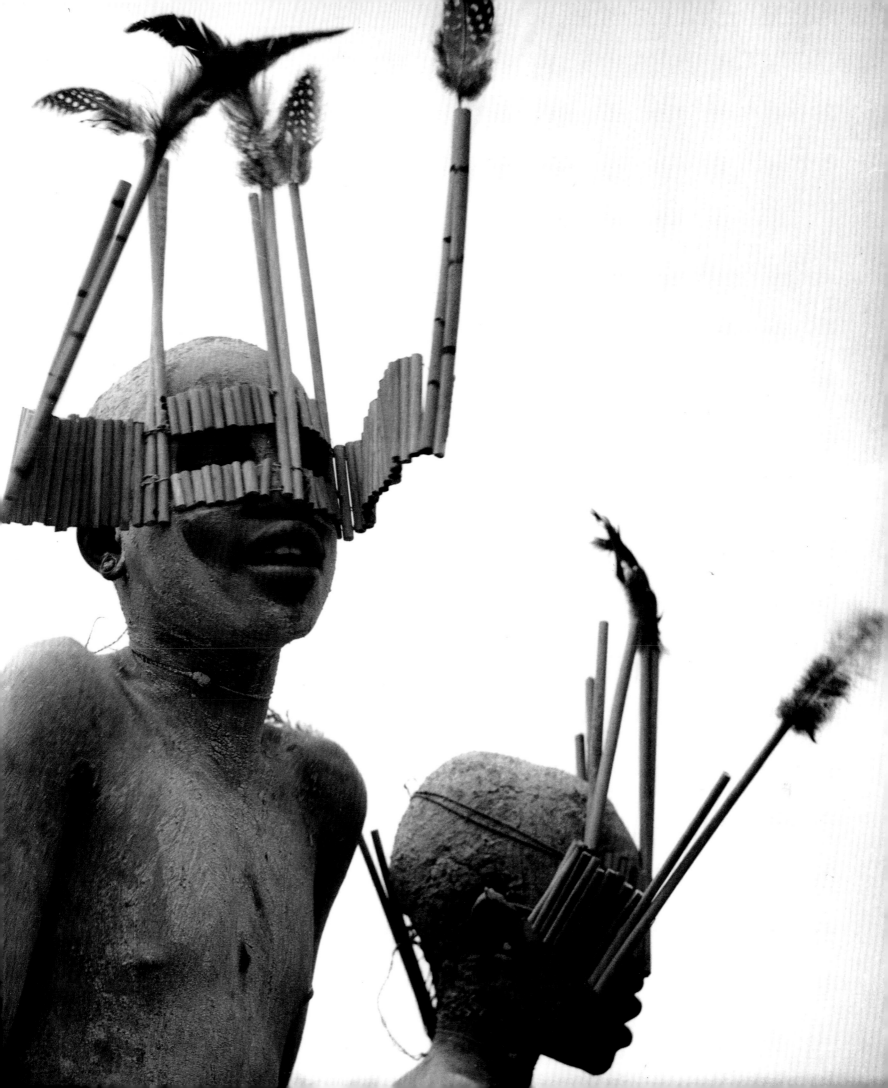

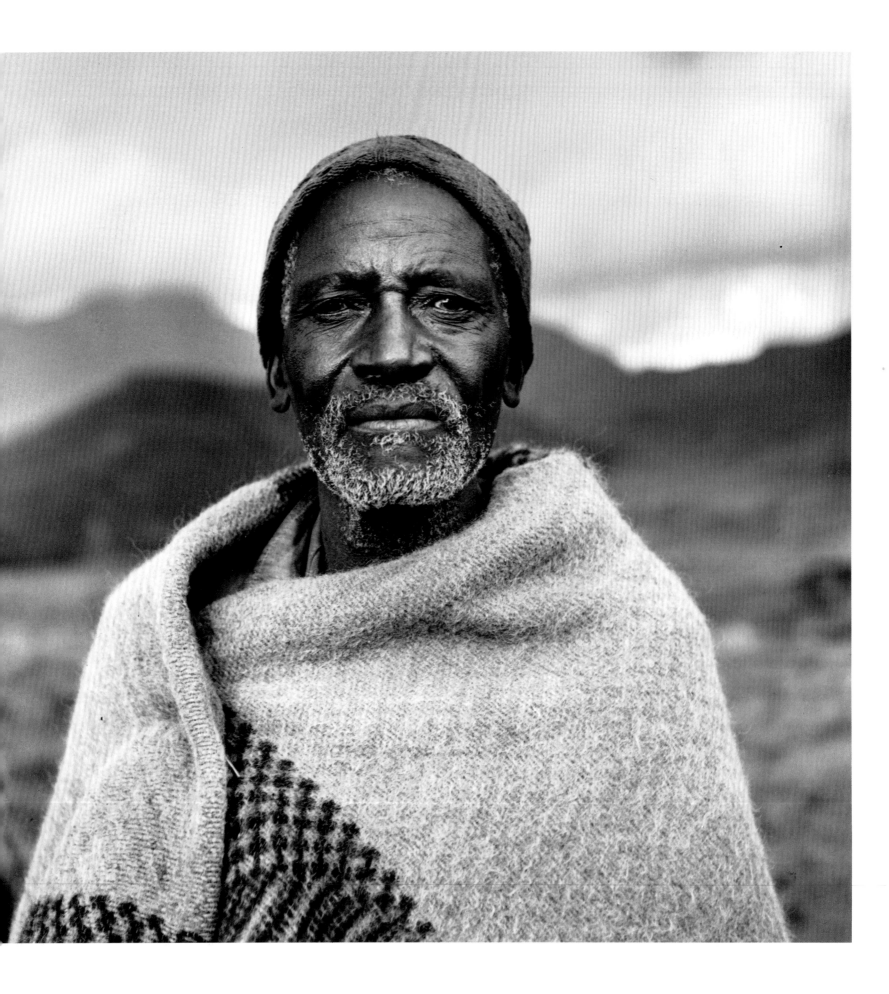

1948, South Africa
A Basuto chieftain in Lesotho

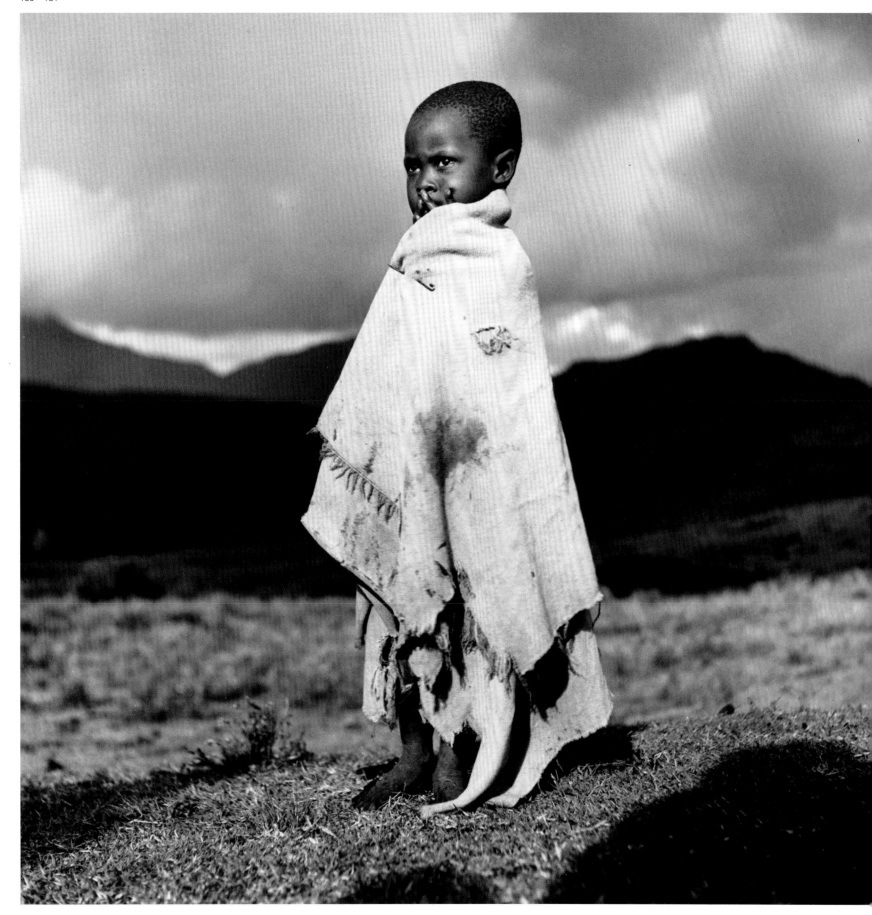

1948, South Africa
A young Basuto boy wrapped in blankets against
the cold on the Thaba Bosiu ('Mountain of the Night')

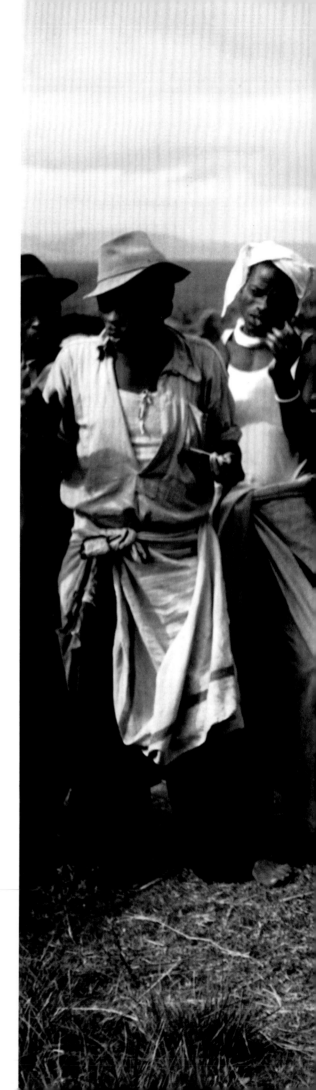

1948, South Africa
Pondo people dance to
celebrate a wedding

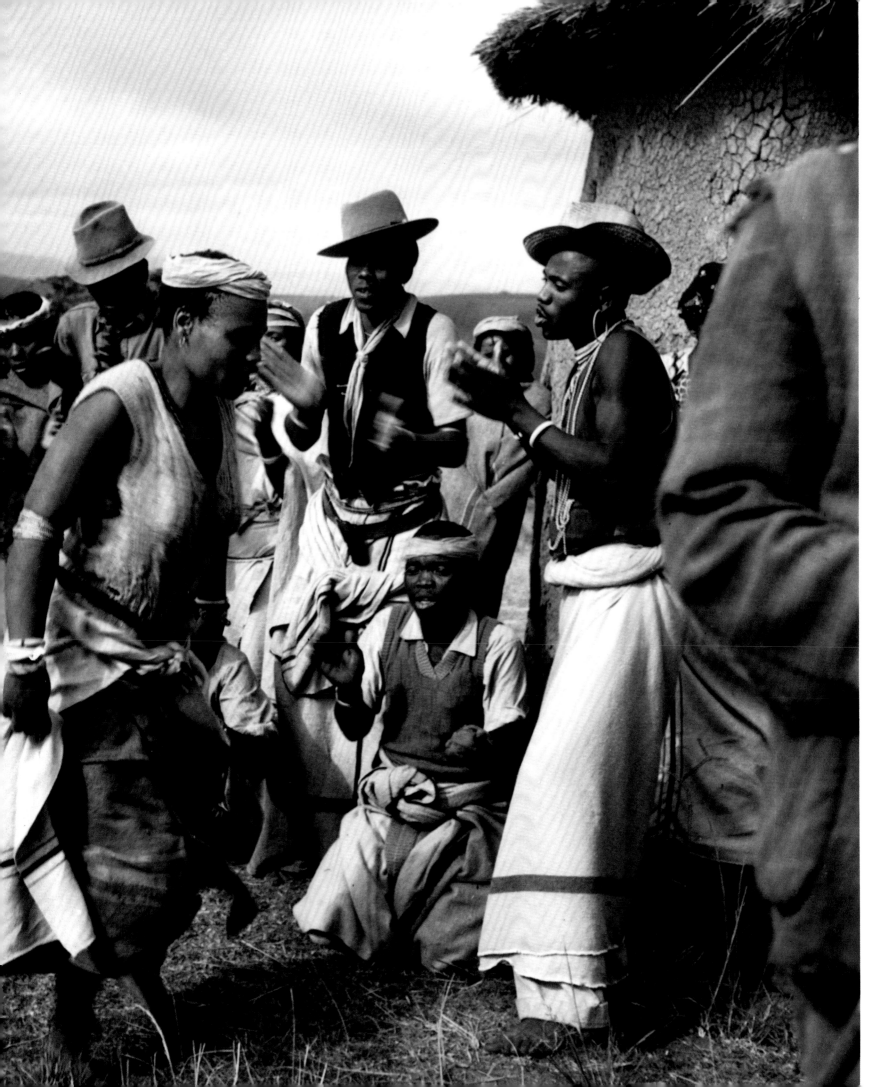

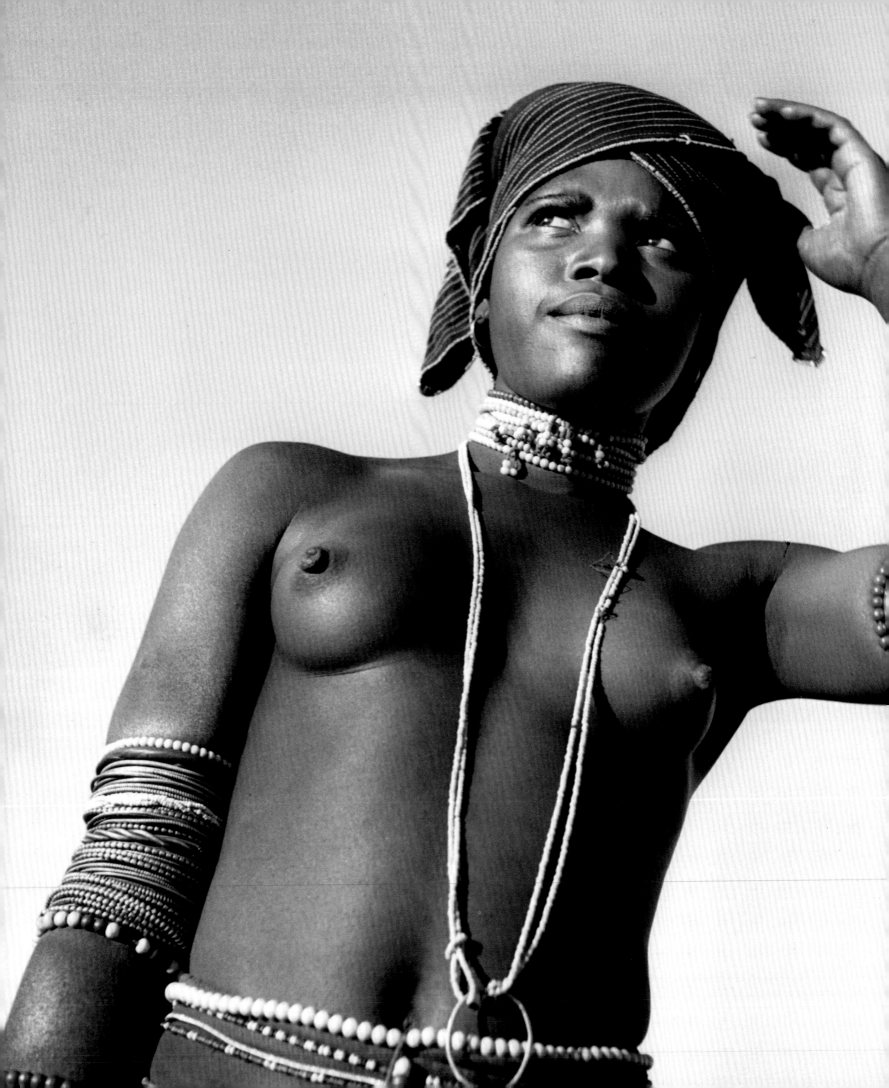

1948, South Africa
A Xosa girl in traditional arm
bands and beads in Transkei

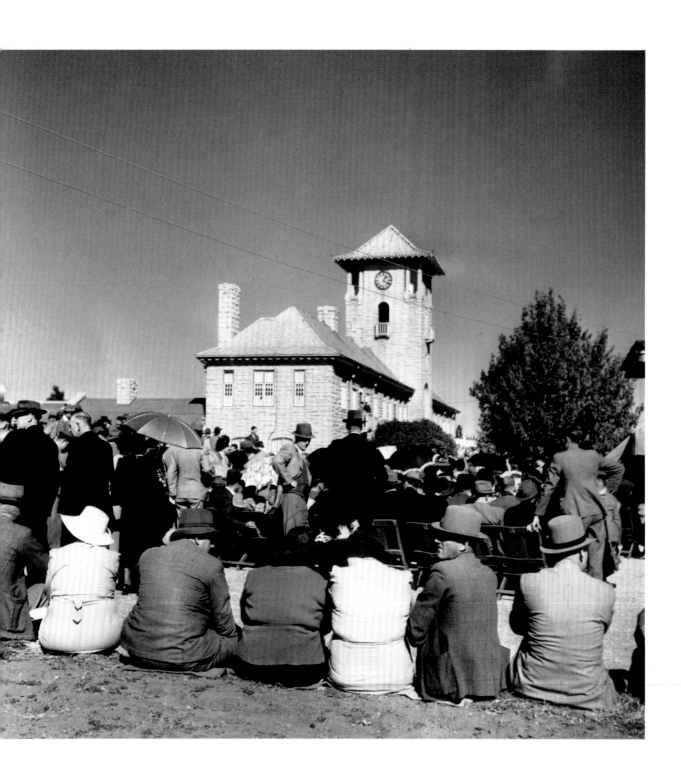

1948, South Africa
Voters at Standerton, listening to General
Smuts' electioneering speech

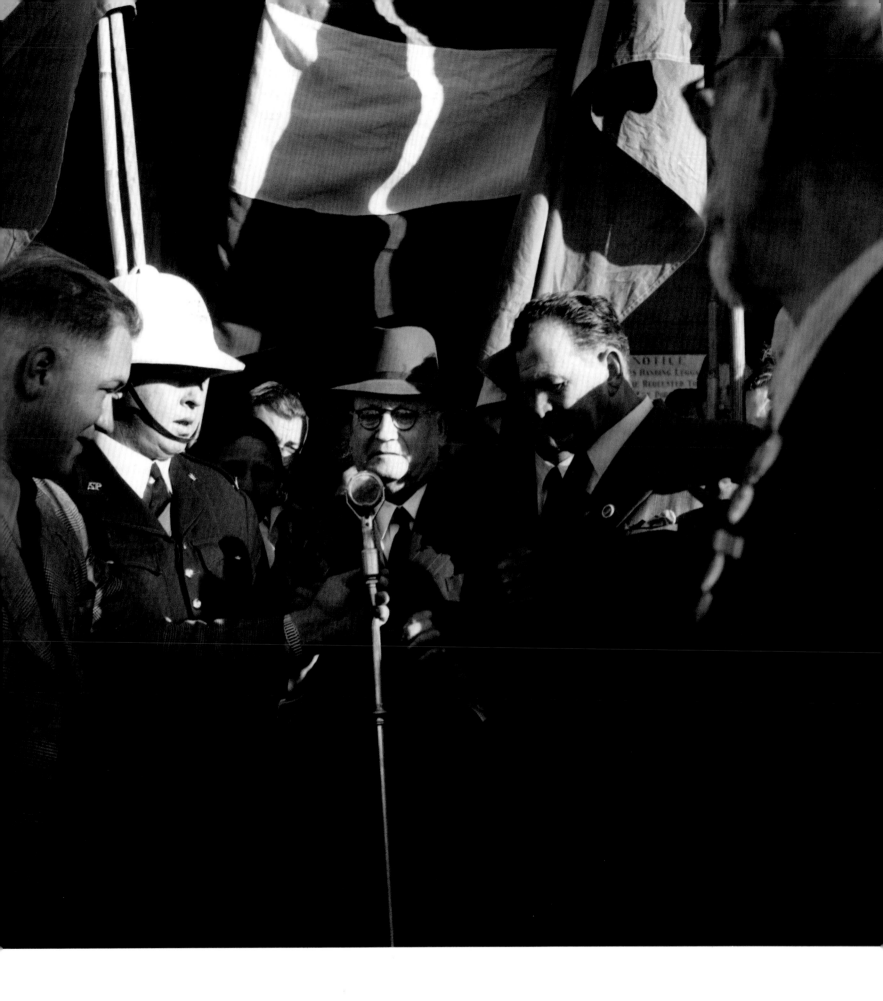

1948, South Africa
Dr Daniel F Malan campaigning in Pretoria
during the South Africa elections

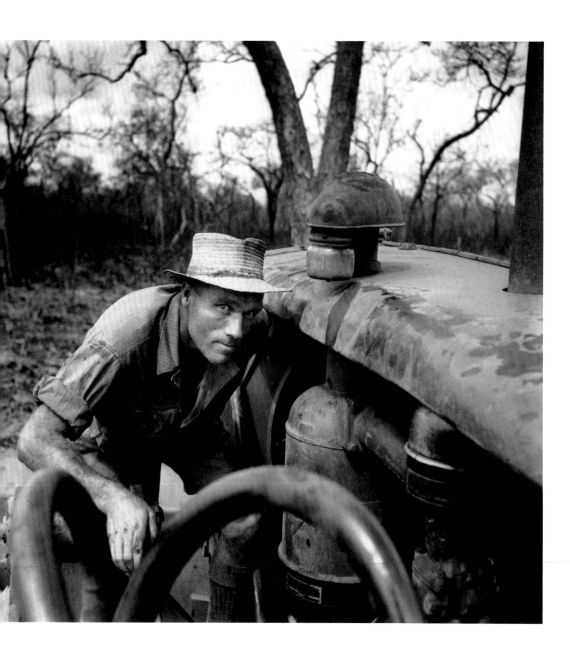

1948, Tanzania
A British engineer brought out to the bush on
the ill-fated Groundnut Scheme

Opposite
1948, Swaziland
The traditional regalia of the Amangwane tribe
includes spears and fighting sticks

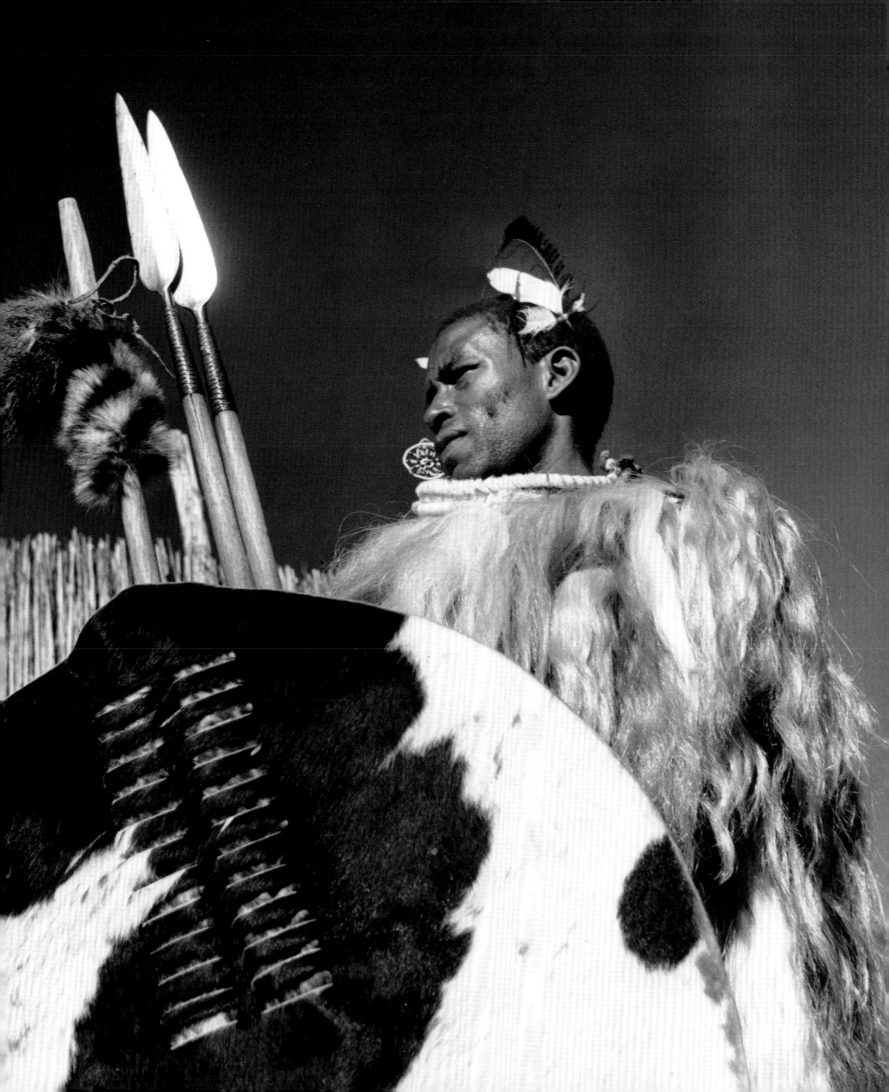

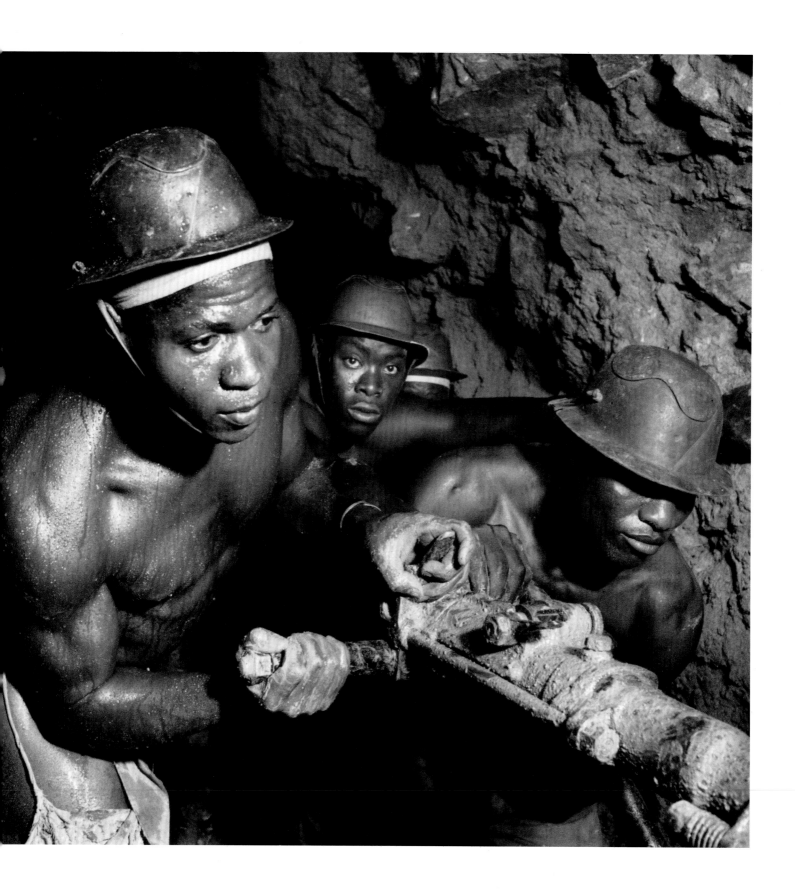

1948, Tanzania
Diamond miners underground at the
Williamson Diamond Mine, Shinyanga

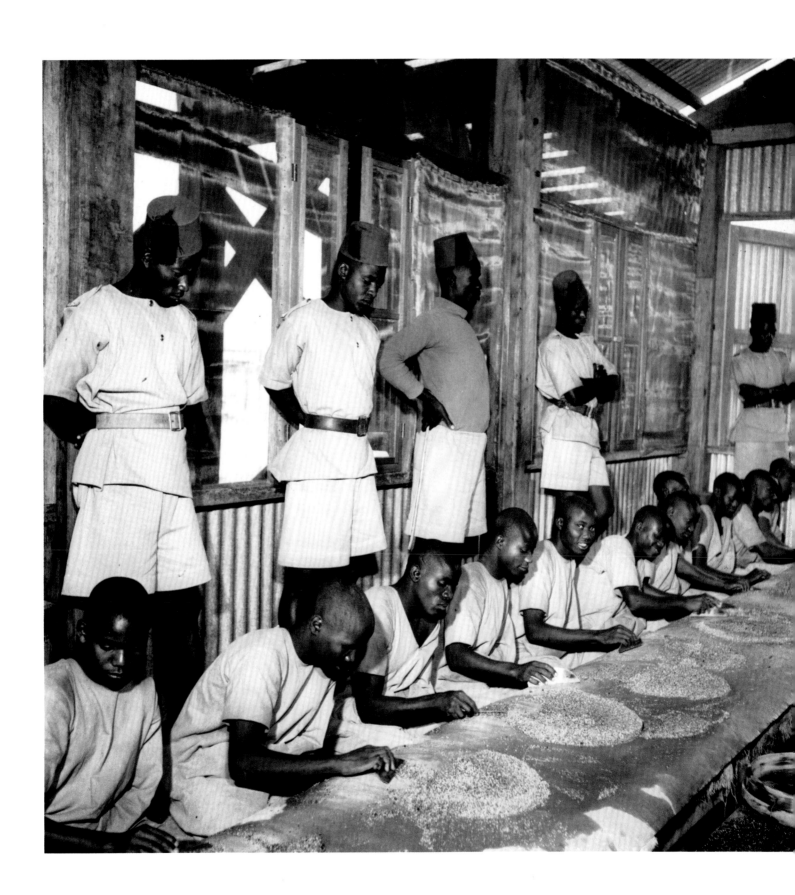

1948, Tanzania
The Williamson Diamond Mine, Shinyanga. Workers are heavily
guarded by Askaris. They use only one hand – the other sleeve
is sewn up to prevent pilfering

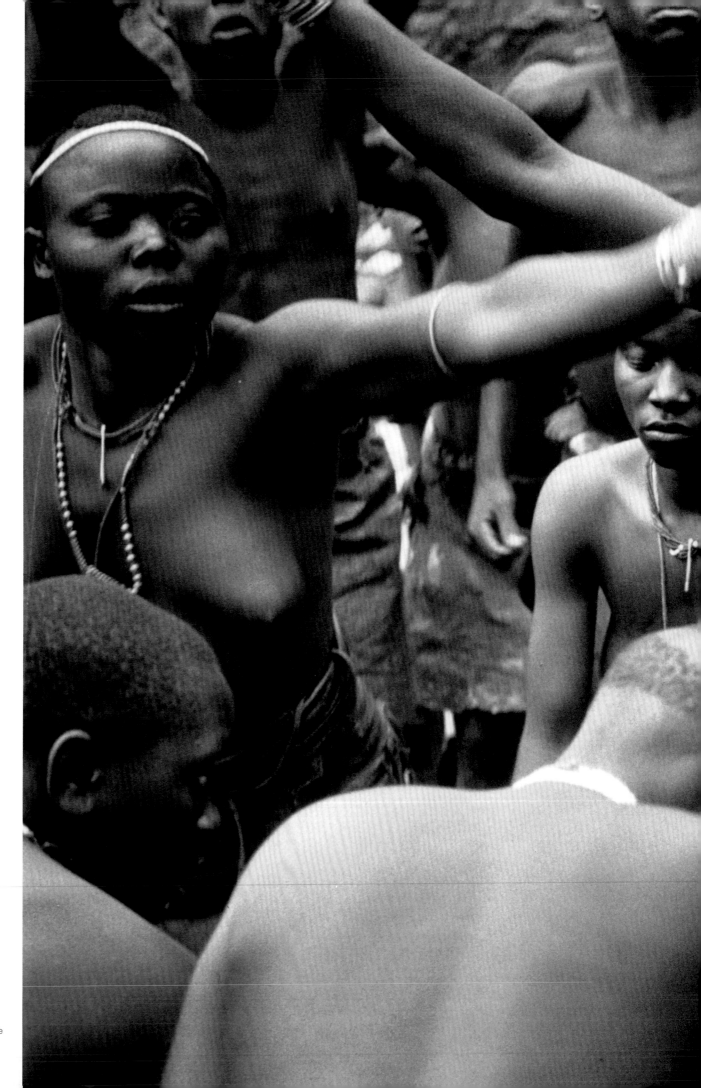

1948, Uganda
Bachimbiri women perform the
'Kamundere' courting dance in the
rainforests of Kigezi

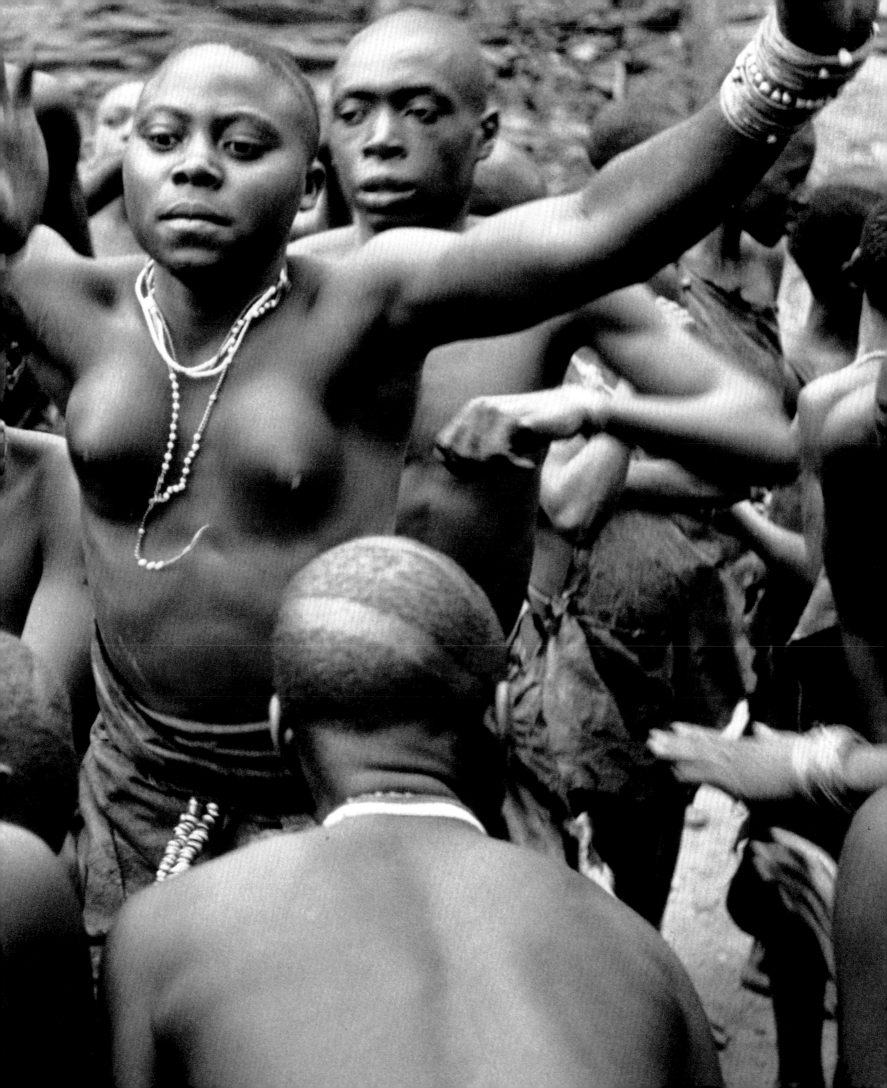

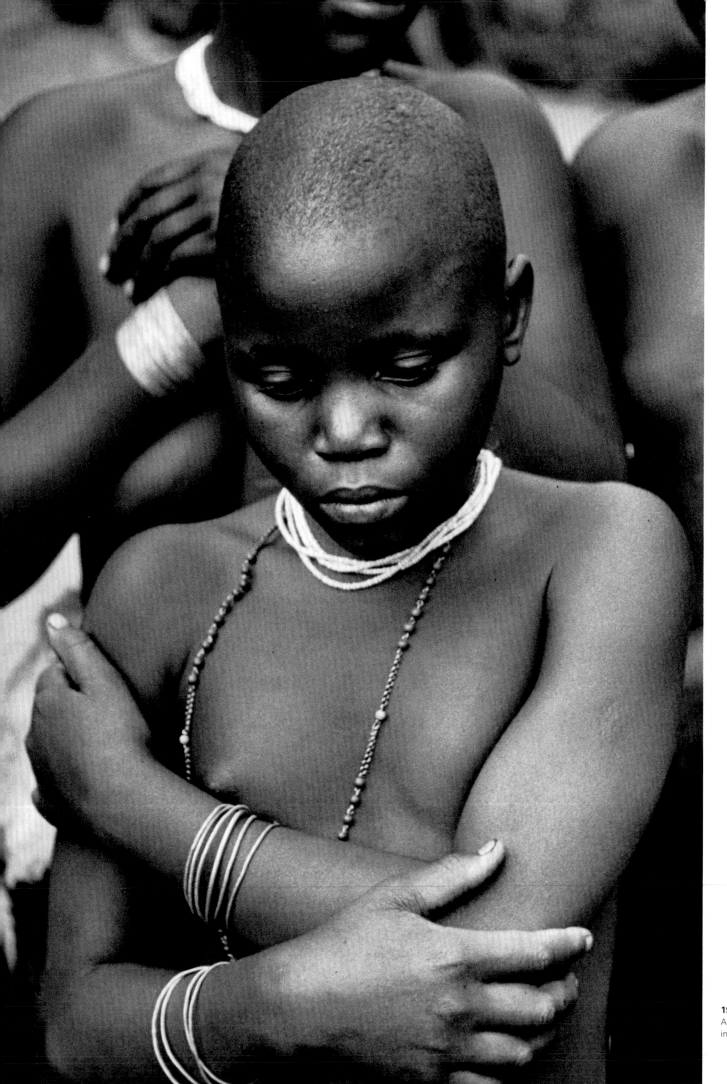

1948, Uganda
A girl of the Bachimbiri tribe
in the high Kigezi rainforest

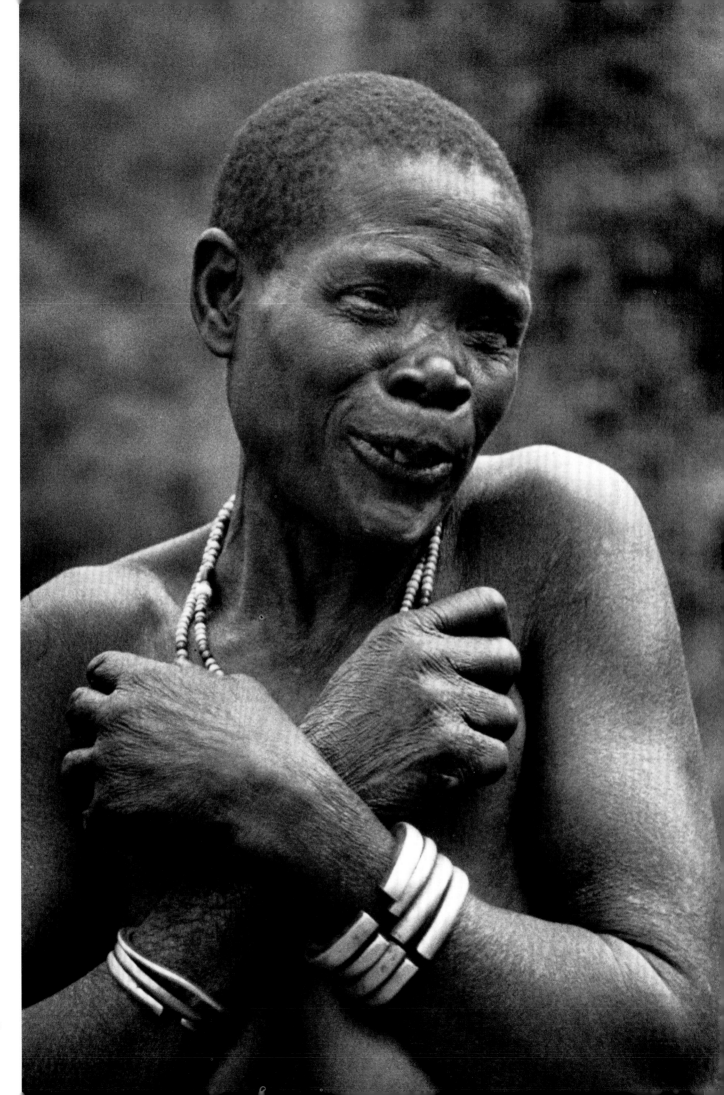

1948, Uganda
An old woman of the Bachimbiri
forest people, Kigezi

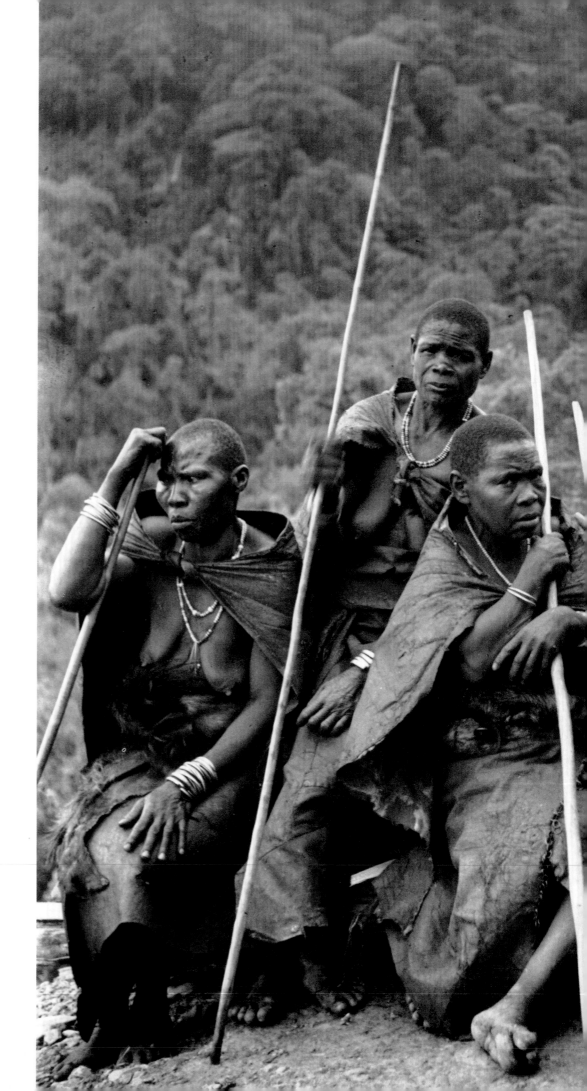

1948, Uganda
Bachimbiri and Wagasero women
in the mountains of Kigezi

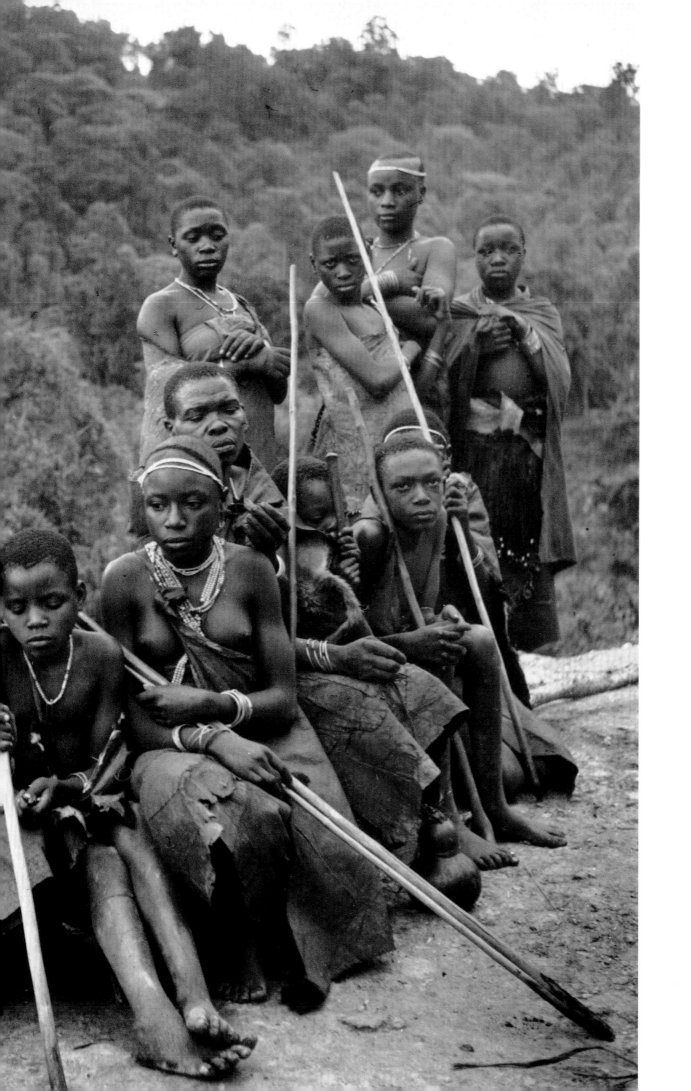

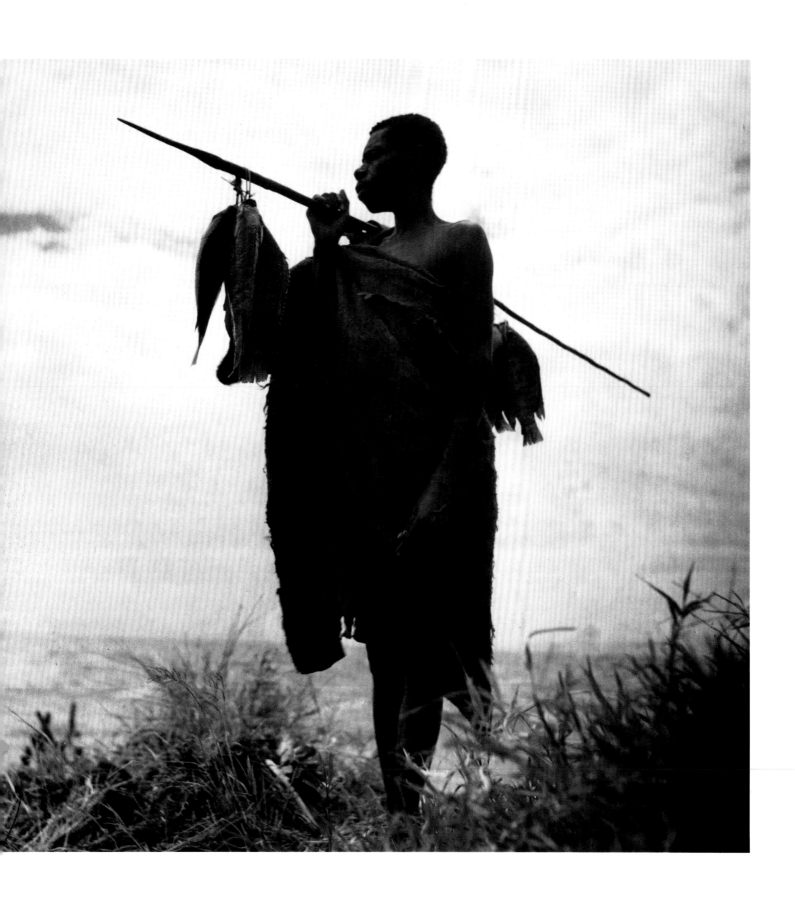

1948, Uganda
A Wakonjo fisherman at the Lake Edward
end of the Kazinga Channel

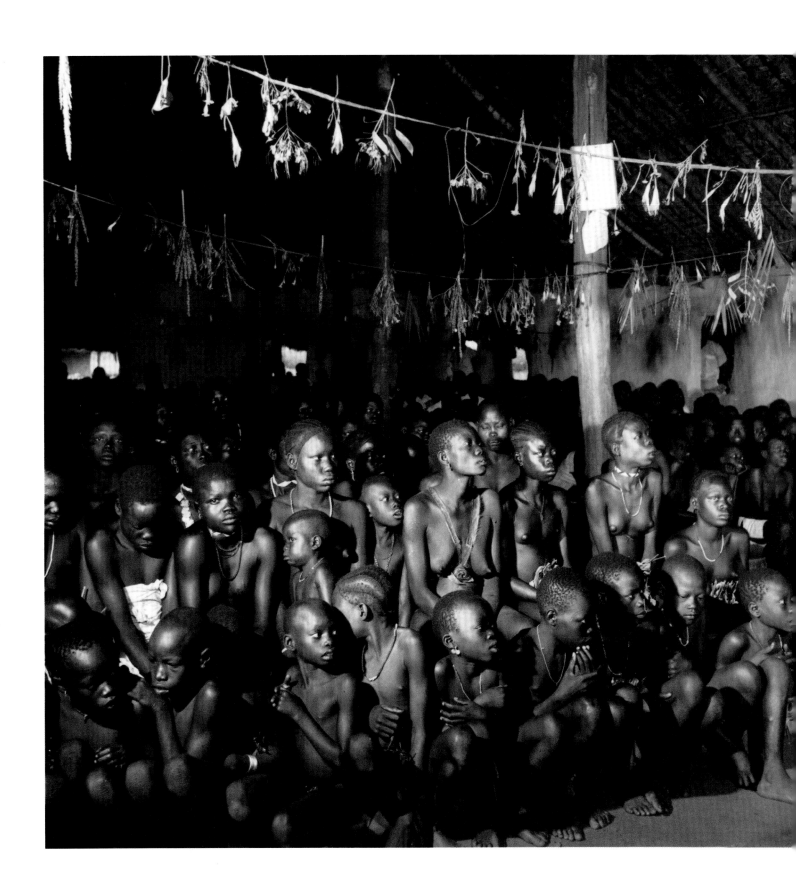

1948, Southern Sudan
A girls' Mission School at Yei

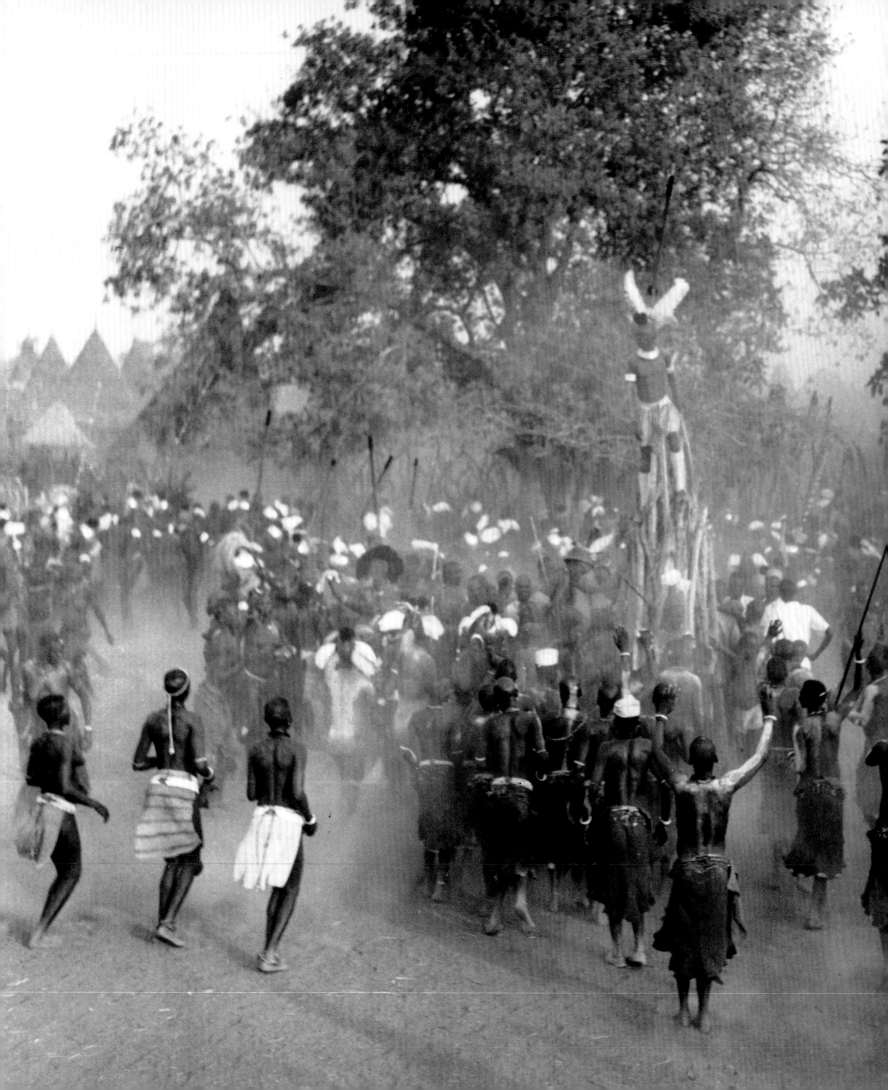

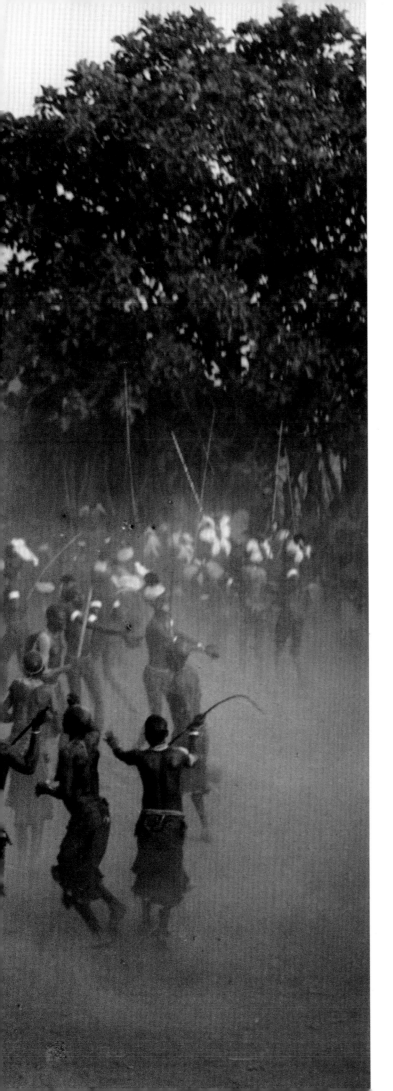

1948, Southern Sudan
The Latuka Dance of the Rainmakers

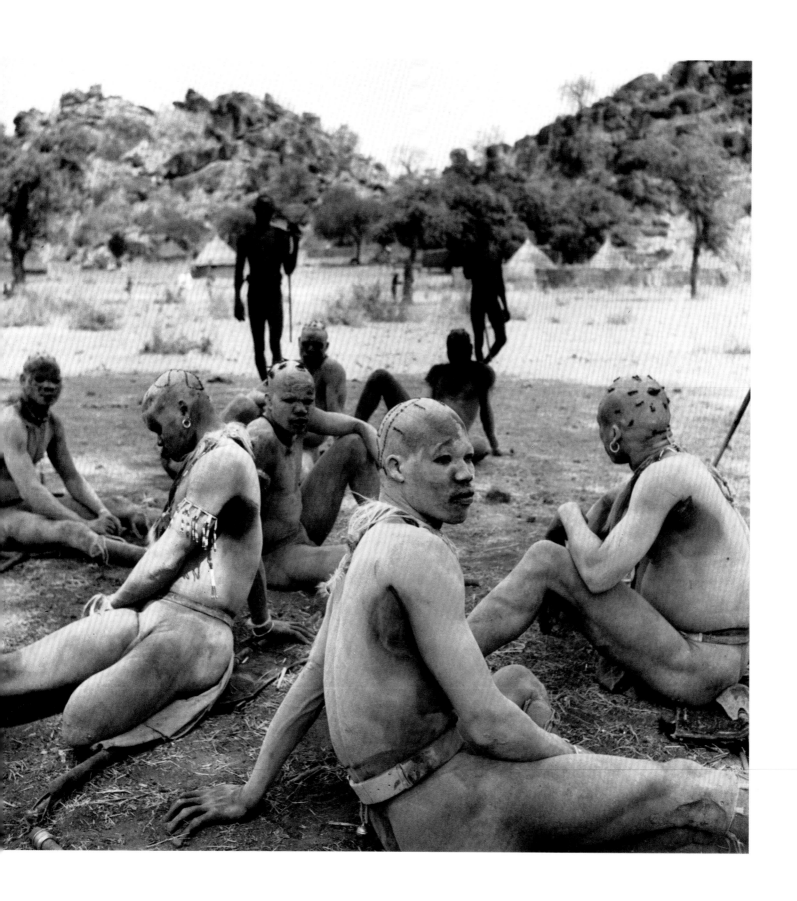

1949, Kordofan, Southern Sudan
Wrestlers of the Korongo Nuba wait to take
part in a match. They are powdered in wood ash
so they can get a grip on each other

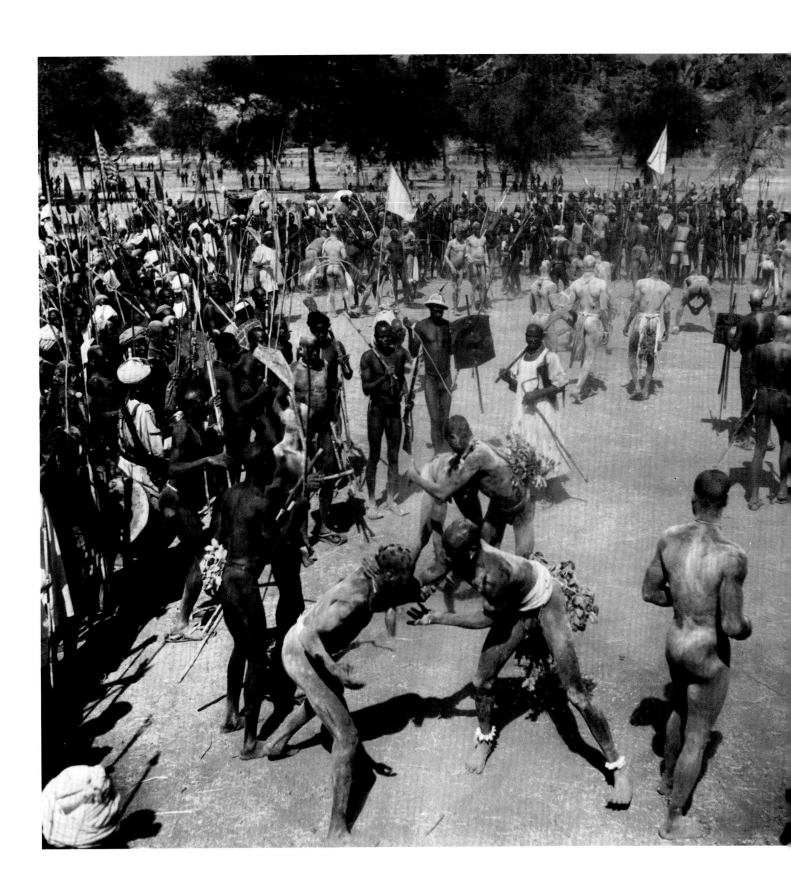

Above
1949, Kordofan, Southern Sudan
A gathering of the Sibr tribe in the Korongo
Jebels (mountains). Wrestlers spar with
each other before the bouts take place

Pages 204, 205
1949, Kordofan, Southern Sudan
Wrestlers face each other before a match

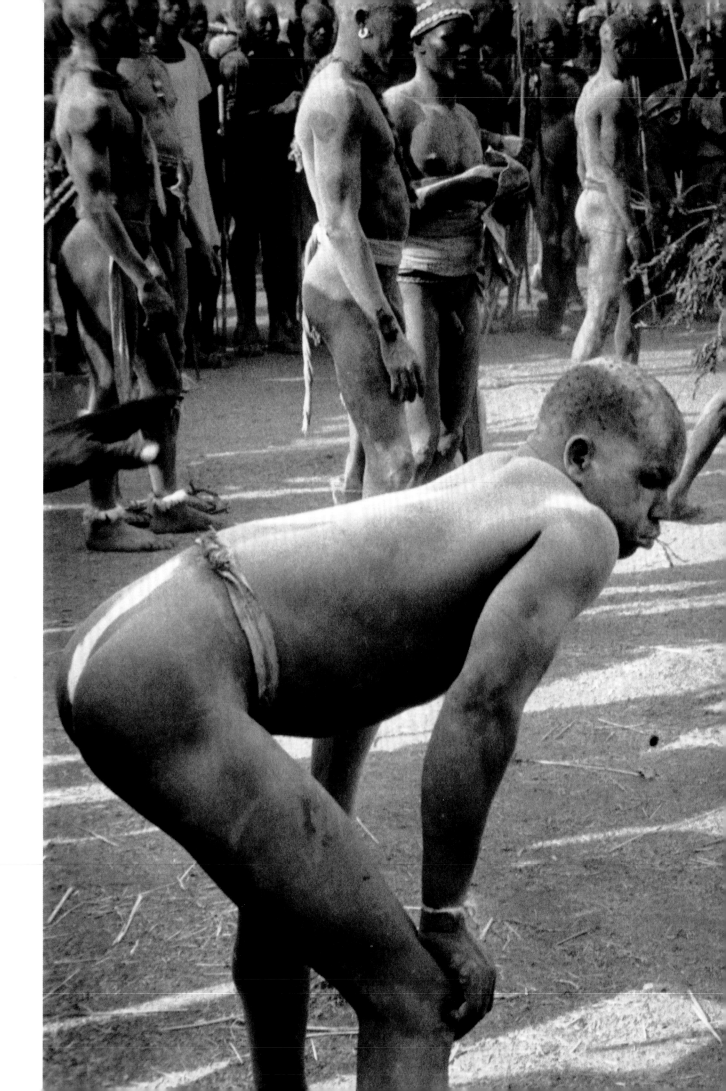

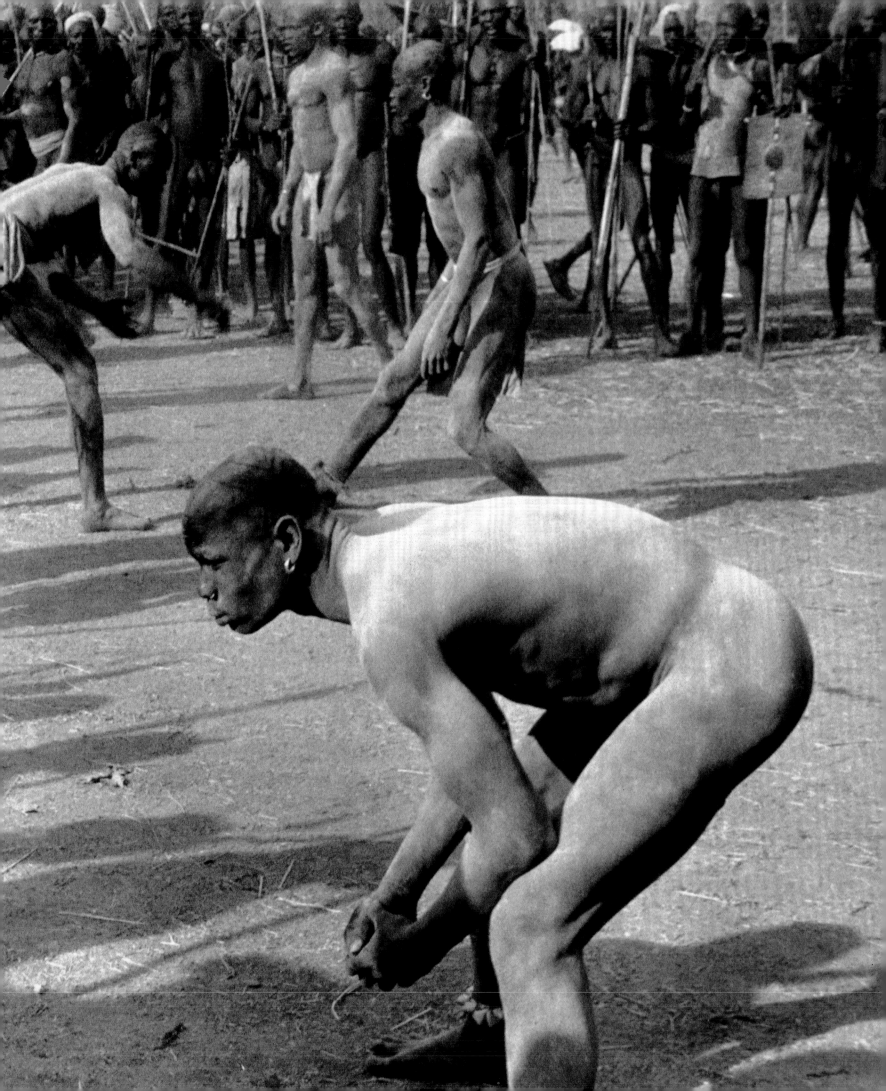

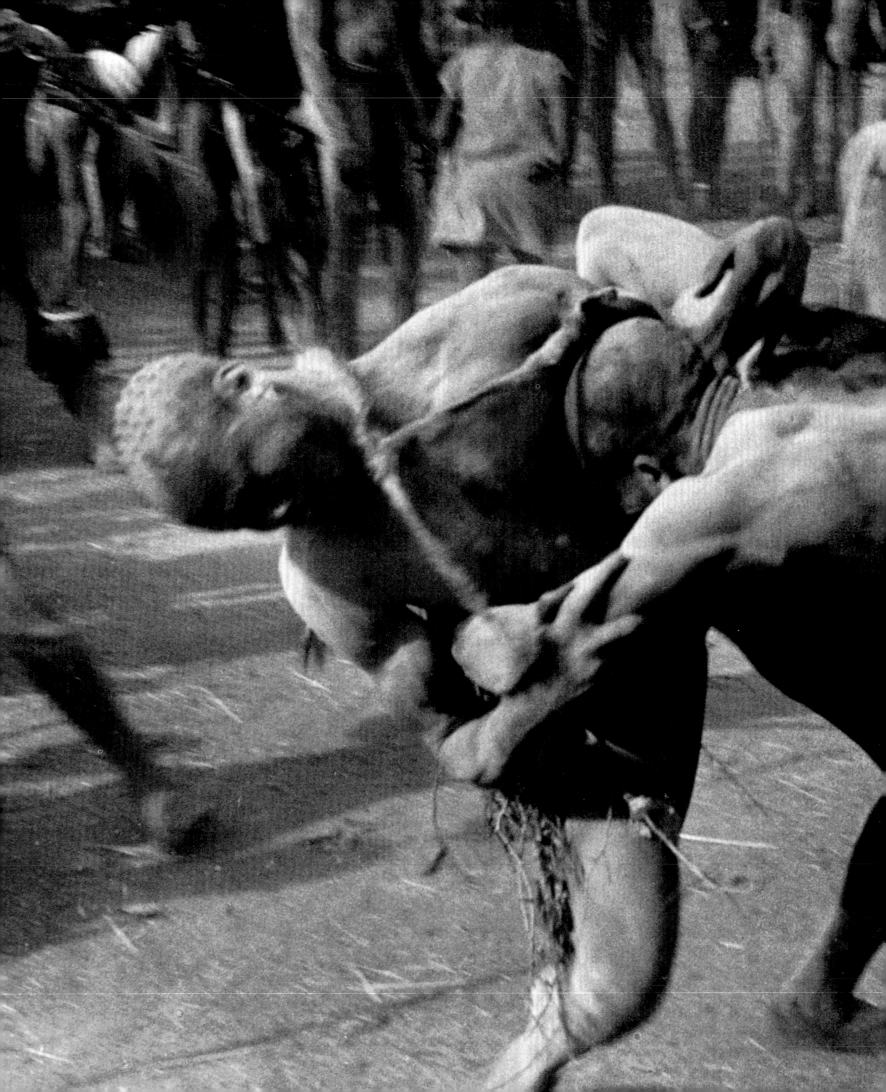

Opposite
1949, Kordofan, Southern Sudan
The champion of a Korongo Nuba
wrestling match is carried shoulder high

Pages 206, 207
1949, Kordofan, Southern Sudan
A wrestling match

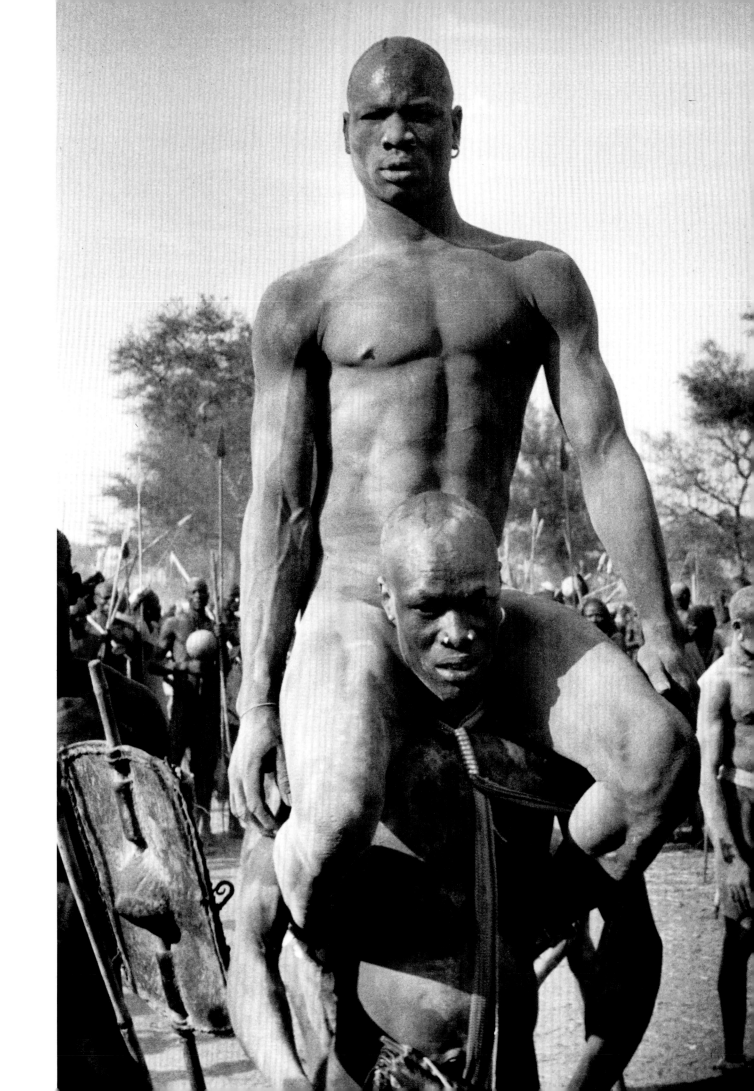

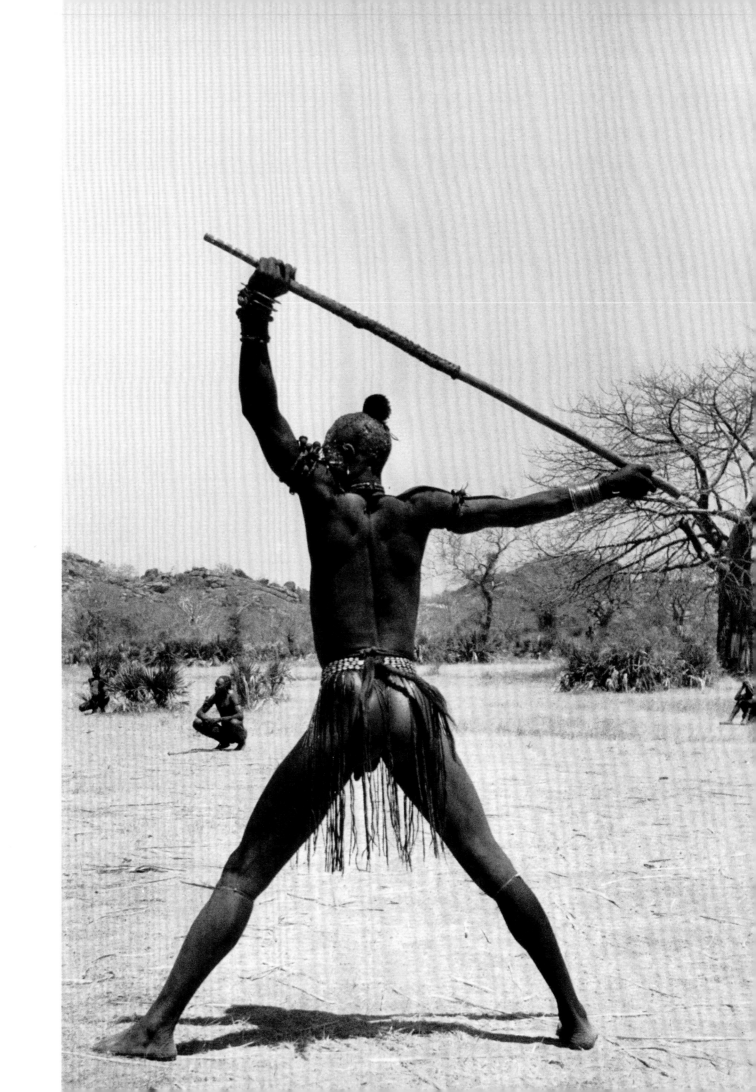

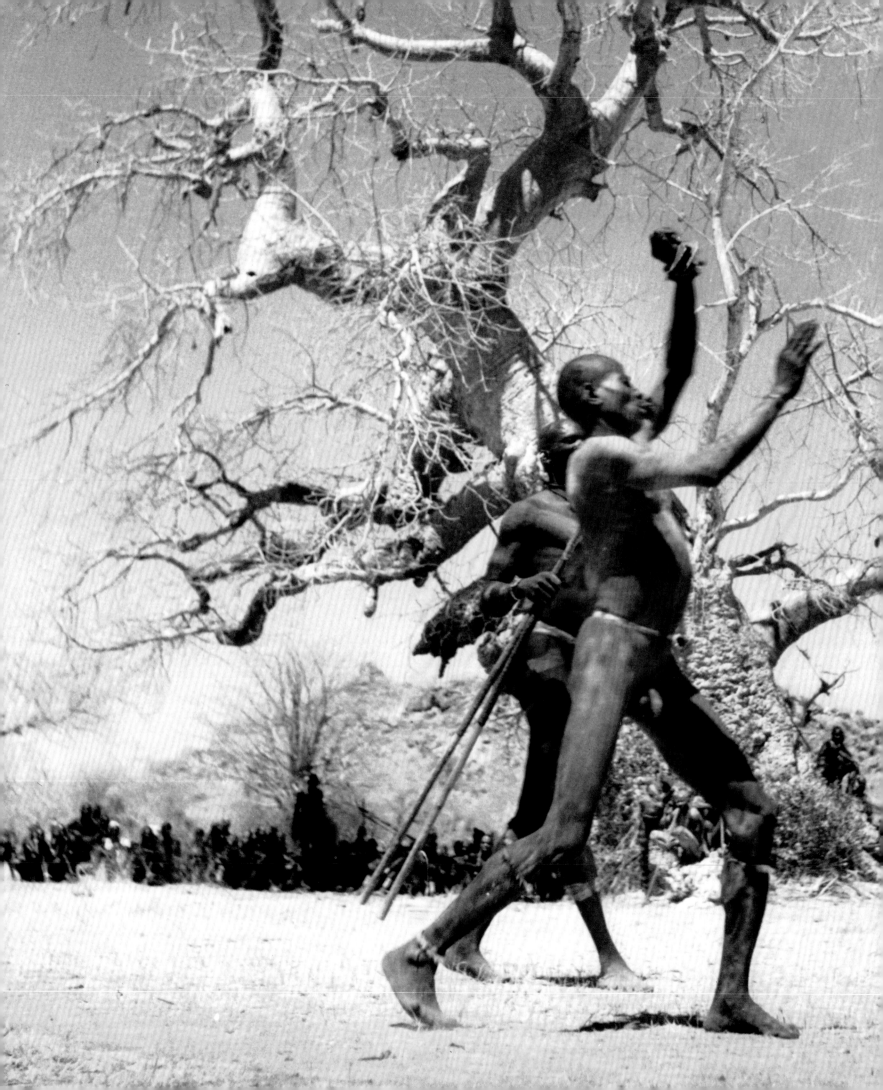

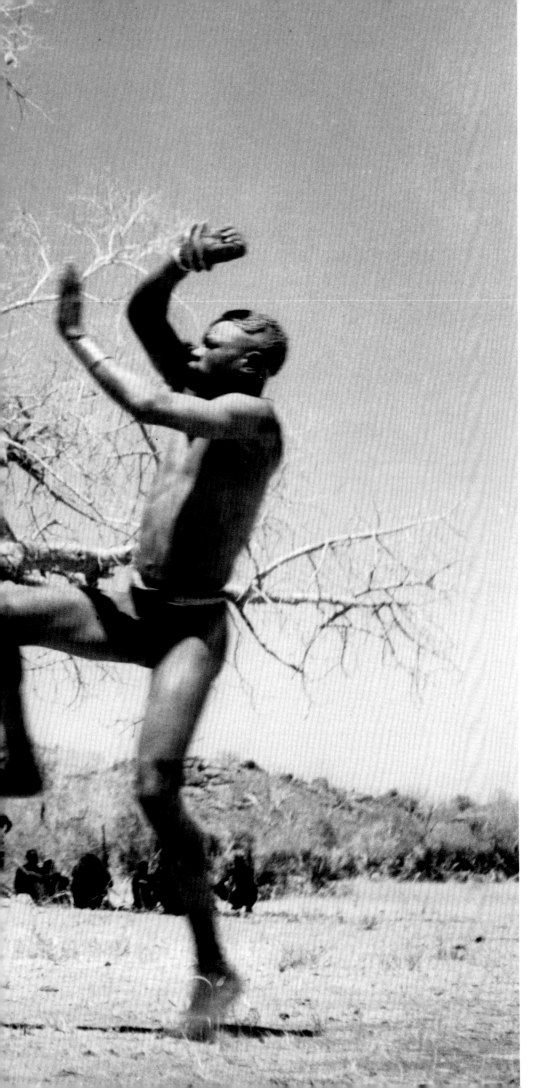

1949, Kordofan, Southern Sudan
A Kao-Nyaro bracelet fight in progress

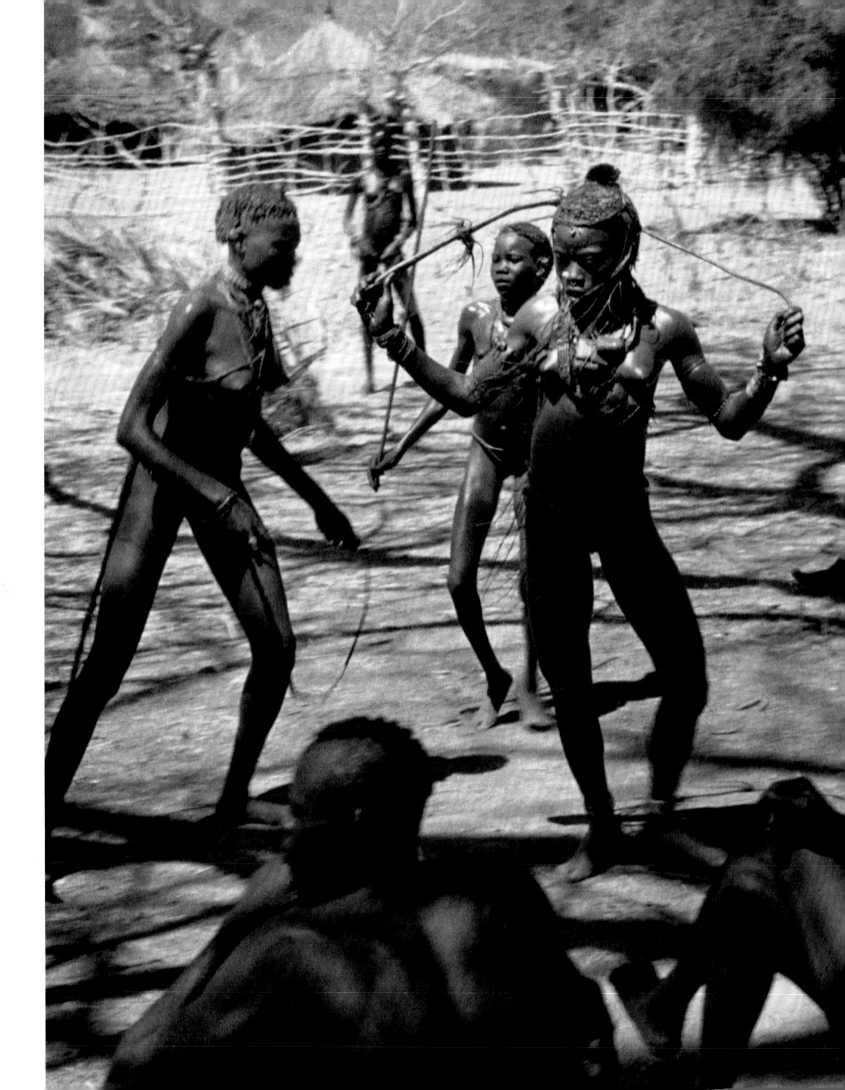

1949, Kordofan, Southern Sudan
Girl dancers of the village of Kao perform
to the drums in front of the young men of the
tribe who will be fighting for them

1949, Kordofan, Southern Sudan
The keyhole entrance to a Nuba house in the Korongo Jebels.
Doorways are shaped to allow admittance to people carrying loads
of firewood on their heads

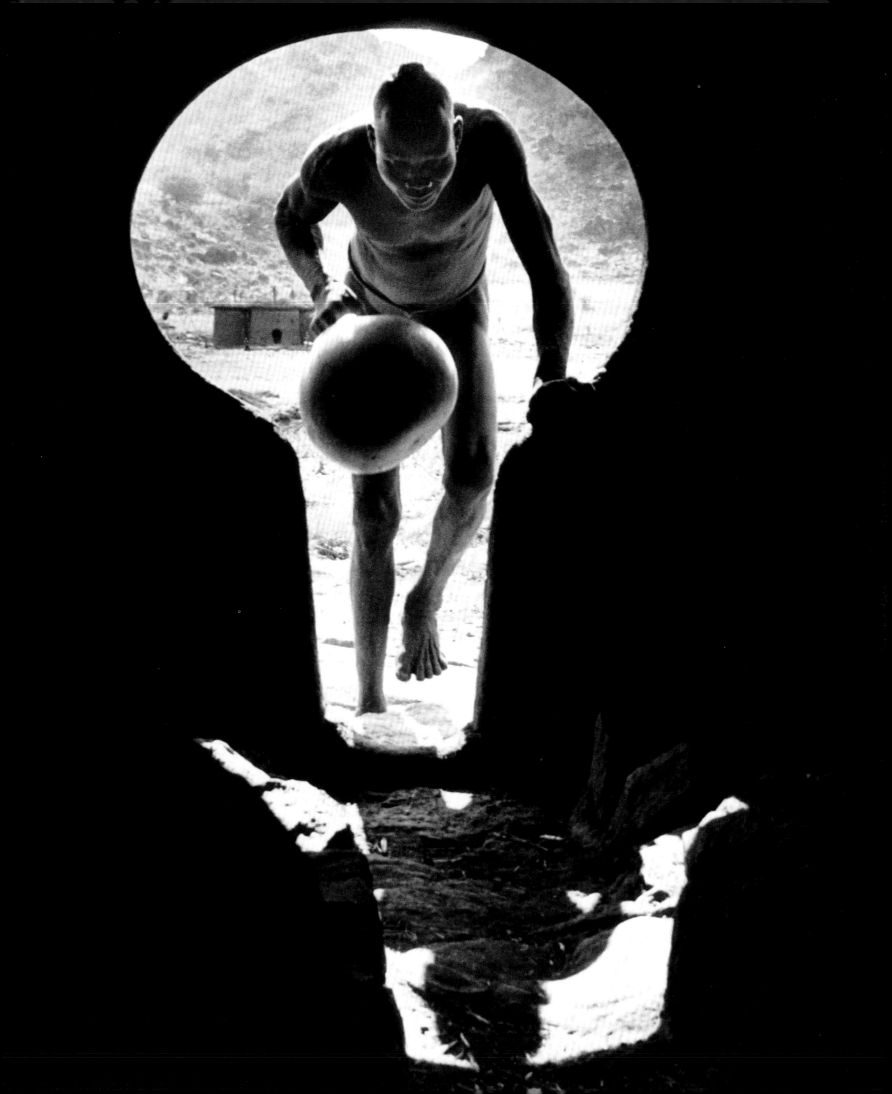

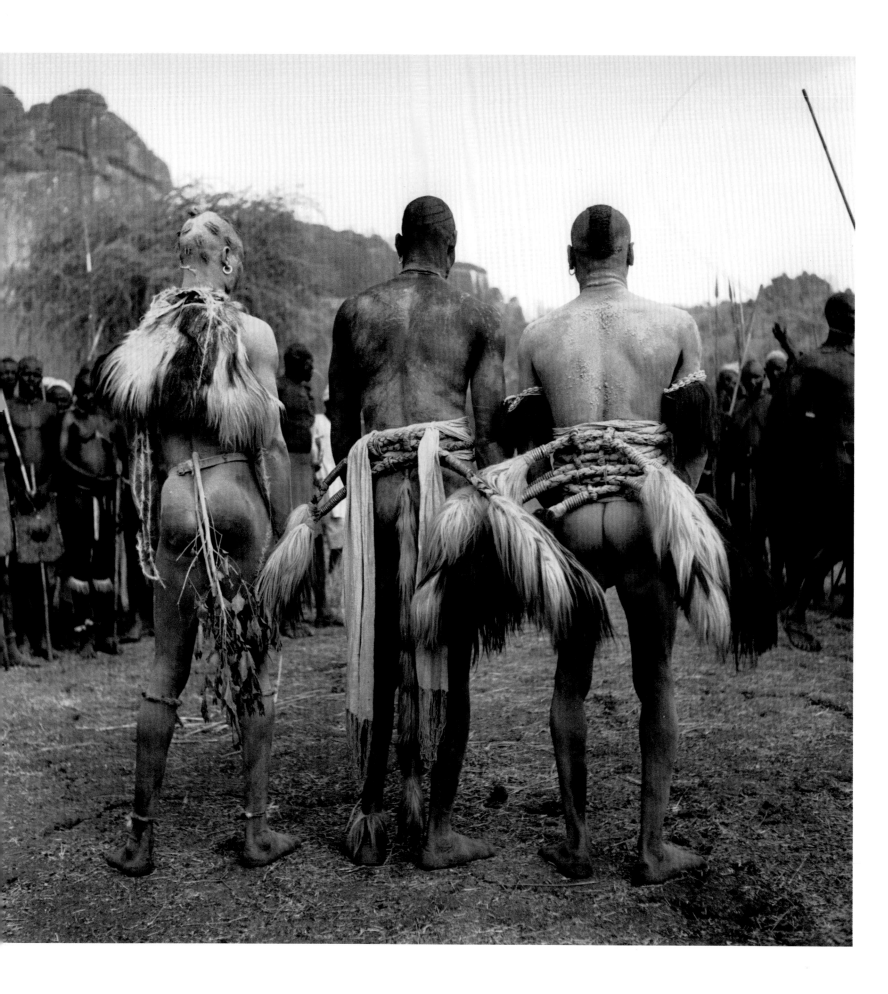

1949, Kordofan, Southern Sudan
Korongo wrestlers. The waistband consists
of woven and plaited cane with wisps of fur
from the colobus monkey

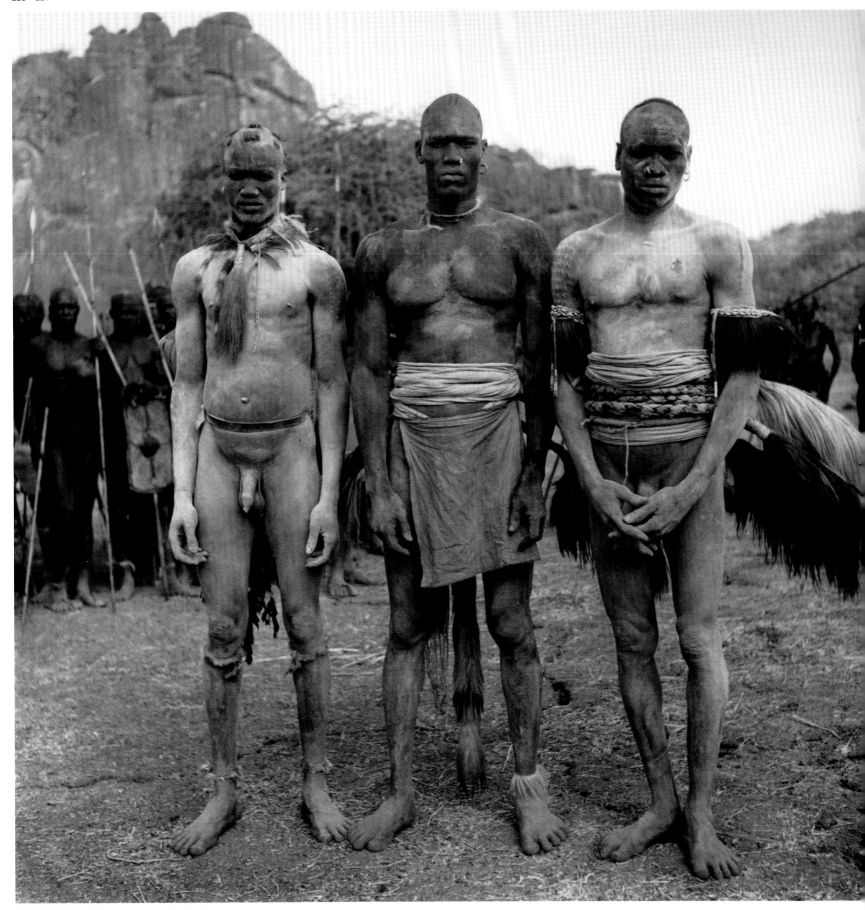

1949, Kordofan, Southern Sudan
Korongo wrestlers

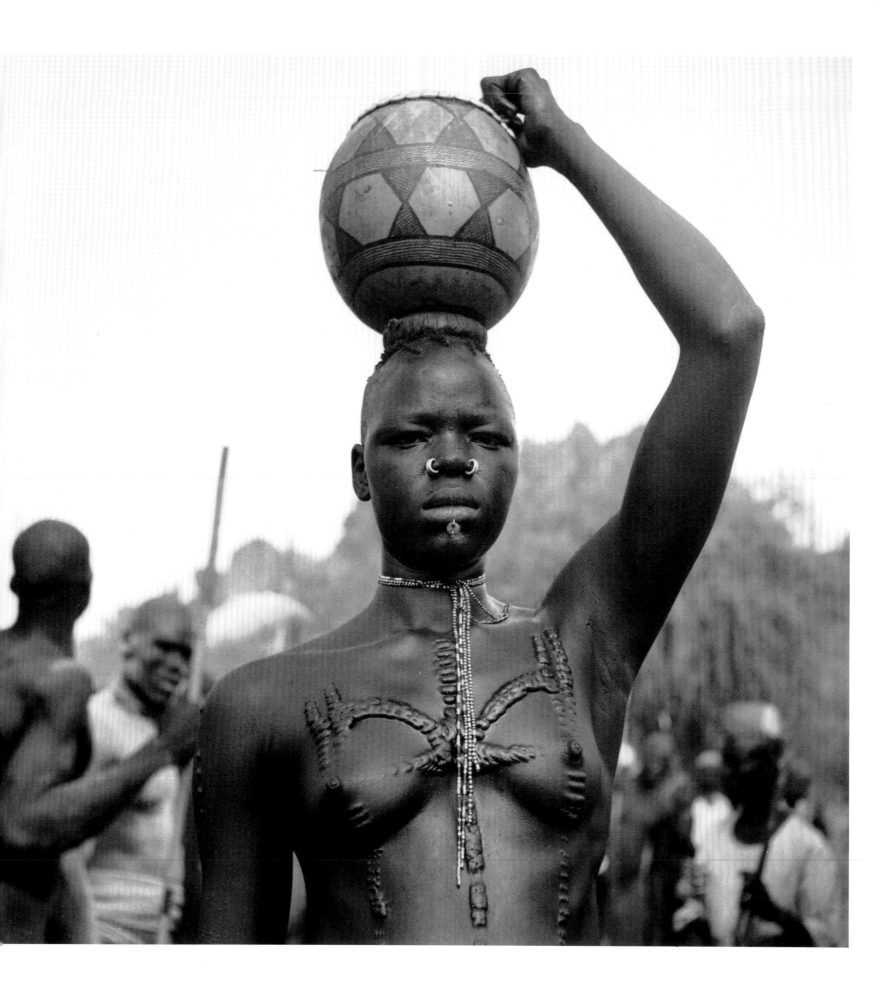

1949, Kordofan, Southern Sudan
A Korongo Nuba girl. Cicatrice designs on her chest are
made in childhood by cutting the flesh and rubbing in wood ash.
The gourd carried on her head contains local beer

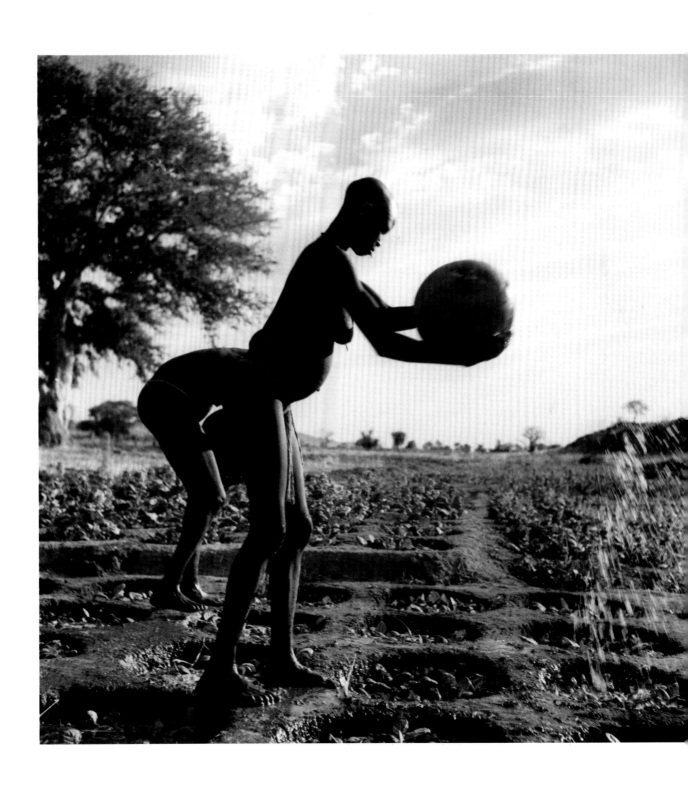

1949, Kordofan, Southern Sudan
Mesakin Qusar Nuba women water tobacco plants

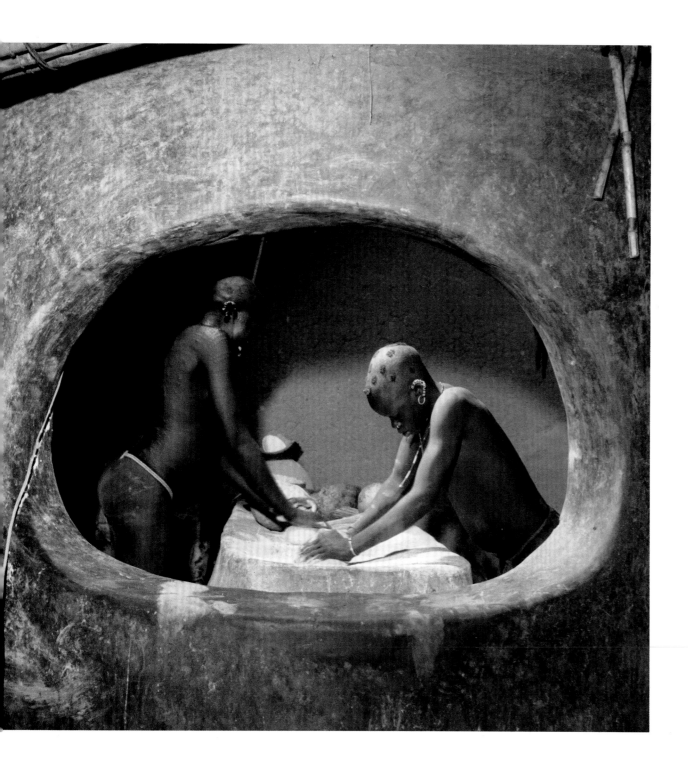

1949, Kordofan, Southern Sudan
Korongo Nuba women in the granary room of their
house, grinding dhoura grain to make bread

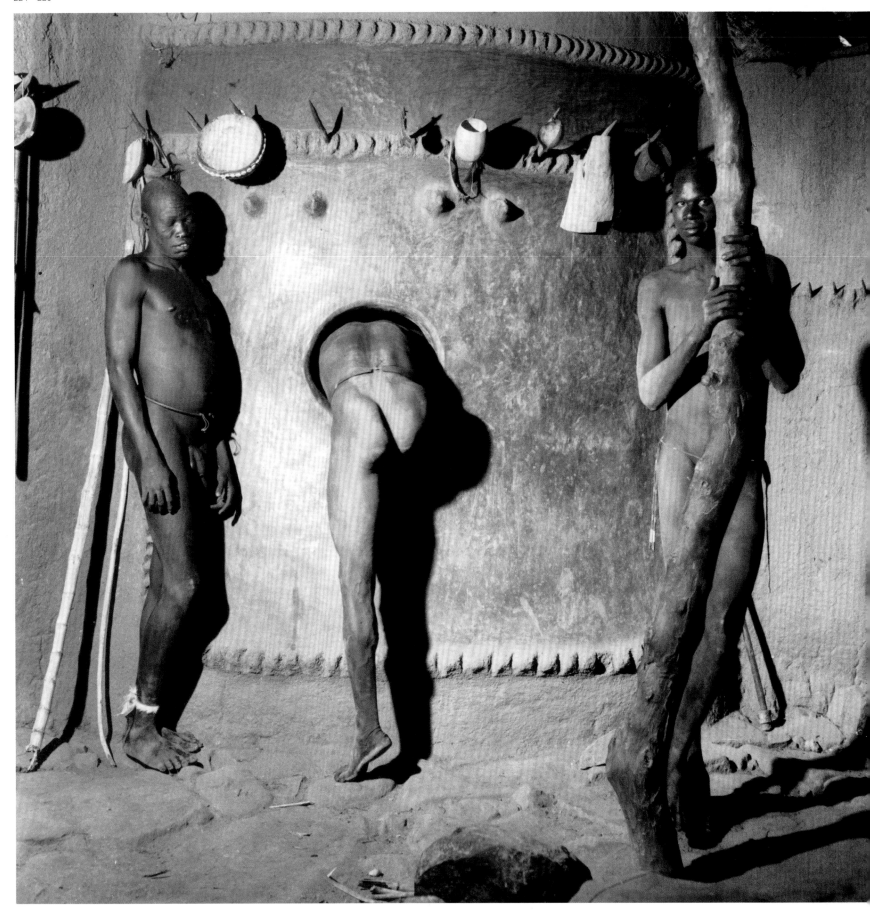

1949, Kordofan, Southern Sudan
A Korongo Nuba tribesman enters the bedroom of
a typical Korongo house – the hole in the wall is the only
means of access

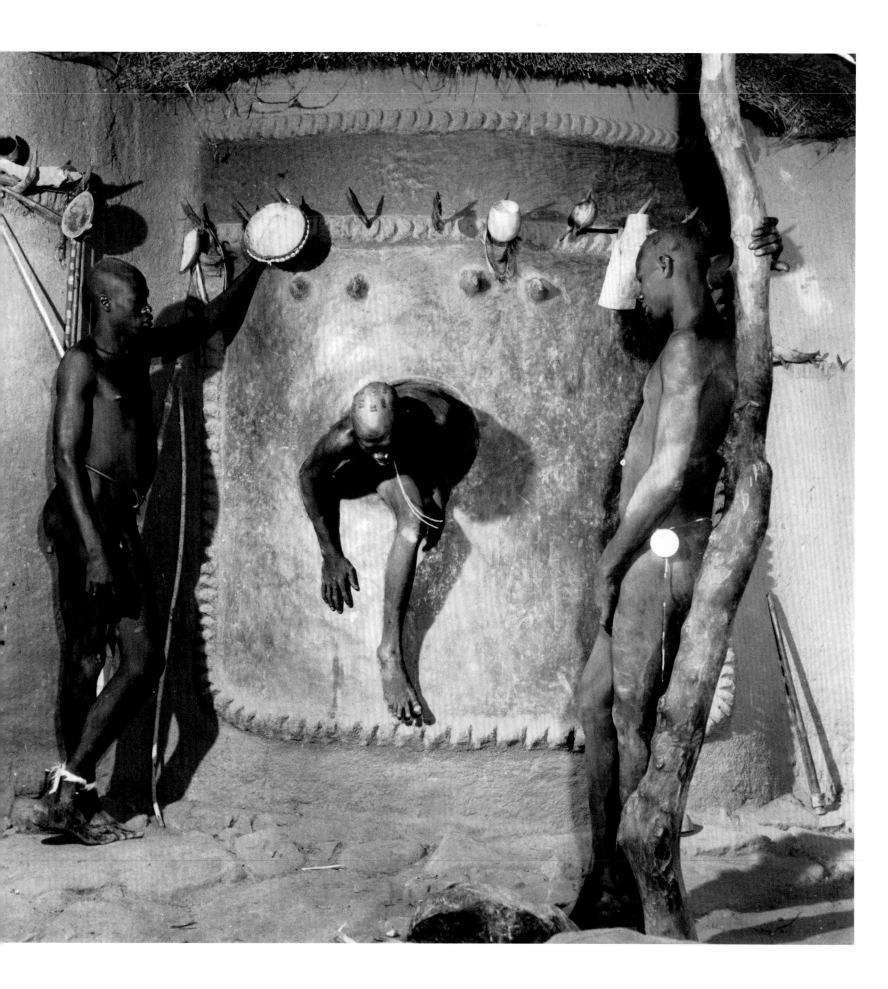

1949, Kordofan, Southern Sudan
Leaving the bedroom

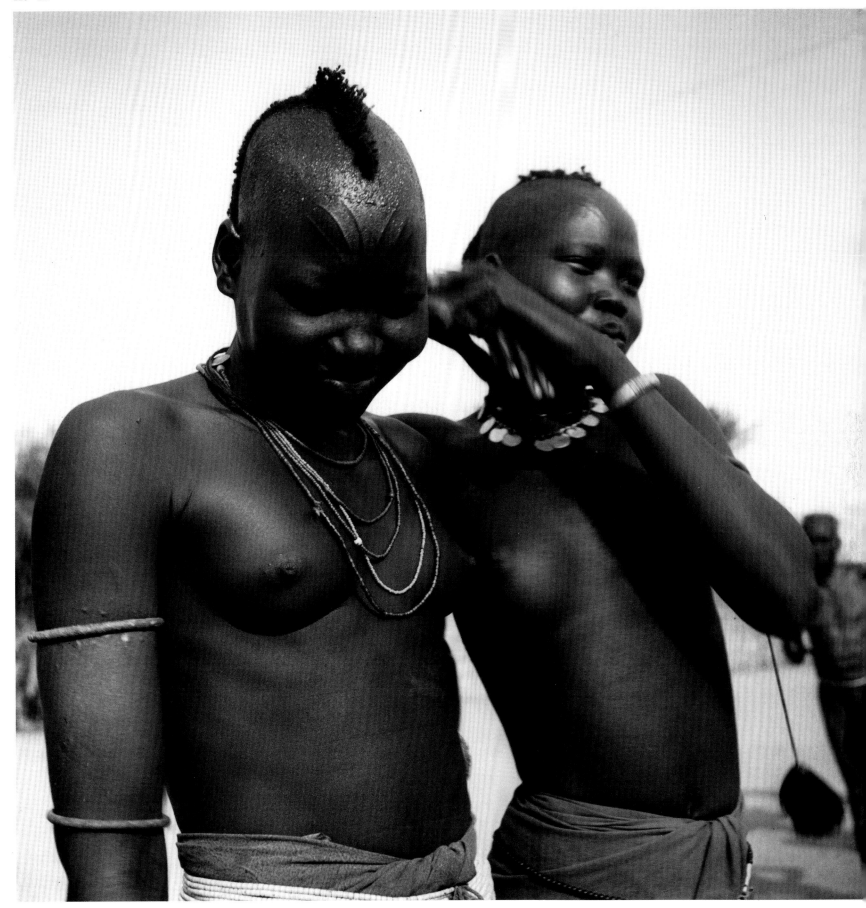

1949, Kordofan, Southern Sudan
Dinka girls of Duk Faiwil, a remote
village in the bush

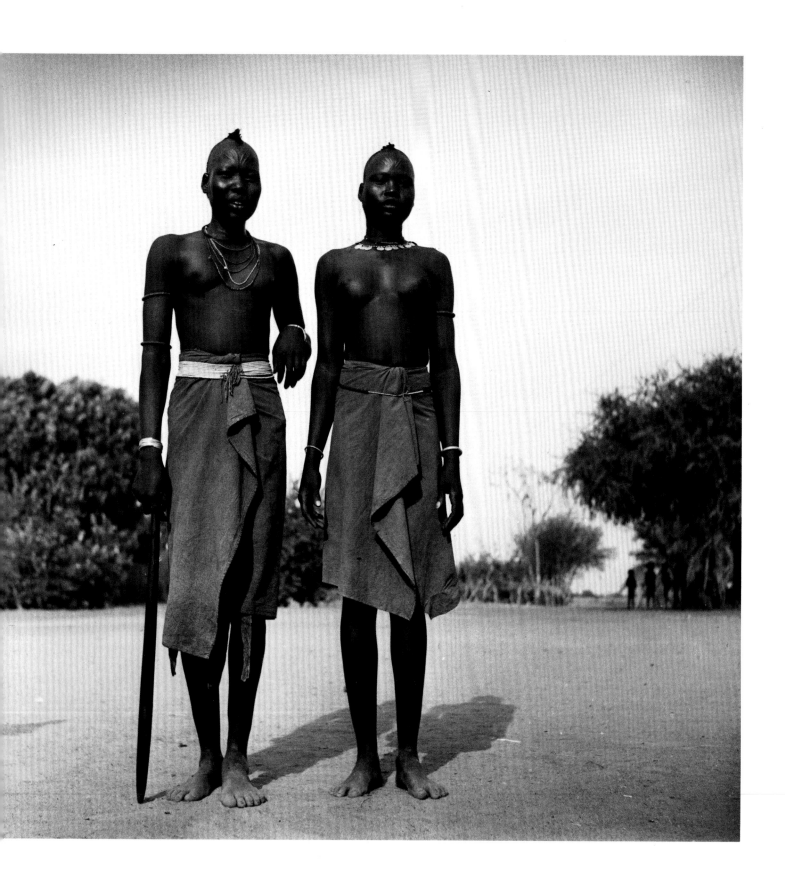

**1949, Kordofan,
Southern Sudan**
Dinka girls of Duk Faiwil

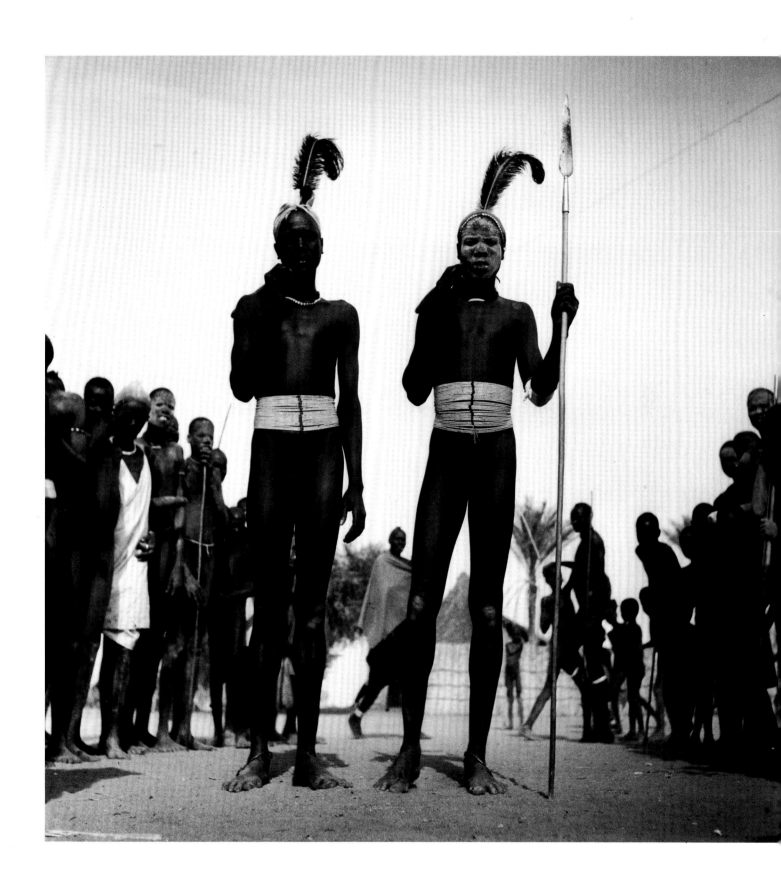

1949, Kordofan,
Southern Sudan
Dinka boys of Duk Faiwil

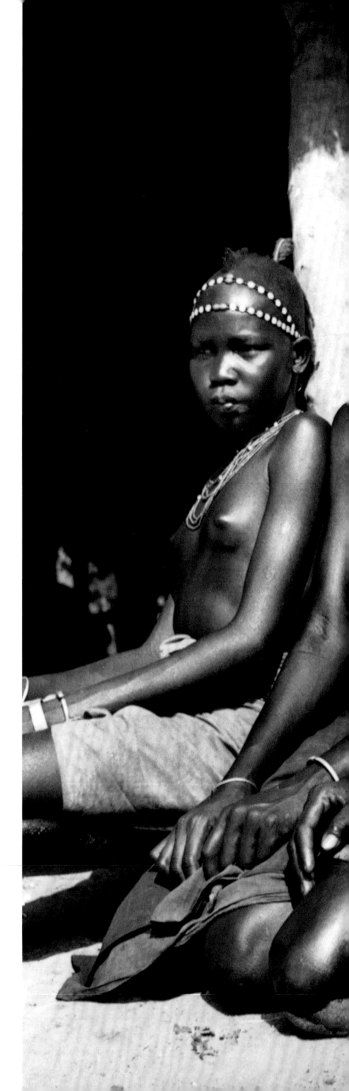

1949, Kordofan, Southern Sudan
Dinka and Nuer girls dressed for
a ceremonial dance

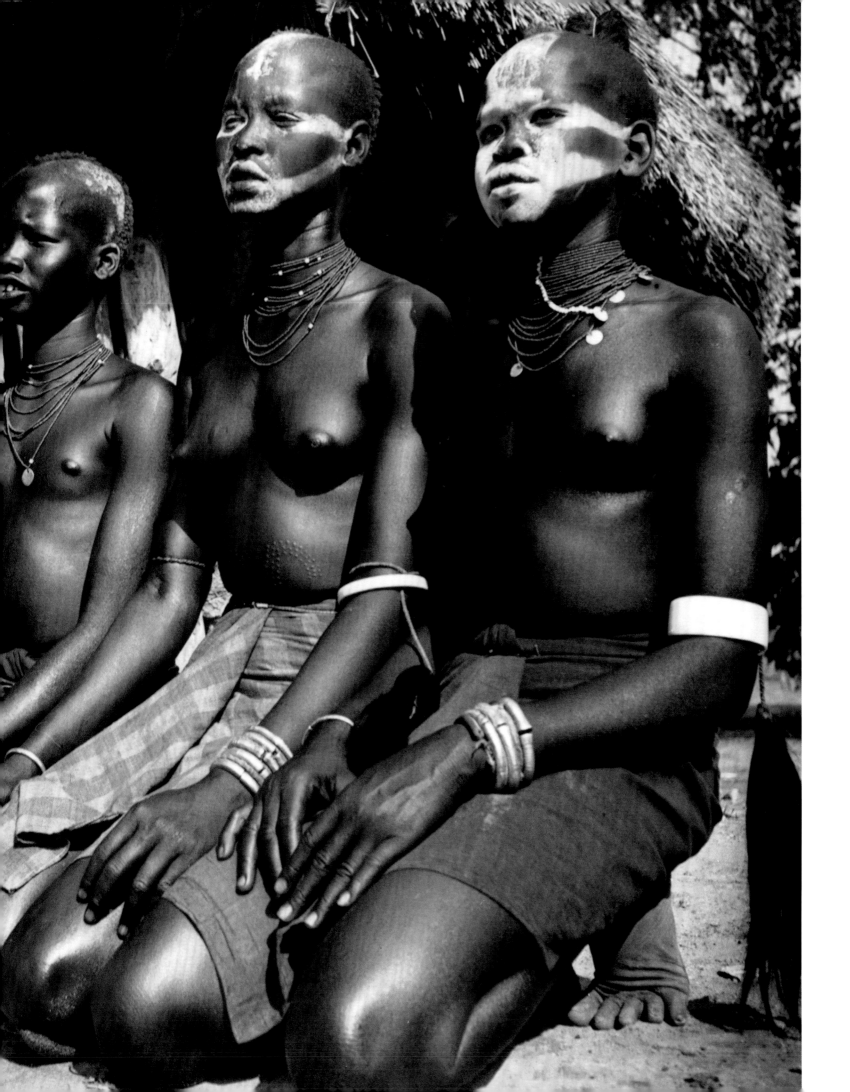

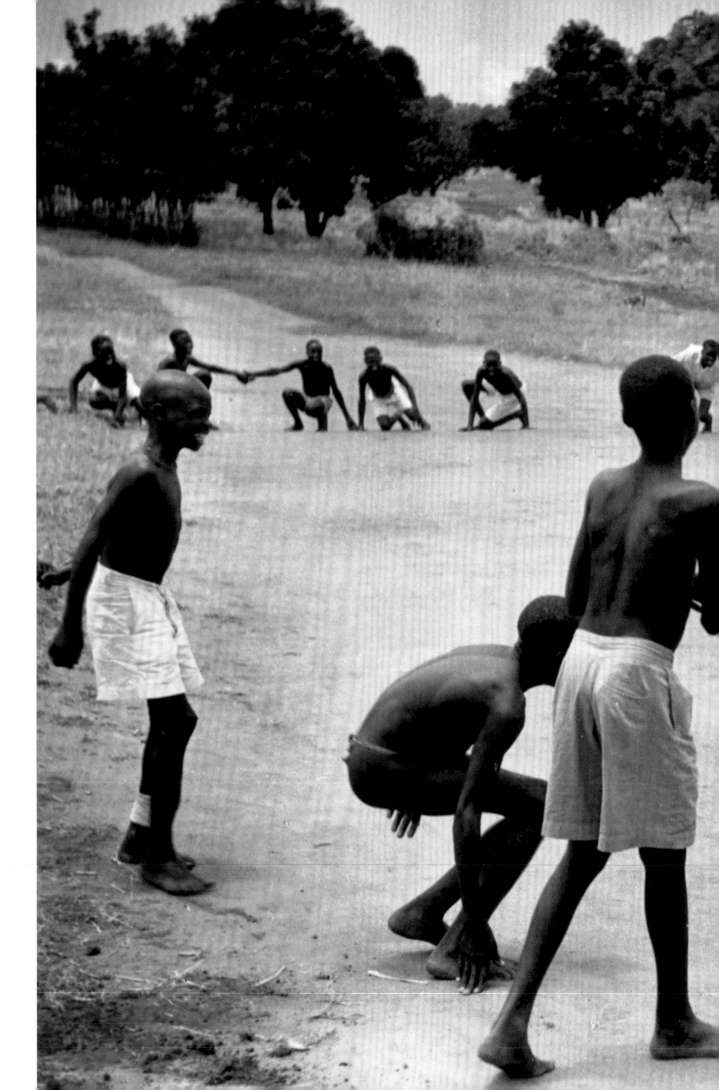

1948, Southern Sudan
Bari schoolboys at play in the
Aluma Plateau

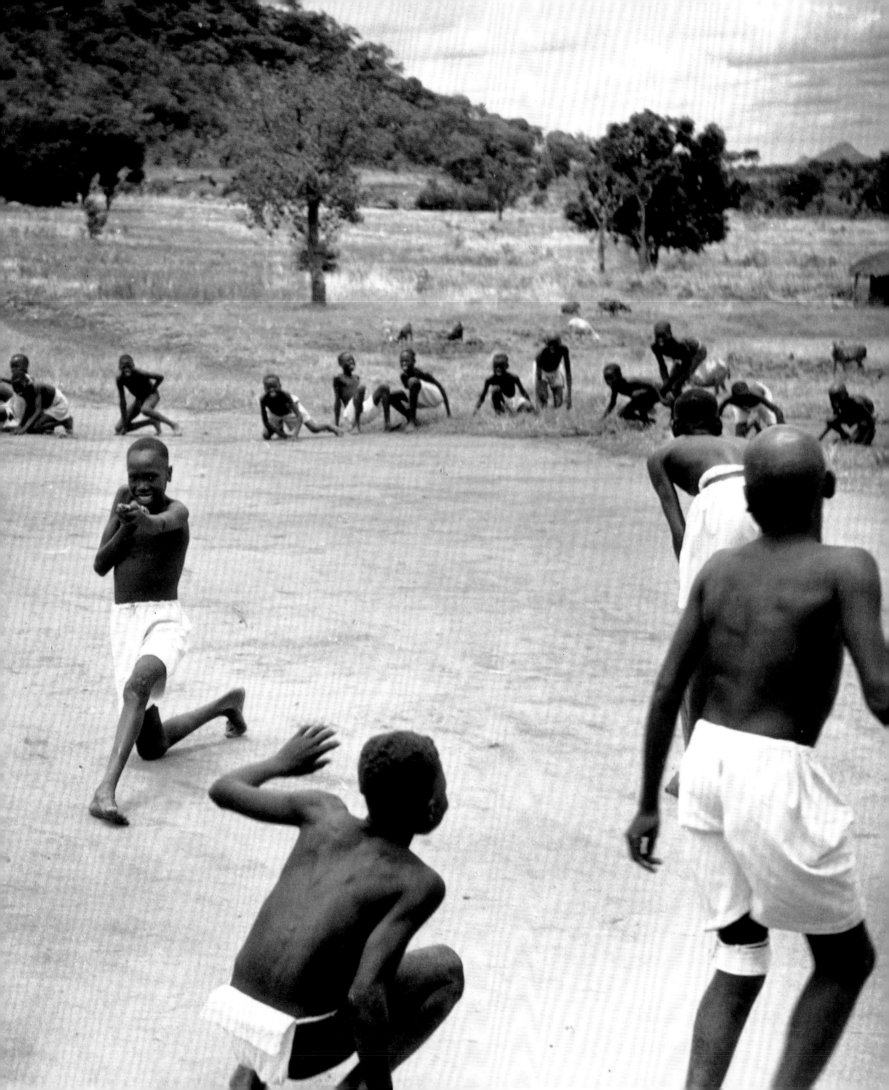

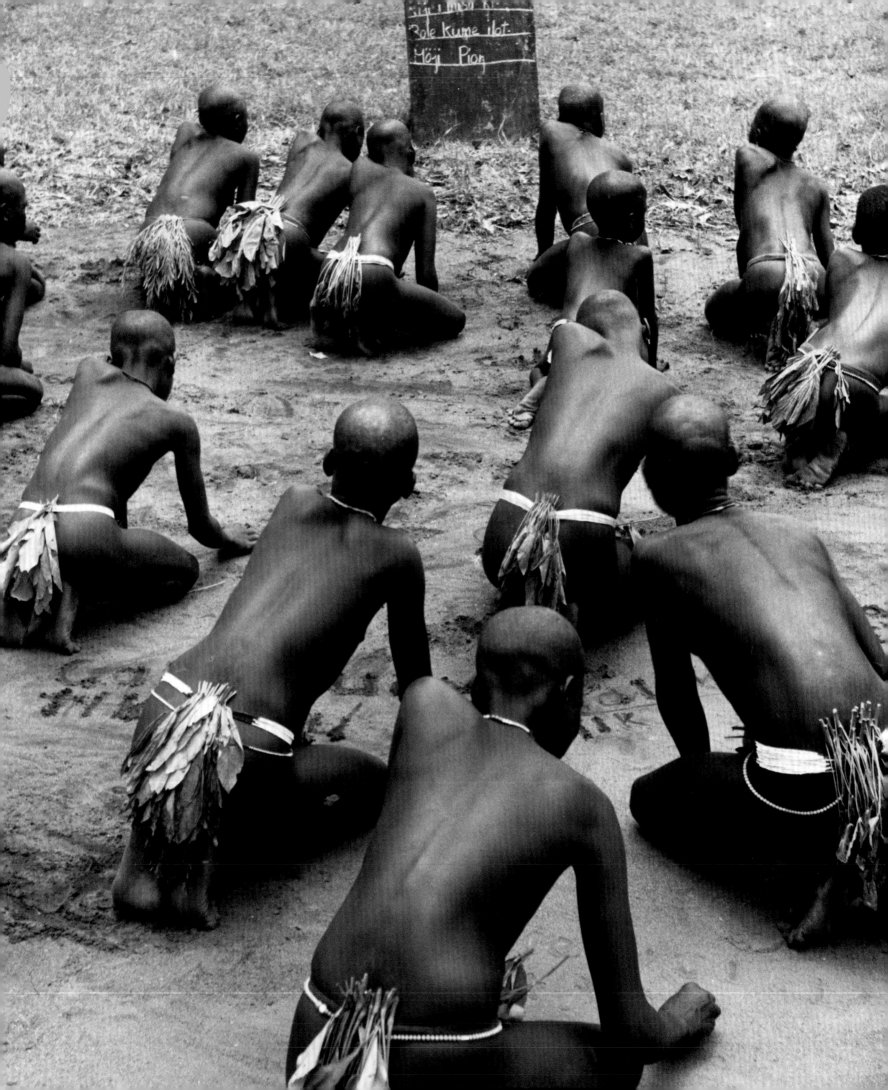

1950, Haiti
Children from Jacmel on their
way to school

1950, Haiti
Coconut palms line the south coast
near Jacmel in Haiti

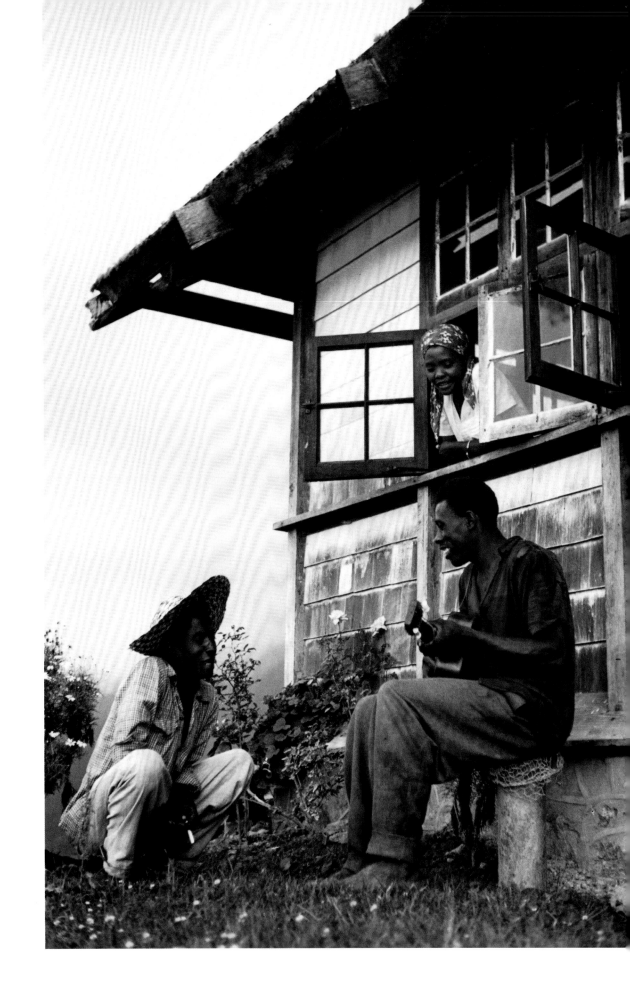

1950, Jamaica
A village scene in the Blue Mountains

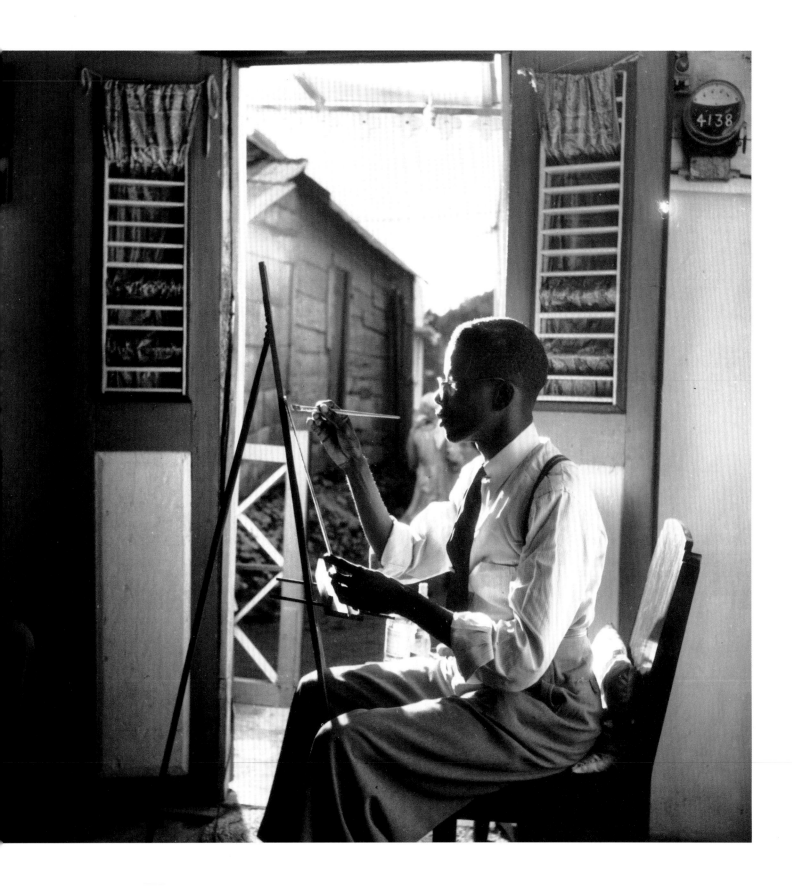

1950, Haiti
Philomé Obin, Haiti's best-known
primitive painter, at his home in Jacmel

1950, Jamaica
Boys in the Blue Mountain area

1950, Haiti
Philomé Obin

1951, Gabon
Dr Albert Schweitzer in his jungle
office at Lambaréné

1951, Gabon
A musician in the leper colony at
Dr Schweitzer's Hospital at Lambaréné

The Middle East

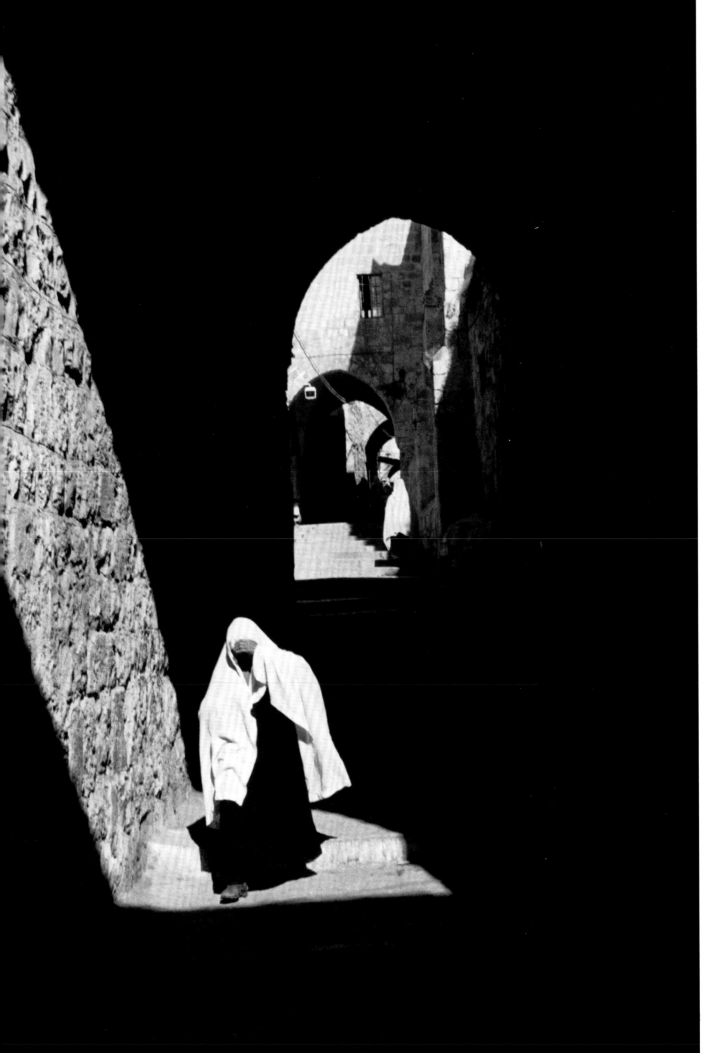

1952, Jerusalem
A veiled woman on the
Via Dolorosa

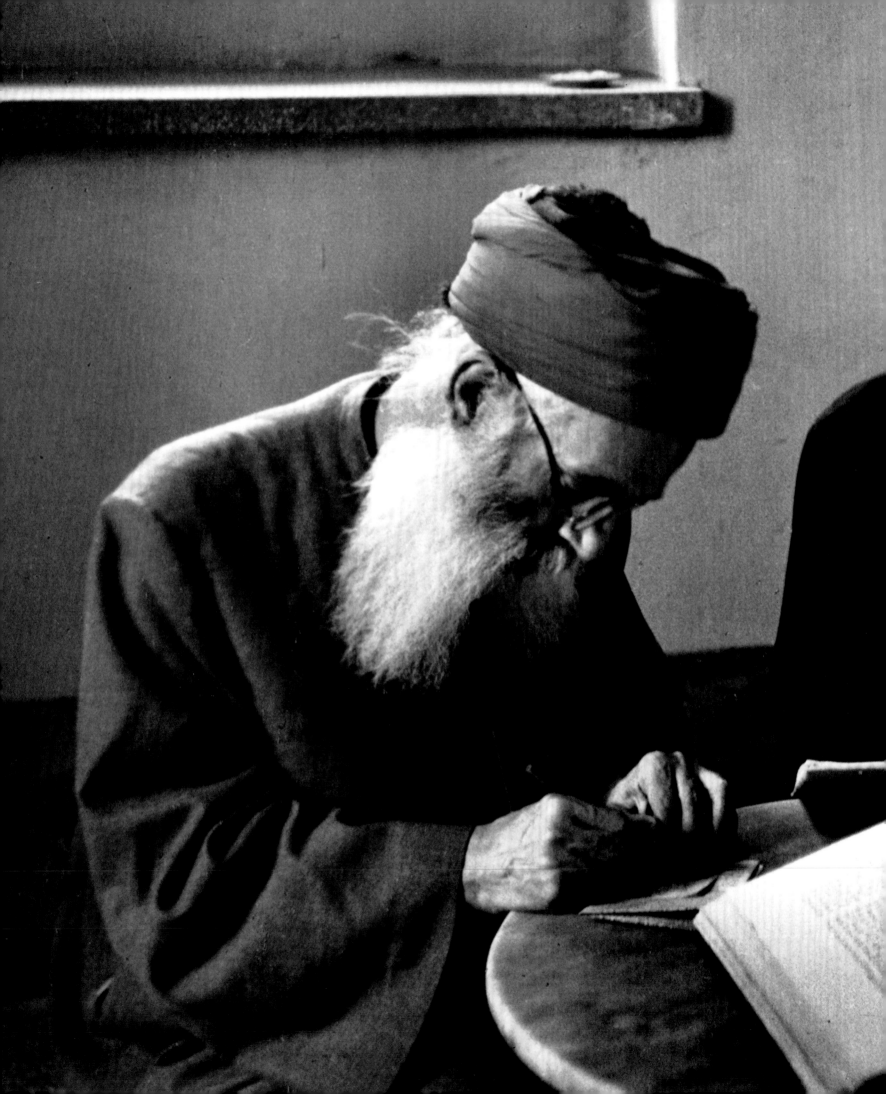

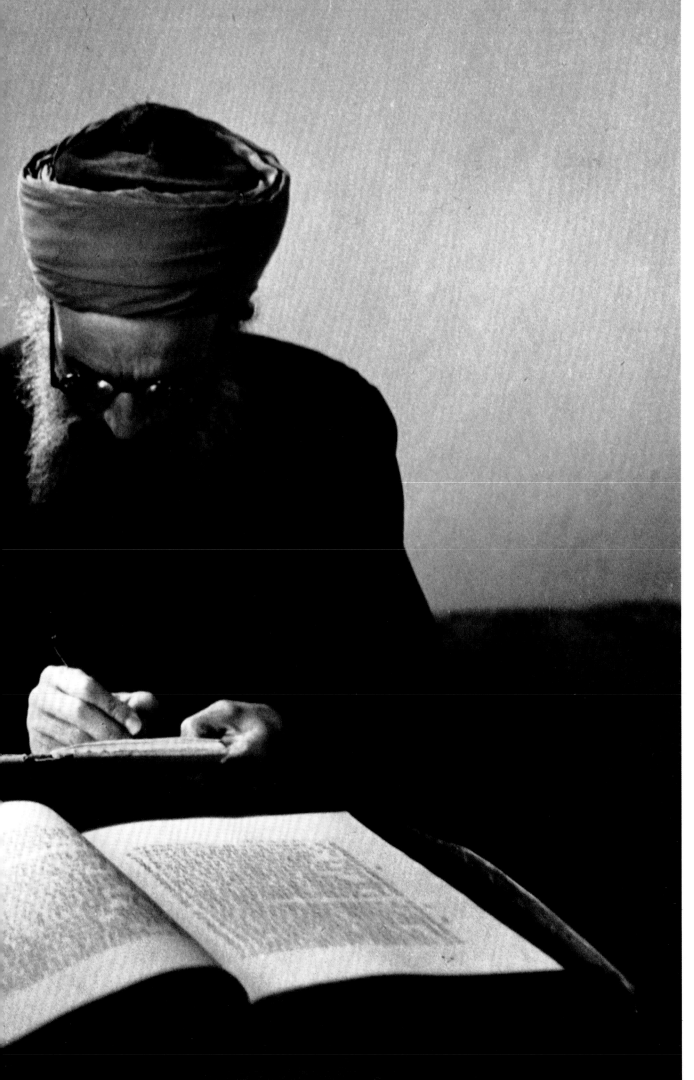

1952, Israel
Two Samaritan priests in Nablus
write in long-hand the history of
the Samaritan people from the
days of Aaron to the present

1952, Jordan Valley
Two Palestinian girls
in a refugee camp

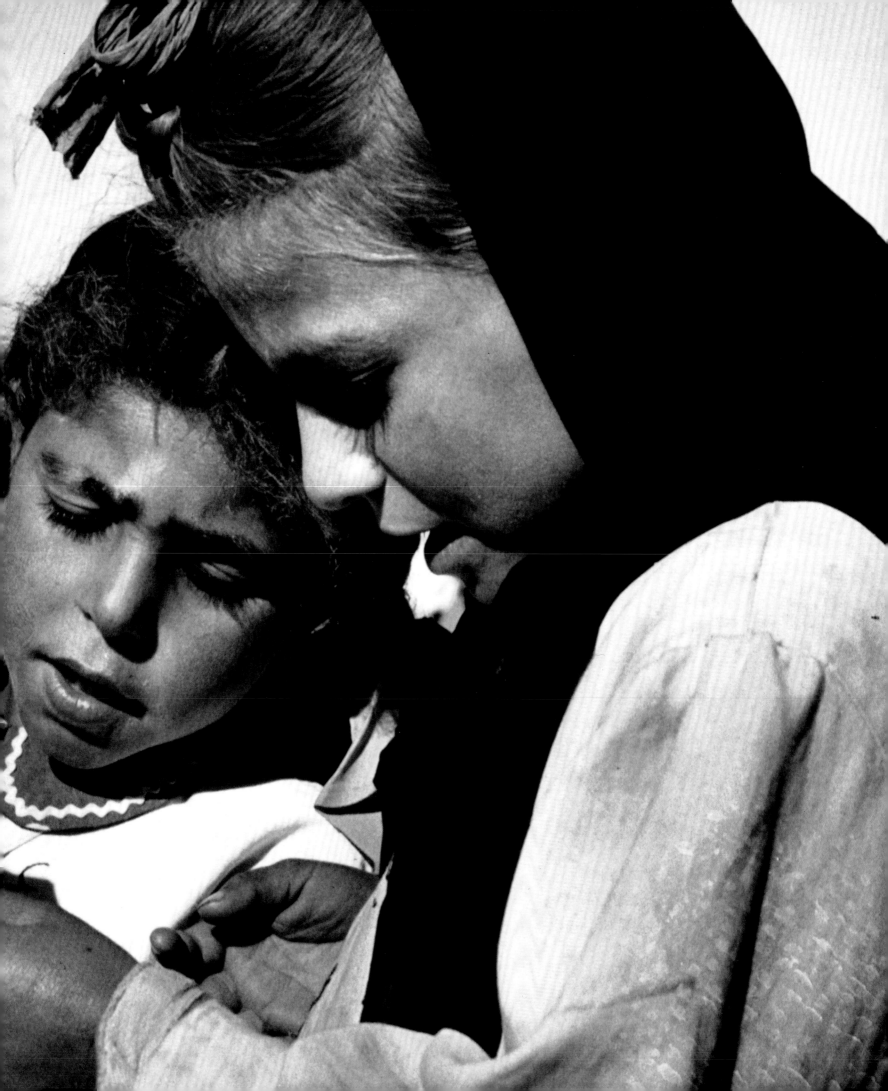

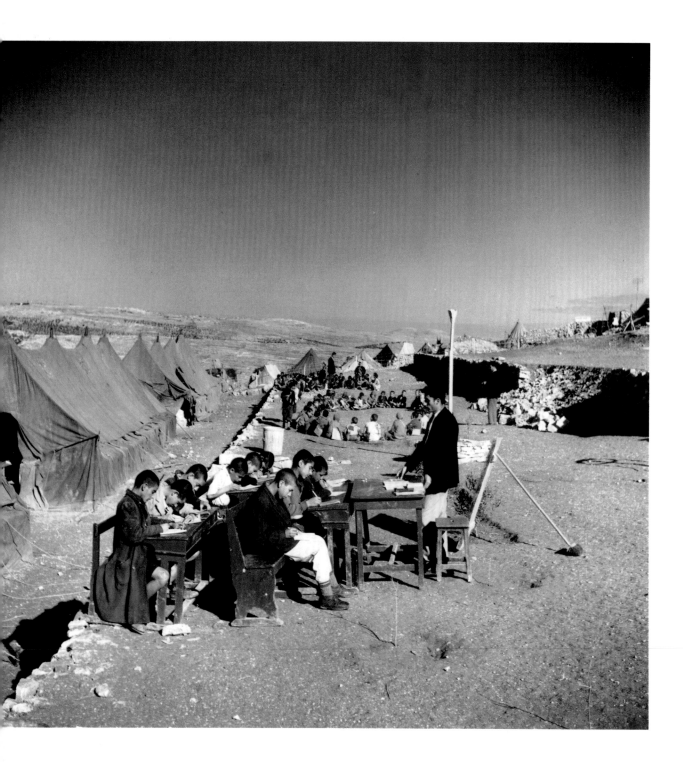

1952, Jordan Valley
A YMCA School for Palestinian
refugee children

Opposite
1952, Jordan Valley
At a YMCA School for Palestinian refugees,
children queue for milk supplied by UNICEF

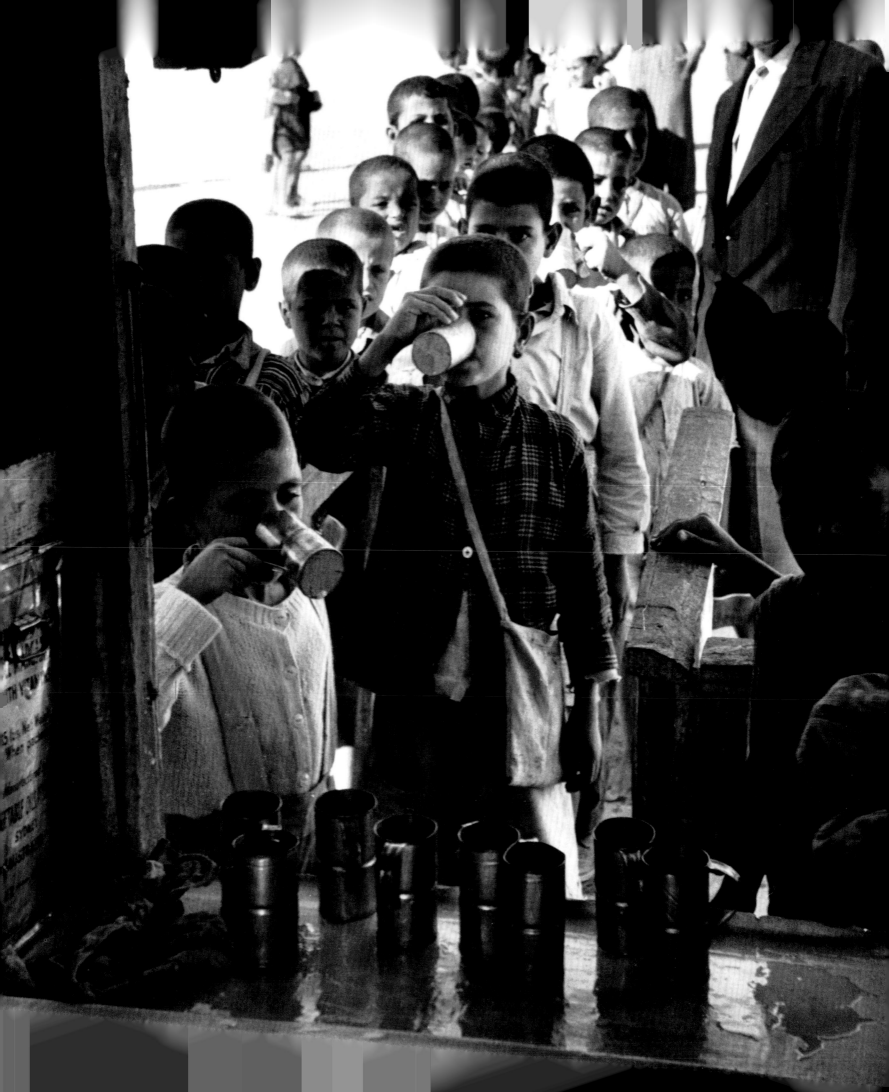

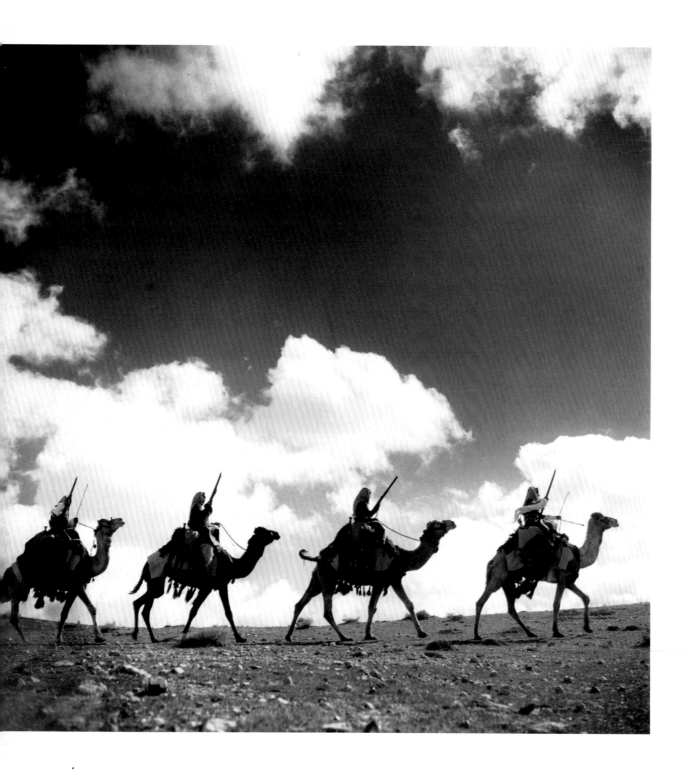

1952, Jordan
Bedouins of the Arab Legion Camel Corps
leave for patrol in the desert

Opposite
1952, Jordan
On his first day in the Arab Legion, an 18-year-old
Bedouin youth, still in his traditional Bedu clothes,
awaits a medical, a haircut and a uniform

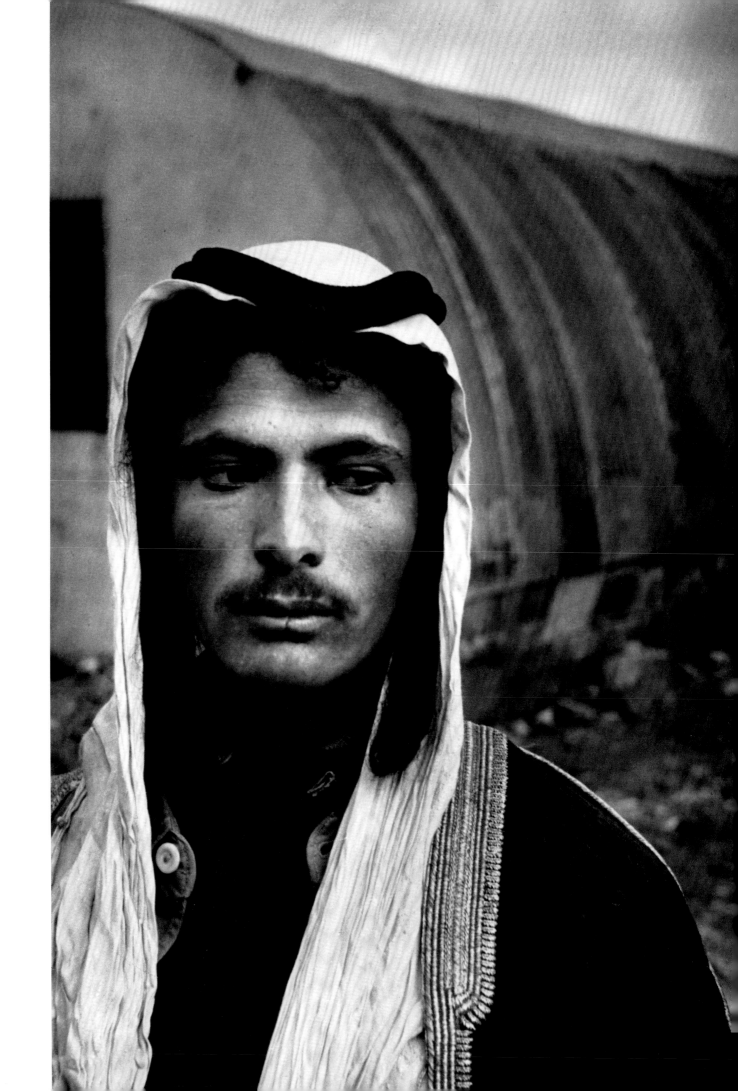

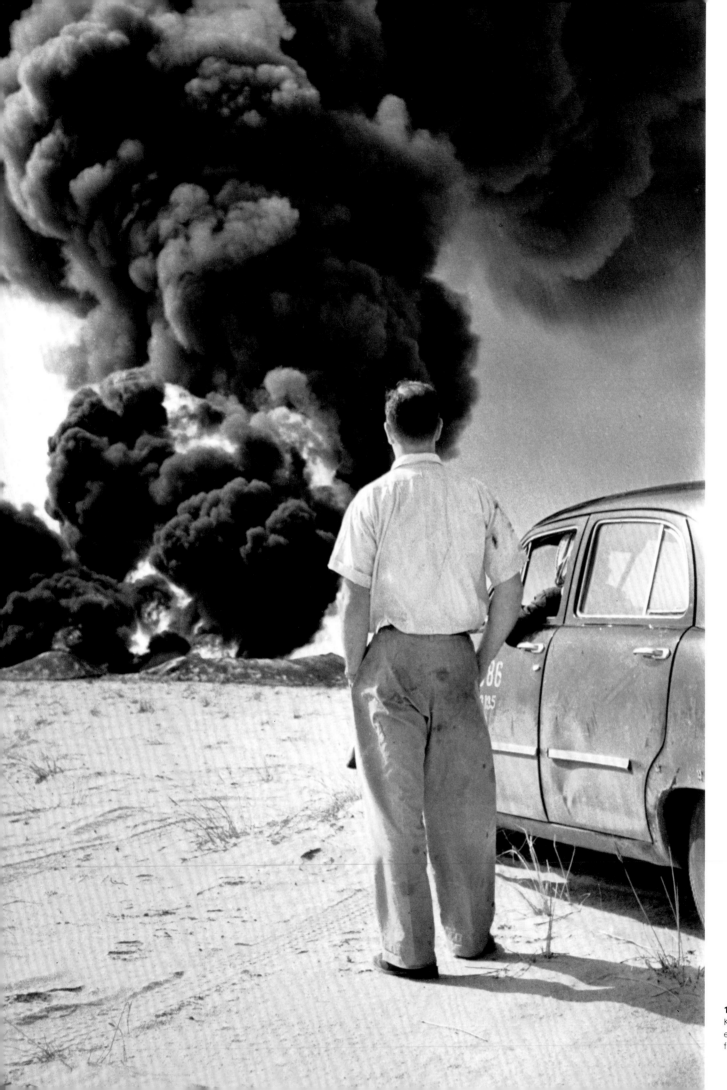

1952, Kuwait
Kuwait oil company
executives watch an oil well
fire in the desert

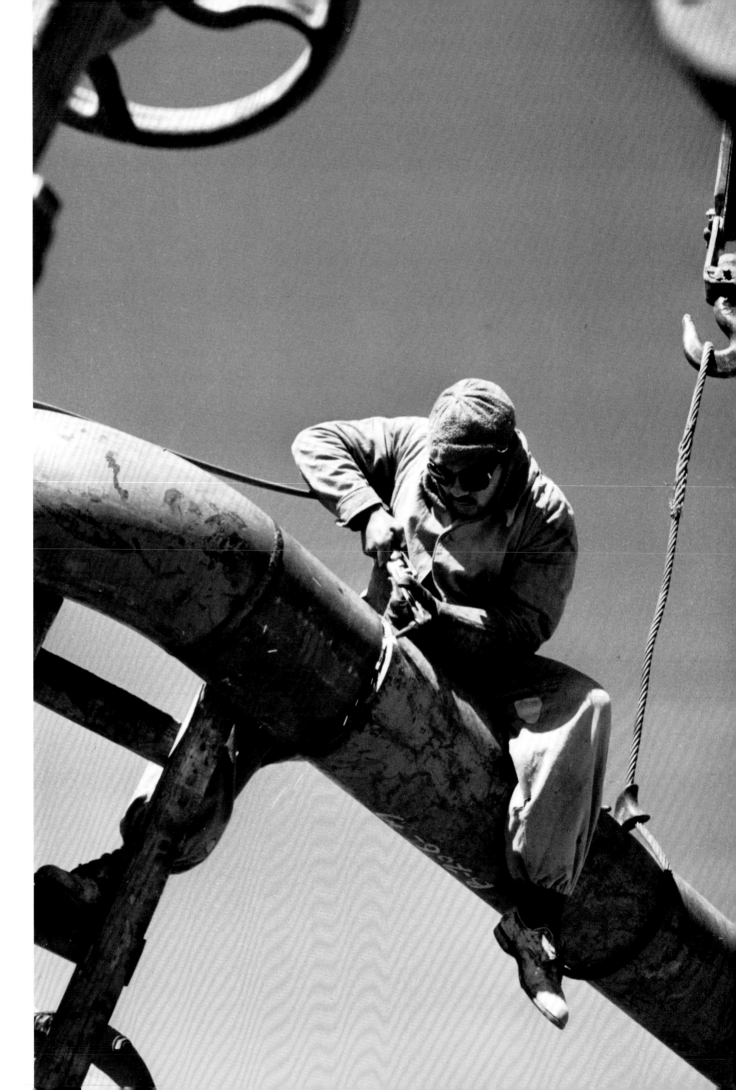

1952, Kuwait
A welder repairs oil pipelines
in the desert

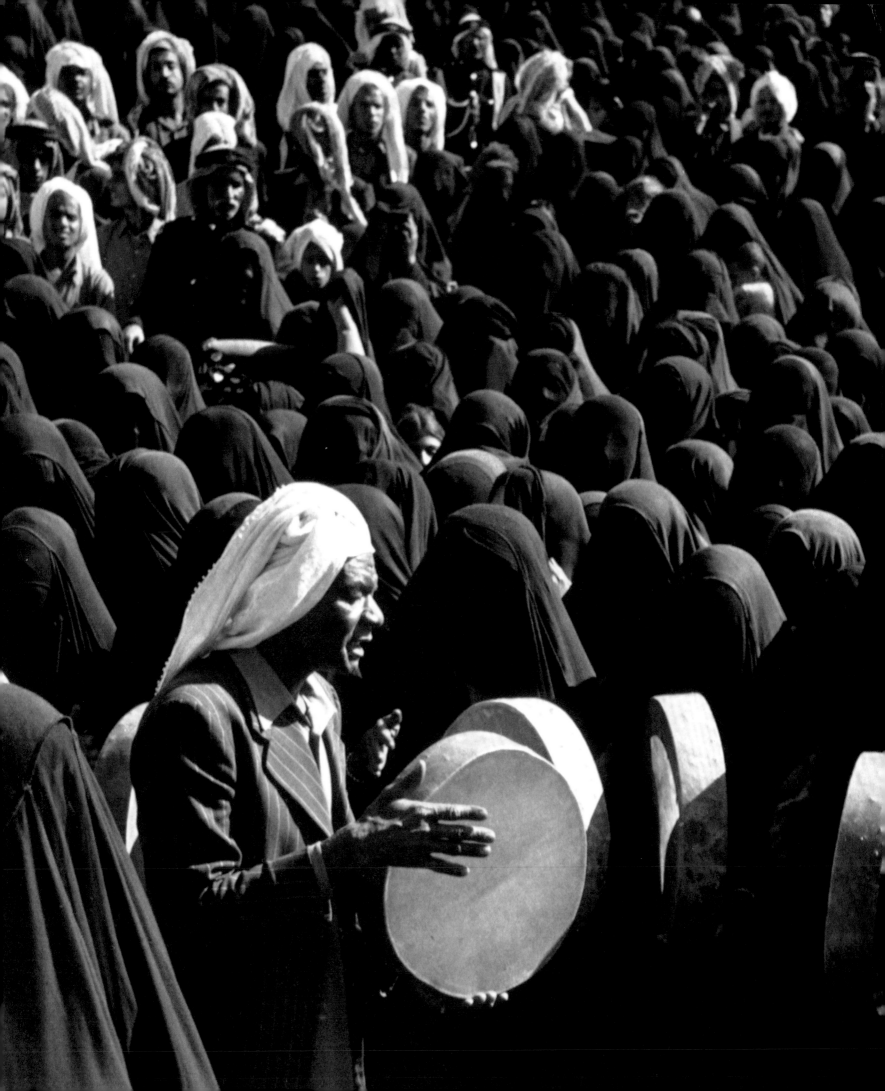

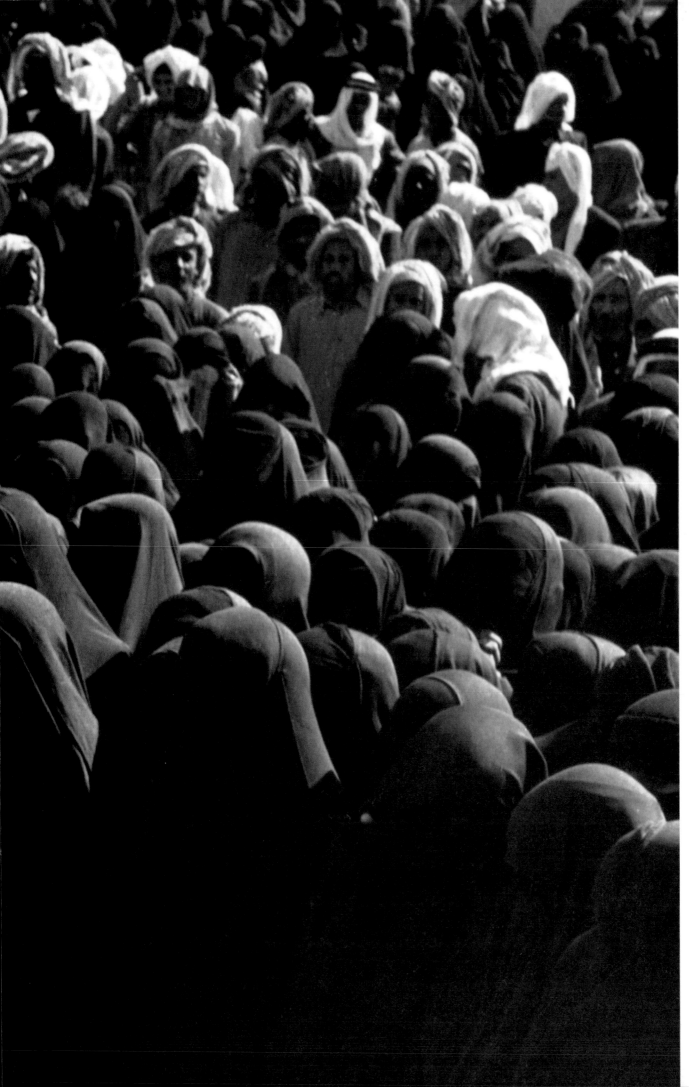

1952, Kuwait
The wedding of a Sheikh

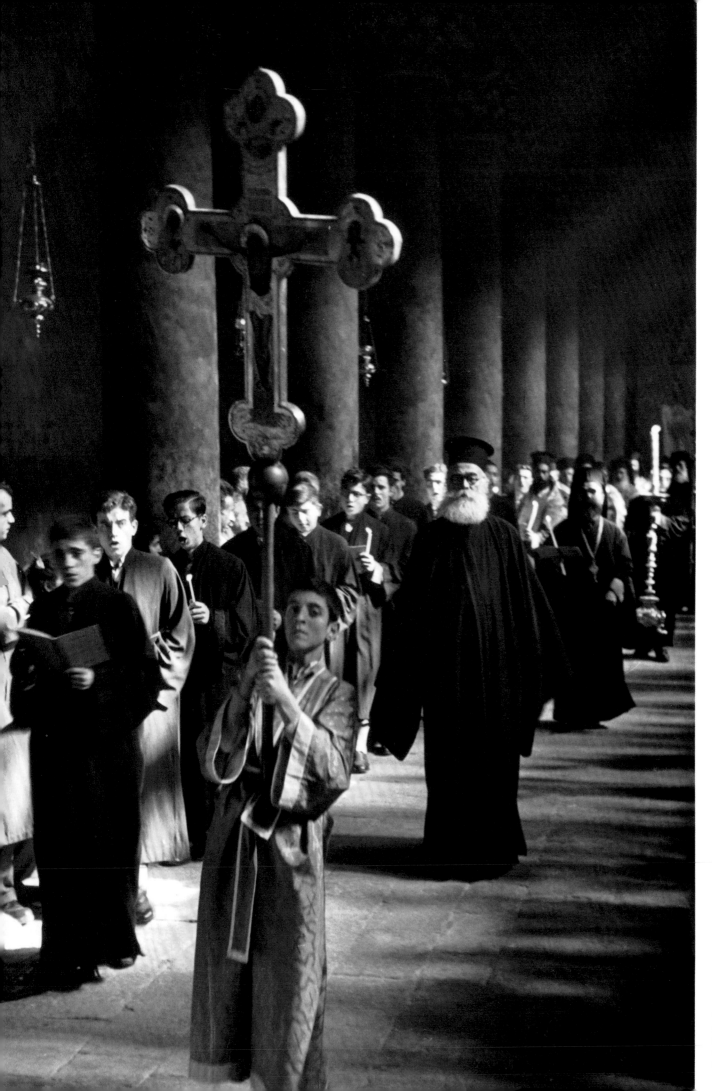

1952, Bethlehem
A Christmas Eve Service in the Church of the Nativity. The Grand Patriarch of Jerusalem moves towards the altar

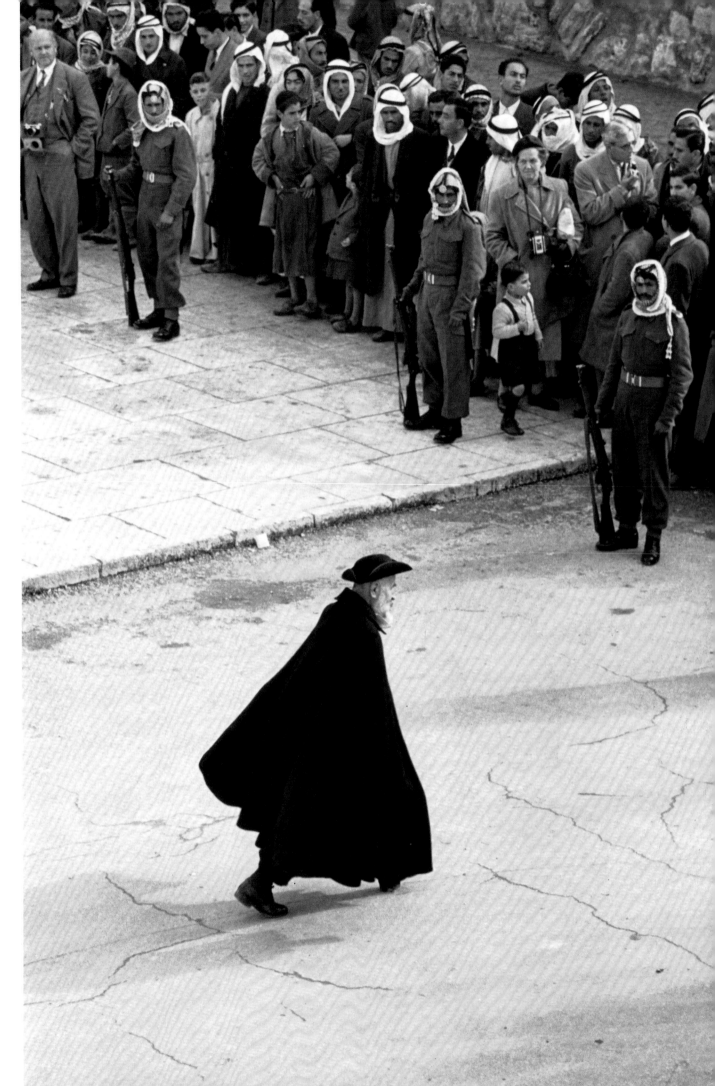

1952, Bethlehem
Christmas Eve. A priest dashes
across Manger Square

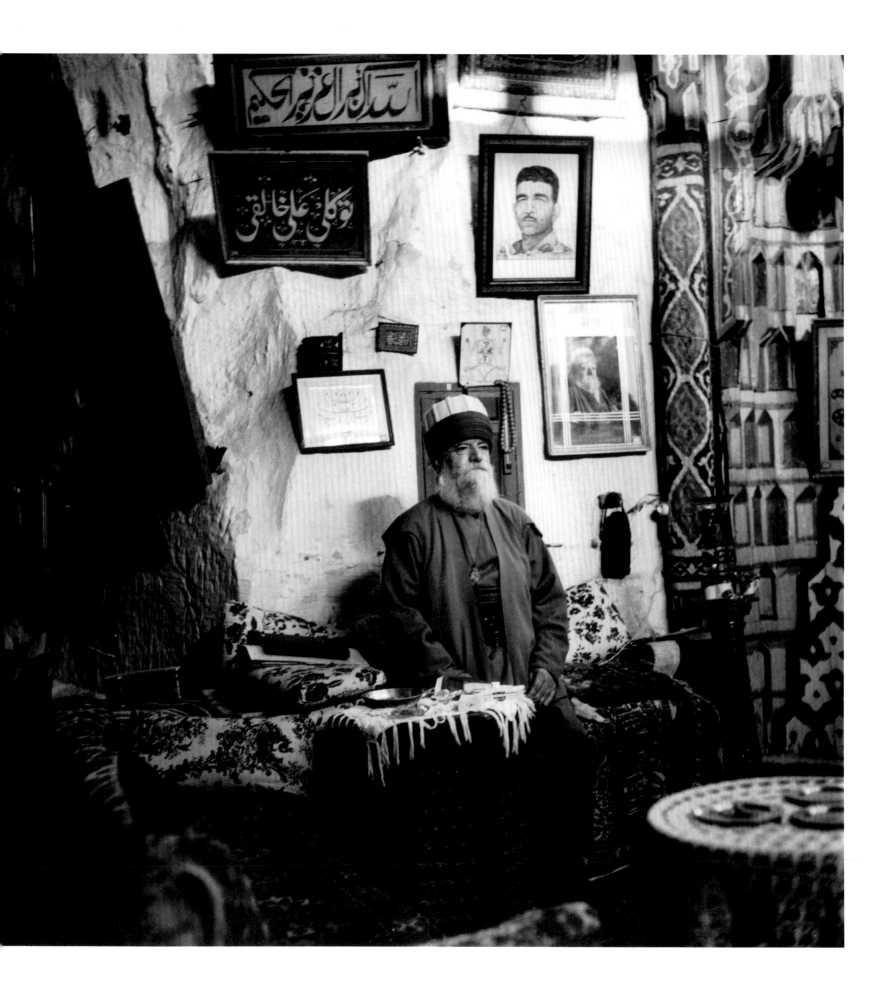

1953, Egypt
Mohammed Ali Ahmed Siridede Baba,
Chief of the Clan of Bektasheya, whose
monastery is in Cairo

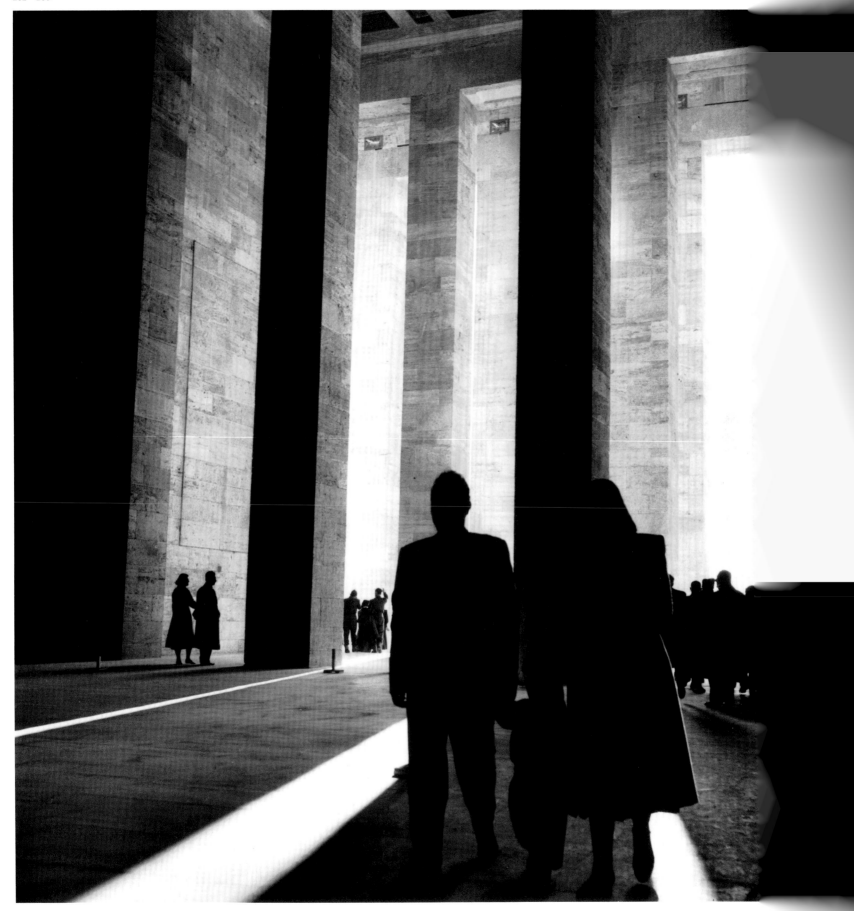

1954, Turkey
The main entrance to the Ataturk
Mausoleum in Ankara

The Far East

1953, The Philippines
Moving house on the island
of Mactan

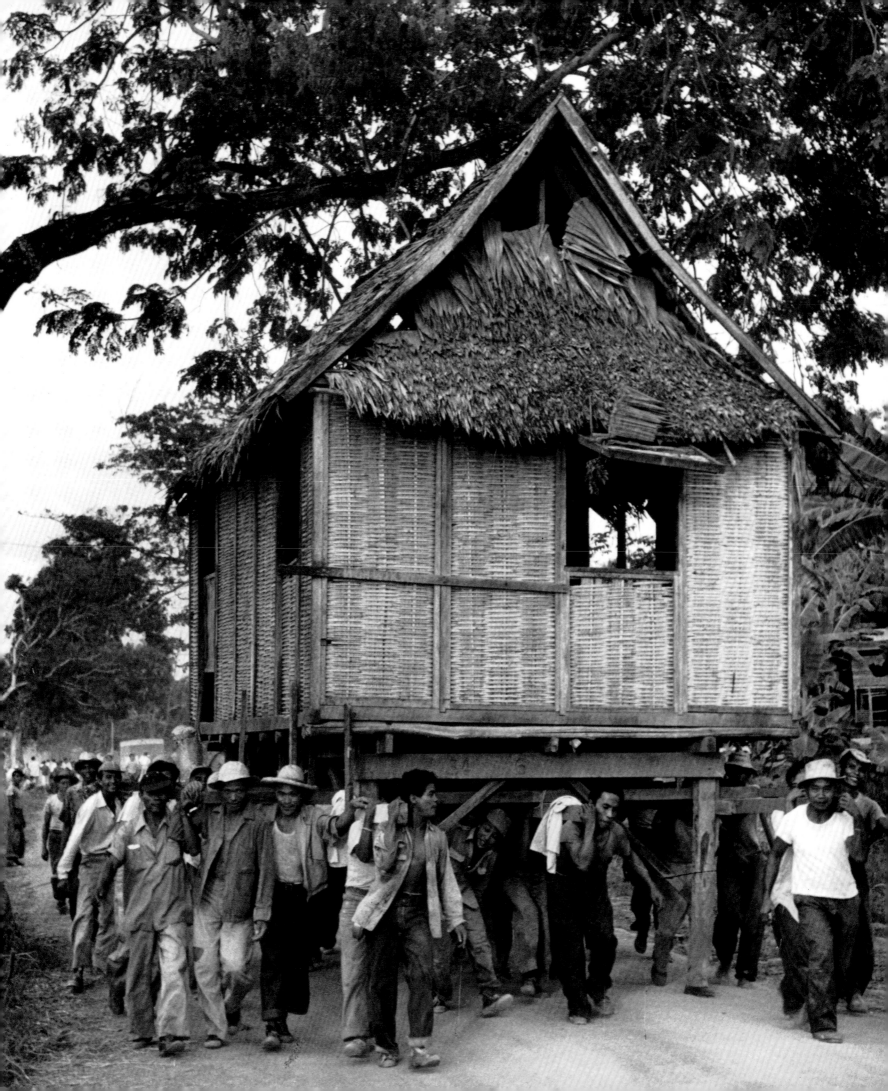

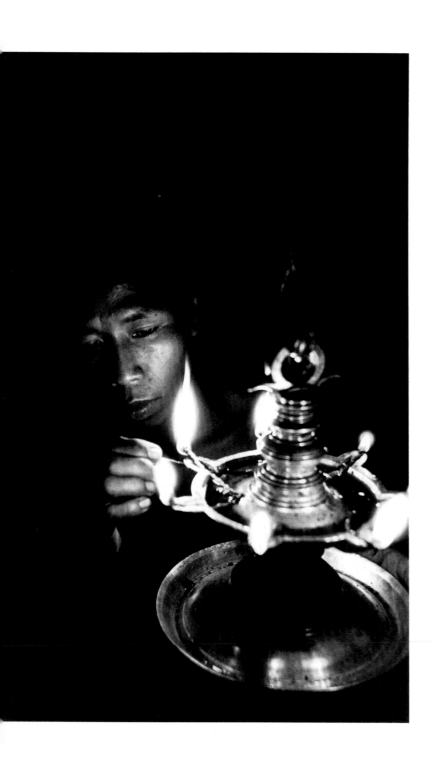

1953, Bali
Kerosene lamps are lit in the
temple at dusk in Ubud

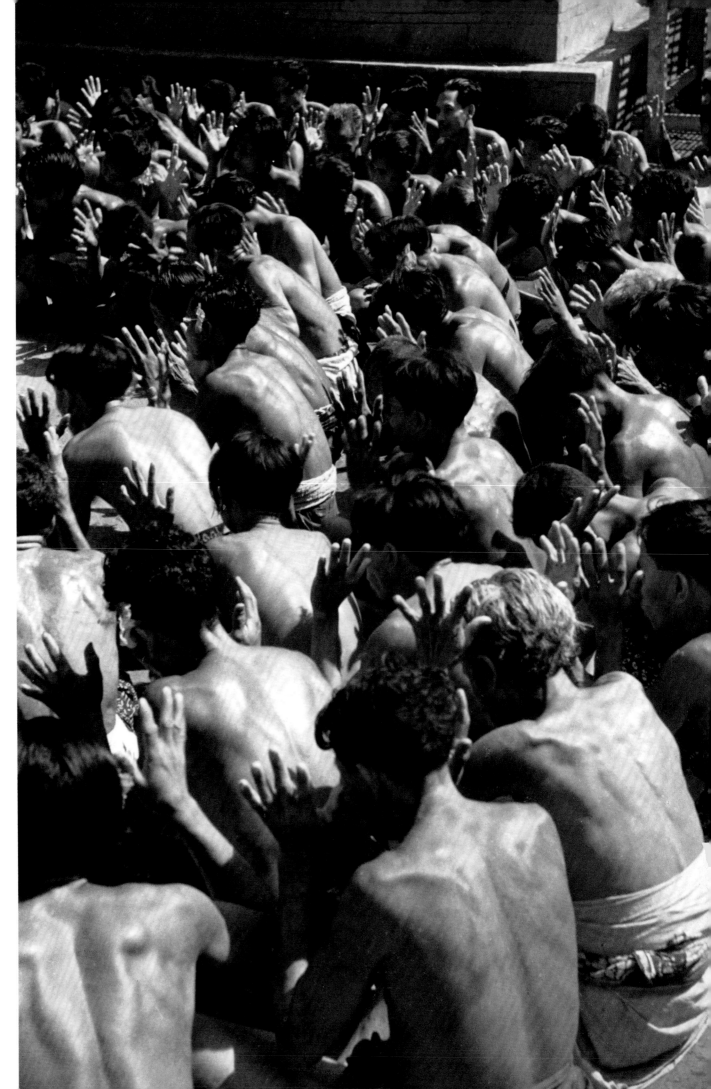

1953, Bali
Performance of the Ketjak in the
village of Bedulu, near Ubud

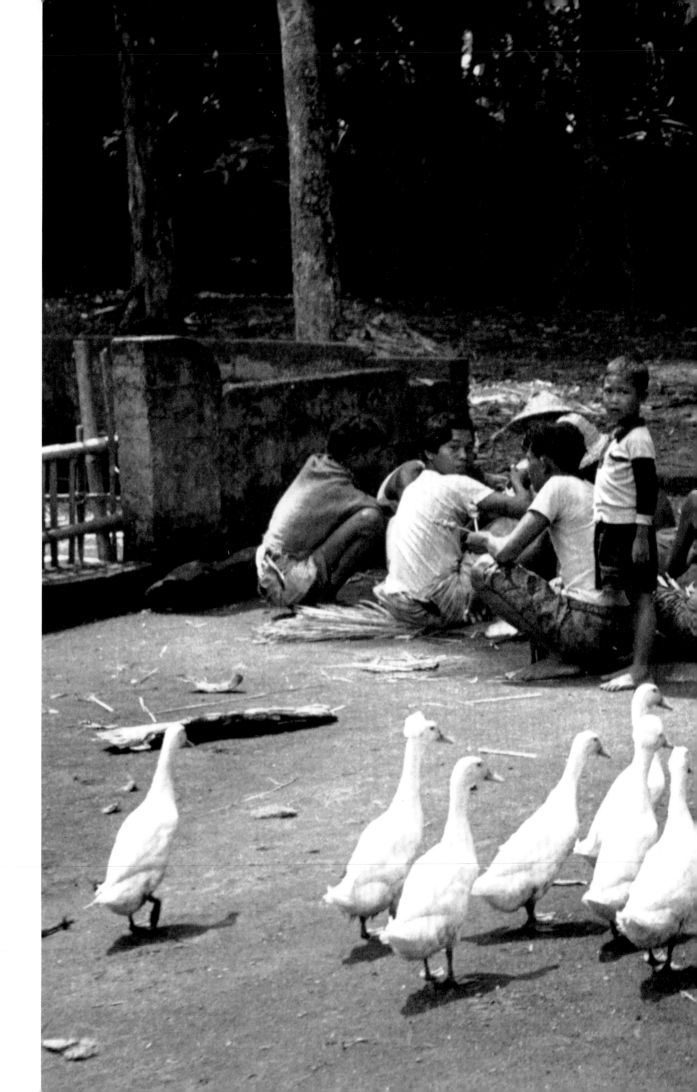

1953, Bali
Ducks in the village of Ubud

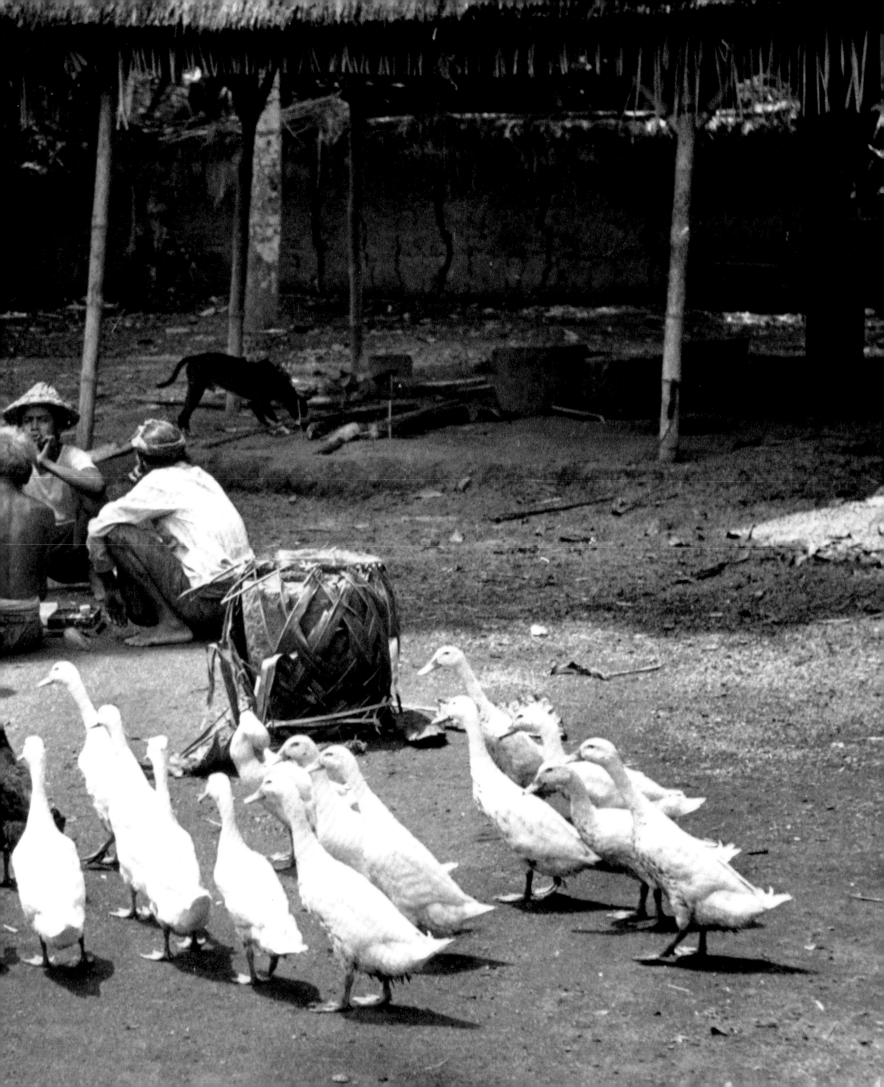

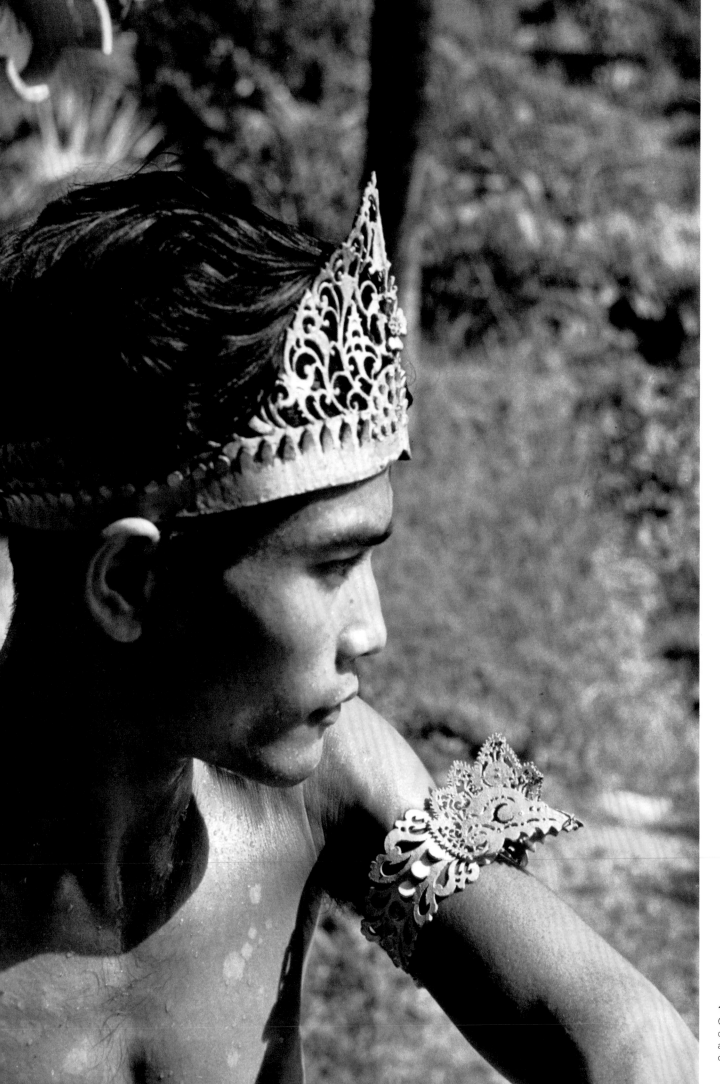

1953, Bali
One of Bali's leading Pandjak dancers, Anak Agung Ngurah, a rice farmer from the village of Ubud

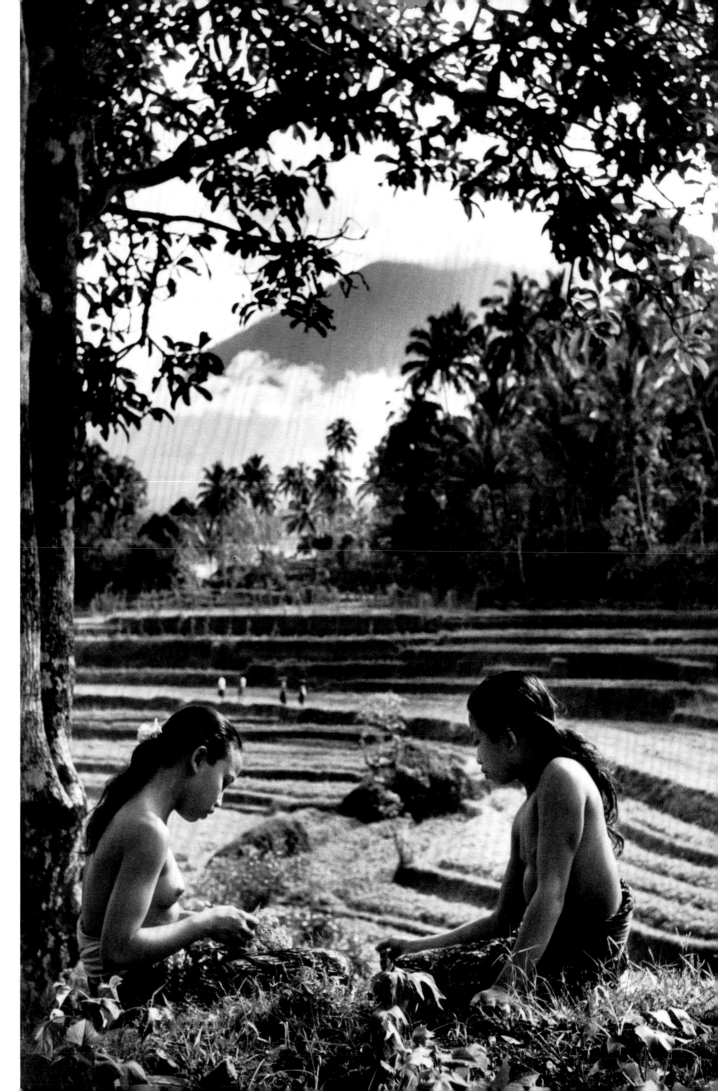

1953, Bali
Two young Balinese beauties
rest by rice paddies under the
sacred mountain Gunung Agung
near the village of Iseh

Africa

1954, Kenya
Kikuyus, rounded up as Mau Mau suspects
in Nyeri, wait in wire enclosures

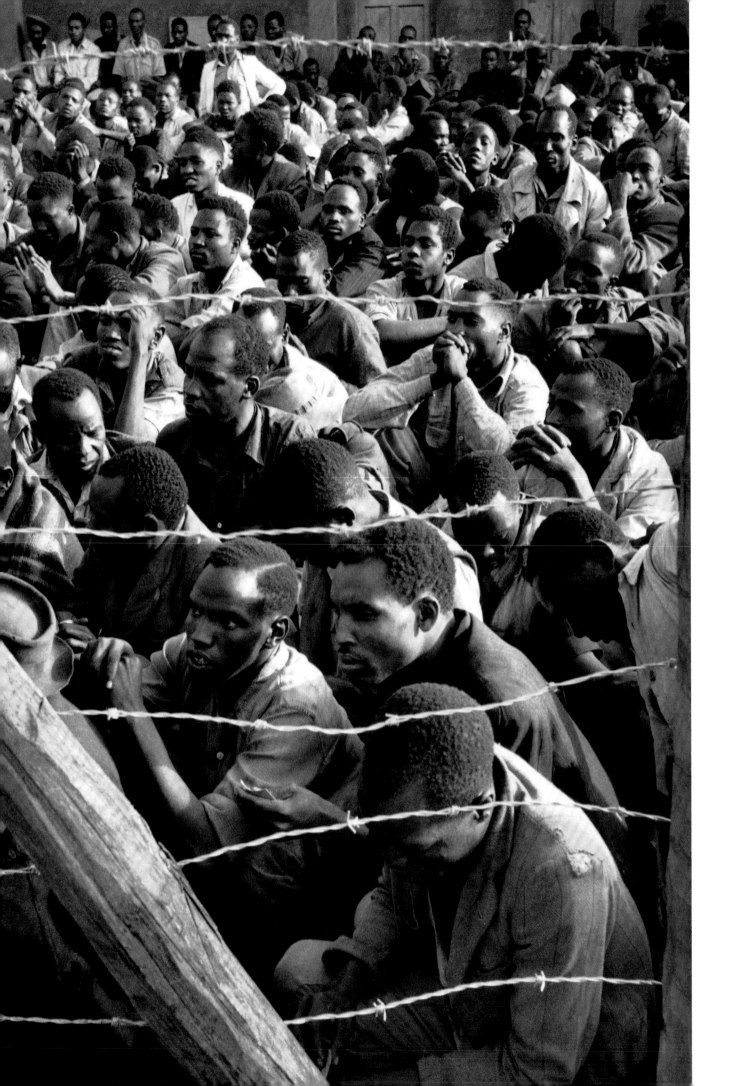

1954, Kenya
Sir Evelyn Baring, Governor of Kenya,
inspects his Guard of Honour in Nairobi

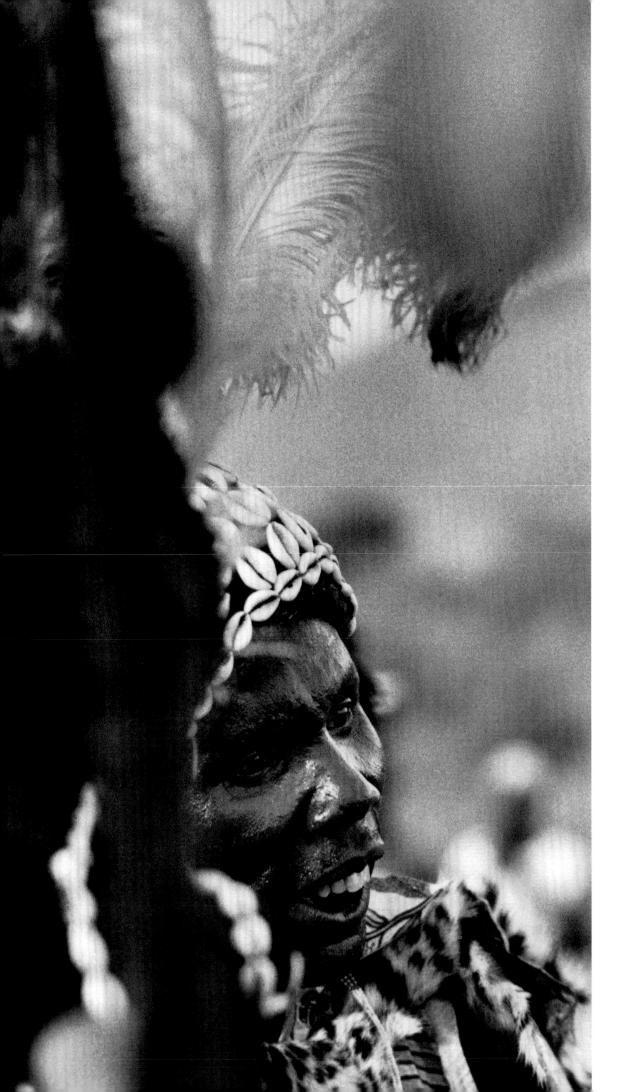

1954, Uganda
A Madi dancer at Moyo, Uganda

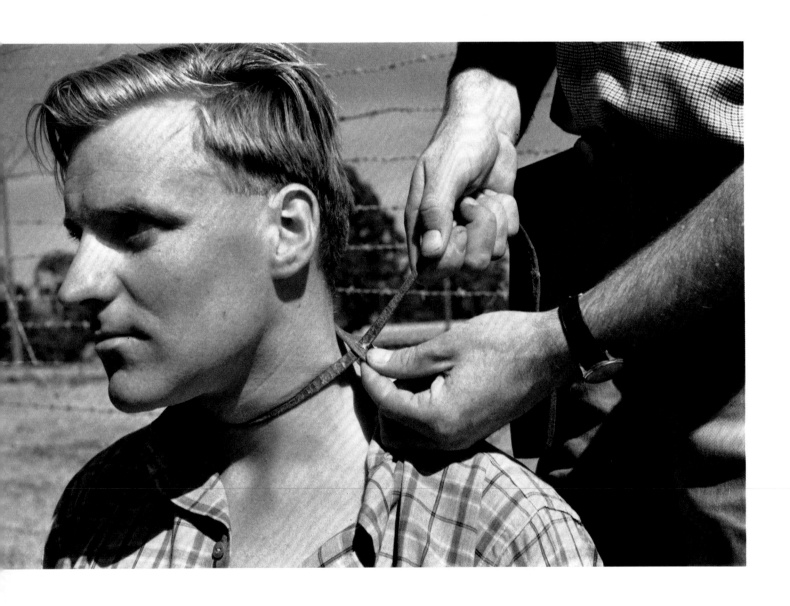

1954, Kenya
A Kenya policeman demonstrates a
Mau Mau garrotte made of rawhide

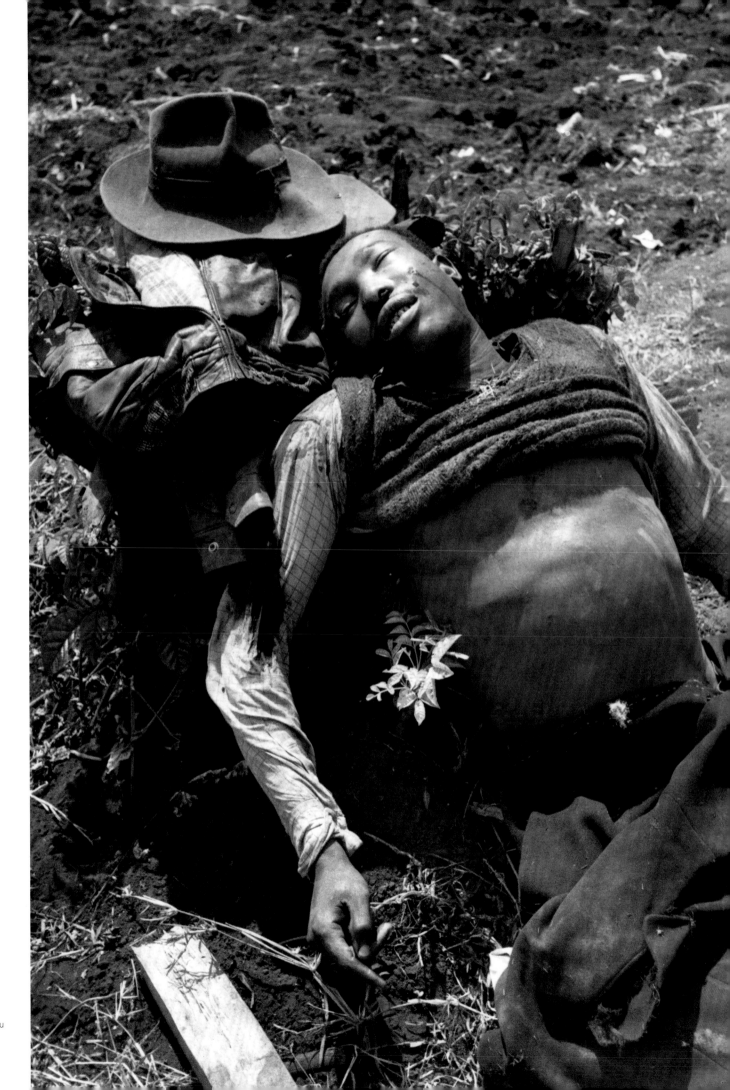

1954, Kenya
General Batu Batu, a Mau Mau
Commander of the notorious
Hika Hika gang, killed in the
Battle of Karatina

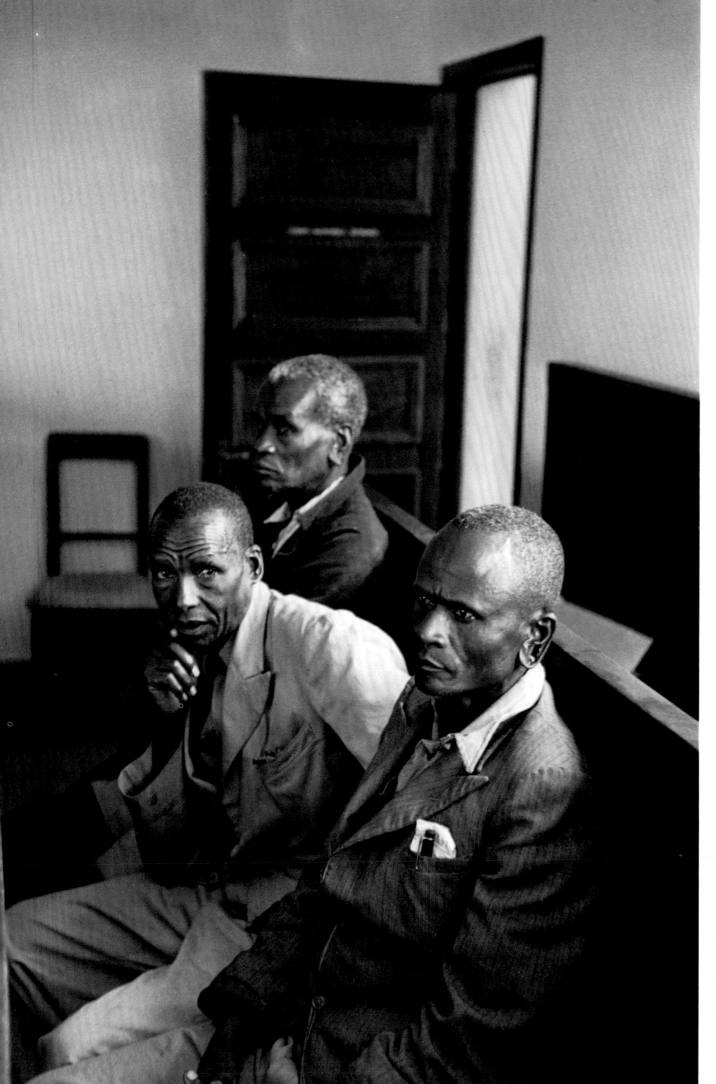

1954, Kenya
A Kikuyu jury at the trial of
Mau Mau 'General China'
in Nyeri

Opposite
1954, Kenya
The trial of Mau Mau 'General
China' in the Nyeri Courthouse

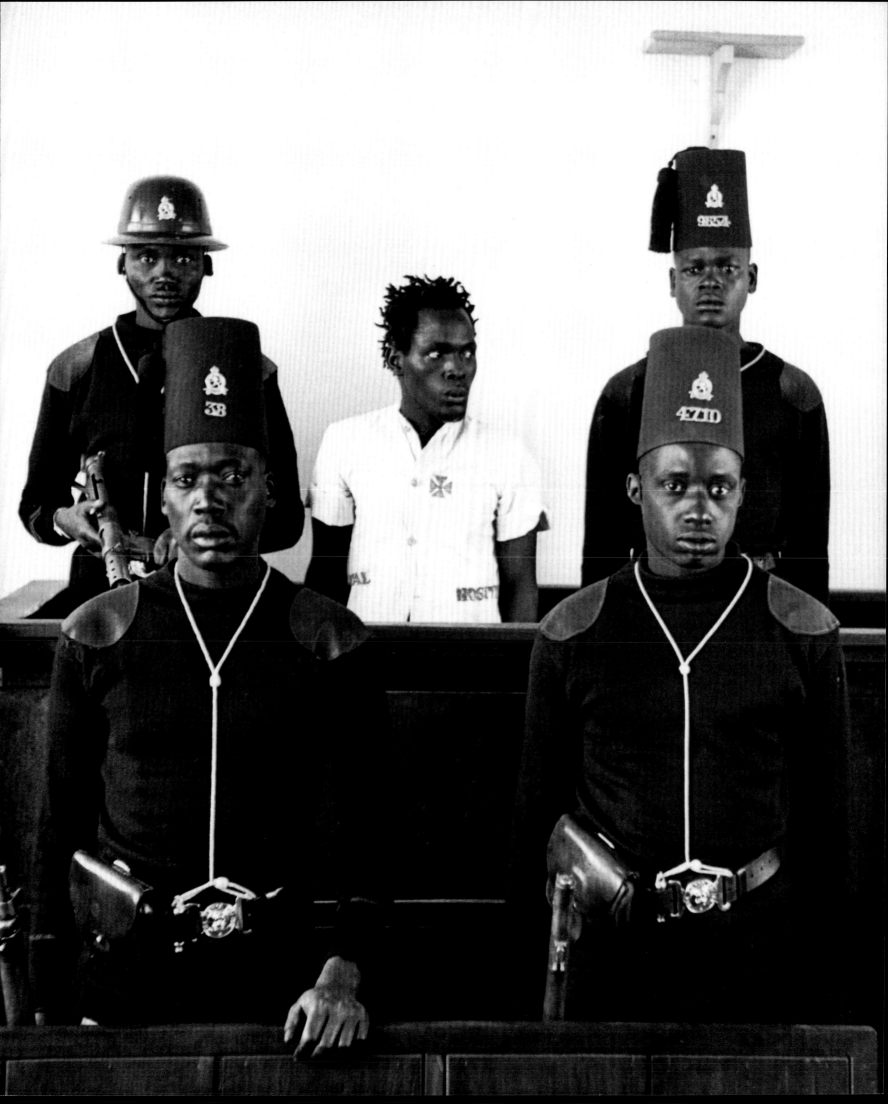

1954, Uganda
Guests at the opening of the Owen Falls Dam,
in the presence of Queen Elizabeth II

Opposite
1954, Uganda
'The Executioner' of Bunyoro with his
symbolic axe. The heavy wooden club, kept busy
in ancient times, is called the 'babogeras'

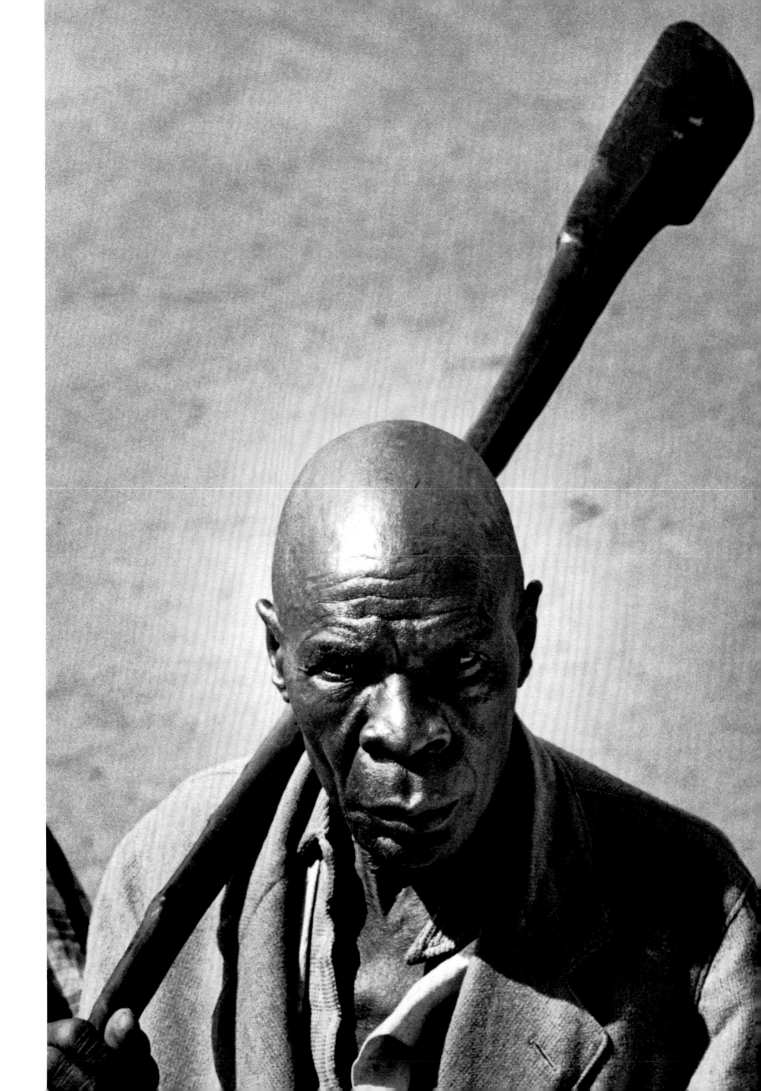

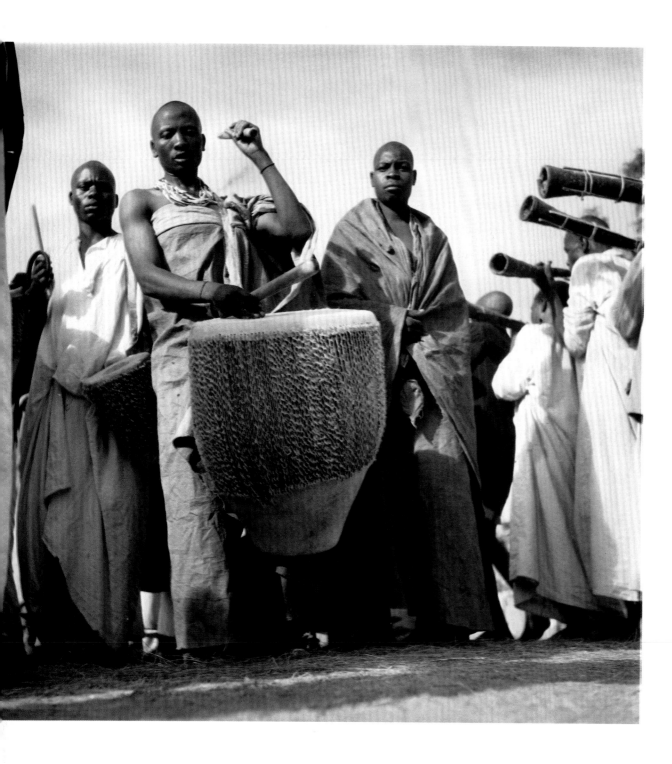

1954, Uganda
The sacred drum of the Kingdom of Bunyoro

Opposite
1954, Uganda
A Royal Courtier to the King of Bunyoro
dances at a tribal celebration

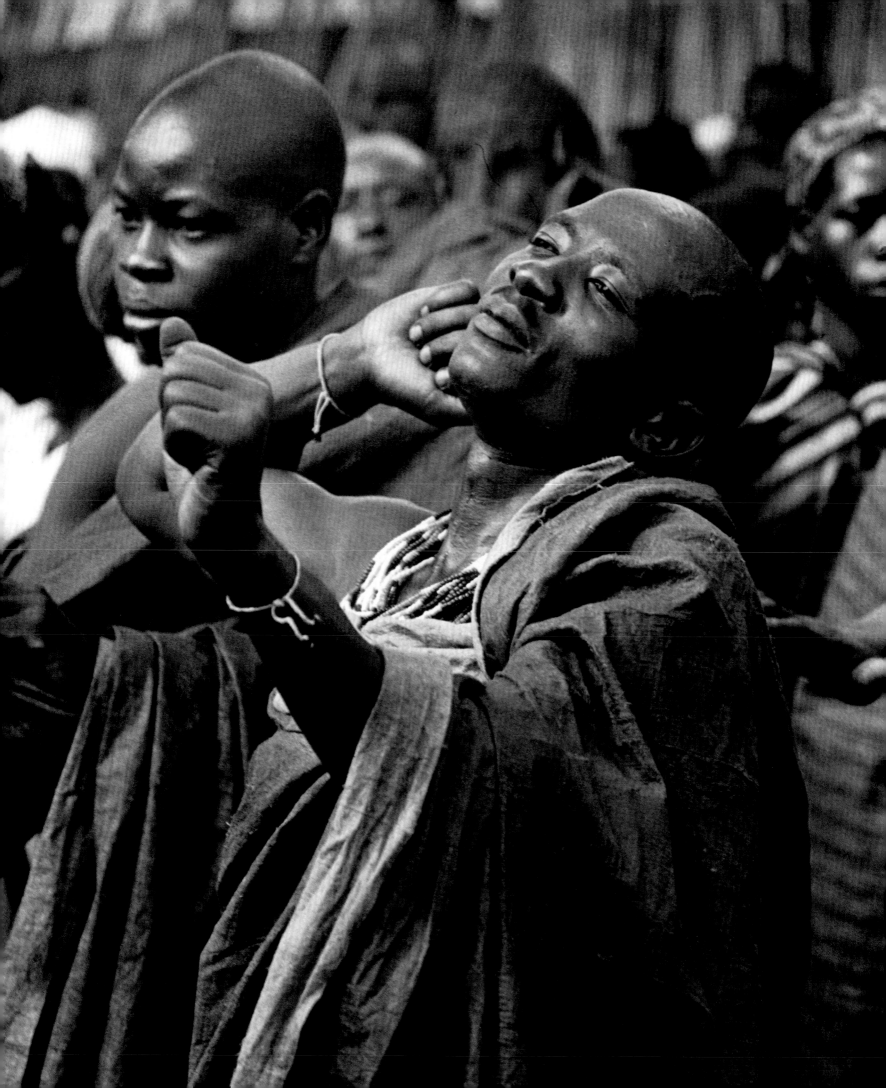

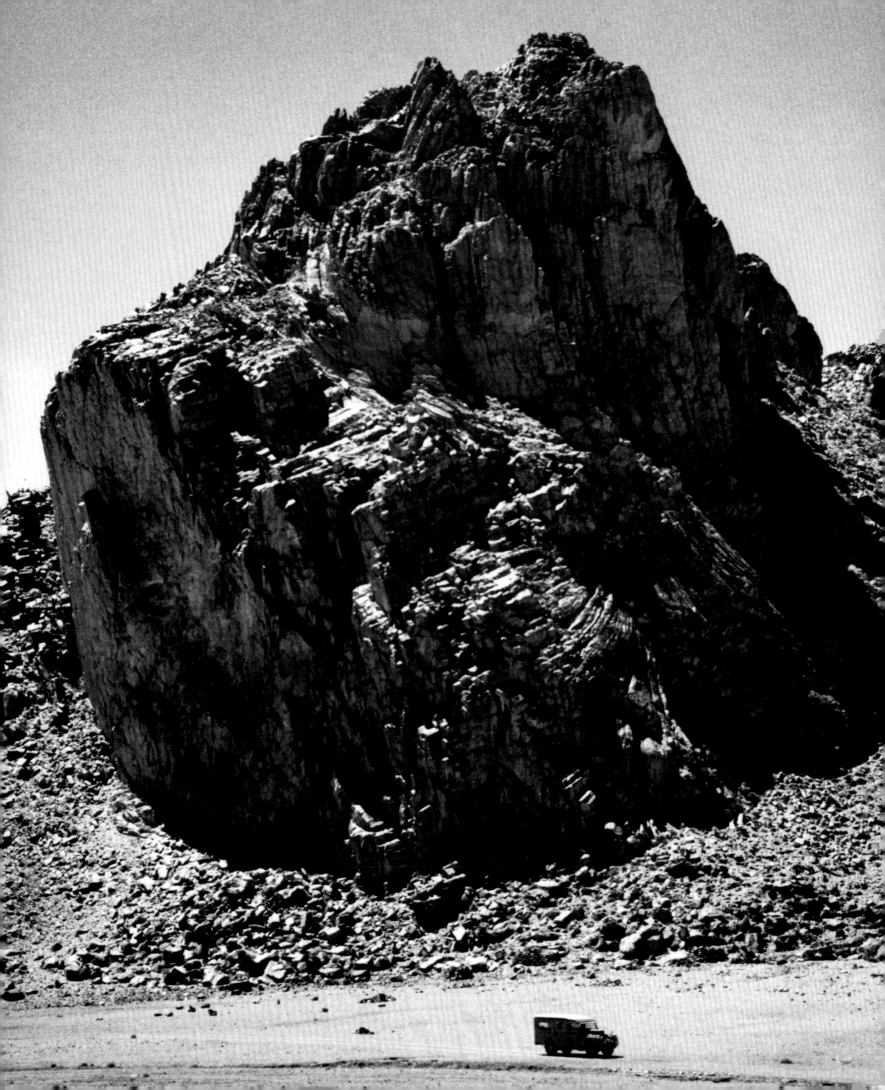

Opposite
1957, Algerian Sahara
A Landrover, dwarfed by an outcrop
of rock in the Hoggar Mountains

1957, Algerian Sahara
A Tuareg baby at Tamanrasset

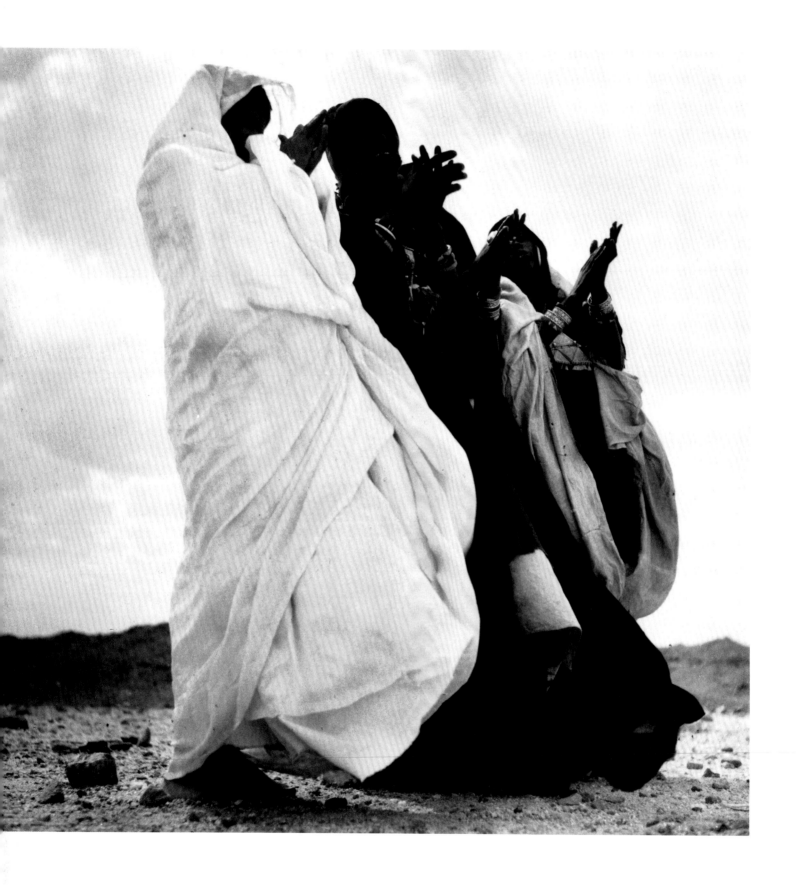

1957, Algerian Sahara
The Dunes of Kirzaz

Page 286
1957, Algerian Sahara
Near Tamanrasset four Tuareg
women, clapping their hands and
chanting, celebrate the birth of a
male child

Page 287
1957, Algerian Sahara
The matriarch of a Tuareg tribe
in Tamanrasset

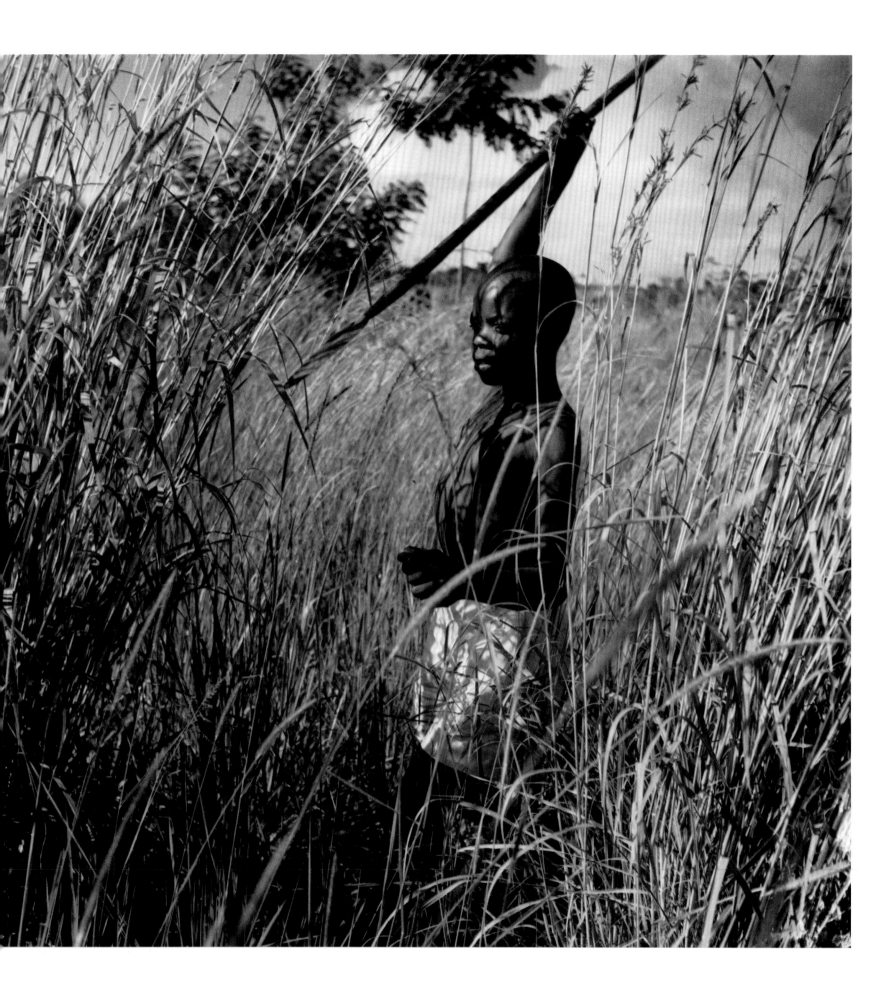

1954, Uganda
Young Emmanuel goes hunting with his spear
in the bush country of Bunyoro

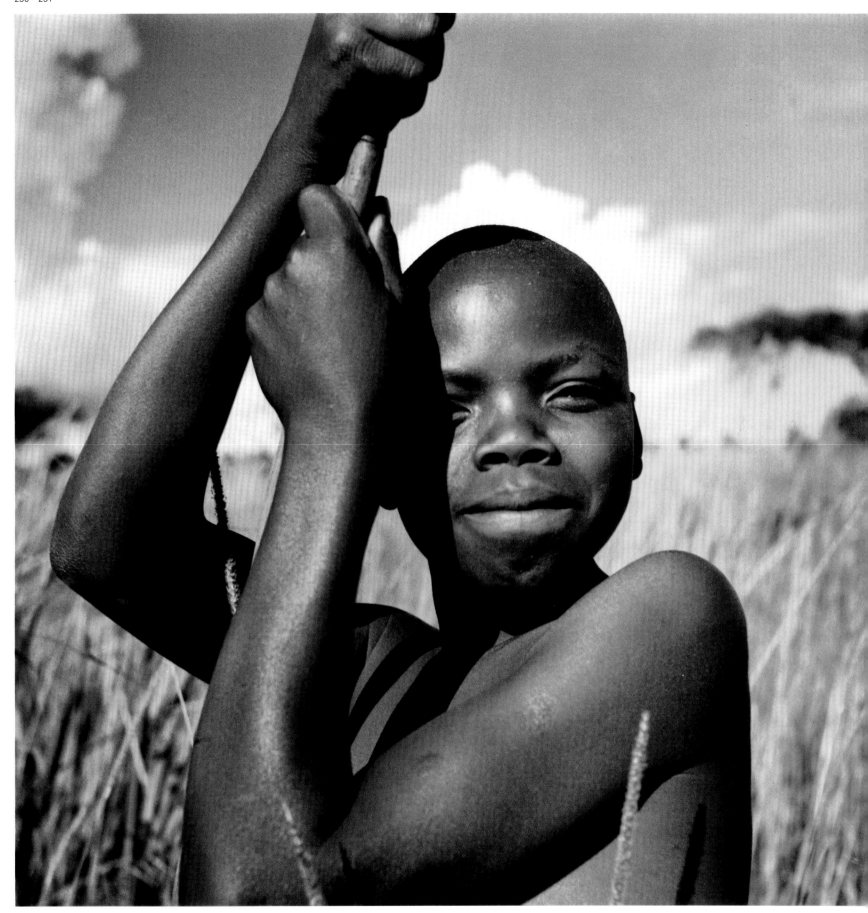

1954, Uganda
Emmanuel, a young acolyte
to the King of Bunyoro

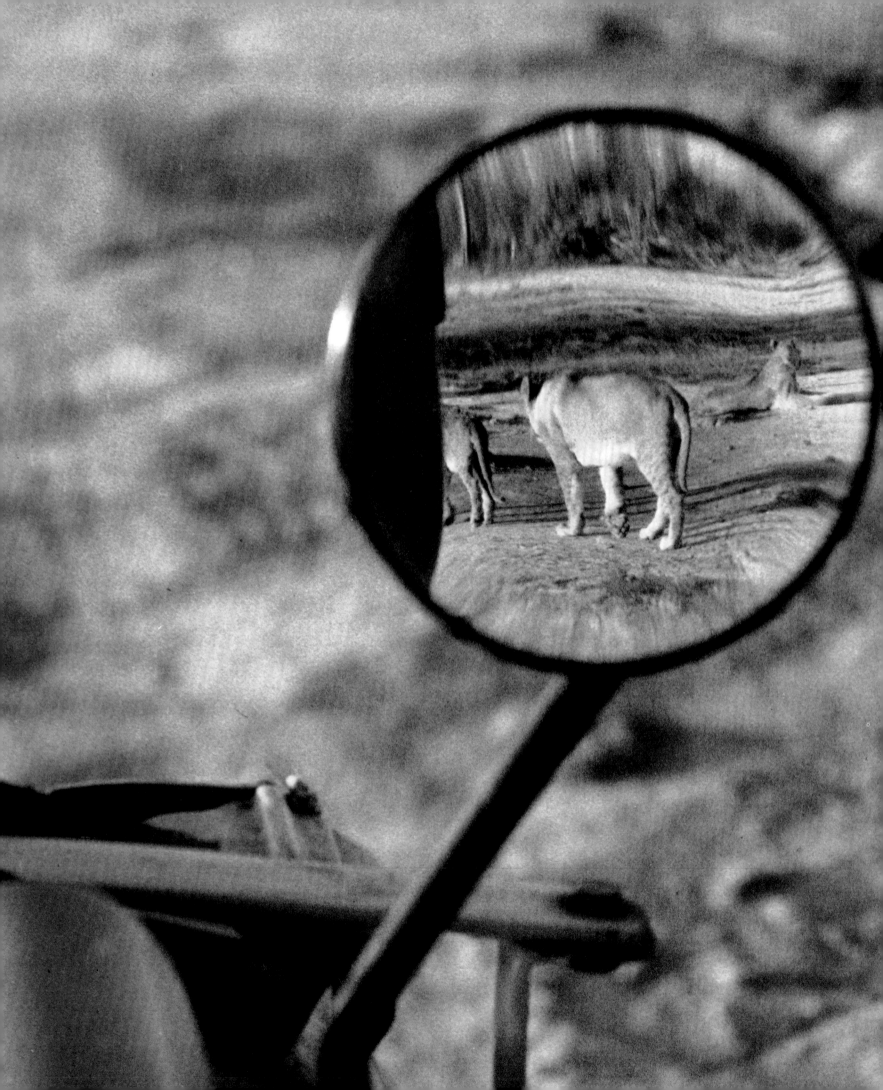

1954, Kenya
Lions spotted at the
Amboseli Game Reserve

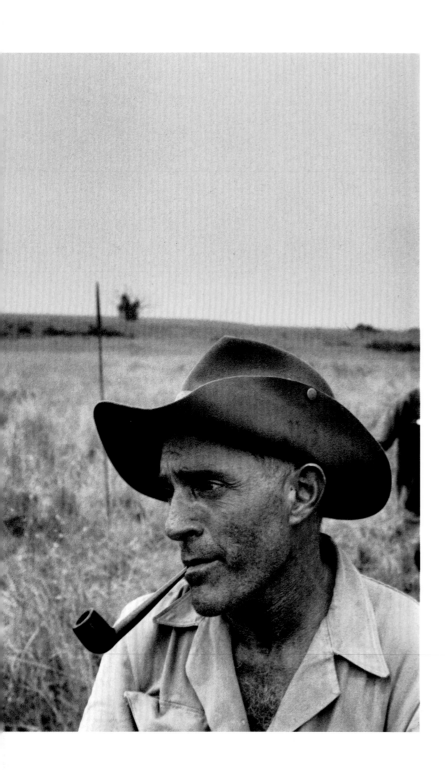

1958, Uganda
Greek big game hunter Emmanuel Fangoudie
on Safari near Ishasha River, Buffalo country

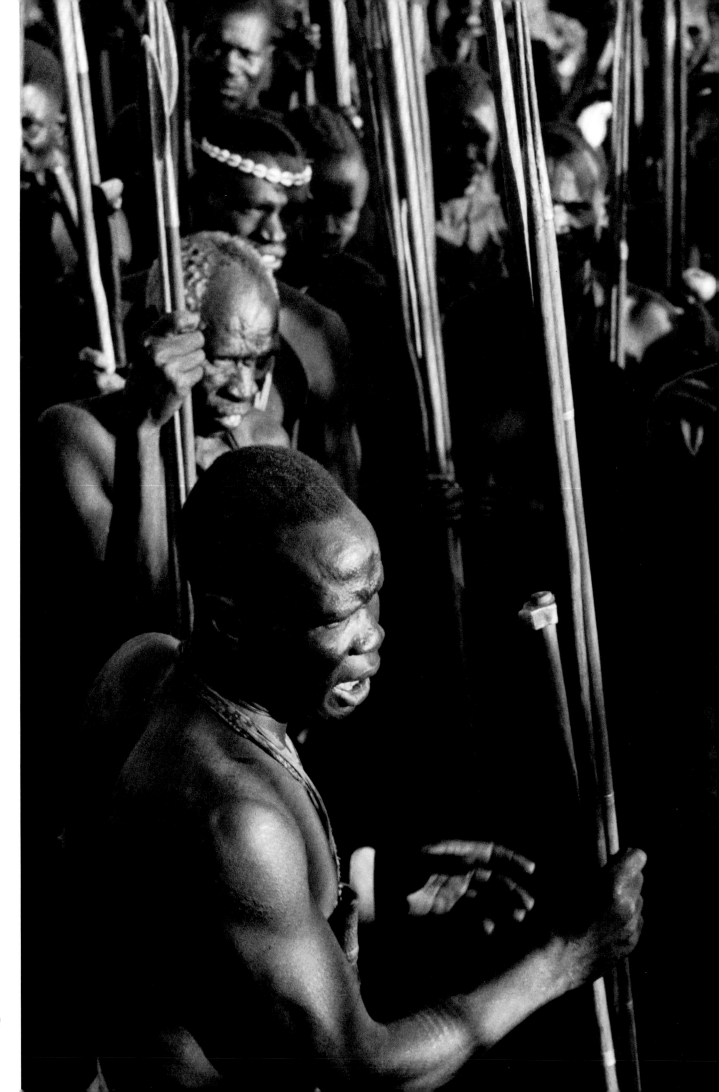

1958, Uganda
Spearmen of the Napore tribe of
Karamoja assemble for a hunt

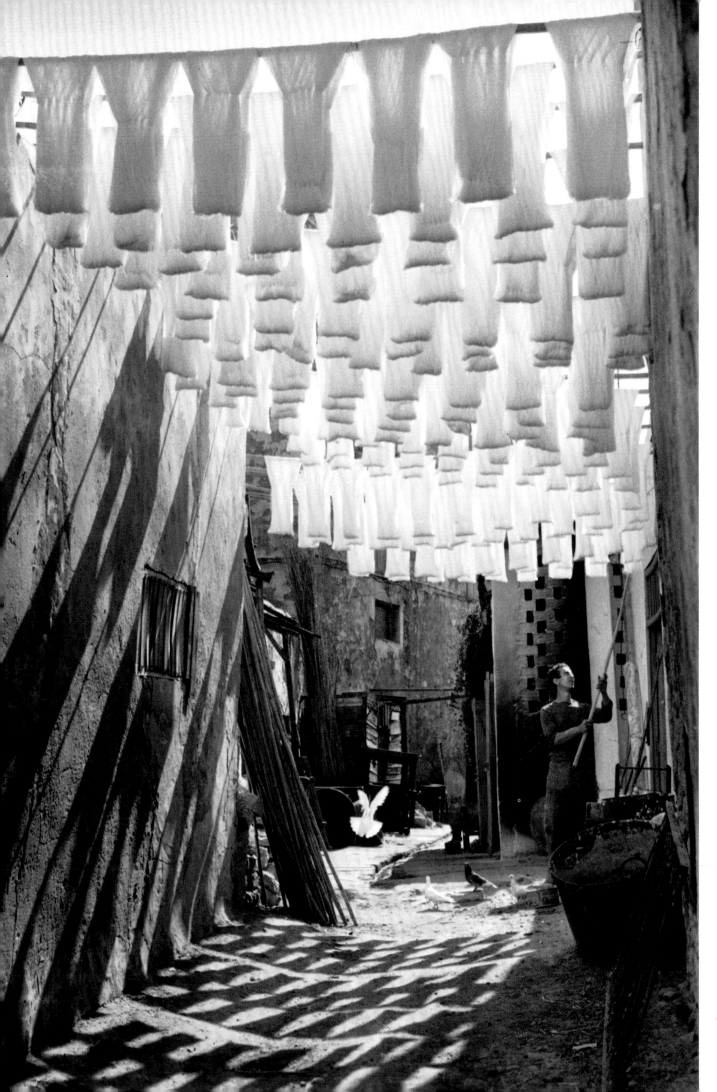

1958, Tunisia
The wool suq, Tunis

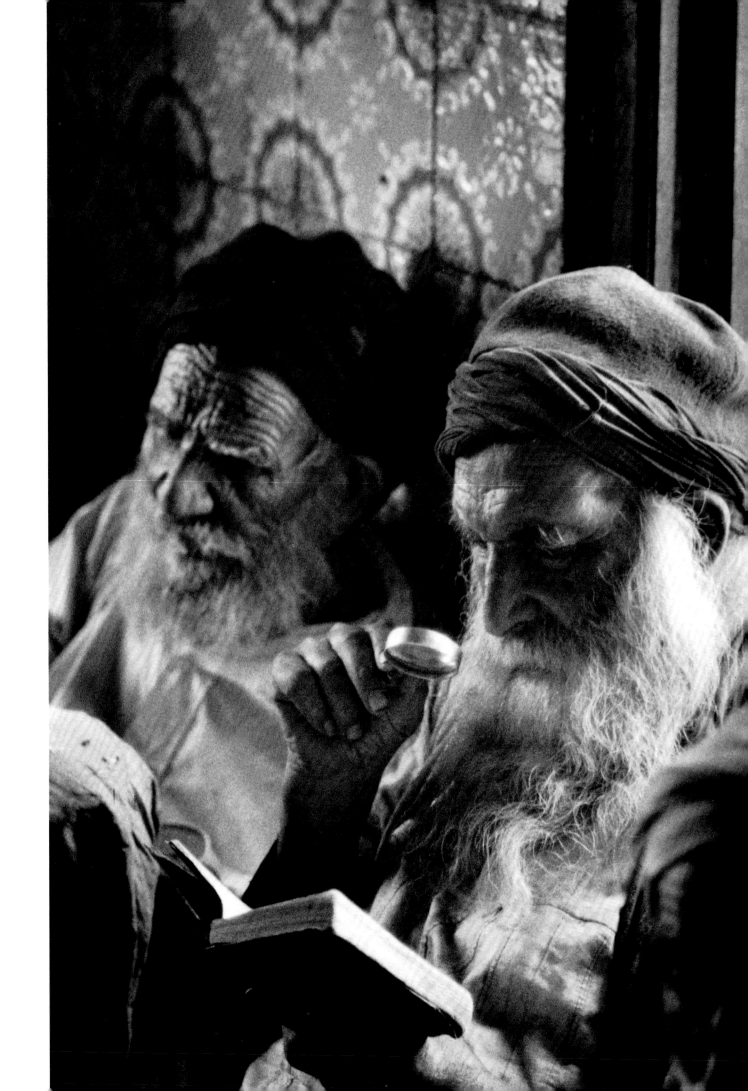

1957, Tunisia
Rabbis in the synagogue
of Djerba Island

England

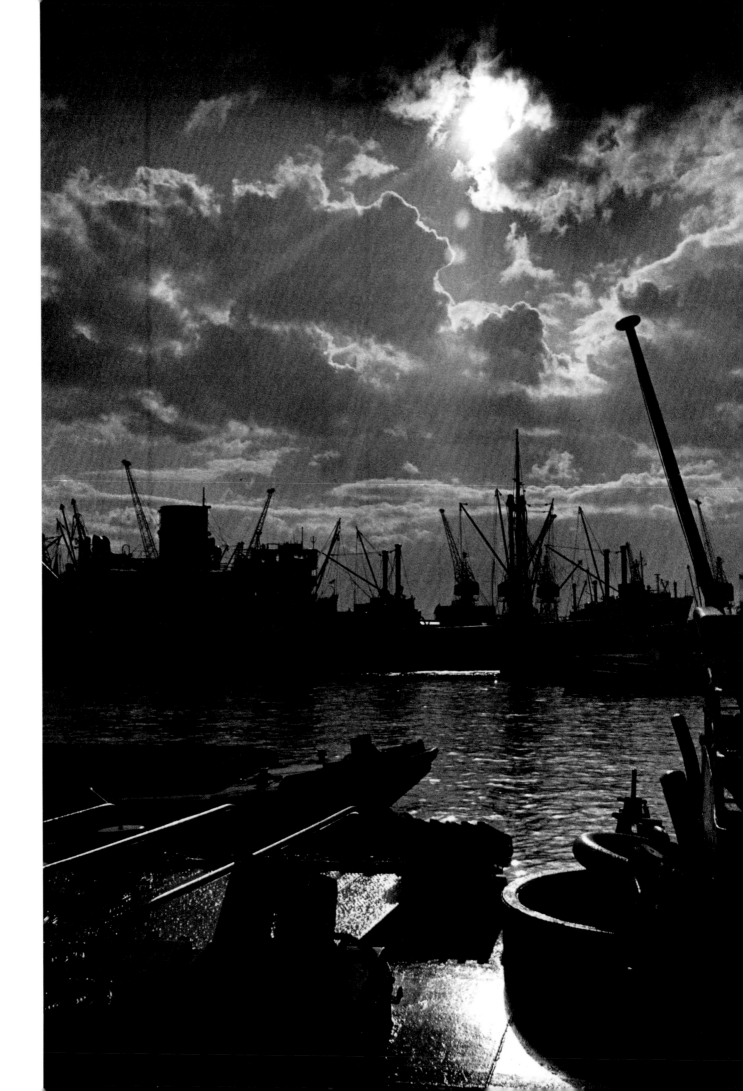

1964, London
London Docks

Pages 300, 301
1963, London
Immigrants arrive at
Waterloo Station

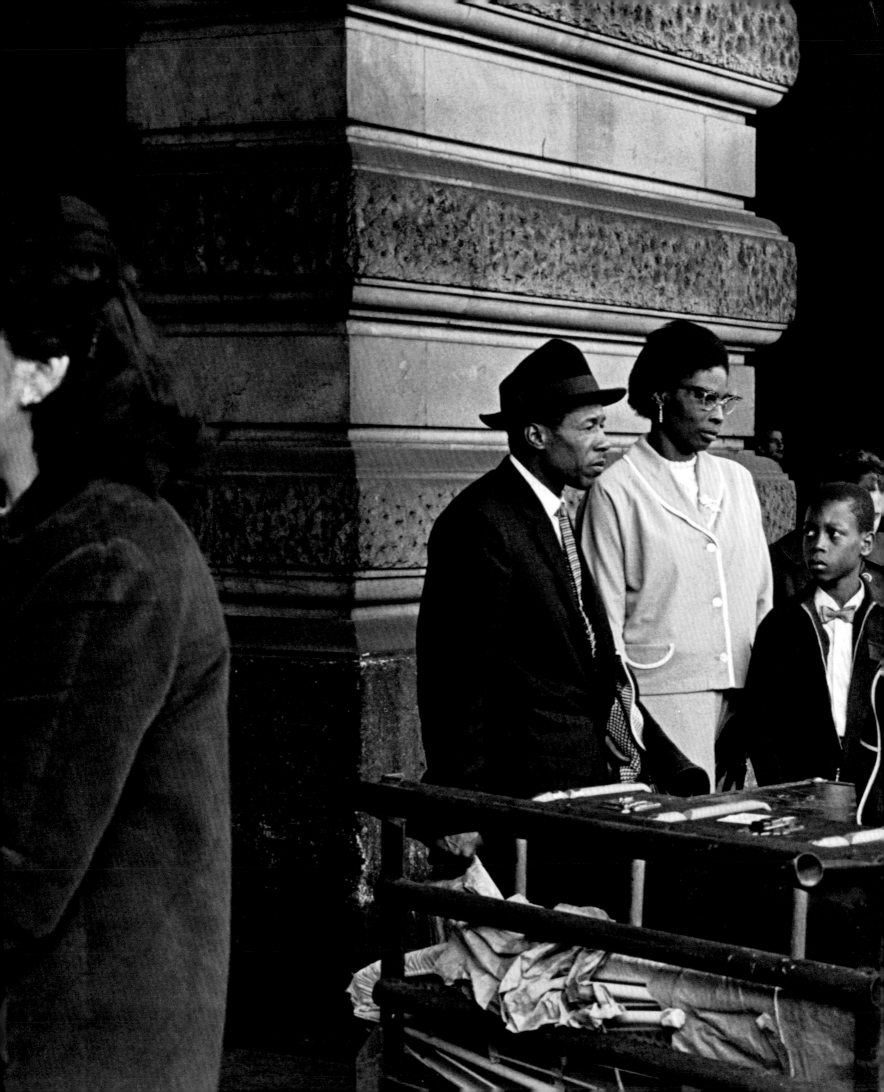

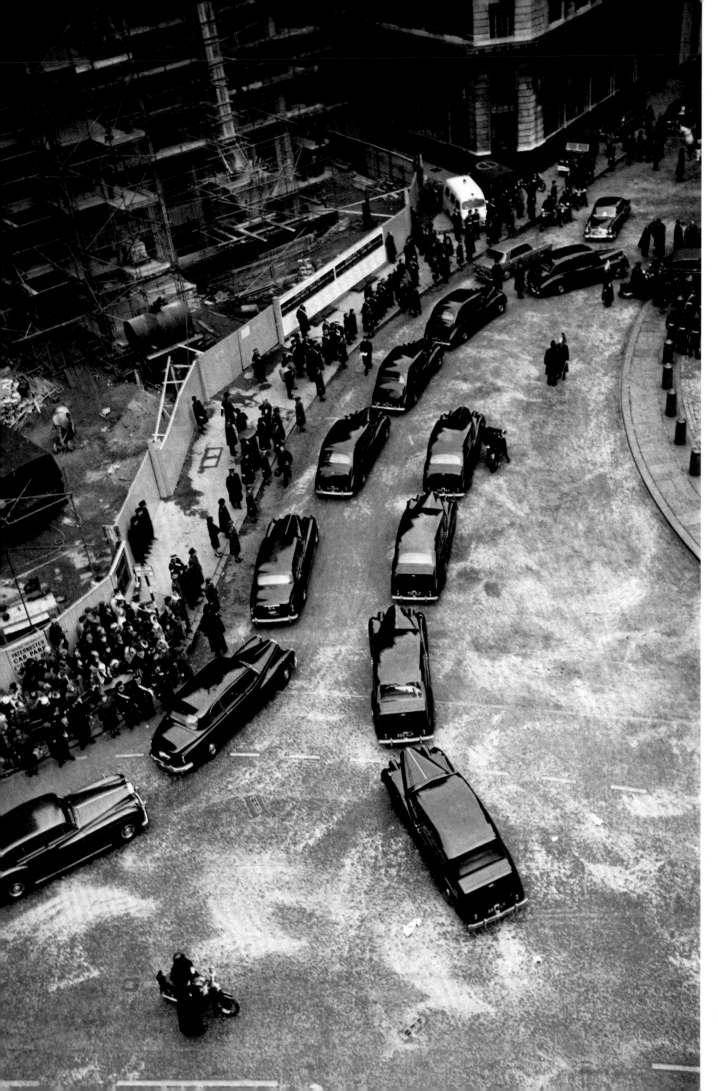

1965, London
The cortège at Churchill's funeral

1965, London
The gun carriage bearing
Churchill's coffin is drawn by
a contingent of naval cadets

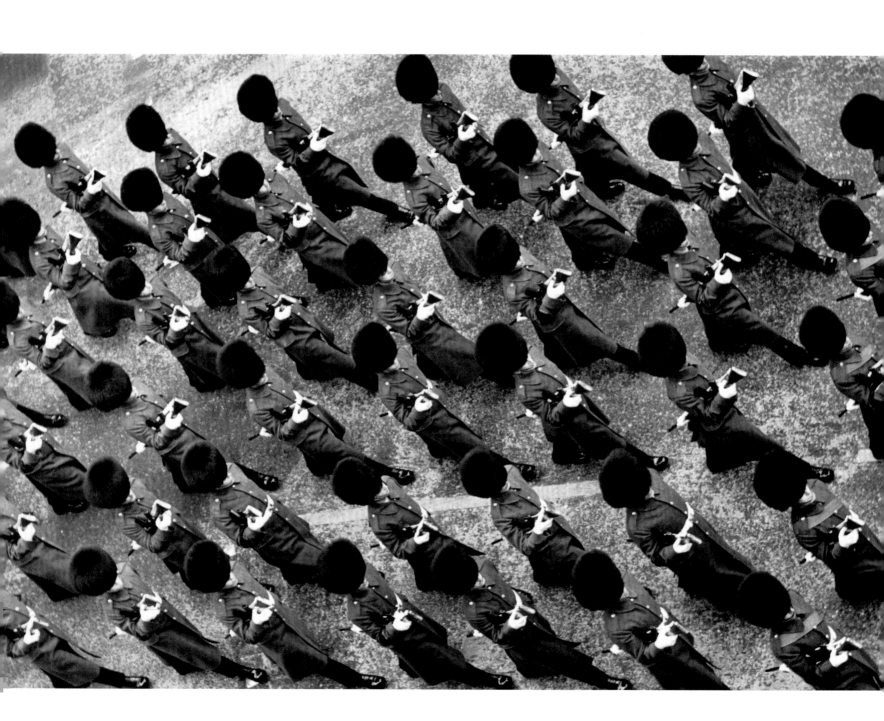

1965, London
Soldiers and sailors at Churchill's
funeral carry their rifles in reverse

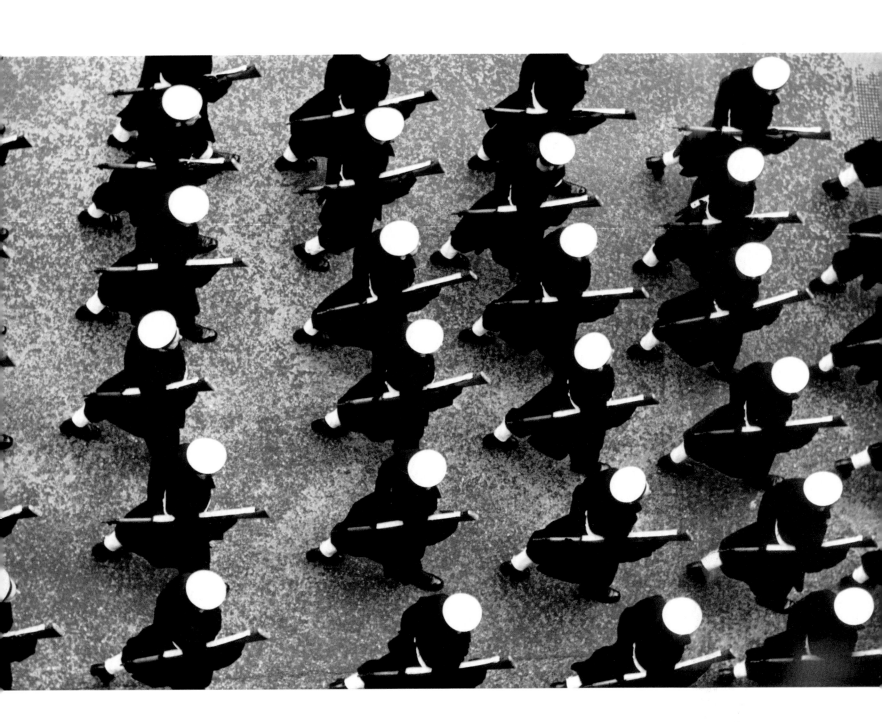

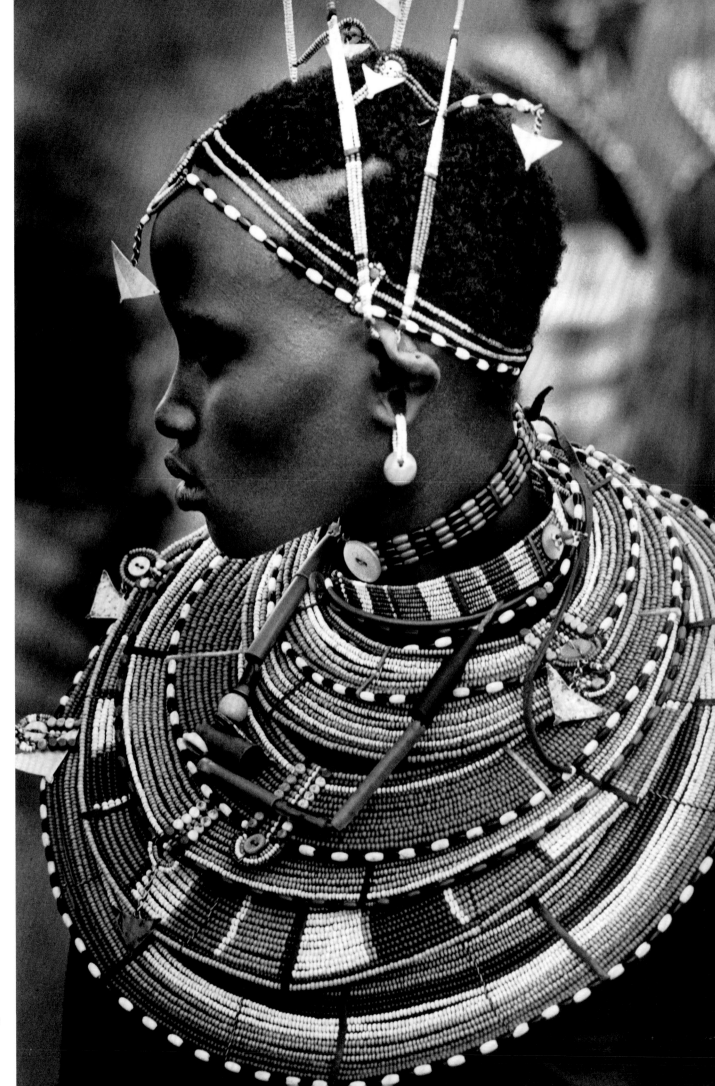

1979, Kenya
A young girl of the Masai (N'Dito)
dressed in beaded finery for a
circumcision ceremony

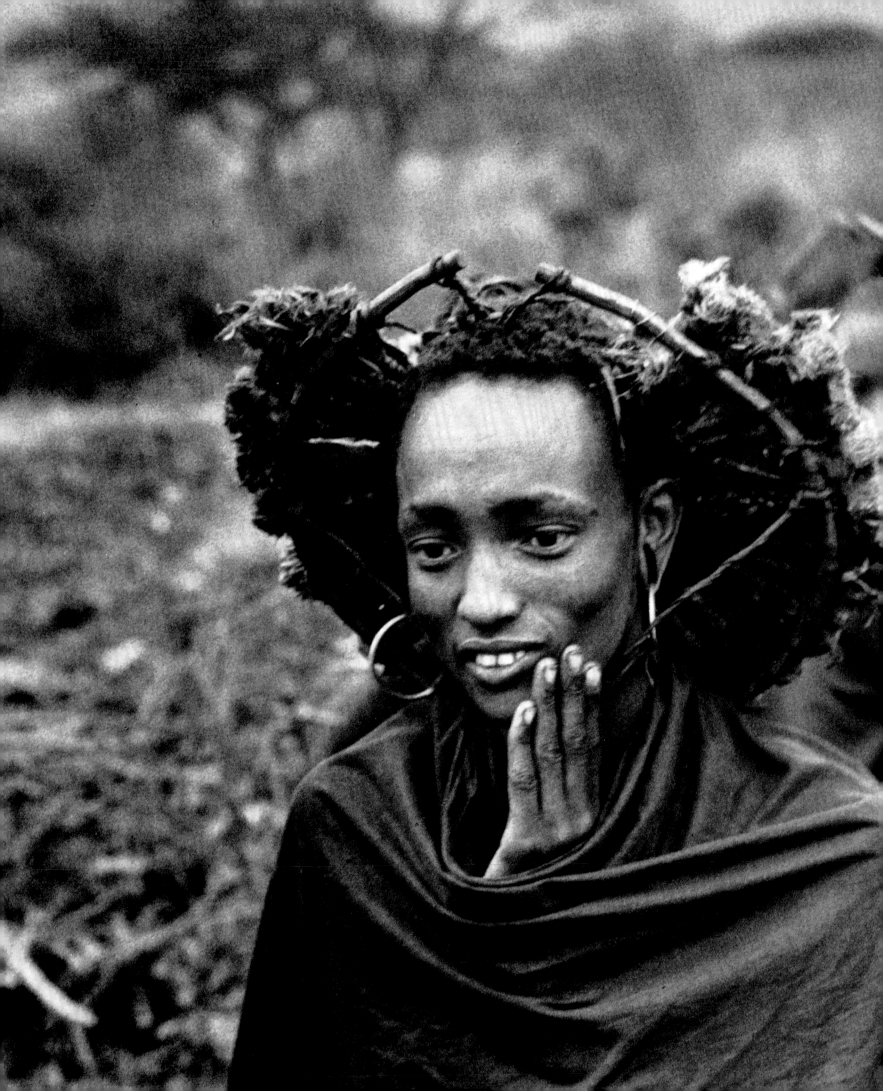

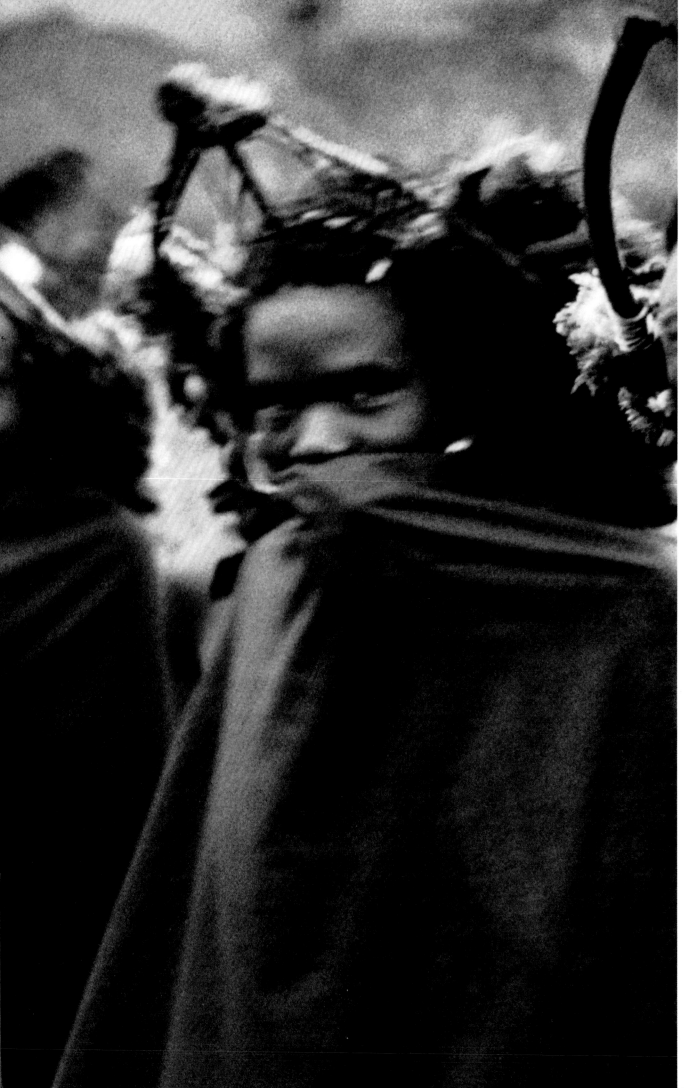

1979, Kenya
Young Masai moran (warriors)
wear their ceremonial headgear
at a circumcision ceremony

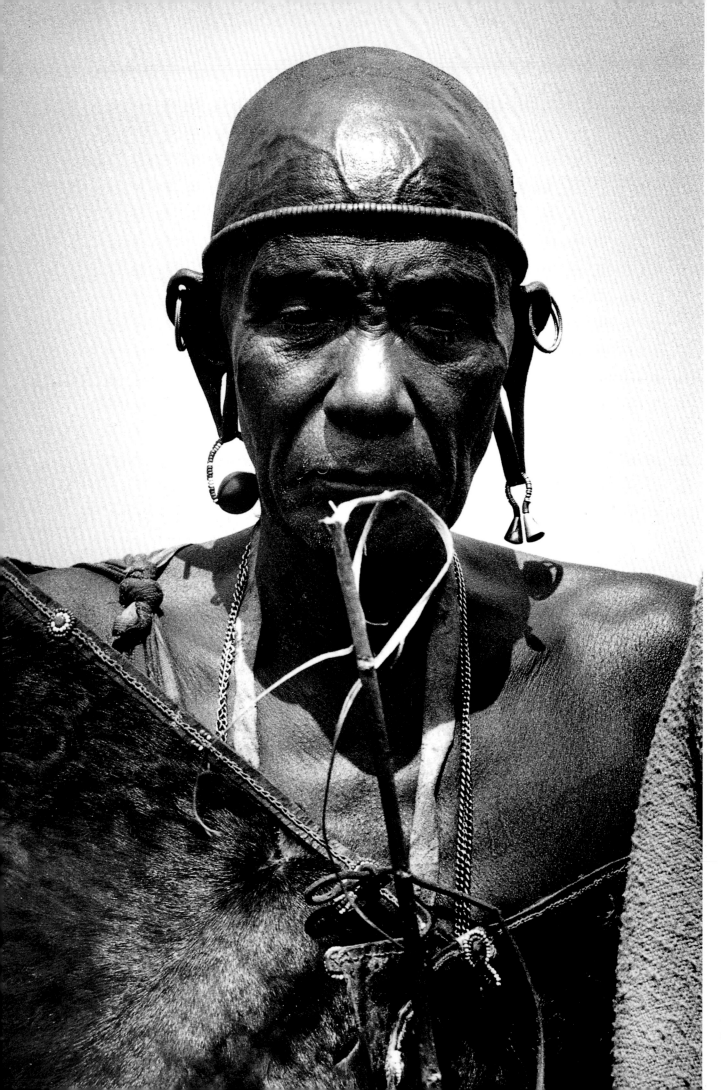

1979, Kenya
The doctor of the circumcision, in tribal regalia

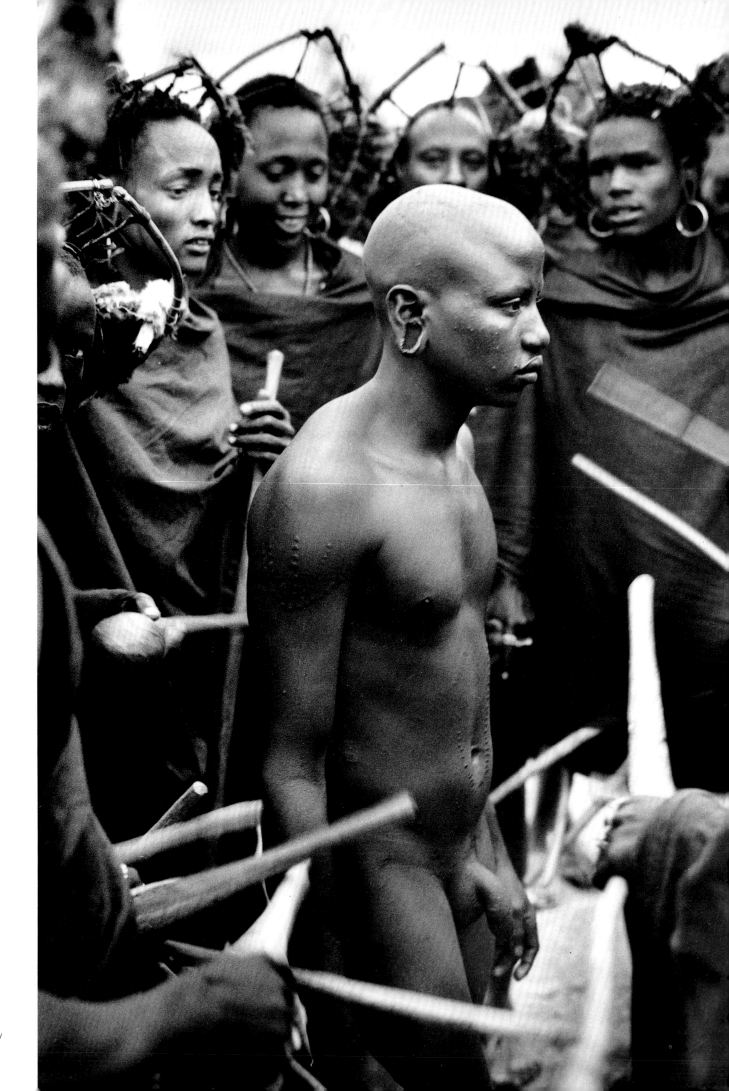

1979, Kenya
A Masai youth about to
be circumcised is taunted by
young moran (warriors)

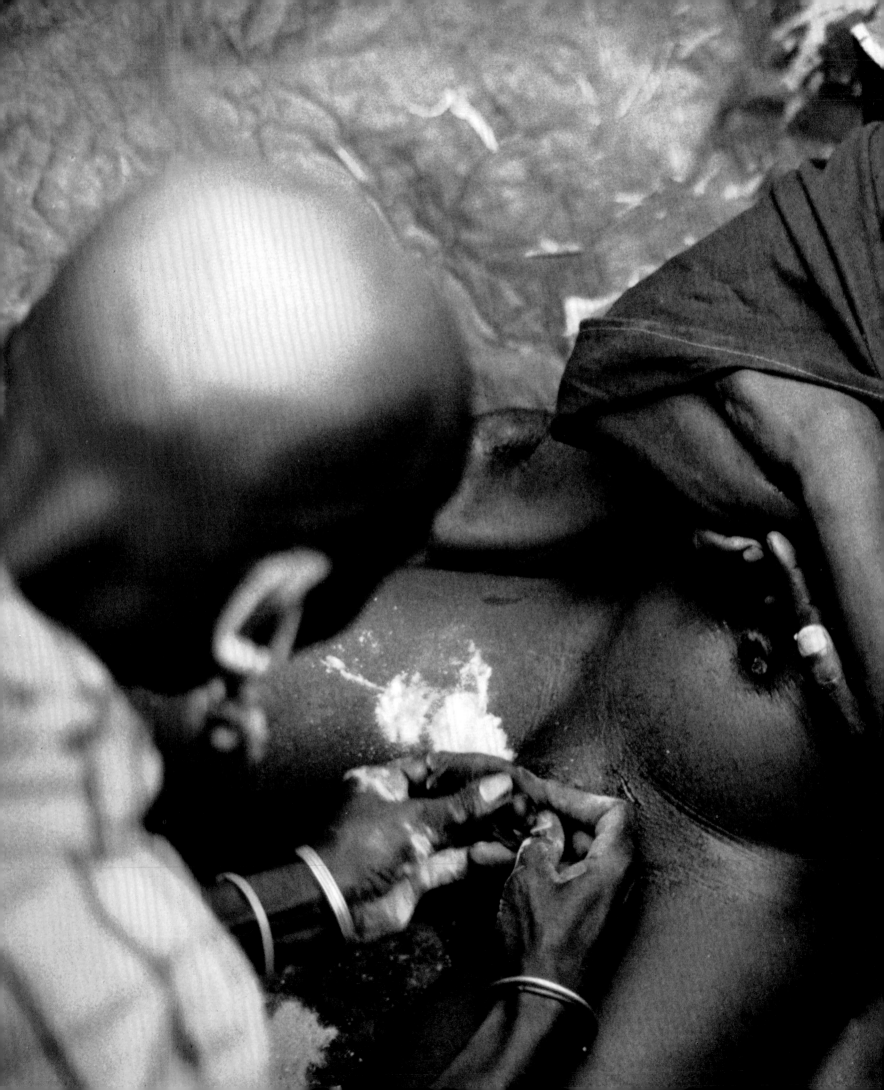

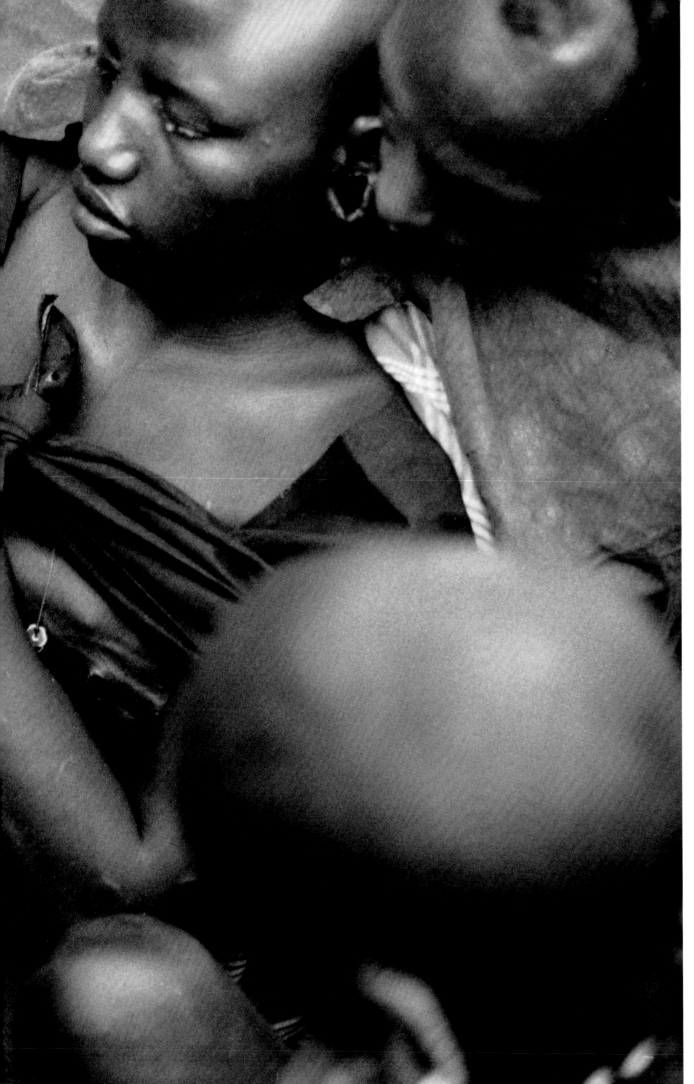

1979, Kenya
The circumcision of a Masai boy

Page 314
1979, Kenya
A junior moran (warrior) with a
headdress of sun-dried bird skins

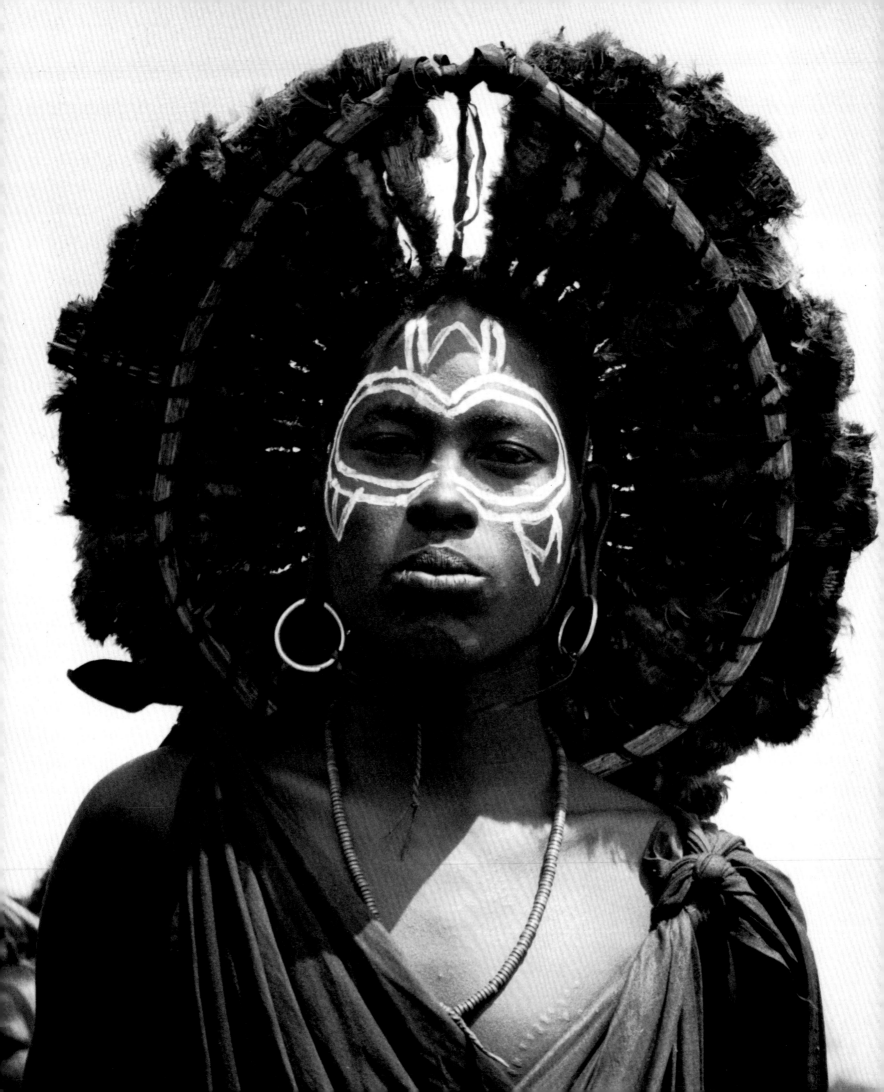

1908	Born on 19 March, in Hale, Cheshire. Educated at St Bees College, Cumbria.
1927–8	Joined the British Merchant Navy. Sailed twice around the world.
1929–36	Lived in the USA. Worked in various non-photographic jobs during the Depression years.
1936–8	Returned to the UK. Joined BBC Television as a stills photographer. Acquired first 35mm camera.
1939	Freelanced in London through the Black Star Agency.
1940	Photographed London Blitz for *Life, Picture Post* and other magazines.
1939–47	War correspondent for *Life* magazine. Military service as a war correspondent: West Africa with the Free French Eritrea with the Foreign Legion Ethiopia with the Indian Army Iran with the British Army North-west frontier with the British Army Tobruk and Western Desert with the British Army Burma campaign with the Chinese Army North African landings with the American Army Sicilian landing with the American Army Italian campaign with the British Army Monte Casino with the Ghurkas (Ortona Front) D-Day Normandy with the British Army Liberation of Paris Liberation of Brussels Liberation of Holland Crossing the Rhine with Churchill and Montgomery German surrender at Luneberg, with British Army Bergen-Belsen concentration camp Liberation of Denmark with the British Army
1947	In May left *Life* magazine and, with Robert Capa, David Seymour and Henri Cartier-Bresson, became a founder member of Magnum Photos.
1948–9	Cross-Africa Expedition. Travelled from Cape Town to Cairo by road.
1950–2	In USA, West Indies, Europe and Middle East on assignment or photographing on speculation for magazines in the USA and Europe.
1953	Made around-the-world documentary for Standard Oil Co.
1954–6	Based in the Middle East covering stories on assignment and speculation. Made two more visits to East Africa.
1957	Sahara Desert expedition for *National Geographic* and other publications.
1958	Six months' travel in East Africa covering tribal and wild life, on assignment for magazines including *Life, National Geographic, Holiday, London Illustrated, Paris Match* and *Der Stern*.
1959	Took up residence in the UK. Worked on assignments for magazines, film companies, industry, company reports, etc.
1977–9	Returned to Africa on three occasions, concentrating on tribal life, assisted by the Arts Council of Great Britain.
1980–	Now working on exhibitions, print sales, books and archive material.

Books

Bondi, Inge. *George Rodger*. London: Arts Council of Great Britain, 1974.

Caiger-Smith, Martin. *George Rodger: Magnum Opus*. London and Berlin: Dirk Nishen, 1987.

Cardinal, Roger. *George Rodger*. Catalogue, Kent Institute of Art & Design, Maidstone and Rochester, 1993.

Naggar, Carole. *George Rodger en Afrique*. Paris: Herscher, 1984.

Rodger, George. *The Blitz – The Photography of George Rodger*. London: Viking, 1990.

Rodger, George. *Desert Journey*. London: Cresset Press, 1943.

Rodger, George. *This England*. Washington, DC: *National Geographic*, 1966.

Rodger, George. *Far on the Ringing Plains*. New York: Macmillan, 1943.

Rodger, George. *Red Moon Rising*. London: Cresset Press, 1943.

Rodger, George. *Le Village des Noubas*. Paris: Robert Delpire, 1955.

Rodger, George, with Campbell, Judith. *World of the Horse*. London and New York: Octopus and Ridge Press, 1975.

Books with biographies or chapters on George Rodger

Boot, Chris. *Great Photographers of World War II*. New York: Crescent Books, 1993.

Elson, R T (ed). *The World of Time Inc.*. New York: Time Inc., 1973.

Gernsheim, Helmut. *History of Photography*. London: Thames & Hudson, 1965.

Hill and Cooper. *Dialogue with Photography*. New York: Farrar, Straus & Giroux, 1979.

Lewinski, Jorge. *The Camera at War*. London: W H Allen, 1978.

Naggar, Carole. *Dictionnaire des Photographes*. Paris: Seuil, 1982.

Naylor, Colin (ed). *Contemporary Photographers*. Chicago and London: St James Press, 1970 and 1988.

Porter, Alan. *Camera die 50er Jahre*. Munich: Bucher Pub., 1982.

Time & Life Books. *World War II: War in the Desert*. Alexandria: Time Inc., 1977.

Time & Life Books. *World War II: War on the Outposts*. Alexandria: Time Inc., 1980.

Articles

'75,000 Miles'. *Life*, vol. 13, no. 6, 10 August 1942.

'Random Thoughts by a Founding Father'. *Creative Camera*, March 1969.

'George Rodger'. *Album* (UK), no. 8, 1970.

'Souvenirs en vrac d'un membre fondateur de Magnum'. *Reporter* (Paris), no. 10, 1973.

Keen, Peter. 'George Rodger'. *The Photographic Journal* (Royal Photographic Society), September 1974.

'George Rodger'. *Fotografia Italiana*. October 1974.

'Magnum – Image and Reality'. *35mm Photography*, September 1976.

'L'Afrique de George Rodger'. *Photo* (Paris), 1984.

'A Brut Secret'. *Dunkirk* catalogue, 1985.

'George Rodger'. *Le Photographe*, no. 1.368, June 1985.

'Desert Journey'. *Creative Camera*, summer 1985.

'George Rodger'. *Photo* (Amsterdam), May 1986.

'Photographer for Life'. *Cyprus Life*, June 1986.

'Rodger's Vanishing Africa'. *Reader's Digest*, September 1987.

'George Rodger'. *Photography Magazine* (UK), October 1987.

'Power, Dignity and Racism?'. *Creative Camera* (UK), November 1987.

'The Inveterate George Rodger'. *World Magazine* (UK), February 1988.

'Master of His Art'. *Kent Life* (UK), March 1988.

Interview with George Rodger. *Focus* (Amsterdam), July-August 1988.

Clement, James. 'View from the Top'. *British Journal of Photography*, September-October 1989.

Review of Founders' Exhibition. *New York Times*, November 1989.

Calado, Jorge. 'Magnum Opus'. *Espresso* (Portugal), 7 April 1990.

'Le Blitz à la Bastille'. *Photo* (Paris), June 1990.

Cross, Robin. 'Living Through the Blitz'. *Telegraph Magazine*, 21 July 1990.

Case, Brian. 'Putting on the Blitz'. *Time Out*, 15-22 August 1990.

Hopkinson, Amanda. Untitled statement. *Photography Magazine*, October 1990.

One-Man Exhibitions

1974 Photographers' Gallery, London

1975 Canterbury City Library (*Photographer for Life*)

1978 University of South Africa (*Tribal Africa*)

1979 Photographers' Gallery, London, FNAC Montparnasse, Paris, and tour to FNAC Galleries (*Masai Moran*)

1982 Festival Africain, Musée Grenoble (*L'Afrique de Rodger*)

 Contrast Gallery, London

 Photogallery, St Leonard's-on-Sea, and UK tour (*London Faces the Blitz*)

1984 Magnum Gallery, Paris, and Espace Image Gallery, Marseilles (*Tribal Africa*)

1985 Ecole Régionale des Beaux-Arts, Dunkirk (*Tribal Africa*)

1985–6 FNAC Montparnasse, Paris, and tour (*Tribal Africa*)

1986 Amsterdam Foto (*Fifty photos from the 50s*)

 Musée des Beaux-Arts, Angoulême, France (*Tribal Africa*)

 Cyprus National Bank, Nicosia and Limassol (*Retrospective: George Rodger the World Over*)

1987 Photographers' Gallery, London

1988 Mid-Pennine Arts, Burnley, Metropole, Folkestone, and Anthropological Museum, University of Aberdeen (*Retrospective*)

1989 Oriel Clwyd, Wrexham, Bolton Art Gallery, and Wakefield Art Gallery (*Retrospective*)

1990 Musée d'Elysées, Lausanne, Musée de la Photographie, Charleroi, Belgium, Astley-Cheetham Gallery, Stalybridge, and Stockport Arts Centre (*Retrospective*)

 Picto at Bastille, Paris, National Museum of Film, Photography and TV, Bradford, and Navy Museum, Washington, DC (*The Blitz*)

 Le Port, Réunion (*Africa*)

1991 Guillaume Gallozzi Gallery, New York (*The Blitz*)

 Portfolio Gallery, Edinburgh (*Retrospective*)

 Bretagne 9th Festival Photographe, Lorient (*Africa*)

1992 Churchill House, London (*Winston Churchill: Britain at War* – permanent exhibition)

1993 Kent Institute of Art and Design, Maidstone and Rochester, and Vision Gallery, San Francisco (*Retrospective*)

1994 Lichtbild Gallery, Bremen, University of Kent, and Royal Photographic Society, Bath (*Retrospective*)

Group Exhibitions

1955 Museum of Modern Art, New York, and world tour (*Family of Man*)

1970 British Council tour in UK and abroad (*Personal Views: 1850–1970*)

1980 Tour in USA and abroad (*Life: The First Decade*)

 Saint-Ursanne Gallery, Switzerland (*Magnum Photos*)

1982 Keflex Collection, Hamilton Gallery, London (*Kindness*)

 Trocadéro, Paris (*La Déportation: 1933–1945* [Life])

1985 Moscow, and tour in USSR (*Peace to the World*)

1987 FNAC, Montparnasse, and tour (*South Africa*)

 National Museum of Film, Photography and TV, Bradford, and Science Museum, London (*Image of the Train*)

 Centre Saidye Bronfman, Montreal, and tour in Canada (*Realities Revisited*)

1989 Barbican Art Gallery, London (*Through the Looking Glass*)

 New York ICP Gallery, Uptown, Palais de Tokyo, Paris, and Hayward Gallery, London (*Magnum Founders: In Our Time – 50 Years as seen by Magnum*)

1990 Manchester City Art Gallery (*Through the Looking Glass*)

1991 Portfolio, London, Pace McGill, New York, Fahey/Klein, Los Angeles, and Parco, Japan (*Year of Tibet*)

1990–93 Magnum exhibition on tour in USA, Europe and Far East

Lectures

1976 Arles, France (*Africa*)

1984 Museum of London (*London – 1940*)

1989 National Museum of Film, Photography and TV, Bradford (*Makers of Photographic History – The Life and Times of Picture Post*)

 Guest of Photojournalism Festival at Perpignan, France (*Interview*)

 New York ICP Gallery, Uptown (Master seminar with slides)

 New York ICP Gallery, Uptown (*A Backward Glance*)

1990 Hayward Gallery, London (Talk with slides)

 Museum of London (*The Blitz*)

1993 Royal Photographic Society, Bath (Talk with slides)

Television and Videos

1975 Italian State Television (RAI), Milan

1977 BBC *Omnibus* (with Eugene Smith, Don McCullum and Bruce Davidson)

1987 Plateau Prods. Ltd. Video directed by Noel Chanan (*George Rodger*)

1989 BBC 3-part series on Magnum Photos

 BBC series on photography. (*Part 1: War Photographers*)

 New York CBS interview on *Sunday Morning News*

1992 BBC documentary (*War and Peace: Stains of War*)

1994 Border Television documentary on George Rodger

Awards

1985 First prize at *Peace in the World* exhibition in Moscow

1993 Fellow of Kent Institute of Art and Design (Honorary)

 Fellow of Royal Photographic Society (Honorary)

1994 D Litt (Kent) (Honorary)

1972, England
George Rodger's sons Jon and Peter

Acknowledgements

This book grew like a tree.

The seed was sown in Japan by Hiroji Kubota and Junko Ogawa.

I would like to thank Hiroji and Junko for sowing that seed.

As a sapling the tree travelled far – New York, Germany and France – but it failed to take root and it was not until it reached the fertile soil of England that it grew and finally blossomed. Thanks to many helpers it never faltered in its growth and I would like to offer my heartfelt thanks to the whole staff of Magnum Photos, London, each one of whom helped in one way or another. Chris Boot co-ordinated the whole production; John Easterby battled with the negatives and Glen Brent, with unparalleled skill, produced fabulous prints from 50-year-old negatives, many of which were sadly ravaged by time, desert sand and tropical boll weevils.

My special gratitude goes to Peter Marlow, whose enthusiasm inspired us all; for his editing and sub-editing of thousands of contact prints. Also to Bruce Bernard who sifted through reams of letters, diaries, wartime notes and cables to condense my life into 25 pages. And to Henri Cartier-Bresson for his foreword and his friendship.

I would like to thank Jinx, my wife, for proof-reading, checking, captioning and selecting negatives into many a midnight hour; Jonathan, my son, for leaving his job to proof-print for me, and my son, Peter, for his constant encouragement.

Further afield and further back into wartime years, I would like to thank all those nameless legions of so many races who helped me on my way, but especially my driver and friend Dick Stratford who covered me with his rifle when I was in danger. But for his unerring aim there would have been nothing to write about.

I would also like to thank the team at Phaidon and the editors of *Life* for allowing me the use of their copyright pictures.

George Rodger
February 1994

Phaidon Press Limited
140 Kensington Church St
London W8 4BN

First published 1994
© Phaidon Press 1994
© Photographs George
Rodger 1994, Magnum
Photos, except for photos
on pages 12 (top), 13, 42,
97 (top), 98-133, 135-148,
150-154, 162-167 and
169-177 which are courtesy
of Life © Time Inc.

A CIP catalogue record for
this book is available from
the British Library

ISBN 0 7148 3165 4 (hb)
ISBN 0 7148 3295 2 (pb)

Printed in Hong Kong